NEW SILENT (

With the success of Martin Scorsese's *Hugo* (2011) and Michel Hazanavicius's *The Artist* (2011) nothing seems more contemporary in recent film than the styles, forms, and histories of early and silent cinemas. This collection considers the latest return to silent film alongside the larger historical field of visual repetitions and affective currents that wind their way through twentieth- and twenty-first-century visual cultures. Contributors bring together several fields of research, including early and silent cinema studies, experimental and new media, historical and archive theories, and studies of media ontology and epistemology. Chapters link the methods, concerns, and concepts of early and silent film studies as they have flourished over the last quarter century to the most recent developments in digital culture, recasting this contemporary phenomenon against key debates and concepts in silent film scholarship. An interview with acclaimed Canadian filmmaker Guy Maddin closes the collection.

Paul Flaig is Lecturer of Film and Visual Culture at the University of Aberdeen. His articles have appeared in *Cinema Journal, Screen, a: the journal of culture and the unconscious, The Brecht Year Book* as well as several edited collections.

Katherine Groo is Lecturer of Film and Visual Culture at the University of Aberdeen and Co-Director of the George Washington Wilson Centre for Visual Culture. Her articles have appeared in *Cinema Journal, Framework,* and *Frames.*

Previously published in the AFI Film Readers series
Edited by Edward Branigan and Charles Wolfe

NEW SILENT CINEMA

EDITED BY

PAUL FLAIG AND KATHERINE GROO

Routledge
Taylor & Francis Group

NEW YORK AND LONDON

First published 2016
by Routledge
711 Third Avenue, New York, NY 10017

and by Routledge
2 Park Square, Milton Park, Abingdon, Oxon OX14 4RN

Routledge is an imprint of the Taylor & Francis Group, an informa business

Library of Congress Cataloging-in-Publication Data
New silent cinema / edited by Paul Flaig and Katherine Groo.
 pages cm — (AFI film readers)
 Includes bibliographical references and index.
 1. Motion pictures—History and criticism. 2. Silent films—History
and criticism. 3. Motion picture film—Preservation. 4. Experimental
films—History and cricism. 5. Motion picture industry—
Technological innovations. 6. Mass media—Technological
innovations. 7. Digital media—History—21st century. 8. Motion
picture producers and directors—Interviews. I. Flaig, Paul, editor.
II. Groo, Katherine, editor.
 PN1995.N389 2015
 791.4309—dc23
 2015010356

ISBN: 978-0-415-73525-4 (hbk)
ISBN: 978-0-415-73527-8 (pbk)
ISBN: 978-1-315-81929-7 (ebk)

Typeset in Spectrum
by Apex CoVantage, LLC

contents

contents

figures

figures

introduction

celluloid specters, digital

anachronisms

p a u l f l a i g a n d k a t h e r i n e g r o o

At the 2012 Academy Awards, two films dominated the competition, both of which summoned the specters of silent cinema. Martin Scorsese's *Hugo* (2011) and Michel Hazanavicius's *The Artist* (2011) won four Oscars each, with the latter congratulated in Hollywood's trade press as "the first silent movie in 83 years to claim [best picture]."[1] Beyond their box office and industry successes, both works offer their own allegories for how we might remember films of the silent past amid the ascendancy of digital forms of production, exhibition, and restoration. *Hugo* illustrates the importance of early film preservation by turning to the figure of an elderly Georges Méliès, haunted by his prior cinematic achievements; *The Artist*'s title character, former movie idol George Valentin, embraces the future of sound film through the redeeming love of a talkies starlet. While Scorsese looks longingly to cinema's past through 3D glasses, Hazanavicius tells his Hollywood tale through the anachronistic conventions of 1920s American melodrama. Both films further share a cinephilic fondness for citing the genres, icons, and attractions of other moving-image eras. *Hugo* references the comedy of Lloyd and Clair; the Dadaism of Ray and Léger; and a filmic

modernism suggested by the brief appearances of Joyce and Dali. Hazanavicius leaps beyond the silent era in his adherence to the 1930 Hays Code; a climactic citation of Herrmann's *Vertigo* (Hitchcock, 1958) score; and an obvious debt to the plot of *Singin' in the Rain* (Donen and Kelly, 1952). Both Valentin and Méliès are showmen of silent cinema, haunted by their former careers. But they are also ghosts, anachronisms from another moving image era. They haunt their diegetic audiences in the 1930s as well as twenty-first-century spectators.

Journalists, critics, and scholars have speculated about the coincident successes of *Hugo* and *The Artist*, and about what this renewed interest in silent cinema might have to say about contemporary visual cultures. For Geoffrey O'Brien, *Hugo* and *The Artist* conjured "the ghost of silent film" "as if to acknowledge the most significant sea change in filmmaking, exhibition, and preservation since the end of the silent era."[2] Others, like David Denby, have asked whether these films might encourage popular interest in the now distant era of silent cinema, what the *New Yorker* critic calls "another country" with "another language."[3] Whatever its causes or effects, recent world cinema continues to communicate in this exotic "language." Examples include the silent Spanish fairytale, *Blancanieves* (Berger, 2012); a creative projection of F.W. Murnau and Robert Flaherty's *Tabu* (1931) onto Portugal's colonial past in *Tabu* (Gomes, 2012); and Leo Carax's *Holy Motors* (2012), which begins with a screening of King Vidor's *The Crowd* (1927) and ends with images from Étienne Jules-Marey's chronophotography. Considering both the visibility and diversity of these efforts, nothing seems more contemporary in recent film than the anachronisms of silent cinema.[4]

Despite the seeming foreignness of silent film and its recent appearance in popular cinema, a process of making film's first decades visible has been under way for decades. These efforts have been led by filmmakers, artists, archivists, restorers, collectors, fans, and scholars intent on preserving, thinking, and reimagining the silent era. Indeed, *Hugo* and *The Artist* are only the most visible instances of a broader impulse to make silent cinema "new" at various moments in film and media history, an impulse perhaps as old as the historiographic categories of *silent* or *early* cinemas themselves. Yet these returns remain tied to ever-changing technological and cultural forms of representation, whether that includes the painstaking restoration of Méliès's hand-tinted *A Voyage to the Moon* (1902) (or its score by French electronic pop duo Air), the increasing availability of digitally transferred silent works, or the numerous major and minor cinematic projects, archival re-mixes, literary counter-histories, new media experiments, film festivals, and scholarly endeavors that recall early and silent cinemas in content, form, or analysis.

Inspired in part by the popularity and visibility of these many appeals to film's first decades, *New Silent Cinema* offers a timely set of meditations for

a phenomenon that is all too untimely. The essays collected here examine the present moment of digital anachronism—wherein the most contemporary of media are haunted by celluloid specters—through a diverse series of images, texts, and concepts spanning film history. Instead of thinking of that history in terms of a one-way, teleological street of origin and end, the contributors to this volume consistently emphasize the crucial space between these terms, the vertiginous ground upon which the past is seen in the present, the present in the past. Linking the methods and concerns of early and silent film studies as they have flourished over the last quarter century to recent developments in digital culture, this collection animates the study of moving images by moving across the threshold of their definition, that is, the limit of what is historically or theoretically proper to them. As our two anecdotal examples suggest, new silent cinema cannot help but engage a host of other periods in film history, not to mention a range of medial or textual references and forms. As we will outline in this introduction, *New Silent Cinema* understands its title subject as a dialectic of seemingly distinct or even contradictory media and media histories, encompassing a range of disjunctive categories and playfully creative concepts: specter and séance, archive and database, dialectical image and double exposure, re-mix and found memory, early and late, the untimely and the anachronistic, etc.

"Parallax view" is one other such category. As one of this volume's contributors, Catherine Russell, has described it, such a view is a parallel that exceeds the merely analogical, a comparative shift in perspective across eras in film history.[5] Russell's contribution to *New Silent Cinema*, "*Paris 1900*: Archiveology and the Compilation Film," fittingly exemplifies this parallax approach. She turns to Nicole Védrès's *Paris 1900* (1947) as an early instance of early film returns and an example of what she calls "archiveology," a term born out of the collage practices of the 1990s. For Russell, Védrès's film moves backwards to the first years of film practice, recalling another "parallax view" of moribund yet prescient media: Walter Benjamin's dialectical images of emerging commodity cultures. Yet Russell also looks forward, connecting Benjamin's redemptive appropriation of nineteenth-century utopias to the mid-century montage of *Paris 1900* as well as contemporary media archaeologies.

As Russell's analysis of *Paris 1900* suggests, the essays in this collection locate contemporary interest in early and silent cinemas within a long trajectory of nostalgia and curiosity. Already in the 1920s, with the development and dissemination of so-called "classical" Hollywood film as well as more artistically ambitious or innovative works, many longed for the bygone days of early film. In Germany, Carlo Mierendorff bemoaned the increasing seriousness of cinema and appealed to the "sensation" of old adventure serials and rude slapstick while modernists in England screened films from cinema's first decade and longed for a return to the

"primitives."[6] Each new event or innovation in cinema's technology, style or, production—each new present—brought with it a mourning for the past, for what had been lost, or alternatively an often facile celebration of the new. Indeed Hollywood often turned to silent cinema as a means of celebrating and mythologizing its most recent self: *Hollywood Cavalcade*, for example, (Cummings, 1939) promotes Technicolor in its retelling of the transition to synchronized sound; and *Sunset Boulevard* (Wilder, 1950) reflects on rapidly changing industries and competing platforms like television as it evokes silent film styles and stars. Television would itself play a role in disseminating film history, often taking advantage of lapses in copyright to show battered and re-edited silent films to young spectators, many of whom were encountering these images for the first time. These films register the present through recourse to the past. Indeed neither one is legible without the other. Offering the anachronistic pleasures of a pianola (not to mention the performance of a fading Hollywood star), Marlene Dietrich's Tana, in *Touch of Evil* (Welles, 1958), suggests something of this parallax: "The customers go for it—it's so old, it's new. We got the television too. We run movies. What can I offer you?"

Refusing or ignoring Hollywood's over-determined separation of old and new, mid-century cinephiles and New Wave filmmakers found kindred spirits and inspiring experiments in the age of cinema's childhood, deploying antiquated techniques and quoting long-forgotten scenes. They paid tribute to actresses like Renée Falconetti and Louise Brooks, filmmakers like F.W. Murnau or D.W. Griffith, and critics like Lotte Eisner. In this they were aided in no small part by the increasing viewability of silent films in archives, museums, and clubs. In the aftermath of the Nouvelle Vague, Jean-Luc Godard lumped the rise of talkies and television together; both allowed governments and movie studios to cynically "harness the extraordinary power [*extraordinaire puissance*] that was brought by silent film," a "power" owing to its popularity among the masses.[7] This familiar tale, told by classical film theorists in the 1930s like Rudolf Arnheim and echoed decades later by critics like Raymond Bellour and Susan Sontag, casts the coming of sound as the eclipse of cinema's relationship to a "mass subject" as well as its aesthetic potential for "brilliance and poetry."[8] The notion of silent or early cinema as a lost age of creativity and political potential before the fall into classical Hollywood cinema and sound (the two become synonymous) has been well debunked by film historians. Indeed, in the same year as Godard's mournful pronouncement, Noël Burch found in American television's emphasis on short forms and spectatorial distraction "a return to the days of the nickelodeon" and a "veritable turning back of the clock."[9] Both ironically sparked the scholar's own mourning for classical diegesis.[10] Following Burch, these returns undermine the myths offered by both Hollywood and those cinephiles mourning film's fall from silent grace. Like Tana's pianola or television set, all media forms and figures are

capable of becoming "so old, they're new": objects simultaneously lost, found, and renewable against the present's becoming.

The retrospective video-montage of Godard's *Histoire(s) du Cinema* (1989) and the call for resurrection in Sontag's essay—tellingly entitled "A Century of Cinema"—found their cinematic contemporaries at the turn of the twenty-first century, as new generations of filmmakers turned to the forms and histories of silent film. Some, like *Hugo*, told or invented stories of famous stars, movies, or cinematic origins and re-births: *Once Upon a Time, Cinema* (Makhmalbaf, 1992), *Centre Stage* (Kwan, 1992), *Chaplin* (Attenborough, 1992), *A Trick of Light* (Wenders, 1995), *Forgotten Silver* (Jackson, 1995), *Irma Vep* (Assayas, 1996), *Shadow of the Vampire* (Merhige, 2000), *The Cat's Meow* (Bogdanovich, 2001), *The Fall* (Singh, 2006), or *Silent Life* (Kozlov, 2015). Others, anticipating *The Artist* and *Blancanieves*, re-worked contemporary or historical narratives through the stylistic conventions of silent film: *Sidewalk Stories* (Lane, 1989), *Lumière and Company* (1995), *Juha* (Kaurismäki, 1999), *Tuvalu* (Helmer, 1999), *The Call of Cthulhu* (Leman, 2005), *Three Times* (Hou, 2005), *Dr. Plonk* (de Heer, 2007), and *In the Shadow of the Maggot* (Bock, 2010). This is not to mention the countless films playing more loosely with silent film conventions or citations, recalling genres like slapstick, styles like German expressionism, or the performance modes and editing rhythms of American melodrama. Whether approaching early films through historical invention or as "formats" by which to view past or present, these films are only the most recent iterations of new silent cinema, which stretches from the early 1930s to our latest *fin de siècle*.[11]

Several essays in *New Silent Cinema* focus on recent attempts to narrate figures and forms from silent film history. Through a close reading of *Hugo*, Constance Balides argues that Scorsese's film offers not only a fictionalized history of early cinema's re-discovery, but its own historiographic writing of cinematic past lives. Whether through 3D effect, proliferating allusion, or transformation of film archive into database, *Hugo*, Balides suggests, offers its viewers lessons in a non-linear, recursive film history. In "*After Life*, Early Cinema: Remaking the Past with Hirokazu Kore-eda," Jonah Corne approaches the Japanese filmmaker's 1998 film as an exploration of human memory inextricably tied to memories on and as film. *After Life*'s recently deceased characters are required to cinematically recreate their most precious memory of life, which they will then watch for a posthumous eternity. Recreation is also a kind of "decreation," as Corne explores the numerous ways attractions and sensations of early cinema are resurrected by *After Life*'s characters as well as by the film's own mingling of celluloid, video, and other screen memories. In "Playback, Play-forward: Anna May Wong in Double Exposure," Yiman Wang curates a diverse series of media reflections of the Chinese-American actress, whose career in silent and early sound cinemas stretched from the United States to Europe. Focusing on both documentary and installation re-mixes of Wong's performances

and encounters (including an interview with Walter Benjamin in 1928), Wang traces transnational and intra-historical re-mediations of the actress, critically linking ethno-sexual stereotypes at work in the 1920s and '30s with those circulating in contemporary media landscapes.

Avant-garde filmmakers and artists likewise point to ways of winding the gears of Burch's "clock" back to their supposed zero hour. Some of the most important structural filmmakers and experimental artists of the sixties and seventies (especially Hollis Frampton, Ernie Gehr, Marie Menken, Thom Anderson, Malcolm Le Grice, Samuel Beckett, Yvonne Rainer, and Peter Kubelka) followed in the footsteps of earlier avant-gardists (e.g., René Clair, Joseph Cornell, Bruce Conner, and Stan Brakhage) by re-examining the essential forms and materials inaugurated in the playful laboratories of film pioneers. Bypassing or resisting canonical modes of cinematic grammar or representation, many of these filmmakers are still active today and have inspired or often taught new generations of artists for whom silent cinema has likewise become a way to, in Bart Testa's words, "remove the accretions accumulated by cinema through its history."[12] Indeed, early and silent film has been used as a kind of primary material for the recuperative practices of recycled, found footage, and remix cinemas, as well as the experiments of digital, video, and analog artists like Martin Arnold, Zoe Beloff, Katharina Gruzei, Oleg Kovalov, Les Leveque, Chris Marker, Steve McQueen, Jennifer Reeves, Peter Tscherkassky, Eve Heller, DJ Spooky, and Sandra Gibson and Luis Recoder (among many others). This diffuse history suggests one of the motivating questions at work in several essays in this collection: what is the relationship between the various "formats" associated with celluloid film and their adaptation or re-functioning across epochs? Do the trappings of celluloid—the graininess of the image, the aspect ratio of the frame, the location or movement of the camera, the style of performance, or the site of reception—reify the legacy of silent cinema, harden its history into a set of clichés to be superficially cited? Against this enclosure, the avant-garde experiments analyzed here demonstrate that legacy's contingency and adaptability and, in doing so, reveal the capacity of contemporary visual culture to be otherwise. Early cinema thus seems to trouble the most basic understanding of the avant-garde as advance guard, as emblem and proclaimer of the new.

Tom Gunning was one of the first to speculate about the synergies between early cinema and the avant-garde.[13] Both, he argues, produce non-narrative forms of expression and participate in exhibitionist modes of display. At the time of his writing (in the early 1980s), Gunning's argument required a "dubious leap of faith" over an historical abyss of many decades. He describes the relationship between early cinema and the avant-garde as "pseudomorphic," which implies a resemblance between two phenomena based upon a deception: "The relationship of a pseudomorphic to an authentic paradigm is that of a counterfeit to an original."[14] On the one

hand, this concept offers Gunning some cover as he takes a major intellectual and historical leap. He reassures his readers that the early image and the avant-garde *are not the same*. On the other hand, the suggestion of a pseudomorphic relationship troubles the stability of both visual phenomena. Importantly, Gunning never clarifies which is the original or authentic paradigm and which is the pseudomorphic counterfeit. The simulacral energy slides between early cinema and the avant-garde, joined as they are by resemblance. By his own account, Gunning saw early cinema anew retroactively, that is, only *after* he had encountered the work of Ernie Gehr, Hollis Frampton, and Ken Jacobs. In the decades following Gunning's intervention, the complexity of this relationship has been largely set aside. It has been displaced by the concept of "attraction," which has been deployed as a kind of catch-all for any and all non-narrative thrills or surprises. The attraction thereby becomes the common ancestor and the antecedent, an artifact of another place and time in a historiography of narrative lines and continuous time. Put another way, a key concept for resisting or refusing narrative ironically submits to an increasingly told story, one with very few surprises.[15]

This collection returns to the pseudomorphic—a conceptual cousin of parallax—and interrogates the very ground by which an image or form (say, attraction) might be compared or connected across periods. Several contributors examine the intersection between the first decades of cinema and the avant-garde, exploring the complex temporal and material concerns that emerge between these moments and modes of film practice. Jennifer Lynn Peterson's essay, "The Life Cycle of an Analog Medium: Tacita Dean's FILM," teases out the tensions intrinsic to Dean's monumental, museum-installed love letter to analog film and the genres of early cinema. Drawing upon her own interviews with the British experimental artist, Peterson argues that *FILM* not only belongs to the digital era, but also depends upon digital images and platforms in its visual afterlife. Brianne Cohen examines two experiments by Harun Farocki: *On the Construction of Griffith's Films* (2006) and *In-Formation* (2005). Both projects encourage a comparative reading of the first decades of the twentieth and twenty-first centuries, including the encyclopedic impulses that define both eras of image production. In "Found Memories of Film History: Industry in a Post-Industrial World, Cinema in a Post-Filmic Age," Brian R. Jacobson counterposes the concept of "found memories" against the broad and undifferentiated category of the "remake." For Jacobson, "found memories" represent ideas from early film history, rather than specific images, objects, or locations. His essay takes Sharon Lockhart's found footage practice as an exemplary model of the concept, one that generates new ways of remembering the intersecting histories of industrial labor and moving images.

Private and national film archives have participated in the revival of early and silent cinema as well. Over the last two decades, film archives

have begun to shift their collections from analog to digital formats and to negotiate the contemporary proliferation of social media, digital video, and remix culture. Thousands of early and silent-era films are available online through the YouTube pages of the British Film Institute, British Pathé, the Library of Congress, and born-digital platforms like archive.org. In 2013, the Media History and Digital Library, directed by David Pierce and Eric Hoyt, launched *Lantern*, a visual database of magazines and journals, with an emphasis on rare resources from the first decades of the twentieth century. Numerous silent film archives have consolidated their online presence through digital consortiums like the *European Film Gateway*, a multi-language platform initiated by the Association des Cinémathèques Européennes and the Europeana Foundation with contributions from twenty-five European archives; and *Images for the Future*, a project that brings together four Dutch visual archives for the express purpose of transferring digitized content to the public. In 2012, *Images for the Future* launched Celluloid Remix, a (now annual) competition that invites the public to recombine silent film fragments from their collections.

These new resources are fundamentally changing how film scholars conduct research and teach film history. In the twenty-first century, many of the obstacles to accessing early and silent film have been removed, perhaps taking with them the archival mythologies that defined the field in the 1980s and '90s. Following these mixtures and migrations, both the content and the concept of the archive have entered an era of tremendous upheaval and change. In making significant portions of their collections instantly accessible, streamable, and downloadable, many archival institutions have embraced an altogether different approach to preservation, one that includes the flexible reformation of film material and film history. These new archival structures likewise blur the national and geographic boundaries between institutions as they recast silent cinema for a global generation of users (rather than on-site viewers). The transformations in what film artifacts are and where they are located have prompted film scholars and curators to consider what difference the digital makes. Does the experience of viewing a digital copy online approximate the experience of viewing the original film in an archive? Do we have obligations (ethical or otherwise) to seek out these archival experiences?[16] Recent scholarship in archival studies has also rigorously explored issues of archival access and preservation in the twenty-first century (i.e. what these changes mean for the actual enterprise of maintaining an archive), especially as this century changes our relationship to experimental cinema and other historically marginalized forms of film practice.[17] In this collection, we extend the conversation to early and silent cinema but we also consider the relationship *between* archival processes and archivable forms, between the structures of the archive and silent cinema. As Jacques Derrida suggests in his seminal writing on the archive, "Archivization produces as much as it records the event."[18]

In our view, the visual past resurfaces and repeats with a difference. It produces a site of mutual exchange and transformation, troubling the stability of objects and origins with deliberate anachronisms and, in turn, posing crucial questions to both film history and theory. What do these digital returns and revisions do to and for the "original" film image? What new or forgotten ontologies and epistemologies take shape in this encounter between past and present, physical and virtual? What kind of histories do these works narrate, repeat, or occlude? And where does the returned, remixed, or recycled belong in the archive of silent cinema? These works straddle distinct times, technologies, and visual practices, at once challenging the historical and historiographic hermeticism of early and silent film studies as well as the concepts (e.g. attraction, monstration, narrativity, medium-specificity, modernity, etc.) that have dominated debates within it.

While archival and historiographic considerations surface in nearly every contribution to the collection, three essays offer a sustained engagement with these concerns. In her essay, "Alice in the Archives," Katherine Groo argues that contemporary archives of early cinema engage in processes of disclosure whereby the physical artifacts and archival infrastructure of the twentieth-century archive are made visible in their digital re-presentation. Brian Price's essay, "Eternally Early" reflects on the incoherence of the temporal categories we rely upon to divide and categorize history: early and late, before and after, younger and older. Price pivots from a provocative reading of Plato's *Parmenides* to consider the figures of "eternalism" that shape Ken Jacobs's *What Happened on 23rd Street in 1901* and, in turn, reshape our understanding of film history. In "Supposing that the Archive Is a Woman," Paul Flaig brings the Freudian concept of "endopsychic perception" into contact with found footage works by Bill Morrison and Gustav Deutsch. Flaig traces the many figures of women that circulate in both theories of the archival and experiments with film archives. He insists that we read the materiality of these archival formations against the fantasies of female corporeality at work in histories, ontologies, and archaeologies of technological vision.

One further aim of this book is to unsettle many of the stark divisions that have characterized recent theoretical investigations of cinematic or digital ontologies. Writing about the contemporary interest in early cinema, Mary Ann Doane observes, "A certain nostalgia for cinema precedes its 'death.' One doesn't—and can't—love the televisual or the digital in quite the same way. It is as though the aim of theory were to delineate more precisely the contours of an object at the moment of its historical demise."[19] Doane's work has contributed to a surge of scholarly (and even popular) interest in the "death" of cinema that followed in the wake of the centennial of the Lumière *cinématographe* in 1995 and the turn of the twenty-first century.[20] The coincidence of the digital—its arrival at the

end of just one hundred years of cinema—creates a set of tidy historical markers and a narrative with a clear beginning and end. Celluloid belongs to the twentieth century, while the twenty-first promises something new. While one might further fix the contours of cinema in a variety of ways—indexicality, finitude, granularity, or a cinephilic "That's not it" in light of Digital Cinema Packages (DCP)—every break between media betrays unspoken repetitions. One of the most astute ontologists of the moving image, David Rodowick, begins and ends his *Virtual Life of Film* with reference to the uncanny echo of cinema's origin in the present moment of all things digital, stating that "the old (cinematic) and the new (electronic and digital) media find themselves in a curious genealogical mélange whose chronology is by no means simple or self-evident."[21] Examining this mélange in all its specificity and dialectical criss-cross is the very task of this collection.

Yet Rodowick's point needs to be taken further. Scholars have a lot to learn from earlier debuts of "new" media, especially as these ancestral events challenge the concept of the new. In one of her last published texts, Miriam Hansen points to the important lesson offered by early cinema's development out of proto-cinematic devices, popular or folk cultures, and various ethnic, gender, or class dynamics. She states that cinema was "itself once a new medium that cannibalized older media and traditions, its very impurity and liminality would allow us to experience our own present as a historical threshold."[22] The point then is not to find some original or ontological essence to film, but rather to find slippages in the beginnings and endings of different media regimes or apparatuses, returns and continuities against the very difference suggested by periodization or technique. This is especially urgent in the burgeoning field of media archaelogy as scholars like Jussi Parikka "thin[k] the new and the old in parallel lines" through so-called "zombie media."[23]

Returning to debates among filmmakers and intellectuals concerning the nature of the cinema during its first decade, we find precedents for contemporary discussions about the simulated nature of digital imagery. For example, there are the first reflections on film by philosophers like Georg Lukacs who celebrated the artificial fantasies of cinema against the immediate reality or "presence" of the theater.[24] This example suggests not only that we have much to learn from prior iterations of such debates, but also that such iteration itself undermines the supposed singularity of the digital present beyond its many past lives. After all, the claim of a total break was endemic to discussions of film at the turn of the century. In contrast to the cinephile's nostalgia, the essays here focus on figures and works that neither mourn nor bury the dead, but instead welcome its haunting, an uncanny revival of something different yet strangely familiar.

While scholars like Rodowick, Hansen, Doane, and others have all pointed to the difficulty of this contemporary *déjà vu*, all of the contributions

to this collection take this difficult mixture of times and technologies as their central concern.[25] The challenge of such a task owes to these works' inherent slipperiness as objects of exhibition, reception, and study. Just as early cinema itself developed out of a confluence of cultures and technologies so, too, do its contemporary specters cross boundaries, moving from analog index to streaming video, international film festivals to the art gallery's white cube. Musicians ranging from Giorgio Moroder to Michael Nyman to Dave Douglas have sonically informed audiences' twenty-first-century experiences of film history. Novelists like Steve Erickson, Glen David Gold, Jerry Stahl, and Paul Auster fabricate secret histories of lost films and once brilliant stars. Dominick Argento has transformed Rudolf Valentino's melodramatic life into an opera. Designer John Galliano turned to the antiquated styles of Chaplin, Keaton, and Linder for his 2011 line of men's clothes. Zaghreb's *PSSST! Silent Film Festival* includes a competition section for contemporary silent films. Sequences from the films of Chaplin and Lloyd are being converted into 3D—perhaps following *Hugo*'s lead—with the famous clock sequence from the latter's *Safety Last* one of the first to gain digital depth. That scene, in turn, plays a crucial role in another recent blockbuster: Christian Marclay's *The Clock* (2010), where it occupies a prime position in this twenty-four hour montage of cinema's obsession with taking and telling time. These creative reformations of silent cinema also extend well beyond professional practice. With apps like *8mm*, *Silent Film Studio*, or *Vintagio*, websites like *The Artistifier*, or the basic filters of a video-editing suite, anyone with a smartphone or laptop can transform digital images into sepia-toned, scratched, and faded stereotypes of filmic antiquity.

Several essays here track this medial proliferation of early cinema beyond celluloid, image, or the cinematic. In "Cross-Medial Afterlives: The Film Archive in Contemporary Fiction," Joshua Yumibe suggests an important intersection between literary and cinematic anxieties concerning digital transformations of word, image, and world. Constellating novels by Theodore Roszak, W.G. Sebald, and Susan Daitch in light of the archive's literary portrayal and digital conversion, Yumibe argues against an all too tempting nostalgia for fragile celluloid. He finds in these cross-medial encounters diverse strategies for reassembling the past through both narrative form and allegorical reflection. Drawing on media archaeological methods, Rob King traces connections between early comic films and unintentionally laughable online videos in "Laughter in an Ungoverned Sphere: Actuality Humor in Early Cinema and Web 2.0." King nimbly charts a technologically induced pattern of user-based humor from early cinematic forms to online viewing habits, a historically zigzagging "counterforce" to mass cultural, narrative-centered comedy. Finally, James Leo Cahill approaches ever-proliferating intersections of old cinema and new media through the medieval, alphabetic form of the bestiary. Offering his own, often

humorous zigzagging, Cahill's "A YouTube Bestiary: Twenty-Six Theses on a Post-Cinema of Animal Attractions" suggests a scholarly form of new silent cinema, each thesis a kaleidoscopic interplay of film theoretical concepts, URLs, and animal images.

As these essays might suggest, much of what is discussed in *New Silent Cinema* seems neither "new," "silent," nor even "cinematic." We use "new silent cinema" less as a coherent descriptor of some developing genre, movement, or school, and more as a paradoxical merging of past, present, and possible futures, each respectively fractured and open to re-functioning. Putting aside "new," "silent cinema" is itself already a fraught term, divided historically or challenged semantically by countless scholars. The era between 1895 and 1927, if one even agrees to these tidy temporal bookends, has been broken up by equally debatable categories: "proto," "first," "early," "transitional," "primitive," "pioneer," "infant," "antique," "classical," etc. To call or describe an image, text, object, or thought "new silent cinematic" is not to apply some stable category from one discrete era or form to another. Rather, it asks us to undo easy oppositions like "new" and "old," "before" and "after," "silent" and "sound," to revel in the paradoxes produced by what Jorge Luis Borges called "the new technique [. . .] of the deliberate anachronism and the erroneous attribution."[26] A form of criticism as much as of creation, this "technique" offers a way of re-thinking the very category of the new, encouraging encounters free of any linear or teleological temporality. Whether as analog avant-gardist or digital anachronist, revolutionaries of the image seek the new not in the seeming self-identity of the present, but rather in the out-of-joint pasts of "silent," "early," "primitive," etc. cinemas.[27] Something of an "erroneous attribution," then, the title *New Silent Cinema* names the convocation of old and new, image and text, pixel and grain gathered across its pages.

This collection brings together several fields of research and thought that currently operate at a distance from one another in film studies. These fields include early and silent cinema studies, experimental and new media studies, historiography and archive theory, and studies of media ontology and epistemology. The visual objects analyzed across chapters are just as varied, ranging from popular Hollywood films to celebrated works of world cinema, archival montages to website search engines, art installations to viral videos. While the contributions reflect a diverse range of historical and theoretical approaches, they are nevertheless joined in responding to the comparative aims and demands of the project through a combination of formal analysis, historiographic critique, and playful reshuffling. Several of the essays explore a distinct instance of contemporary or historical return, while others thread a particular concept or question through multiple sites of historical practice. Some contributors are interested in what the silent era means for the twenty-first century, while others examine this line of influence as it moves in the opposite direction.

And several contributors leave cinema-specific repetitions behind to consider the reiterations of the silent era as they emerge in literature, music, and other aspects of popular culture.

We are privileged to include in this collection conversations conducted between ourselves and a few very generous subjects: Professor Rick Altman, a film scholar and performer of The Living Nickelodeon, a pedagogical mixture of live music and early cinema; the film archivist, theorist and, most recently, found footage artist, Paolo Cherchi Usai; and Canadian filmmaker Guy Maddin, one of the most consistently creative of new silent cinema practitioners. Maddin's most recent project, *Séances*, a website for contacting the spirits of lost or never-made films, with the filmmaker acting as conjuring medium, offers an extraordinary instance of this collection's concern. *Séances* conjures many of the preceding essays' presiding spirits: archival database, scene machine, YouTube bestiary among other medial afterlives and resurrections.

In his 1988 introduction to the English translation of *Cinema 2: The Time-Image*, Gilles Deleuze concludes on a curious note, one that suggests that the impending centennial of cinema had already begun to make itself felt. The introduction also offers a fitting conclusion to our own beginning. He writes:

> It is foolish to talk about the death of cinema because cinema is still at the beginning of its investigations: making visible these relationships of time which can only appear in a creation of the image. It is not cinema which needs television—whose image remains so regrettably in the present unless it is enriched by the art of cinema. The relations and disjunctions between visual and sound, between what is seen and what is said, revitalize the problem and endow cinema with new powers for capturing time and the image [. . .]. Yes, if cinema is not to die a violent death, it retains the power of a beginning. Conversely, we must look in pre-war cinema, and even in silent cinema, for the workings of a very pure time-image which has always been a breaking through, holding back or encompassing the movement image.[28]

In this brief but extraordinary passage, Deleuze overturns the fundamental division between movement and time, pre- and post-war cinema, that subtends the very philosophy of cinema *he is in the process of introducing*. Deleuze produces an alternative conception of the time-image, one that is untethered from any one historical moment or mode of film practice. There are a few different ways one might read his claims. Perhaps, like Gunning, Deleuze sees an alliance between the experiments of the post-war

time-image and those that unfold in the first years of film production. But, more interestingly, perhaps he is reframing the time-image as something that can be produced through processes of historical return, through *investigations* of the image. If, as he suggests, we should go searching in silent cinema for time-images, maybe it is not (or not only) because radical lessons in history, temporality, and thought are there, waiting to be discovered like so many archaeological treasures, but rather that we can learn these lessons by bringing together past and present, living and dead. Cinema does not need television . . . or new media. But if it does not die a violent death, it will owe its "powers of beginning" to them. We trace a few of those beginnings here. Many more remain to be created.

notes

1. Gregg Kilday, "Oscars 2012: 'The Artist,' 'Hugo' Top Academy Awards," *The Hollywood Reporter* (26 February 2012): http://www.hollywoodreporter.com/news/oscars-the-artist-hugo-academy-awards-295194. Accessed 5 March 2015.

2. Geoffrey O'Brien, "The Rapture of the Silents," *The New York Review of Books* Vol. 59 No. 9 (24 May 2012): http://www.nybooks.com/articles/archives/2012/may/24/rapture-silents. Accessed 22 August 2012.

3. David Denby, "The Artists: Notes on a Lost Style of Acting," *The New Yorker* (27 August 2012): http://www.newyorker.com/arts/critics/atlarge/2012/02/27/120227crat_atlarge_denby. Accessed 6 August 2012.

4. See also Joshua Clover, "Enjoy the Silents," *Film Quarterly* Vol. 65, No. 4 (Summer 2012): 6–7; Jason Sperb, "Specters of Film: New Nostalgia Movies and Hollywood's Digital Transition," *Jump Cut* No. 56 (Winter 2014–2015): http://www.ejumpcut.org/currentissue/SperbDigital-nostalgia/index.html. Accessed 8 March 2015. Michael Atkinson, "Viva Mabuse #53: The Neo-Silent" (6 September 2013): http://blog.sundancenow.com/weekly-columns/viva-mabuse-54-the-neo-silent. Accessed 8 March 2015; Tom Newth, "Silence, Sound, and *Tabu*" (2 November 2013): http://blog.frieze.com/silence-sound-and-tabu. Accessed 8 March 2015.

5. Catherine Russell, "Parallax Historiography: The Flâneuse as Cyberfeminist," *Scope: An Online Journal of Film and TV Studies* (July 2000): http://www.scope.nottingham.ac.uk/article.php?issue=jul2000&id=287§ion=article. Accessed 19 February 2013.

6. Carlo Mierendorff, *Hätte ich das Kino!* (Berlin: Erich Reiß Verlag, 1920), 37; Oswell Blakeston and Kenneth MacPherson, "We Present—A Manifesto! And a Family Album (Pre-War Strength)," *Close-Up* Vol. 9, No. 2 (June 1932): 92–93.

7. Godard makes this statement in Wim Wenders' documentary, *Room 666* (1982). Silent film would go on to play a crucial role in his *Histoire(s) du Cinema*.

8. Raymond Bellour, "The Cinema Spectator: A Special Memory," in *Screen Dynamics: Mapping the Borders of Cinema*, eds. Gertrud Koch, Volker Pantenburg, and Simon Rothöhler (Vienna: Österreichisches Filmmuseum, 2012), 10; Susan Sontag, "A Century of Cinema," in *Where the Stress Falls* (London: Penguin Classics, 2009), 117.

9. Noël Burch, "Narrative/Diegesis—Thresholds, Limits," *Screen* Vol. 23, No. 2 (1982): 16, 18.

10. See Susan Sontag, "The Decay of Cinema," *New York Times* (25 February 1996).

11. Hazanavicius uses the term "format" to describe his stylistic approach in *The Artist*. See Nick Allen, "'The Artist' Interview with Director Michel Hazanavicius" (24 December 2011): http://thescorecardreview.com/articles/interviews/2011/12/24/the-artist-interview-with-director-michel-hazanavicius/26697. Accessed 15 August 2012.

12. Bart Testa, *Back and Forth: Early Cinema and the Avant-Garde* (Toronto: Art Gallery of Ontario, 1992), 9.

13. Tom Gunning, "An Unseen Energy Swallows Space: The Space in Early Film and Its Relation to American Avant-Garde Film," in *Film before Griffith*, ed. John Fell (Berkeley: University of California Press, 1983), 355–366. See also "The Cinema of Attractions: Early Film, Its Spectator, and the Avant-Garde," in *Early Cinema: Space, Frame, Narrative*, ed. Thomas Elsaesser (London: British Film Institute, 1990), 56–62.

14. Gunning, "An Unseen Energy Swallows Space," 355.

15. For a recent discussion of twenty-first-century attractions, see Wanda Strauven, ed., *The Cinema of Attractions Reloaded* (Amsterdam: University of Amsterdam Press, 2006); see also André Gaudreault, Nicolas Dulac, and Santiago Hidalgo, eds., *A Companion to Early Cinema* (Malden, MA: John Wiley and Sons, 2012).

16. For different perspectives on this debate, see Paolo Cherchi Usai, David Francis, Alexander Horwath, and Michael Loebenstein, eds., *Film Curatorship: Museums, Curatorship and the Moving Image* (New York: Columbia University Press, 2008); and Giovanni Fossati, *From Grain to Pixel: The Archival Life of Film in Transition* (Amsterdam: Amsterdam University Press, 2009). See also Caroline Frick, *Saving Cinema: The Politics of Preservation* (Oxford: Oxford University Press, 2011).

17. For examples, see Marsha and Devin Orgeron, eds., *Moving Image Journal* Vol. 12, No. 1 (Spring 2012); "In Focus: The Twenty-First Century Archive," *Cinema Journal* Vol. 46, No. 3 (2007): 109–142.

18. Jacques Derrida, *Archive Fever*, trans. Eric Prenowitz (Chicago: University of Chicago Press, 1996), 17.

19. Mary Ann Doane, *The Emergence of Cinematic Time: Modernity, Contingency, the Archive* (Cambridge, MA: Harvard University Press, 2002), 228.

20. Paolo Cherchi Usai, *The Death of Cinema: History, Cultural Memory and the Digital Dark Age* (London: British Film Institute, 2001); Victor Burgin, *The Remembered Film* (London: Reaktion Books, 2004); Laura Mulvey, *Death 24x a Second: Stillness and the Moving Image* (London: Reaktion Books, 2006).

21. D.N. Rodowick, *The Virtual Life of Film* (Cambridge, MA: Harvard University Press, 2007), 184. See also Dudley Andrew, *What Cinema Is!* (Chichester, UK: Wiley-Blackwell, 2010), xxvi; Sean Cubitt, *The Cinema Effect* (Cambridge, MA: MIT University Press, 2004), 98.

22. Miriam Hansen, "Max Ophüls and Instant Messaging: Re-framing Cinema and Publicness," in Koch et al., eds., *Screen Dynamics*, 28.

23. Jussi Parikka, *What is Media Archaeology?* (Cambridge: Polity, 2012), 2–3.

24. The key film of reference in this essay is Porter's *Dream of a Rare-bit Fiend* (1906). Georg Lukacs, "Thoughts on an Aesthetics of Cinema," in *German Essays on Film*, trans. Lance Garmer (New York: Continuum, 2004), 13.

25. Miriam Hansen, "Early Cinema, Late Cinema: Permutations of the Public Sphere," *Screen* Vol. 34, No. 3 (Autumn 1993): 200. This term, "déjà vu," has also been used in a recent critique of Hansen's Benjaminian account

15

by Gabriele Pedulla, *In Broad Light: Movies and Spectators After the Cinema* (New York: Verso, 2012), 71.

26. Jorge Luis Borges, "Pierre Menard, Author of the Quixote" in *Labyrinths*, eds. David Yates and James Irby (London: Penguin, 2000), 71.

27. A related concept of anachronistic revolution and medial specter can be found in Jacques Derrida, *Specters of Marx*, trans. Peggy Kamuf (New York: Routledge, 2006), especially 138–139.

28. Gilles Deleuze, *Cinema 2: The Time-Image*, trans. Hugh Tomlinson and Robert Galeta (Minneapolis: University of Minnesota Press), xiii.

alice in the archives

o n e

k a t h e r i n e g r o o

When the British Film Institute (BFI) completed the preservation and restoration of Cecil Hepworth and Percy Stow's *Alice in Wonderland* (1903) in 2010, the organization uploaded the digital file to its YouTube channel, where it joined hundreds of other films and film clips from the national archive. The restoration of this particular film coincided with the UK-wide release of Tim Burton's adaptation of Lewis Carroll's novel, a mixture of live-action footage, computer-generated animation, and 3D imaging produced and distributed by Disney. The convergence of BFI's digital platform, the market forces of commercial Hollywood cinema, and the itinerant interventions of contemporary social media produced an unlikely viral sensation out of this scrap of early cinema. To date, the film has received more than 1,700,000 views on BFI's YouTube channel alone. It has been reposted, tweeted, blogged, and remixed ad infinitum. It is likely that more viewers have seen *Alice in Wonderland* since 2010 than had seen the film during the entire twentieth century. Archivist and early film blogger Luke McKernan speculates that the extraordinary circulation of the film owes to the spectacular disappointments of the contemporary *Alice*: Burton's

film, he argues, made viewers long for a simpler cinema and they found it in the Hepworth studio.[1]

But what exactly had viewers seen? What kind of artifact had they been invited to encounter? And just how *simple* are the historical expressions of early cinema as it migrates from the physical to the digital archive? Its restoration notwithstanding, *Alice in Wonderland* remains a badly damaged film. Scratches, tears, and decomposition join the many diegetic forces that threaten Alice's bodily integrity. She shrinks and expands, but also disappears as the image erodes and erodes her in turn. Both the digital transfer and its compression for online circulation contribute yet another layer of visual and historical noise. The image pixelates and blurs as it stretches to fill in the gaps of the original analog document *and* those created by reducing the detail of the restoration for virtual consumption.

Alice in Wonderland bears the trace of other historical inscriptions, other genres of forgetting and loss. Just eight minutes of the film survive. When the film was originally released, it was the longest ever made in Britain at just over 800 feet (about twelve minutes). The unusual length of the film ensured that it rarely would have been screened in its entirety. Rather, the film was divided into twelve vignettes (following the structure of the novel), each of which could be hired and screened independently as part of a variety program. Taken together, the film did not retell the tale of Alice, but invited spectators (as so many early film adaptations of literature often did) to recall key scenes from the book. In other words, the film was physically and narratively fragmented from the start. A complete recovery and restoration of *Alice in Wonderland* would not have bridged the gap between contemporary and turn-of-the-twentieth-century spectators. Indeed, the *failures* of preservation and restoration—that is, the absences and discontinuities in the archival document—along with the style of spectatorial scavenging that digital video platforms encourage more closely approximate the original document and its reception than twelve uninterrupted minutes of *Alice* ever could.

The viral version of *Alice in Wonderland* is a curious artifact, an index of multiple film-historical events and documents: the original, the unrestored copy, the "real" restoration archived at the BFI, and, finally, the self-same digital copy that the archive circulated in order to promote the archive, its restoration work, and Disney's own (mis)adventure in wonderland. However, the film also draws our attention to the broader intersection between early film objects and archival digitization. For its part, the BFI has expanded its digitization strategy since the early days of its YouTube channel. At the end of 2012, the organization announced plans to digitize 10,000 British films by the end of 2017 as part of a £500 million *Film Forever* scheme and, just one year later, it launched its own media player in which early and silent cinema remain a centerpiece.[2] Numerous institutions join the BFI as they transition film's first decades to digital formats and negotiate

the contemporary proliferation of social media, digital video, and remix culture. These new archival and artifactual formations raise crucial questions both for recent theorizations of the digital archive and for early and silent film history. How do these early images intervene in our thinking about the digital? And what does the digital do to our conception of the early archive? The film artifact? The film historian? What kind of histories do these archives encourage or exclude? And where do the images produced out of the archive—the digital, virtual, viral, etc.—belong among the "original" objects of cinema's past? It is precisely these questions that I intend to take up here.

No matter the many echoes that seem to sound between old and new media, physical and virtual archives, I do not collapse the distance between them or cut the digital to fit the shape of its early ancestors. Nor do I understand the intervention of the digital as a radical break, one that (depending on your disciplinary perspective) either annihilates film history or finally rescues it from the influence of archival institutions. Instead, I am interested in the simultaneous and irreconcilable differences that these archives produce, the historical confusions that they both signify and inscribe upon the surface of their collections, their movement in two directions at once. This discussion of *Alice in Wonderland*, then, is not just a rhetorical gesture, a way of beginning or deferring. And the film itself is more than an accidental appearance in the circulation of early cinema. *Alice* offers an initial figure for understanding the ambivalent historical expressions of the digital early film archive.

The genealogy of *Alice in Wonderland* moves us from a nineteenth-century novel to early and contemporary cinemas to new media, but its narrative also explicitly takes up questions of genealogy, or the relationship between beings and the processes of coming into being. Gilles Deleuze dedicates several chapters in *The Logic of Sense* to the writing of Lewis Carroll and *Alice in Wonderland* in particular. The text involves a special category of things he calls "pure events" or "pure becoming."[3] As many familiar with Deleuze's writing and thought will know, this category stands in contradistinction to "limited and measured things," to the fixed object and the present tense.[4] For Deleuze, Alice embodies a kind of interminable movement, elasticity, and rebellion, "a veritable becoming-mad, which never rests."[5] The event of pure becoming—whether Alice or (as I will argue here) an archive—presses very forcefully against the structures of good, common sense. In so doing, it equally withdraws from the historical methodologies that have shaped early film studies for more than three decades. Deleuze writes:

> [B]ecoming does not tolerate the separation or the distinc-
> tion of before and after, or of past and future. It pertains
> to the essence of becoming to move and to pull in two

directions at once: Alice does not grow without shrinking, and vice versa. Good sense affirms that in all things there is a determinable sense or direction (*sens*).[6]

Of course, Alice lacks this kind of sense. And so, too, as I will argue, do digital archives of early film.

In this essay, I concentrate on *Images for the Future*, a recent digitization project that exceeds the contingent effects of BFI's vision of early film forever. The project began in 2007 as a collaborative effort to preserve the audio-visual heritage of the Dutch archives. Like BFI's initiative, *Images for the Future* is a large-scale, government-funded endeavor, dedicated to the restoration and digitization of more than 700,000 hours of film. *Images for the Future* also aims to distribute its digital content as widely as possible and develop a contemporary community of archival "users." The project not only aims to preserve Dutch visual history for the future but also actively encourages the production of future images out of the visual past. To this end, the Dutch consortium has partnered with social media and software design firms to create several digital applications that experiment with new modes of archival encounter. In this archival formation, the digital is not an invisible architecture that serves early film objects. It does not repeat or re-present, nor does it extend effortlessly into a utopian future of limitless preservation and open access (as the title of BFI's *Film Forever* project would seem to suggest). Instead, *Images for the Future* stages a series of *interactive* encounters (or what Deleuze might call "events"). Here, I am using the term "interactive" to describe not only the relationship between users and archives, but also, and more interestingly, a visible reciprocity between old and new media, imagination and calculation, the past of film history, the present of its production, and a speculative future of archival objects. I am also suggesting that the operation at work in these archives exceeds the techno-utopian similitude of "convergence."[7]

In what follows, I sketch a brief genealogy of post-structuralist engagements with the archive. This foundational series of interventions informs a recent wave of scholarship in film and new media studies that takes the technological substrate of the digital archive as a starting point for understanding how our artifacts and modes of historical telling change in the twenty-first century. While this recent work goes some way towards challenging conservative historiographies and conceptions of the archive, neither this contemporary scholarship, nor its post-structuralist antecedents accommodate the specters of past time and old media that continue to inhabit the "new" and the "now" of digital archives. I therefore pivot from this précis to the specificities of *Images for the Future* in order to explore a different model of the digital archive and another mode of contemporary archival thought. The figure of Alice returns in my conclusion. She is the madness at the center of film history and metahistorical thought.

the new archivists

Nearly two decades after the publication of *The Archaeology of Knowledge*, Foucault's seminal work on discursive historical regimes, Deleuze claimed that "a new archivist" had been appointed and a "new age" had dawned in historical thought.[8] The emphasis on the "newness" of Foucault must have seemed a little odd (at least for Foucault), given how long his arguments had been in public circulation. The belatedness of this nomination speaks to just how much disciplinary resistance Foucault's original incursion into the field of historical studies had met and just how little had changed in historical thought. Even twenty years later, Deleuze remarks, Foucault appeared, at best, to operate independently of the disciplinary mainstream and, at worst, to be forcefully excluded.

A set of metahistorical claims underpins both the radical threat and the seeming newness of the *Archaeology*. Here, Foucault collapses the boundaries between language and objects, words and things. Both, he claims, are part of and produced out of discursive systems that bind them together and define their encounter. Foucault thus encourages us to dispense with "the enigmatic treasure of 'things' anterior to discourse" and abandon our incessant search for origins, "the *ground*, the *foundation of things*" (emphasis in original).[9] He redirects our attention to the body of rules that produces discourse.

The archive is one such body of rules. It does not recuperate history or secure its artifacts but rather constitutes a certain arrangement of past time and a particular formation of objects. Foucault explains, "Instead of seeing, on the great mythical book of history, lines of words that translate in visible characters thoughts that were formed in some other time and place, we have in the density of discursive practices, systems that establish statements as events [. . .] and things [. . .]. They are all these systems of statements (whether events or things) that I propose to call *archive*."[10] In this reformation of historical practice and knowledge, the archive surrounds us and yet remains unavailable to us. The archive belongs to the conceptual category of the *dispositif*, or apparatus, and, in this way, governs the activities of human subjects. It is "the law of what can be said," thought, or remembered.[11] It does not receive our active search (on the great book of history) but rather *acts upon* us and determines the possibilities (creative, historical, epistemological) of this encounter *in advance*.

Foucault's conception of the archive as determinative in the construction of historical knowledge crucially intersects with Jacques Derrida's multivalent *mal d'archive* (though disagreement sustained their debates about the archive more often than consensus, a point to which I will return in my conclusion).[12] For Derrida, the archive instantiates the *mal*—the danger, threat, evil—of state authority and power. It is the place where commandment commences, where the law begins and builds. The dangers of the

archive and the annihilation of memory it necessarily guarantees derive from the kind of spatio-temporal relationship that the archive maintains with the very things (subjects, objects, events) it claims to preserve. Insofar as the archive is separate from the origins of objects and events, consigned "to an *external place*, which assures the possibility of memorization, of repetition," it can only ever approximate those origins with other histories and different kinds of writing.[13]

While Foucault and Derrida understand the archive as an expression of power, they equally acknowledge that these expressions radiate from manifold sources. In other words, in redefining the archive as a discursive system or a set of rules (rather than, say, a physical structure), the archive ceases to be just one *thing*, one monolithic or monumental authority. No longer synonymous with the library (or even the book), the archive becomes multiple, flexible, and, most importantly for our purposes here, subject to change. Indeed, Derrida acknowledges that his own conception of the archive as an external, amnesiatic operation draws upon specific archivo-technological formations or "machine tools," forever consigned to the outside and after of experience, including (among others) Freud's *Mystic Writing Pad (der Wunderblock)*.[14] Derrida asks (in the early 1990s): What if Freud and his contemporaries had had access to "telephonic credit cards, portable tape recorders, computers, printers, faxes, televisions, teleconferences, and above all Email"?[15] Derrida speculates that the history of psychoanalysis would have been radically transformed by these technologies, both in the way that this history would have been archived (what Derrida refers to as the "secondary recording") *and* in the very formation of its historical events. Derrida's momentary meditation on a past that never was—the retrospective science fiction he claims could have been another, more interesting lecture—nevertheless opens onto an archival future that has become our recent history. In one of the lecture's most provocative moments, Derrida suggests that new archival technologies will transform both how we remember the experience of living and how we actually live, how we preserve history and how history gets constructed in the "first recording" of our experience.

Many film and media scholars engaged in debates about digital archives—what they are and how they mean—take Derrida's speculation on the technological transformations-to-come as their starting point. This work inherits the view that the archive is just one system or structure among so many others and that history as it is both experienced and preserved depends upon the nature of these formations. However, this body of scholarship also paradoxically uses the post-structuralist view as the very means by which to reject post-structuralist theories of the archive. Just as Derrida predicted, the technological substrate of the archive has changed and so, too (the argument goes), have the structures of archival power.

We might characterize one strand of this research as a "phenomenologi-cal" turn in archive studies. Importantly, this strand overlaps with a broad field of scholarship in media theory, including the work of Katherine Hay-les, Mark Hansen, and Tara McPherson (among others).[16] Taken together, the phenomenological view concentrates on the cognitive and/or sensory reception of new media. For historian Carolyn Steedman, the response to Derrida has *always* been a phenomenological one, a practice of simply coun-terposing the experience of working in archives (the silence, boredom, everyday details) against the exceptional concept that circulates in Der-rida's lecture. She notes, "No one historian's archive is ever like another's (much less like Jacques Derrida's)."[17] The phenomenological approach to digital archives, however, makes the case for new media modes of specta-torial address and subjectivity, which fundamentally shift the balance of power. No longer does the archive act upon us; rather, we interact *with* the archive, receive and respond to its transmissions. Jaimie Baron's concept of the "archive effect," for example, describes a reorganized experience of reception whereby the existence of archival documents depends upon the viewer's recognition of their archival status, or what we might call their "archival-ness." She writes:

> The ideas of the location, provenance, and authority of
> an archive have become increasingly uncertain as online
> digital archives are constituted and accessed not only by
> institutions but also by individuals and groups all over
> the globe. The notion of an archive as a particular place
> and of archival documents as material objects stored at a
> particular location has ceased to reflect the complex appa-
> ratus that now constitutes our relation to the past. [. . .]
> The reformulation of archival footage and other indexi-
> cal documents as a *relationship* produced between particu-
> lar elements of a film and the film's viewer allows us to
> account not only for emergent types of archives and the
> diverse documents held within them, but also for the ways
> in which certain documents from the past [. . .] may be
> imbued by the viewer with various evidentiary values as
> they are appropriated and repurposed in new films.[18]

Where exactly the archive effect comes from, if not the archive itself, and what this effect ultimately means remains ambiguous in Baron's account. Foucault and Derrida always understood the archive as a "complex appa-ratus" and they both conceded that our encounter with actual archives was a relational one. It is, however, in their view, a relation determined in advance by discursive or technological systems. For Baron, the digital does not construct new *relationships* with the archive and its artifacts so

much as it seemingly transforms human subjects into autonomous sites of archival experience and sources of archival knowledge. This is a rather counter-intuitive conclusion. The digital archive, it would seem, is somehow *more human* than any archive has ever been.

Domietta Torlasco's concise study of multimedia exhibitions, *The Heretical Archive*, similarly re-imagines the archive, the subject, and the terms of their encounter. The new media archive, she argues, produces a kind of "dissonance or resistance" against the old archives of "physical and symbolic [. . .] supervision."[19] Such is the nature of its "heresy." Like Baron, Torlasco shifts the locus of power away from the apparatus towards users and viewers who participate in the formation of memory as active co-creators and even passive receivers. For Torlasco, the digital saves "us" from the discursive matrix within which we were once captured. It redefines the processes of perception *as well as* the perceiving subject. In the heretical archive, the "I" fractures, multiplies, dissolves. And yet, adhering to the phenomenological paradigm, this new digital-archival self remains quite a corporeal thing: "Caught up in the flesh of the world, this self is openness to the thickness of the perceptual field rather than assimilation, permeability rather than absorption."[20]

However compelling, the digital utopianism that underpins these interventions ironically emerges out of an elision of actual digital technologies. For Baron, the digital reasserts the primacy of the perceiving subject (not to mention analog modes of film spectatorship). And while Torlasco's phenomenology radically reconsiders what it means to be a perceiving human, her work also performs a kind of technological sleight-of-hand. So long as the digital subject is coextensive with a world of thick flesh and bodily depths (rather than the deep structures and surface effects of new media and machines), the hegemonic power of the archive dissolves. But so, too, does the archive.

The field of media archeology exists at the other end of the digital scholarship spectrum. Jussi Parikka describes this school of thought as "cool" against the purported warmth of French media theorists (excluding, it would seem, both Foucault and Derrida).[21] But one can also detect the difference that separates this approach from the phenomenological strain of contemporary archival thought. Media archaeology stretches from Marshall McLuhan and Friedrich Kittler to, more recently, Erkki Huhtamo, Siegfried Zielinski, and Thomas Elsaesser. As a practice, media archaeology refers to a "hardware materialist, technodeterminist, or even technofetishist emphasis on the primacy of the machine."[22] In its most radical iterations as object-oriented ontology, media archaeologists make the case for the *agency* of machines, for understanding media as *subjects* who write and remember in ways that exceed the modes of expression and memorialization available to their human counterparts.[23]

While a thorough introduction to these views would take this chapter far afield, I would like to briefly gloss the work of two figures who straddle the divide between media archaeology and archive theory: Lev Manovich and Wolfgang Ernst. These scholars reposition technology at the center of their archival concerns and take up the post-structural demand to read the role of archival technology as a determinative one. In *The Language of New Media*, Manovich nominates the "database" as the archival formation of the digital era. The database stretches and sprawls; it is a potentially endless collection of digital objects, subject to infinite and instantaneous algorithmic permutations (including, among many other possibilities, search and retrieval). The database "projects itself" onto the whole of contemporary culture and "reorganizes the world according to its own logic."[24] In this way, it displaces the narrative impulses of twentieth-century historiography and seemingly tempers the archival threats that trouble Derrida. While database users can reorganize its contents into linear structures, these interactive processes of making sense or writing history remain secondary to the space and structure of the database itself. Put another way, the database rather counter-intuitively takes on a physical, material quality in the digital era; whatever gets made out of the database, whatever algorithmic operations come into contact with it, belong to a category of potential, virtual, and imaginative operations, none of which displace the security of the database structure.

Wolfgang Ernst shares in this surprising view of digital culture. For him, as for Manovich, the digital archive is not a virtual experience, an immaterial substrate, or an imprecise new media "nowhere" posed against the concrete spaces and things of the twentieth (or nineteenth, eighteenth, etc.) century. The digital archive, as Ernst understands it, is not *less material* than a physical archive (e.g., library or museum), but *more* material, more matter, machines, and data. What further distinguishes the digital archive from its predecessors is a radical shift away from what he describes (borrowing from McLuhan) as the "hot" processes of imagination and narrative towards the "cold" or concrete paradigm of mathematical code. The alphanumeric archive produces a new kind of institutional memory, one that "counts rather than recounts"; one of indiscriminate accumulation, calculation, recycling, and reconfigurability; and one that does not easily bend to the demands of human historiography. For Ernst, the digital requires new, archaeological modes of analysis—"enumerative rather than narrative, descriptive rather than discursive, infrastructural rather than sociological, taking numbers into account"—but, crucially, the digital archive ultimately does away with us.[25] We can analyze all we want, but the archive, it seems, is no longer *for* us. These new memorializing institutions escape the Foucauldian bind of the apparatus as well as the commandments of the archive by operating independently of both the subject and the state. Ernst writes: "Words and things happen within the machine (computers) as logic and hardware. [. . .] Human beings, having created

logical machines, have created a discontinuity with their own cultural regime."[26]

The phenomenological and materialist schools of archival thought are divided by different—and, I would argue, antecedent—theoretical commitments. Still, these seemingly opposed foundations produce remarkably similar claims, from their descriptive accounts of the digital archive (as open, infinite, and flexible) to their reading of the non-narrative historiographic formations that the digital makes possible. But, more obviously, the views are joined in a radical and monolithic *reduction* of the archive to either phenomenological experience or the "material" of alphanumeric data. Both navigate away from twentieth-century archives and archival theories by collapsing the operations of the archive, its two-fold *mal*, into a single point: a fleshy archive or a machine with memory. Either the body becomes the locus of archival agency or the archive becomes an independent and autonomous subject. Put another way, both resolve the problems of the archive—its consignation to an external place, the division between first and second recordings, its failures of memory, and its expressions of power—by redefining the subject and the archive, the experience of history and its recording *as the same thing*. Setting aside the complexities internal to phenomenology and media archaeology as systems of thought, this shared maneuver at once oversimplifies the digital archive, overstates the difference between old and new, and overlooks the digital archive whose divisions cannot be undone, that is, the digital archive that is already tethered to the artifacts and the archival formations of the twentieth century.

The digital archive of early cinema offers an important counterpoint to the phenomenological-materialist spectrum and the essentializing tendencies of contemporary archival thought. These archives cannot be distilled into autonomous functions or discrete theoretical categories. Rather, as I will argue, they are sites of interactivity and simultaneity, multiple directions or impulses at once. Following Derrida, I argue that technology plays a determinative role in structuring (or restructuring) the archive. Here, however, the digital does not annihilate its physical or analog ancestors—what Ernst refers to as "radical digitality"—but instead *makes these objects visible*, alongside the annihilating processes of *both* physical and digital archives. While many early film archives open onto new historiographic possibilities, these new histories emerge out of the analog past as much as they do the digital present. *Images for the Future* exemplifies this mixed inheritance, especially in its *Scene Machine* application, a project to which I now turn.

archives for the future

On July 1, 2007, a consortium of Dutch archives, including the EYE Film Institute, the Netherlands Institute for Sound and Vision, and the Dutch Nationaal Archief, launched *Images for the Future*, a digital preservation project

that came to a close at the end of 2014. In the press release, *Images for the Future* defines the ends of this collective archival project in terms of potential economic losses and precise material gains. The audio-visual history of the Netherlands cost billions to produce in the first instance. For a fraction of that original expenditure, the processes of digital preservation seemingly will ensure that nothing goes to waste:

> The [national archives] contain the visual history of the past 100 years. Films, documents, radio broadcasts, and television programmes comprise more than 700,000 hours worth of material. The costs for creating this oeuvre ran into the billions. The educational, cultural, and economical value of this material is unprecedented. **We cannot let these collections go to waste.** Spread over a period of seven years, the FES (Fund for the reinforcement of Economic Structure) has provided a budget of 154 million euros for the digitization of the Netherlands' audiovisual memory. With it, the imminent threat of decay and loss of vulnerable films, video, and audiotapes is taken away. During the project a total of 91,183 hours of video; 22,086 of film; 98,734 hours of audio; and 2.5 million photos from these archives will be restored, preserved, digitized, and disclosed. [emphasis in original][27]

The precision of its archival math notwithstanding, *Images for the Future* exceeds the tidy transaction of money for artifacts (154 million euros for 113,269 hours of footage and 2.5 million photographs, to be exact). It offers something in excess of preservation and, in so doing, overturns the naïve discourse of salvage and recuperation that frames the project from the start.[28]

In this brief institutional text, "disclosure" is the anomalous term. It disrupts the contemporary archival trilogy of "restoration, digitization, preservation," as well as the spatial relationships that tend to circumscribe archival practice (i.e. the archive protects against the outside and external forces by internalizing, sheltering, enclosing its artifacts). Disclosure suggests a practice of opening, exposing, or making visible, a pathway out of the archive and towards the very threats it claims to protect against. Disclosure counters the emphatic appeal to purity, the institutional promise that nothing will be wasted or made waste—*We cannot let these collections go to waste*—with the suggestion that the waste or wasting is yet to come, in the very act of disclosing. The term also recalls Martin Heidegger's *Erschlossenheit* (or world disclosure), whereby a word or thing comes into being through processes of encounter (with other words and things, as well as thinking subjects). Disclosure therefore exceeds mere reproduction or spatial

shifting (from inside to outside); it signals a future potential, a becoming new or different.[29]

In the archival practice of *Images for the Future*, the term "disclosure" corresponds to a series of websites and web-based applications commissioned for the express purpose of disseminating audio-visual artifacts. These applications focus almost exclusively on early and silent cinema. They include *Film in Nederland*, a website that makes available to the public more than 2,300 animated, experimental, and feature-length films from 1896 to 1923 (along with detailed meta-data for each title in the catalog), and *Celluloid Remix*, a site that encourages users to download dozens of film fragments from the EYE Film Institute's unusual "Bits & Pieces" collection, an ongoing project that aggregates the archive's untitled, unauthored, and incomplete film scraps into volumes of contingent visual encounters. Digital users can remix this content (for a second time) using software specifically designed for this participatory practice and share their remixed works through Open Images, a platform built expressly for the Dutch collective based on the Creative Commons licensing model. *Images for the Future* also sponsors an annual remix competition that circulates yet more physical and digital fragments.

Here, I would like to concentrate on *The Scene Machine*, an interactive installation (available in both Dutch and English) launched in 2012. The project was developed by Dima Stefanova and David Lammers, and programmed by Jim de Beer and Marcus Besjes.[30] *The Scene Machine* invites users to explore film fragments from the EYE Film Institute's collection by choosing from a set of predetermined themes, including (among several others) "romance," "livelihood," "showstopping," and "conflict." According to its designers, *The Scene Machine* lets viewers explore the film collection in "an intuitive way." Though one might struggle to pin down what exactly an "intuitive" approach to virtual spectatorship of film fragments might be—Do we have intuitions about this media mixture?—*The Scene Machine* nevertheless endeavors to accommodate your intuitions, whatever those might be. Once viewers make their thematic selection, a black screen stretches across the page. Film fragments appear, transparently, stacked one upon the other before they spread out side-by-side (figure 1.1). Each one appears from the right and slides across to the left, stretching to its complete width at some point along the way, before collapsing into a narrow sliver and slipping out of view. As the fragments move within the screening space, appearing and disappearing, the edges of their frames create rigid vertical lines, visible points of contact and collision. But these edges also occasionally give way as the moving images pass by, over, underneath one another, creating fleeting moments of superimposition and recombination. No more than four fragments ever appear at once. While users can pause the simultaneous play, they cannot control the movements or the duration of individual fragments. Some will linger and begin again. Others

Figure 1.1 Fragments from *The Scene Machine.*

will never reach their "conclusion" before they slip out of view. Once a fragment disappears, another moves in to take its place.

The Scene Machine opens up other avenues of intervention or ("intuition"). Each clip has a small menu at the bottom of its frame with a visible keyword. These keywords do not reiterate the theme, but introduce yet another taxonomy. For example, the keywords tied to the "romance" theme include "malefemale," "intimacy," "flirt," "flower," "crying," "love," "couple," "marriage," "sadness," and "drama." Any fragment tagged with these keywords might appear when one selects this particular theme. The menu allows users to remove a fragment from the stream or replace it by selecting another keyword. At this stage, however, users have access to an expansive keyword menu: nearly three hundred terms like "anger," "breeze," "colony," "dairy," "eman," and "goodbye," as well as meta-categories like "audience," "film," "mass media," and "compartmentalization." To describe this more simply: whatever arbitrary thematic category a user might begin with eventually comes apart as she begins to subtract fragments from her stream and add keywords. The combinations can easily drift towards the absurd or subversive (or, in the case of "romance," the explicitly queer). In *The Scene Machine*, the concrete ("horses," "snow," "airplane") mixes with the abstract and ambiguous ("salvation," "unmasking," "emotion"), significant historical events ("colonization") meet their minor counterparts ("violence," "despair"), and the seeming same collide with wild visual non-sequiturs. Once users are satisfied with their recombinations, they can save their projects, share them with others, or upload them to other visual platforms.

So: What kind of *machine* is this? What is the nature of its mechanics or its material processes? And what objects or effects does it produce?

29

Remarkably, *The Scene Machine* elicits a play and production of language as much as it does a reiteration and remixing of scenes. Its verbal taxonomy recalls the free association of psychoanalysis, the marvelous contingencies of surrealist collage, and Borges's list of animal categories ("embalmed," "tame," "fabulous") that makes Foucault laugh—and shatters his "familiar landmarks of thought" on the very first pages of *The Order of Things*.[31] For materialists like Manovich and Ernst, the categories and keywords might suggest something of the database or cold structure that ostensibly controls the EYE Film Institute's visual data, along with our experience of it. We are invited to intervene and rearrange, but certain limits have been put in place (the kind and quantity of visual categories, the number and nature of the film fragments, the duration of each clip, for example), which temper whatever political or playful effects our remix might produce, whatever new ways of seeing we are allowed to imagine. Importantly, however, *The Scene Machine* stages an encounter not only between the digital archive and its users, but also between language and image, between the infrastructure of the digital database and the moving-image artifacts this database attempts to name. As film fragments spill across the screen, they inevitably exceed the demonstrative function that they are meant to serve. Whatever category they carry fails to capture the other nouns and verbs that circulate in these images, as well as the aspects of the film fragments that exceed language: the rips, gaps, tears, colors, and textures of celluloid, the oscillations between silence and sound, to name just a few. Insofar as *The Scene Machine* mediates our interaction through language, and makes this mode of mediation *visible* (as a tag, a scrollable list, a menu option), one cannot help but notice the imprecision of the algorithm, the failure of the digital protocol. The film fragments that we call upon never match the nature of our call; they do not meet our expectations nor map onto whatever we might imagine or intuit. Put slightly differently, *The Scene Machine* confesses the archival apparatus, that is, the apparatus of *every* archive. In *The Scene Machine*, we are kept at a distance, consigned to an external place by the algorithms of the digital archive, limited in the kinds and quantity of tinkering we might do with the film-historical past. But the digital archive also makes visible its own external consignation as its efforts to order and organize the early film archive reach a visual limit over and again.

In this way, *The Scene Machine* introduces a kind of third term to the binaristic structures that circumscribe debates about the digital archive (cold database on the one hand, hot users on the other); the materiality of early cinema cannot be reduced to code nor the processes of spectatorial encounter. *The Scene Machine* instead triangulates the digital database, the living present, and the celluloid past, embedding these sites within each instant and image. Indeed, the project carries with it an excess of the analog as it indexes both the material qualities of early film and the physical structures

of early film archives. The material presence of early film, however, does not return us to some kind of pure historical origin wherein "real" cinema bursts forth and somehow resists its digital reinscription. Rather, as I have suggested from the start, *The Scene Machine* keeps the interaction between these media and material traces in constant, simultaneous play. In presenting the fragments of early film side by side (and on top of one another), for example, *The Scene Machine* not only draws attention to the photographic substrate of film, but also encourages viewers to engage in a comparative form of visual encounter, one that would not have been available to historical spectators of these images. The digital archive instead mimics a form of archival spectatorship, one that invites viewers to notice—alongside the pixelation and blurs of digital expression—the differences between early film shapes, stocks, and tints; the wide spectrum of restoration and decay; the distance (or lack thereof) between the visual grammars of silence and sound. And as the film fragments slide past one another, crossing and combining their images, the digital recalls the transparency and fragility of celluloid. Nearly everywhere on *The Scene Machine*, viewers are reminded of the materiality of film, the contingent constructions of visual media, and the physical infrastructure of the archive. Here, in other words, there are multiple machines and scenes always in circulation and on display. Even the language of the database—the taxonomy of terms attached to each film fragment—signifies in several directions at once; it is an algorithmic function that automatically, if imperfectly, organizes our experience of the images. But the digital archive inherits this taxonomy from its physical predecessor, taking these terms—and the mechanism of a linguistic protocol—from the system of identification that archivists had used for decades to organize EYE's analog collection. The language of the digital database belongs to the physical archive. And the slippage that we see between word and image equally undermines them both.

How exactly does *The Scene Machine* respond to theorists of the digital archive? And what does an archive such as this allow us to say more broadly about contemporary archives of early cinema? In taking up Derrida's call to read the relationship between technology and the archive, both the phenomenological and materialist approaches make strong claims about ontology and historicity. Derrida's reading of Freud's mystic writing pad perhaps goes some way toward encouraging this kind of historico-technological determinism. Its layers of celluloid and wax neatly correspond to the layers of conscious and unconscious knowledge and, in this way, the physical apparatus directly informs our experience and recollection of the world. In the digital archive, however, this one-to-one relationship between technology and historical expression comes undone. Even if we simply consider the division in digital historicities—phenomenological and materialist—one can begin to detect

the manifold ways in which the digital determines history, or what is historically meaning-bearing. But looking more carefully at archives like *The Scene Machine*, the digital presents itself as a scavenger not only of history and historical images, but also of visual technologies.

The transformations that digital technologies make possible are transformations precisely in how we see and understand technological and archival infrastructures, both past and present. The digital archive *discloses*. It reveals or opens onto the external *and* historical consignations of the twentieth-century archive, a disclosure that crucially folds back upon the digital, interacts with the contemporary, and makes visible the distances that intervene between every experience and any archive. At the very same time, in the very instant of disclosure, the digital archive engages in processes of production, in the making of objects and archival encounters whose contingencies and mixed-media ancestries escape our efforts to consign them to the category of the radically new.

digital archives, analog histories

Thus far, I have been taking up the question of how these archives intervene in debates about the digital archive and the key conceptual frameworks that circulate in archival theory; I would like to conclude by moving in another historical direction in order to consider what digital archives such as this might mean for early film historiography, or the conception of film-historical artifacts as it informs the practice of writing film history. For decades, the field of early film studies has cobbled together an historical method out of nineteenth-century schools of historical thought, including empiricism, positivism, and objectivism. We have endeavored to read film-historical artifacts with these artifacts of intellectual history, as though there might be some kind of natural or necessary relationship between them. While our objects of study are playful scraps of celluloid in various states of decay and disappearance, our histories elide the specific ontologies of these artifacts (i.e., What is an archival film?) and the epistemologies of archival encounter (i.e., What kind of meaning gets made in the archive? What kind of work unfolds between historian and moving-image artifacts?), precisely because our historical methods—inherited as they are from elsewhere (and when)—cannot accommodate these lines of inquiry. For decades, therefore, the annihilation of film material has presented itself as a future to be overcome, rather than an intrinsic property of film to be understood. As film historians proclaim their commitment to saving and salvaging early film objects, they remain ironically incapable of reading those objects, of bringing an analysis of material loss or decay to bear on the writing of film history. Framed in this way, the arrival of the digital can only ever be another annihilating force to be prevented or warded against. As I will suggest here, however, the arrival of digital archives of

early cinema demand that we begin addressing the physicality of film objects and more carefully theorizing the interactive encounter between film historians, archives, and artifacts. That is, the digital archive makes celluloid objects and archives *more*, not less, visible in the twenty-first century. Its annihilating function is aimed at our approach to film history, not the objects that constitute it.

The origin story of early film studies begins at the 1978 International Federation of Film Archives (FIAF) conference in Brighton, which brought together early film scholars and archivists to screen nearly 600 films from archives around the world. The Brighton conference consolidated film-historical studies against the monoliths of "Grand Theory" (semiotics, psychoanalysis, Marxism, and textual theory) that seemed to dominate the field of film studies in the 1960s and '70s. As Richard Abel notes in the introduction to his *Encyclopedia of Early Cinema*, "The so-called Brighton Conference soon led to long-term archive efforts to collect, preserve, and restore as much as possible of what early film material has survived."[32] It is worth noting that the Brighton conference, acknowledged in so many introductions to the field, is a symptom of a historiographic method more than it is a disciplinary starting point.[33] Brighton is a mythology of beginnings, one that conceals the complexity of past time and historical events with a cultural fiction of material abundance. Nevertheless, the archival impulse to "collect, preserve, and restore" intensified in the post-Brighton decades and played a significant role in shaping the methodology of early film history. This era united archivist and historian in a shared commitment to the integrity of film objects and the implicit value of an empiricist historical project. Even as the first wave of early film historians explore the imprecise and fluid movements of film practice from the fairground to the music hall, from non-narrative attractions to the consolidation of commercial narrative cinema, the instability of film objects and the assumptions underlying film-historical methodology often go uninterrogated (when they are not wholly invisible).

The digital expressions that I trace across this essay disclose the objects of early cinema as fragmented, fractured, and incomplete. They reveal the fact that these objects cannot be revealed in their entirety, that they are defined by loss, by processes of degradation and decay, by the failures of preservation, and by the impossible and imperfect systems of the archive. In their digital rebirth, these physical losses become points of departure (as we have seen) for playful reorganization, remixing, and reimagining. These archives sidestep the search for what Paolo Cherchi Usai describes as "the model image," that utopian or platonic form that fuels the fantasies of early film historians: the perfect copy, the unseen image, the film undisturbed by the actual forces of history.[34] The digital archive does not destroy or deform film artifacts (though perhaps it does compound their fragmentation). Rather, it discloses the disorder and deformation of its analog

33

ancestors, along with the contingencies of archival encounter, as much as it does the state of any one film object or collection. The remixes that *The Scene Machine* makes possible, for example, are precisely that: remixes, mixtures of material already mixed. Large portions of the Dutch national archive—of any national film archive—have already been consigned to an open category of endless accumulation and arbitrary encounter (with other films and perhaps a few film historians, should they happen to stumble upon them). Our virtual interventions with the contemporary *Scene Machine* thus mimic the contingent practices of the archive and the imprecisions of archival encounter. *The Scene Machine* does not break film apart or destroy its artifactual future, but instead shows us the material and structural breakdowns that have been there all along, invisible in both the writing of early film history and its thinking of moving-image ontologies.

It is perhaps these revelations about the archive that are most disruptive to the practice of film historiography, where time spent in the archive, a process of simply being-with film artifacts, has become a *de facto* model of empiricist film-historical knowledge. This mythology of historical labor has gone largely unchallenged by the burden of presenting arguments about what these archival encounters might entail or how the early film archive might mean compared with, say, any other archival formation. In presenting us with the anonymous and unknown, the decayed and deteriorated, all remixed ad infinitum, *The Scene Machine* suggests that time spent in the archive—whether real or virtual—might necessarily lead us away from any historical model that presumes the stability of film objects or the self-evidentiary content of archival study. These objects do not speak for themselves nor do they easily give way to objectivist accounts of film history: just the facts, translated with a minimum of intervention. Like Alice, the digital detritus of the early film archives plays games with film history (and film historians) as these artifacts move in multiple directions at once: indexing the past of their production, the interventions of the archive, and the limits of historical understanding in their gaping visual absences. These materials encourage a historiography of imagination and speculation, one that acknowledges the contingencies of film archives, the material limits of film artifacts, and the radically subjective encounter that unfolds between historian and image. The digital archive of early cinema, then, foreshadows a future of images (already present) whose histories we will need to write, especially as they mix and mingle with twentieth-century media, but these archives also demand that we return to the foundations of early film studies and begin defending our metahistorical positions for the first time.

A concluding provocation. We can draw one possible position out of another history, one to which I have already alluded in my gloss of Foucault and Derrida. While it is true that Derrida's archive owes something to Foucault's *Archaeology of Knowledge*, the *Archaeology* itself was written (in part) as a response to Derrida's 1963 critique of Foucault's history of madness. In

this lecture, Derrida asks whether it is possible to write a history of madness, whether it is possible to represent madness with the tools of history (e.g., reason, order, language). As Foucault himself insists, madness does not speak; it is the essence of what cannot be said and what refuses to work. Derrida writes:

> It is a question, therefore, of escaping the trap or objectivist naiveté that would consist in writing a history of untamed madness, of madness as it carries itself and breathes before being caught in the nets of classical reason, from within the very language of classical reason itself, utilizing the concepts that were the historical instruments of the capture of madness. [. . .] Foucault's determination to avoid this trap is its admirable tension. But it is also, with all seriousness, the *maddest* aspect of the project.[35]

In other words, Foucault's effort to *write* madness, to tell its history, suggests a fundamental misunderstanding of madness. The effort itself is mad. If, as I have been suggesting, early cinema both past and present exemplifies a kind of madness, one embodied by the figure of Alice, one that moves in multiple and irreconcilable directions at once, it might be worth asking whether it is possible to write a history of a cinema such as this.

notes

1. Luke McKernan, "Alice: Random But Cool" (3 March 2010): thebioscope. net/2010/03/03/alice-random-but-cool. Accessed 16 February 2014.
2. Mark Brown, "BFI to Launch Online Player with 10,000 Films," *Guardian* (3 October 2010): theguardian.com/film/2012/oct/03/bfi-online-film-player-heritage. Accessed 15 January 2014.
3. Gilles Deleuze, *The Logic of Sense*, trans. Mark Lester with Charles Stivale (New York: Columbia University Press, 1990), 1.
4. *Ibid.*
5. *Ibid.*, 3.
6. *Ibid.*
7. See, for example, Henry Jenkins, *Convergence Culture: Where Old and New Media Collide* (New York: New York University Press, 2006).
8. Gilles Deleuze, *Michel Foucault*, trans. Séan Hand (New York and London: Continuum, 1988), 3.
9. Michel Foucault, *Archaeology of Knowledge and the Discourse on Language*, trans. A.M. Sheridan Smith (New York: Pantheon Books, 1972), 47–48.
10. *Ibid.*, 128.
11. *Ibid.*, 129.
12. Jacques Derrida, *Archive Fever*, trans. Eric Prenowitz (Chicago: University of Chicago Press, 1996). For evidence of their disagreements (about the archive, history, and epistemology), see Jacques Derrida, "Cogito and the History of Madness," in *Writing and Difference*, trans. Alan Bass (London and

New York: Routledge, 1978), 36–76; Michel Foucault, "My Body, This Paper, This Fire," in *Aesthetics, Method, and Epistemology: Essential Works of Foucault, 1954–1984, Vol. 2*, ed. James Faubion (New York: The New Press, 1999), 393–418; and Jacques Derrida, "To Do Justice to Freud," trans. Pascale-Anne Brault and Michael Naas, *Critical Inquiry* Vol. 20, No. 2 (Winter 1994): 227–266.

13. Derrida, *Archive Fever*, 11.

14. *Ibid.*, 16, 13.

15. *Ibid.*, 16.

16. See, for example, Katherine Hayles, *How We Think: Digital Media and Contemporary Technogenesis* (Chicago: The University of Chicago Press, 2012); Mark Hansen, *New Philosophy for New Media* (Cambridge, MA: MIT Press, 2006); and Tara McPherson, "Reload: Liveness, Mobility, and the Web" in *New Media, Old Media: A History and Theory Reader* (New York: Routledge, 2006), 199–208.

17. Carolyn Steedman, *Dust: The Archive and Cultural History* (Manchester: Manchester University Press, 2001), 9.

18. Jaimie Baron, *The Archive Effect: Found Footage and the Audiovisual Experience of History* (New York: Routledge, 2014), 7.

19. Domietta Torlasco, *The Heretical Archive: Digital Memory at the End of Film* (Minneapolis: University of Minnesota, 2013), xv.

20. *Ibid.*, 79.

21. Jussi Parikka, "Introduction" in *Digital Memory and the Archive*, Wolfgang Ernst (Minneapolis: University of Minnesota Press, 2013), 6–12.

22. *Ibid.*, 6.

23. For key texts in object-oriented media theory, see Ian Bogost, *Alien Phenomenology, or What It's Like to Be a Thing* (Minneapolis: University of Minnesota Press, 2012); and Graham Harman, *Tool-Being: Heidegger and the Metaphysics of Objects* (Open Court, 2002).

24. Ernst, *Digital Memory and the Archive*, 197.

25. *Ibid.*, 70.

26. *Ibid.*, 71.

27. Excerpted from *Images for the Future* press release, http://beeldenvoor detoekomst.nl/en/project. Accessed 16 February 2014.

28. Few contemporary archivists would agree that digitization eliminates the threats that films face in the archive. For example, Paolo Cherchi Usai suggests that digital and physical images are "subject to the same destiny." See Usai, *The Death of Cinema: History, Cultural Memory, and the Digital Dark Age* (London: British Film Institute, 2008). See also Jan-Christopher Horak, "Editor's Introduction," *The Moving Image* Vol. 3, No. 2 (Fall 2003): vi–ix.

29. Martin Heidegger, *Being and Time*, trans. Joan Stambaugh (New York: State University of New York Press, 2010), 74–75, 129.

30. The moving image content for *The Scene Machine* was curated by David Lammers, Remco Packbiers, Maike Lasseur, and Rommy Albers; the project was coordinated by Annelies Termeer and Irene Haan of the EYE Film Institute.

31. See Michel Foucault, *The Order of Things* (New York: Routledge, 1989), xvi.

32. Richard Abel, *The Encyclopedia of Early Cinema* (New York: Routledge, 2005), xxx.

33. For examples, see Thomas Elsaesser, *Early Cinema: Space, Frame, Narrative* (London: British Film Institute, 1990); Richard Abel, *Silent Film* (London: Athlone Press, 1996); Paolo Cherchi Usai, *Silent Cinema: An Introduction* (London: British Film Institute, 2010 [2000]); Simon Popple and Joe Kember, *Early*

Cinema: From Factory Gate to Dream Factory (London: Wallflower Press, 2004); André Gaudreault, Nicolas Dulac, and Santiago Hildalgo, eds., *A Companion to Early Cinema* (Oxford: John Wiley and Sons, 2012).

34. Usai, *Death of Cinema*, 21.
35. Jacques Derrida, *Writing and Difference*, trans. Alan Bass (Chicago: University of Chicago Press, 1980), 40.

eternally early

two

brian price

All cinema is early cinema, no matter when a film was made and no matter when a film is seen. I want to position this notion against the by now commonplace assumption that early cinema was either primitive or proto, insofar as we can see in films made at the turn of the nineteenth and early twentieth centuries the signs of a mature cinema that would realize itself in time, and largely as a result of technological progress and aesthetic innovation. Likewise, I have no interest in joining the chorus of the attractions—to see in so-called "early film" an aesthetic of non-narrative display, which marks a tendency that has persisted through time as an alternative to a conception of film style as something always in service of narrative comprehension, or meaning; though my argument is not necessarily at odds with such a claim either. As Jane Gaines has rightly pointed out, with respect to Tom Gunning's characterization of the endurance of the attraction, the attraction is a concept.[1] And concepts cannot be easily submitted to periodization; the function of a concept is nothing historical, despite what one might want to indicate about a concept's emergence. What I should like to say, instead, and with respect to a conception of time

on offer in Plato's *Parmenides*, is that *cinema is eternally early, since it cannot help but become younger than itself at the very instant in which it becomes older than itself*. One way of putting this is to say that cinema is a form of the eternal return, insofar as the moving image disappears but only to return as same. It is a sameness that makes difference possible and also inseparable from what does not change.

No mere philosophical model, "cinema," under such a description, is better understood as the automation of the eternal return on a small scale, which is also why cinema cannot be separated from life, even as it draws its resources from life. Even though we have no trouble distinguishing a moving image as something that can be distinguished from what it shows, this most basic of all formative recognitions in the history of film theory does little—no matter what is made of that fact—to unsettle the strange hold that cinema has over the life that it cannot but aim to exceed. And while "cinema" will come to name the automation of the eternal return, insofar as it cannot help but become younger than itself as it gets older than itself, cinema is not something merely mechanical. Rather, cinema requires the cooperation of humans, whom it will nevertheless outlive, and also a reckoning with our own mortality, which is what cinema gives back to its spectators who are, by comparison, epiphenomenal.[2] For this reason, any consideration of cinema's "earliness" as a mark of eternity must include the work of the artist—even before what is shown in and as the "work"—in the elaboration of what returns, again and again, so much so that every film is an instance of early film. In this case, I will be considering the exemplary work of Ken Jacobs, whose art is enabled by a process that he has invented and dubbed "eternalism." And it is not by accident that what Jacobs regularly submits to eternity is what so many have called, up to now, "early cinema."

the problem in history is what exists, not what is bygone

To speak of the eternal return is to invoke what is, perhaps, the most vexing—if not also the most influential—of all of Nietzsche's concepts, especially since the question of what it would mean to say that the concept belongs to Nietzsche is already to begin to state the difficulty of the problem. If something can be shown to return just as it once was, what sense will it make to give it a different name and a different date? For instance, one could object that Marx got there earlier than Nietzsche, when, in the opening lines of *The Eighteenth Brumaire of Louis Bonaparte*, written in 1851, he declared that: "Hegel remarks somewhere that all great events and characters of world history occur, so to speak, twice. He forgot to add: the first time as tragedy, the second time as farce."[3] And it should be noted that Marx moves the origin of the return—paradox withstanding—back to Hegel. For this reason, the very notion of eternal recurrence—of

something repeating itself just as it has been, the variation of which comes by way of our response to what returns, not in what returns—complicates the idea of both origin and historical specificity, related notions that have been utterly sacrosanct in film studies.

And yet, there is an unresolvable paradox that resides at the heart of every claim for historical specificity and periodization. The problem has less to do with narrative or subjectivity or the continual transformation of material and media—the more familiar themes of historiographical reflection—than it does with time and the partitions we find and also institute in being. When one demands "historical specificity," what one wants to know is how this thing before us can be best understood in terms of its absolute singularity. We want to know how this thing before us can be distinguished from other instances from other times, which it nevertheless seems to resemble, so that we can then set it in sequence—restore the thing to its rightful place in the succession of necessarily unequal instants—which can only be achieved if we resituate what we see in its "original" context, if we situate this singular thing in relation to a generalization about a time and a place that is other to the one in which we now regard this or that thing, where I might be regarded as speaking about a film in a general way.

But how reasonable is this? It sounds like the right thing to say. But is it, in fact, defensible?

"Historical specificity" demands that we understand time as a succession of instants, each of which shows difference in itself: this thing that cannot be shown to be like anything other than itself, which is what will earn it a date. But if a film can be shown to exhibit difference-in-itself, such that what it shows as a singular expression of a date, how will we tell it apart from anything else, since it must, as a "pure" singularity, feature nothing that can be related to something else? If difference-in-itself demands no relation whatsoever, then we will have no reasonable way to submit this instance to a succession of instants that are themselves distinguished on the basis of an absolute singularity. If something is absolute, it cannot be subject to conditions. If so, then we have also introduced a related aesthetic object—in this case, a context that we develop as a way of indicating the specificity of what is shown—which means that difference-in-itself can no longer be sustained. If this difference can only be identified in relation to whatever else it may resemble, then we are faced, in turn, with a problem of distinction, partition, and recurrence.

A series of questions now present themselves to us: If this film can be shown to be like some other, including the para-aesthetic text as a related source of signification, which date will come to matter more? Can one date a resemblance, since resemblance demands at least two images from two separate times? Do the respective dates not cancel each other out? The problem that the historian needs to take more seriously is not what is bygone, but what continues to exist.

If the problem of history is not what is bygone, but what continues to exist, then we will need—in order to understand what the "early" of early cinema might come to imply—a different conception of time than the chronological conception of time as a succession of instants will allow. This is especially the case if the notion of succession depends on a total de-emphasis of the multi-temporal character of any given phenomenon, on a capacity to participate in no less than two incompatible temporal logics at once. That is, if chronology requires a conception of the instant as something complete in itself, fully differentiated from what comes before or after it, then we will have no way of coming to terms with the way that anything can be said to have more than one time at one time. Let us consider, then, two examples from Plato's *Parmenides*, in which we find a record of Parmenides's reflections on the difficulty of distinguishing the one from the many—which is posed, initially, as a question of space and continuity—and also his reflection on time that follows from it.

In the first example, Plato reports a conversation that occurred between Socrates and Parmenides, in which Parmenides is keen to criticize the idea that a part can be known separately from the whole, which it nevertheless contributes to as a part. This particular dialogue begins as Parmenides demonstrates how we regularly imagine that something is either a whole or else part of a whole, and thus not a whole at all. It can be put thusly: as a resident of Toronto, I am likely to say that I live in a part of Ontario. I would not be regularly inclined to say that Toronto is the whole of Ontario. And yet, if we can say that there is a whole, and that nothing could exceed what counts as a whole, then we will have to say that Toronto is equally constituted by the whole that goes by the name of Ontario. If constituted by the whole, then how can the part be said to partake in the whole while also being separate from the whole? If Toronto is not continuous with the whole that is Ontario, then it will be whole in itself, and thus no part, never separate from the whole that nevertheless constitutes it.

Consider the problem in Parmenides's terms. In what follows, Parmenides leads Socrates to discover for himself the problem of telling part from whole:

> "Then does it seem to you that the whole form is in each of the many things, while still being one, or how?"
>
> "What prevents it, Parmenides," said Socrates, "from being one?"
>
> "Although one and the same, then, its whole will be in many separate beings at the same time, and so it would be separated from itself."
>
> "Not if it is like a day," he [Socrates] said, "which, although one and the same, is many places at once and is

not separate from itself. In this way each of the forms could be one, the same in all things at once."[4]

Socrates attempts to resolve the problem of the part and the whole posed by Parmenides—the idea that the part cannot partake in the whole as something separate from the whole, such that the whole becomes separate from itself—as a problem of time. Could we deny, for example, that it is Tuesday in Beirut when it is Tuesday in Toronto, even if Beirut reaches Wednesday seven hours "sooner" than Toronto? If Tuesday is a continuous whole and occurs at once, then it is equally impossible to say that Wednesday can come sooner in one place than it would in another. Tuesday is a whole that cannot be reduced to its spatial partitions. 7:00 a.m. on Tuesday cannot be separated from Tuesday as a whole that infuses each part, such that Tuesday will come to be separated from itself. As a whole, "Tuesday" subsumes Toronto at 7:00 a.m. just as it does Beirut at 2:00 p.m. The difference in time zones, which contributes to our sense of space as something partitioned can never disrupt the whole marked by Tuesday, which is, among other things, an indicator of the continuity of the earth as a whole without difference-in-itself.

As a problem of periodization, Socrates's temporal complication enlarges our own, where cinema is concerned. Imagine that a film is released simultaneously in Toronto at 5:01 p.m. on 31 December 2014 and in Beirut on 1 January 2015 at 12:01 a.m. The same film will be shown at the same time in two different places—which cannot, in any case, be different in themselves since each can also be understood in spatial terms as a continuous whole, they belong together as earth, thus are without absolute partition. Yet, would we not have reason, if we are in Lebanon, to say that this film is from 2015—supposing that we date films by the event of their appearance? It would be just as reasonable to say, if we are in Toronto, that the film is from 2014. If we enlarge our set—moving, as we must, from days of the week to a calendar year—the differences we had previously articulated as separate parts of a week find their continuity as parts of a single year that cannot be taken separately. Until, that is, we have two different years that happen in the same instant. And now that we have identified one phenomenon by two names, 2014 and 2015, we need only enlarge the set further, so that we can consider eternity—as that which persists until nothing else does—as a whole, which cannot be separated from itself and undoes the partition between one year and another, one place and another.

All of this assumes that a film is other than what it actually is: something that appears for some time and disappears, which it certainly can be, but is never made with the expectation that it will. This is why eternity—as an indicator of what persists as same—presents problems for any distinction we would like to make between 2014 and 2015. Or perhaps, better to say that individual films outlast the people who make them. For now, though,

let us say that a film persists across many Tuesdays and many years, more or less as it always has been. What ages in a "film" is its delivery system, not the people or trees or animals that appear in them. How a film endures depends greatly on human care and sustainable interest in the film itself, and is not unrelated to the second scene I want to recount.

Having considered the difficulty of the part as a problem of time, Plato recounts another conversation that occurs between Parmenides and Aristotle, which concerns the One, a whole that cannot be exceeded or interrupted by the naming of parts within it. If so, Parmenides concludes, the One must, by necessity, exist out of time: "IF the One has no part, it would have neither beginning nor end nor middle [. . .]. And yet the beginning and end are certainly a limit to each thing [. . .]. Then the One is limitless, if it has neither beginning nor end."[5] From here, we encounter one of the more difficult passages in Plato's text. Parmenides says:

> One thing cannot become different from another when it is already different; rather, since it already is, it must already be; and if it has become so, it must have become so; or if it's going to be so, it must be going to be so. But if it's becoming so, it must neither have become nor be going to be nor be different yet; rather, it must become so and nothing else.
>
> That's quite necessary. [Aristotle]
>
> But to be sure, the older is a difference from the younger and nothing else.
>
> It is. [Aristotle]
>
> Then whatever is becoming older than itself must necessarily at the same time also become younger than itself.[6]

If the older is a difference from the younger and nothing else, it is because "younger" and "older" require each other as temporal distinctions that assure sameness by the introduction of difference.[7] We never progress, in a temporal succession of instants, since the demand of the chronological—i.e. that we identify something as older—is what also cancels out the very idea of succession, since saying that something gets older means that we must also insist that it is younger. What Parmenides appears to do here is re-route every "becoming," by which something passes from one state into another, toward a process of recurrence, in which every difference can only ever ratify sameness, the recurrence of the same in the act of temporal distinction. If I have to become younger than myself in order to be older than myself—as one continuous being—then "I," as the thing that persists, must always be younger *and* older than myself. If I "turn" forty-four, I will be older than myself than at forty-three, but I must be younger than myself if I am going to persist in time, as a being who can

also "become" forty-five. I am younger than the "me" that will "become" forty-five, even though what counts as "me" cannot have changed, since I endure as a whole that makes the difference of "younger" to "older" differences from each other, and, as Parmenides suggests, nothing else. Can I separate my forty-fifth year as a part of me that can be separated from the whole that is me? "Younger" and "older" name parts, which sustain the whole that subsumes every partition as instance of difference-in-itself.

what happened on 23rd street in 1901?

If something (or someone) must become older than itself in order to be younger than itself, then periodization loses, in the moment it is established, the force of nomination its very gesture supposes. The establishment of a date that is meant to serve as an explanatory context for what is shown—and is to be understood in just one way—merely marks the perpetuation of an instant in limitedly other terms. In this way, the historian becomes least like him/herself when he is most like him/herself. In submitting a date, the object is released to eternity and defies all partition as anything other than a question that we might submit back to Being as a form of individuation that cannot be sustained in the object any more than it can be in life more broadly—as a whole with no parts. The function of periodization is to anchor an image in time, such that time, in the form of a date, creates a privileged context for the legibility of an image that one cannot stop from persisting across time, which is why, I presume, the date seems necessary. And yet, as our example from Plato suggests, the act of temporal inscription forces a larger question about the partitions we introduce in being when the date given secures a sense of sameness beyond difference. Put otherwise, the difference we note or introduce as a date—forever other to the moment in time in which we perceive that image—guarantees that the image will remain older and younger than itself. It will always be early, always late, no matter when we see it.

There is, perhaps, no better celebration of the poetics of partition and temporal inscription, as a feature of eternal recurrence, than one finds in the work of Ken Jacobs, especially in the moving image works that he makes with a process that he has patented under the name "eternalism." It is with Jacobs that we will be able to consider the question of eternal recurrence as a condition of creativity that is ultimately inseparable from immortality.

In films such as *Nymph* (2007), *Alone at Last* (2008), *Pushcarts of Eternity Street* (2006), *Capitalism: Child Labor* (2006), *New York Ghetto Fishmarket 1903* (2006), and *What Happened on 23rd Street in 1901* (2009), to name only a few, Jacobs submits early film and photography—often Edison films—to the "eternalism" process, where films and photographs take on new movements, new rhythms, and longer durations. The most significant feature of

Jacobs's eternalisms is to be seen in the way in which "early cinema" reappears in 3D, which gives new emphasis to things, new relations between things, in images that have otherwise been celebrated for their primitive appeal. What Jacobs recognizes, like Parmenides before him, is the post-structural instance of periodization—this date that relativizes time at the very moment in which it attempts to fasten it forever as a way of seeing, so much so that the period (grammatically speaking) implied after "what happened" should be replaced by a question mark. We might say that Jacobs is honoring—redoubling—the fascination of Edison films like *New York Ghetto Fishmarket 1903* and *What Happened on 23rd Street in 1901*, which include the post-structural temporal gesture in the titles themselves. Of this cinema, Jane Gaines has suggested: "It both references past events (or the "what already happened" in its title) and shows in its present "what happened" *as it is happening* again."[8]

Of the "What Happened" films, Gaines notes an even more peculiar problem that works against the idea that such films purport to show "events themselves" in an objective way, so that inference is no longer necessary. Her observation has much to tell us about Jacobs's eternalisms. Gaines notes how in *What Happened in the Tunnel* (1903) we are faced with a blind spot that troubles the evidentiary status of the film as a record of a possible interracial kiss between a white man and an African-American woman. Edison's film consists of three shots. In the first, we see a white man seated behind a white woman and an African-American woman. There, the man appears to flirt with the white woman who sits in front him and also screen-right of the African-American woman. As the white woman turns partially in the direction of the man, as if slightly seduced by whatever it is he was saying, the screen goes black—presumably to signify that the train has passed through a tunnel. When the image returns, we see the man pulling away from the cheek of the African-American woman, who is now seated where the white woman previously was. Gaines argues that:

> The blackness-in-the-tunnel moment—like the gap between the historicity of what happened and the historicity of what was said to have happened—gives us direct evidence of nothing at all. We must infer the missing event from given or available evidence of events before or after. Still, the vast past is much more than the sum of the missing or found pieces of it. The great gap between the two historicities also means that historical excision and eclipse is the norm.[9]

If excision and eclipse is the norm, it is because the black screen that constitutes the second shot of the film announces the limits of the frame even when the frame features a picture of something. For Gaines, this problem

indicates the necessity of the inferential and narrative dimension of film history. However, it also provokes a larger philosophical ambition for film. Namely, the norm of excision as the demonstration of a limit suggests film itself as one form of the partitioning of being, insofar as film draws an image from life, such that it stands against life—once it takes what it shows—and yet, remains *in* life as the part that cannot, in the end, be taken separately from the whole. Even the enclosed work—the "whole" of *What Happened in the Tunnel*—features a blind spot that prevents it from being relegated to the realm of the evidentiary, where nothing else is needed or can be said about it.

At the center of Jacobs's process is the blind spot that Gaines identifies in the "What Happened" films. However, Jacobs does not feature the black screen as a self-reflexive caesura in the narrative. Rather, the black screen is the blind spot of creativity that gives more to an image while adding no new images to the image that had previously been regarded strictly as evidence of what happened in 1901 in this or that place for this or that amount of time. In his patent application, Jacobs describes the process:

> Specifically, two or more image pictures are repetitively presented together with a bridging interval (a bridging picture) which is preferably a solid black or other solid-colored picture, but may also be a strongly contrasting image-picture readily distinguished from the two or more pictures that are substantially similar. In electronic media, the bridge-picture may simply be a timed unlit-screen pause between serial re-appearances of the two or more similar image pictures. The rolling movements of pictorial forms thus created (figures that uncannily stay in place while maintaining directional movement, and do not move into a further phase of movement until replaced by a new set of rotating units) is referred to as Eternalisms, and the process of composing such visual events is referred to as Eternalizing.[10]

The repetition of the contrasting picture is what gives Jacobs's figures a three-dimensional character. They are pushed to a state of extreme elasticity, such that we see in and around what we might otherwise merely have looked *at* as a flattened portrait of life with implied planes. In Jacobs's eternalisms, the world on film expands and contracts; figures move back and forth in rhythmic ways to the extent that the stutter effect sends figures and objects in both straight and curved lines *at once*. Hence, Jacobs's description of "figures that uncannily stay in place while maintaining directional movement." It is a visual experience that cannot be indicated by the publication or presentation of still images, in which case Jacobs's version will be

indecipherable from Edison's. The experience of eternity, it would seem, depends on the repetition of the moving image as a whole, so that the repetitions within the film—the to and fro of people, pushcarts, apples—can be witnessed as always different because always the same.

Consider the difference between Edison's *What Happened on 23rd Street in 1901* and Jacobs's. Edison's film is, in one telling, a snapshot of life in New York in 1901. The camera, mounted in place on a sidewalk on 23rd street, shows people moving up, down, and across the street; trolleys and horse-driven buggies fill the street and move at a slow, wobbly clip. At the center of the frame, and in the middle of the sidewalk, is a grate. For most of the film, we see men and women walking by the grate but never directly over it, and we begin to recognize the grate as the focal point of the image—a steady point of reference in a film that otherwise shows disorderly motion. In the closing seconds of the film, a couple appears, who will "unknowingly" walk straight over the grate, at which point the wind blows the woman's skirt upward. Together, the couple dips low and to the side as she attempts to hold the dress down, while the man moves away from the grate while holding the woman's shoulder, as if to prevent her from falling while nevertheless featuring the motion she makes as a kind of curtsy—as if the pair were translating, in the instant, a source of shame into a gesture of respect.

In Jacobs's *What Happened on 23rd Street in 1901*, the film begins with what constitutes the last twenty seconds or so of Edison's footage, the moment in which the couple appears and heads straight toward the grate. For a brief moment, Jacobs allows the footage to play in its original speed as the couple nears and as trolley and buggy pass by. Just before the couple makes contact with the grate, Jacobs freezes the frame, as if to give us one last look at the photograph in its flat, "evidentiary" state. The pulsation begins again and the couple finds their way onto the blowing grate. The world that was stilled and ordered as still begins to open up in three dimensions: as the couple moves back and forth, the image takes on a rounded aspect, even as figures and objects move back and forth in a straight line, the pulsation of which lends a curve to a movement that also stays straight at the same time. One effect of the repetition Jacobs introduces here has to do with the way in which the fabric of the man's pants and the woman's skirt blow in unison. The fabric takes on an abstract texture—a visual sense of tactility that also retains depth. At the same time, to the right of the couple, the horse pulling a buggy appears to be moving in the direction of the camera, which is diagonally opposed to the straight path that the buggy nevertheless appears to be pursuing, even though the horse that appears to be moving in the opposite direction pulls it.

Barely advancing the frames, Jacobs then moves into a more abrupt stutter pattern, in which we witness the couple dancing in unison: he steps laterally, while she steps forward and backward. The repetition of the

stutter step gives motion to her hips, and the dance begins to take on a less reserved character. As the dance continues, as an expression of infinite motion in place, one notices the frame contracting and expanding on the left side—a pulsation of blackness that expands what we can see in the image even as the surface of the image itself shrinks. In this case, as the couple dances—he, side to side, she, back and forth—the rear plane of the image surges forth as though it might push itself through the couple and toward the front of the frame. Just slightly later, Jacobs moves in closer on the pair to the extent that they occupy the entire frame, and focuses on the moment in which the woman begins to reach down for her skirt. Stuttering on the moment of the initial reach, the woman now appears to rhythmically swing her arms at an angle: a major variation in what is now describable as a dance, which is itself derived from one small instant in a larger, otherwise continuous movement of the body.

A few observations. First, we can now consider what the process of "eternalism" might have to tell us about eternity as a cinematic phenomenon. In taking the Edison film just as it has been, Jacobs plays it again, such that "what happened" happens again, as Gaines observed. Jacobs, however, is not content merely to repeat the film.[11] Rather, he shortens the film so as to lengthen the film. In isolating two frames at a time, moving rhythmically between them, the original gesture takes on a new aspect. What was once an image of embarrassment now becomes an expression of joy. The same thing, Jacobs shows us, can be told in more than one way. Jacobs wrests the film from 1901 as signifier submitted to meaning, this one thing only, which is a conceptual horizon that blocks the sign from the polyvalence that shows itself only in repetition, even if "showing" now has to include eluding. If elusive, the sign is also an expression of abundance and wonder that follows from contraction. Many times in the film, Jacobs re-frames the Edison image to show less, which has the effect of multiplying what we can see, not only in the tighter frame, but also in the larger frame or sequence once we return to it with an altogether different visual orientation than we had before. Just as one must become older in order to become younger, the frame must shrink so that it can expand; it must get smaller in order to become bigger. This expansion that is also a reduction, and occurs as a question of space, is motivated by a question of time, which is, as we have seen, subject to the same logic of the perpetually present, the eternally recurrent.

Jacobs's interventions, which he describes as a process of eternalizing, are not aimed at the evidentiary and the historical, as something sealed and defined by periodization, so much so that we would say that the film is only about this or that. What Jacobs stages by virtue of repetition is a much broader ontological problem about partition itself; namely, how it is that we tell one thing apart from another, knowing that every distinction undoes itself by virtue of the larger one to which it must be submitted as the part of a whole.

In place of categorical distinction, Jacobs introduces a play on distinction itself—knowing that something has to be brought to coherence as a distinct thing, so that we can see it and engage with it, but never for the sake of an understanding that regards what is gathered as something complete in itself. Rather, "distinction" is merely one more way of thinking about how we give shape to things and release, in turn, what has been shaped to other ways of appearing, which is what happens when one is old enough to be young enough; when we are prepared to give way to the immensity that shows itself as something that cannot be framed at once and known as whole. Or as Deleuze puts it in *Difference and Repetition*: "When representation discovers the infinite within itself, it no longer appears as *organic* representation but as *orgiastic* representation: it discovers within itself the limits of the organized; tumult, restlessness and passion underneath apparent calm."[12] In Deleuze's account, what any representation shows us in the cultivation of calmness is the univocity of Being, the ongoing and restless source of every framing that no frame can contain or exceed, which includes the human being as something both cultivated and to be returned, as such, to the indistinction of a volatile Oneness. There is nothing for nihilism here, even though Deleuze himself thought of the univocity of Being as "crowned anarchy." Rather, as Jacobs suggests, the play on form and distinction in the work of art is a matter of care in relation to the immensity of Being:

> Art is the human product, even though the grass and flowers may see things differently. I say beyond science because art is largely a diary of caring. I've felt obliged to answer to many demands, wife and kids, students when I was a teacher, but most essentially to our communal discovery of Being.[13]

As a diary of caring, art is a record of matter given shape, life given distinction against itself. Care opposes mastery in what it admits of the orgiastic pull beneath or around whatever is given appearance as a distinct thing. If I care for something, then I tend closely to what cannot but exist in a state of vulnerability. Caring is not a matter of knowing what happened on 23rd Street in 1901 but, instead, of wondering: what happened on 23rd Street in 1901? Our question is not about 1901 at all. In asking the question, which demands a repetition of the same, 1901 is released to eternity. Seeing it again in 2015 means that the film keeps becoming younger than itself as it gets older than itself. As partitions are introduced and resubmitted to Being—the close-up of a limb in just two of a possible two thousand frames—more and more do the lines of demarcation indicate a question, even though some would prefer to place a period, temporally and grammatically, instead. Form is a question that comes to us as an enclosure among—and not merely inside—other enclosures.

to be changed as we are, or crushed?

In *The Gay Science*, Nietzsche imagines a scenario in which a demon is said to "steal after you into your loneliest loneliness" where he will propose the possibility of living life again exactly as it has been lived before.[14] Given the choice, Nietzsche wonders whether it would be a source of terror or joy: "If this thought gained possession of you, it would change you as you are or perhaps crush you."[15] Jacobs answers Nietzsche's question in the affirmative. What happened once as a source and expression of shame appears again in exactly the same way, but this time as an image of joy. Strictly speaking, Jacobs's film does not change Edison's film; rather, he shows what can now be seen as having always been there. If Jacobs's and Edison's films are both "now" and "always" then they become younger as they get older. By virtue of the interventions that Jacobs's makes, it is difficult to look at Edison's film, on its own, and not see what Jacobs's film has shown us, a consequence of which, in ontological terms, is that the very work of distinction and partition collapses two into one, Jacobs into Edison. Is this not what happens, when in Jacobs's film, the image goes still for just a moment?

As I suggested at the outset, as a form of the eternal return, cinema is no mere model. What cinema offers us is both an experience of, and opportunity for, care—supposing that we take repetition to be a source of difference-in-sameness that opens us up to the "crowned anarchy" of the univocity of being, which shows itself in the drawing of every distinction as a question, in the establishment of form itself as a question that we re-submit to Being. *Can this be so? Then what about this?* What we do with *and as* film, we do in every other aspect of our lives, if we are given to the question as the steadily unsteady staying-with of care. For this reason, film may be better suited for philosophy, insofar as philosophy concerns itself with what constitutes a good life, than it is for history, which has rarely shown itself to be a diary of caring, so much as an exercise in category construction, or, the covering over of every blind spot.

In this respect, what cinema gives us as an eternally recurrent thing is less a form of knowledge than it is a form of thinking, both as a reflection on the activity of production and on the work that comes of that effort. In his reflection on what it means to be serious—which is strongly related to the experience of care—Alexander García Düttmann has suggested that, in place of a question about "How can I avoid being crushed?" or else "What do I judge to be important in my life?" we ask instead: "How can I be old and young enough, old enough to be young enough?"; and "How can I, how can creation, disclose eternity?"[16] The latter two questions involve the creativity of the blind spot as an expression of individuality on the way to immortality:

> Yet the unintelligibility of selfhood also denotes individuality. It denotes the singularity, the idiosyncrasy, the

contingency, the strange mobility of a "blind spot" in the self that defies conceptualisation and for this reason must attract thought. By accepting the challenges of life, by accepting life as a menace and a challenge, the individual strengthens its will to life, petrifies itself as it becomes more and more mature and surrounds itself with an aura of foreignness and remoteness that expresses not a premature death but the improbability of ever succumbing to death, a flowing and inexhaustible fountain of youth.[17]

If the blind spot is productive of thought, insofar as it refuses all conceptualization, and especially as it has faced the challenge of an unrelenting outside, serious thought is what remains untethered to what one has seen or done once before in an insistent, if also non-cognizable way, which is what avails serious thought, serious art, to eternity. To have become old enough to be young enough is, in just this regard, the moment in which one has done something in a serious way, which will now repeat as same without its maker but also as its maker, and will do so on the basis of the difference that greets the serious work every time it repeats. In this scenario, to be young is to have just begun to live forever. If so, immortality follows from a diary of caring, which marks a sustained commitment to one's blind spot in the face of an unforgiving and unrelenting outside. One need only note the urgency in the titles of Jacobs's films to have a feeling for the artist's opposition to this unwelcoming outside: *The Surging Sea of Humanity*, *Star-Spangled to Death*, *A Primer in Sky Socialism*, but also, *We Are Charming*. Cinema repeats as same when it is serious, not simply when it has been marked as historical, since what so often counts as "historical" is the very horizon of expectation to which every blind spot stands in opposition as something "unintelligible," and thus always early, especially when it repeats as same, which is how the immortal remains a part of life.

notes

1. Jane M. Gaines, "What Happened to the Philosophy of Film History?" *Film History* Vol. 25, No. 1–2 (2013): 76.
2. Thomas Elsaesser has made a similar point by emphasizing how, in Greek usage, "kinesis" marks the way that light animates cellular movement, which means that what happens with film happens also as an experience of life. See "Is Nothing New?: Turn-of-the-Century Epistemes in Film History," in *A Companion to Early Cinema*, eds. André Gaudreault, Nicolas Dulac, and Santiago Hidalgo (Oxford, UK: Blackwell Publishing, 2012): 589.
3. Karl Marx, *The Eighteenth Brumaire of Louis Bonaparte* (New York: International Publishers, 1963), 1.
4. Plato, *Parmenides*, trans. Albert Keith Whitaker (Newburyport, MA: Focus Publishing, 1996): 28–29.
5. *Ibid.*, 37.

6. *Ibid.*, 44.

7. I am not the first to be reminded of cinema by this passage in Plato's *Parmenides*. See, for instance, Stanley Cavell's invocation of it in *The Pursuits of Happiness: The Hollywood Comedy of Remarriage* (Cambridge, MA: Harvard University Press, 1981), 258.

8. Gaines, "What Happened to the Philosophy of Film History?" 74.

9. *Ibid.*, 75.

10. Ken Jacobs, "Eternalism, a method for creating an appearance of sustained three-dimensional motion-direction of unlimited duration, using a finite number of pictures," U.S. Patent 7030, 902, filed 22 January, and issued 18 April 2006.

11. Although, it should be noted that he has, in fact, done just that, with *Perfect Film* (1986), in which he shows without alteration a film about the assassination of Malcolm X just as he found it.

12. Gilles Deleuze, *Difference and Repetition*, trans. Paul Patton (New York: Columbia University Press, 1994), 42.

13. Ken Jacobs, "About Myself," *World Picture* 4 (Spring 2010): http://worldpicturejournal.com/WP_4/Jacobs_Essay.html. Accessed 20 May 2014.

14. Friedrich Nietzsche, *The Gay Science*, trans. Walter Kaufmann (New York: Vintage Books, 1974), 273.

15. *Ibid.*, 274.

16. Alexander García Düttmann, "Against Self-Preservation, or can *SCUM* be Serious?" *World Picture* 9 (Summer 2014): http://worldpicturejournal.com/WP_9/Duttmann.html. Accessed 3 May 2015.

17. *Ibid.*

"historicity begins with decay and ends with the pretense of immortality"

an interview with paolo cherchi usai

Paolo Cherchi Usai is the Senior Curator of Motion Pictures at the George Eastman House in Rochester, New York, where he founded the L. Jeffrey Selznick School of Preservation. He is a founding board member of the Pordenone Silent Film Festival and co-director of the Davide Turconi Project. Usai has written extensively on film history and conservation. His book, *The Death of Cinema* (British Film Institute, 2001), rerouted debates about the future of film preservation through the first decades of film and the phenomenon of celluloid decay. He made his filmmaking debut in 2006 with *Passio*, a work that participates in the found footage practices that *New Silent Cinema* takes as one of its central concerns. In her *Film Quarterly* (Spring 2007) review, Linda Williams describes *Passio* as "the hardest-hitting, cruelest, and most affecting collection of sound and image this side of Buñuel."[1] Usai insists that the film be exhibited with full orchestral and choral accompaniment; and, in a further provocation, he destroyed the film's original negative. This interview was conducted by Katherine Groo via email between April and December 2014. It has been condensed and edited.

In the early stages of developing *New Silent Cinema*, Paul [Flaig] and I discussed the mid-1990s as an important moment in film history, a centenary responsible for the most recent wave of interest in film's first decades among popular and avant-garde filmmakers alike. On the surface of it, *The Death of Cinema* seems very much of this era, perhaps a symptom of our collective concern about the future of film as digital media were expanding all around us. However, as you explain in your introduction, it had been a project in development since the 1980s. The title itself went through multiple revisions (from *A Model Image* to *Decay Cinema* to *The Last Spectator*). The argument you make is also one that escapes any kind of easy historicism. You ground the "death of cinema" in the materiality of film itself; it is an intrinsic property of the medium, not the effect of digital annihilation. Could you describe the relationship between this project and the era(s) in which it was written?

The Death of Cinema was published in 2001; its appearance within months of 9/11 and the fact that one of the book's illustrations shows Taliban activists burning films in Kabul has, for me, a special significance. It is true, however, that its seed was planted long before, at a time when film preservation was barely on the radar of public opinion. My starting point, back in 1988, was a profound dissatisfaction with the general view of film as an "art of reproduction," a prejudice based on a simplistic reading of Walter Benjamin's writings. This misconception was shared by film critics and curators alike—from their perspective, *Casablanca* (Curtiz, 1942) was "a film," regardless of the print used for its projection.

I was utterly fascinated by this proud indifference to the medium, even more so as I learned the basics of film preservation and realized that one of its primary goals was to conceal the ravages of time as much as carelessness and incompetence. So, on the one hand, it was implicitly understood that all prints are equal, therefore my 35mm copy of *Casablanca* was as good as yours because it is "a film" after all. On the other hand, protecting the print as an artifact was not a matter of urgency, either: if damaged, the print could easily be replaced because, again, it's "a film" after all.

Notwithstanding all of the above, the loss of a large portion of film history was generally acknowledged. But, guess what? Once a film had been "restored," its new reincarnation was mistreated as before, on the basis of the Benjamin postulate. No original, therefore no "aura."

This cluster of contradictions triggered my curiosity and marked the beginning of a long journey. Yes, the project has evolved and, yes, my views on film preservation have kept changing since 2001, but I still stand by what I wrote in Chapters XXXI, XLVIII and L of *The Death of Cinema*.

Your response reminds me of the many scenes of historical trauma that appear in *The Death of Cinema*. I am interested in the image that has

special significance for you. What is the significance of the image of Taliban students burning film, perhaps beyond the historical coincidence of 9/11? What does this image suggest about the medium of film? Or, as you note, the limitations of "mechanical reproduction" as a framework for understanding it?

The BBC broadcast showing Taliban students burning film was aired on October 15, 1996; at the time, I was struck by the fact that a deliberate act of destruction of moving images would be documented through other moving images. Five years later, the ministry of religious affairs of the Taliban regime decreed the destruction of the Buddhas of Bamiyan, erected in the sixth century. The painstaking process of demolition was, again, documented with moving images. This new manifestation of iconoclasm occurred in March 2001, just when *The Death of Cinema* was going to press. The "twin towers" in Manhattan were attacked six months after the "twin Buddhas" had been blasted with explosives. Here was another intriguing coincidence: images had been created in order to portray the obliteration of other images, other icons, other symbols. This was the catalyst of *Passio* (2006); to this day, the question of why human beings feel the urge to create and to erase artificial visions remains at the core of my interests. "Reproduction" is the name we give to this illusion of control over the longevity of those visions.

How exactly did *Passio* develop? And why did you make the decision to destroy the negative?

One of the most surprising—and revealing—reactions to *Passio* has actually to do with my decision to destroy its negative. I have heard and read a few lively responses to this decision, ranging from outrage to sheer disbelief, and I find this rather astonishing. If there is nothing wrong with an artist who destroys the matrix of her or his etching, why should this be a problem for a filmmaker who does the same thing with her or his own work? I did not destroy someone else's negative and would certainly never do that unless its creator asked me to! I think the reason for the outrage—and what I find so revealing—is that the notion of a film that cannot be reproduced indefinitely is widely perceived as a sheer contradiction in terms. It is as if my gesture was blatantly at odds with the decision to make the film in the first place. I felt it was important to expose the ideology underlying this prejudice.

I have admired Arvo Pärt's *Passio* since hearing its first recording. Aside from regarding it as one of the last music masterworks of the twentieth century, I have been intrigued by what I perceived as two competing aspects of its essence: on the one hand, the miniature-like precision of its structure; on the other hand, the intrinsic challenge of performing it with

55

the same tempo on two consecutive performances, something that happens with virtually every piece of music but more acutely so, I think, in the case of *Passio*. As I was rehearsing the film with the Theatre of Voices, Paul Hillier reckoned how difficult it was for him to conduct the music in the same way he did at the time of his 1988 recording. I wanted to make a film at the service of the music and as a tribute to its being the source of unique sonic events. Destroying the negative was like disposing of the placenta after a childbirth; it is a flawed comparison to say the least, but it is my way of suggesting that I do not wish to create two entities that are identical to each other and that I do not want them to live two identical lives, ever. Let each screening be a different occurrence.

Passio and the reactions it provoked also raise some important questions about the creativity of curatorship. Just a few years ago, you co-edited (with David Francis, Alexander Horwath, and Michael Loebenstein) a collection of interviews and discussions (between all of you) on the state of contemporary film curatorship. Here, I think you make a number of important and perhaps controversial points. You claim, for example, that the role of the curator is not only to preserve and to guard, but also to encourage creativity. Can you expand upon the "creative" aspects of film curatorship?

The term "curatorship" has been the victim of considerable semantic abuse in recent times. Curatorship is an art rather than a science. Whether we like it or not, it is based on connoisseurship, the discipline of learning through recognition, careful contextualization, and sensible interpretation. To think that some people consider themselves curators just because they have selected some works for exhibition and wrote some program notes is an eloquent indicator of our *zeitgeist*, but the fact remains that, yes, curatorship is an inherently creative act and that, yes, the key responsibility of a curator is to be at the service of what is being exhibited so that the total (the exhibition) is more than the sum of the parts (the individual works). To preserve and to guard are not valuable endeavors per se. They become useful to culture and society when they foster a deeper understanding of the past. When they do, they become catalysts for the development of new ideas, and that is all that matters to me.

My late friend Jonathan Dennis, founder and first Director of the New Zealand Film Archive, never got tired of quoting his conversation with filmmaker Len Lye at a time when the institution was still in its formative stages. "That's all good," said Lye, "but will it encourage creativity?" His question was not at all rhetorical. Keeping stuff (paintings, statues, music scores, moving images) and ensuring their permanent availability is the means, not the goal, which is why the best act of curatorship is a profound, ongoing pledge of selflessness. Those who have a problem with

their own ego can find more rewarding ways to find their place in the world.

I wonder if the *zeitgeist* of what one might describe as a "defensive" or "protectionist" curatorial practice (i.e. "keeping stuff") goes hand-in-hand with the more open and creative curatorship you describe. Has the film archive always been a site of creativity (of what we might call production, rather than preservation)? Or has the relationship between an archive (or a curator) and its film artifacts changed in significant ways?

Back in 1990, Eileen Bowser—then Curator of Film at the Museum of Modern Art in New York—wrote a brief but seminal article in the Italian journal *Griffithiana*, spelling out the principles underlying the act of preserving moving images.[2] In her view, films may be preserved in order to a) make them visible in the state in which they had been found; b) restore them to their original condition; c) make use of their images in order to create new works. In my opinion, the formulation of the last goal was nothing short of visionary. Moving images of the past can and should indeed be used for the purpose of generating something else. It remains to be seen how quickly film archives captured the meaning, but the fact remains that filmmakers have attempted to do so on a variety of occasions. Whether or not they did so with the active collaboration of film curators is another matter. When Giorgio Moroder produced in 1984 his "disco" version of Fritz Lang's *Metropolis* (1927), most of them cringed at what they regarded a desecration of a cinematic icon, and yet this very version brought a new generation of filmgoers to the world of silent cinema. It was by all means a different work, and it should have been reserved as such. The film is virtually inaccessible today in 35mm format but can be seen through digital media.

Creativity expresses itself in a variety of ways. Destruction and recycling is one of them. In this respect, film curators' approaches to the issue can only be described as schizophrenic. On the one hand, they have been quite correct in trying to be faithful to their mandate to prevent or slow down the decay of the film artifact; on the other hand, they have inadvertently promoted the cause of their own nemesis by being too careless in the handling of the films they want to show to their audiences. As a result, you will now have a hard time finding a good projection print of John Ford's *Stagecoach* (1939). The battered copies available today are in themselves different works, as we—the curators—have passively endorsed the ongoing degradation of the objects we were supposed to safeguard. It is time to stop moralizing about the loss of the world's cinematic heritage and recognize our role in the demise of what we have been claiming to protect. Now that film is treated as a quasi-extinct species, we celebrate its disappearance in art galleries through the work of artists like Yervant Gianikian, Angela

57

Ricci Lucchi, Bill Morrison, Tacita Dean, DJ Spooky. What these forms of creativity have in common is that they no longer manifest themselves in a cinema. The "installation" format has legitimized cinema outside its native territory, with different rules and a totally different set of economic values.

Artists like Gianikian, Ricci Lucchi, Morrison, Dean, and DJ Spooky (among so many others) are joined in moving spectatorship out of the cinema, into galleries, and other economic networks. But many of them also seem joined in making the archive and the materiality of film visible (and maybe even mythologizing them both in the process). In other words, whatever we lose in losing traditional forms of spectatorship, there seems to be something "gained" in the process for film itself. Do you agree? Or, to follow your own line of thought: How might the rules be different with these works?

"Materiality" is currently a fashionable term in academic circles, but we should not forget that film curators have been touching film prints for decades. Curators should take the blame for not having been able to promote their cause in persuasive terms, but I feel an instinctive diffidence towards the current infatuation with "materiality." When so-called experimental films were projected in cinemas, their makers could barely survive with the risible income derived from film rentals. Then, with the gradual decline of traditional spectatorship, it became clear that the art gallery was their only viable alternative; Matthew Barney paved the way to this trend, many others followed. I feel a profound sadness in watching installations by Gianikian and Ricci Lucchi; much as I admire them, I wish they had been faithful to their original vision (in a different context, I feel the same about Anthony McCall's more recent work). But the truth of the matter is that for many of their colleagues the "content" of the image is more important than the way the image is perceived. Peter Hutton, Nathaniel Dorsky, and Peter Kubelka are brilliant but relatively isolated exceptions. One has to watch Kubelka's *Monument Film* (2012) to understand what the others have lost.

What has been gained is nothing more than respectability and market value. Fine arts museums have been spending outrageous sums for the acquisition of would-be digital masters or, worse, DVDs. Bill Viola has gone even further by attributing the arbitrary clout of a limited edition to works that can be reproduced indefinitely. In this sense, Tacita Dean has at least been coherent enough to do the same with actual film prints, and her works do not give the impression that the art gallery is a Plan B, a surrogate for the theatrical experience. This, of course, raises the question of whether or not fine arts curators care for the difference between the analog and the digital image. Christian Marclay's *The Clock* is a perfect case in point. It is presented as a hybrid between the two, the digital rendition of

a cumulative cinematic experience. I maintain that it is, in fact, something else: a clever, at times inspired and yet inexorably un-cinematic exercise, a triumphant product of the YouTube approach to the moving image, the *ars combinatoria* of distraction.

This is not good or bad per se. Destruction, theft, and deceit are at the core of artistic creativity. I am only saying that the newborn cult of materiality is being used as a pretext for degrading the cinematic event into a parody of itself, the unfunny mythology of our visual past, with or without the mystique of physical decay. Film is not just an object. It is the embodiment of a mode of perception.

In her recent book, *From Grain to Pixel*, Giovanna Fossati makes the case for a very expansive understanding of the historical experience of cinema[3]. Fossati draws upon Jean-Louis Baudry's concept of the *dispositif* to describe the EYE Institute's approach to its artifacts and exhibitions. Recast in the archival context, a *dispositif* is any situation in which film meets its viewer or user. Fossati argues that EYE turns away from the "film as original" model of historicity to conceptualize the film artifact as a dynamic and ongoing accumulation of *dispositifs*. In this way, "a silent film viewed on an ipod should not be seen as an historical falsification[4] but rather as one of the many *dispositifs* that can take shape." What is the cinematic event as you understand it? In your view, what modes of perception does it embody or allow for?

"Degrading" is not necessarily a negative value. Buildings, sculptures, and many other forms of aesthetic expression acquire new meaning through the progressive alteration and eventual disappearance over time. Performing arts such as cinema are not immune from this. Historicity begins with decay and ends with the pretense of immortality implicitly or explicitly proclaimed by any new technological innovation. Insofar as cinema matters to us as a phenomenon of historical relevance, curators and scholars should be committed to treating it as such. Film preservation has three facets: the cinematic entity that has existed in photochemical form for over 120 years and is now evolving into another incarnation; the presentational context embodied in the projection within a physical space; and the mechanical apparatus created in order to make the cinematic event possible. This third component has been largely overlooked as an object of preservation, and we are now paying the consequences of such neglect. Preserving "film" is not enough. What needs to be preserved is also the apparatus and its specific role in shaping the identity of cinema as a mode of expression. Scholars and curators have been reluctant to engage with the "human factor" that reveals itself in a projection booth through the interaction between the projectionist and the machine. George Eastman House holds a formidable collection of cameras and projectors whose

mechanisms would uncover a great deal of knowledge on why moving images looked the way they did, and yet this is the most unseen jewel in the Rochester collection. The film curator of the future should be able to restore a projector's Maltese cross as much as a Technicolor dye; scholarship should reflect this diversification of intellectual skills by interpreting and explaining the consequences derived by the choice of a given pigment over another, of an intermittent mechanism over its predecessor.

It is too easy to dismiss this variable by arguing that light sources, anamorphic lenses, and sound systems have changed over time and we cannot resurrect them. Not long ago, Renaissance music was languishing in the collective belief that there was no way to replicate the original instruments with which it was created; then, musicology and craftsmanship joined forces in demonstrating that it was indeed possible to do so. As a result, early music with restored or reconstructed instruments of the period is now widely featured in concert halls. A viola da gamba manufactured two hundred years ago is a far more complex object than a 35mm projector; if the former can be rebuilt, I do not see why we should not be able to do the same with the latter.

The point is that this reconstruction effort should matter to us. By the same token, any responsible scholar or curator of the twenty-second century should seriously think about reconstructing the viewing experience conveyed by an iPhone. We need to be very clear on this point: recognizing the protean nature of the moving image does not divest us from the responsibility of understanding the path which connects one kind of visual event to another. By all means, we should also try to examine the reasons for the viewer's relative indifference to the media that make moving images exist. The difference between an oil painting, a watercolor, and a tempera did matter enormously to the viewer; the fact that this has not happened to the moving image is important enough to give us pause. Ted Turner's colorized versions of the Hollywood classics for television are not more false than a polyester print of *The Wizard of Oz* (Fleming, 1939), or less legitimate than a DCP of *Metropolis*. They exist, period. Acknowledging that every version is "authentic" in its own right, however, does not release the curator nor the scholar from the imperative of keeping a meaningful record of their temporary incarnation. This is the best answer one can offer to the questions about the future of museums. As long as we care to know how a moving image has been experienced over time, there will be places—physical spaces—where this experience is recreated and repeated, however imperfectly.

Along with Joshua Yumibe, you have been involved in the development and management of the Turconi collection, a project dedicated to the preservation and digitization of more than 23,000 35mm nitrate film frame clippings. The clippings came from Italian film historian Davide

Turconi, who had acquired the film collection of Joseph Joye. When Turconi inspected Joye's collection, which consisted mostly of early cinema (*c.* 1907–1915), he found most of the films to be in an advanced state of decay and decided to salvage what frames he could by simply cutting them out of the reels. The clippings are preserved at the George Eastman House, but you have also made them available through a digital database. How did this project develop? And why did you decide to make the visual fragments available online?

Over the years, I had received from Davide several thousand clippings, the bulk of his collection, and I had used them for my own research as well as to assist other scholars—from Richard Abel to Kristin Thompson and David Bordwell—who reproduced several of them in their published works. With the advent of the Internet it became clear to me that something should be done to make Davide's legacy available to all. He was a very generous man, and I felt there would be no better way to pay tribute to his work than sharing his findings with the scholarly community.

I was also concerned about the physical integrity of the nitrate frames and the incomplete information available about them. Davide had put the frames in small envelopes of the kind used by stamp collectors, with handwritten titles taken from the prints, often precious, sometimes hard to read. Many films were unidentified. Students of the L. Jeffrey Selznick School of Film Preservation became interested in working at this treasure trove of early cinema, well aware that its systematic preservation would be a daunting task. Joshua Yumibe, then a student of Yuri Tsivian, quickly grasped the potential embedded in this mass of visual evidence and was instrumental in creating a solid framework for the digital access to the collection.

The infrastructure of the database was developed through a partnership between George Eastman House and the Cineteca del Friuli. In the course of about twelve years, all frames were carefully catalogued and housed in custom-made archival folders made of acid-free paper. All the data pertaining to each clipping would be carefully reproduced from Davide's envelopes while proper identification was attempted wherever possible. We then created digital scans for each clipping, and eventually include them in the database. Putting it online was at the same time the culmination of our project and our gift to Davide.

61

Turconi seems to have saved any/everything he could. But the fragments he saved (and that you preserved)—the very fact that he saved fragments—also seems to encourage a kind of openness, playfulness, and, as you describe, creativity. The collection foregrounds absence and loss; spectators and viewers must imagine what is missing. What kind of resource did you want the collection to be? And how is it actually being used?

The value of this research tool is obvious: everybody can now look at the frames and explore the range and depth of the knowledge they can generate. In essence, I felt it would have been unfair to keep this knowledge to myself. An entire lifetime would not be enough to delve into this unique time capsule of early cinema. Had he lived in the digital age, Davide would have had no hesitation in making the frames accessible to all. The Turconi Project is my way of saying thank you to a friend and a mentor. Equally important is the fact that virtually all the fragments once scattered among several individuals and institutions are all in one place. They are properly preserved, protected in a suitable climate-controlled museum environment, and can be seen in their original form.

However massive, the database is only a reference tool; one of its key purposes is to encourage users to look at the originals as tools for intellectual inquiry as well as sheer creativity. Poets have been inspired by these clippings; individuals with no vested interest in early cinema have been using them for purely decorative purposes, and that's fine with me. For example, Sam Sampson has asked us to use images from the Turconi Collection for the cover and several pages of his second book of poems, *Halcyon Ghosts*, published by Auckland University Press. Film director Guy Maddin knows about the Turconi nitrate frames, and has been flirting with the idea of making a film with them. A young couple asked for some images reproduced at the highest possible resolution, to be installed as wallpaper for their bedroom.

I love to think that new works can be created through their use, thus fulfilling one of the core principles of curatorship—cultivate new ideas by interpreting the evidence of the past.

notes

1. Linda Williams, "*Passio*," *Film Quarterly* Vol. 60, No. 3 (Spring 2007): 16–18.
2. Eileen Bowser, "*Some Principles of Film Restoration*," *Griffithiana* No. 38–39 (October 1990): 172–173.
3. Giovanna Fossati, *From Grain to Pixel* (Amsterdam: University of Amsterdam Press, 2010).
4. *Ibid.* 127.

paris 1900

archiveology and

the compilation film

c a t h e r i n e r u s s e l l

introduction

Paris 1900 has been largely overlooked by film historians, perhaps because
its director, Nicole Védrès, made too few films and was the wrong gender
to become recognized as an important French *auteur*. It may also have been
overlooked because in 1947, the year of its release, it challenged the usual
paradigms of film classification. Jay Leyda recognized it as the first impor-
tant compilation film made after the war, and he situated it within a history
of filmmakers drawing primarily on newsreels.[1] However, Védrès takes the
compilation format a substantial step forward by combining clips of fiction
film footage with photographs, newsreel, and actualité footage, and by the
scope of her archival research. In addition to film libraries, she repurposed
imagery from personal collections, flea markets, and other sources includ-
ing garrets, blockhouses, cellars, garbage bins, and even a rabbit hutch.[2] In
other words, *Paris 1900* expands the concept of the archive and "official"
history to include many other histories that were recorded on film and
subsequently abandoned as inconsequential.

Paris 1900 consists of excerpts from over 700 films, with original music by Guy Bernard, to represent the period from 1900 to 1914 known as *La Belle Époque*, a mythical period of peace in which social optimism and the arts flourished in France. The film could be described as "superficial" in that it depicts Paris as a kind of image culture (and this is precisely how Bosley Crowther described it in 1950) and yet there is a lingering undercurrent of impending disaster that is finally realized with the commencement of the Great War in 1914.[3] The omnipresent camera underscores the role of technology in this excitable culture and the archival excess seems indirectly responsible for the impending collapse. As Védrès herself puts it, she felt she had completed a "novel that ended tragically—although no one can tell, even now, whether it was by crime, accident, or suicide—in August 1914."[4] Despite the light-hearted commentary and the playfulness of Parisian fashions, entertainments, and diversions, this post-war city film is significantly less celebratory than the famous pre-war antecedents of Vertov and Ruttman, which celebrated their own modernity, rather than a former one. *Paris 1900* is less a "symphony" than a kind of sugar-coated eulogy. Instead of nostalgia, it exhibits an undercurrent of failure and false promise.

As Leyda indicates, *Paris 1900* comes out of a newsreel tradition that had flourished since the silent period. Esther Schub is usually credited as the first compilation filmmaker with her re-editing of Tsarist era newsreel footage into a pro-Soviet narrative of the pre-revolutionary past in one of the first "creative treatments of reality."[5] Indebted to the newsreel tradition, the voice-over commentary of *Paris 1900* may strike contemporary audiences as somewhat heavy-handed, although Arthur Knight's review in 1950 describes the English version written by John Mason Brown and read by Monty Woolley as "witty, polished, and highly sophisticated."[6] The voiceover in both French and English (the French version is read by Claude Dauphin) is indeed witty and sardonic, but like the newsreel format, it is somewhat relentless, pausing only occasionally in its commentary, spoken in the voice of the "present tense" of the late 1940s. This is one of only two films Védrès made before her death in 1965. A public intellectual, novelist, and journalist, she was very much part of the Left-Bank scene, with a background as a researcher at the Sorbonne.[7] Despite the key role of narration in the film, Védrès understood her project as one in which silent pictures were an invitation and opportunity to talk: "to give voice to things, facts, and faces."[8] Védrès is one of the first filmmakers to double as an archivist, and like the generations of found-footage and compilation filmmakers who followed, she turns the archive into an expressive, experiential language of history. *Paris 1900* should be recognized as an early example of appropriation art.

In this essay I would like to examine this film as an example of what I call "archiveology," by reading it against Walter Benjamin's theory and

practice of history. Archiveology refers to the reuse, recycling, appropriation, and borrowing of archival material that filmmakers have been doing for decades, in found-footage filmmaking, compilation films, and collage and essay modes. The term has been around since the early 1990s, and as digital technologies have transformed our conception of the archive as something far more accessible than ever before, it is past time for a more clear understanding of the potential of this form for historical thought.[9] Archiveology is not a genre of filmmaking as much as a practice that appears in many formats, styles, and modes. Reading *Paris 1900* against Benjamin's diverse and fragmentary writings on cultural critique will serve to illuminate the essayistic potential of archiveology as a film practice.

The perspective from the digital era brings into relief *Paris 1900*'s innovative montage-based treatment of history in which the moving-image archive is mobilized for uncanny, allegorical effects. As one of the first films made after the war, the film embraces the counter-archival properties of the cinema: the uncanny excess and incompletion implicit in the archival film "document." It also allows us to take a second look at the compilation film, a genre much maligned in found footage circles as lacking the aesthetic magic and critical impetus of collage modes.[10] In fact, Védrès deploys creative collage effects within her compilation, and moreover, creates an important portrait of the city that is not without critique. One of the first compilation films made after World War II, *Paris 1900* recognizes its own historicity, and its own present, as part of the work.

La Belle Époque is depicted as a vibrant period of amusements and artistic expression; the city of Paris is a living, breathing entity in which floods, slums, and criminals may be briefly glimpsed, but are quickly swept up in a self-congratulatory pride. At the same time, the narration is coy and ever-so-slightly ironic, as if the sudden and surprising outbreak of war in 1914 should not have been so sudden and surprising. The mystique of the period is undercut precisely by the cinema that seems to intervene everywhere between history and its representation. Védrès has also included fashion designers, along with notorious dancers and models, representing the period as one in which women were very much present in public life, even if it was principally "to be seen" (figure 4.1). The film's reflexivity emerges from the display culture of the period, which Védrès's collage structure highlights, and then undercuts with the final build up to the outbreak of war.

Dozens of artists, writers, musicians, painters, poets, musicians, and socialites appear in the film, including Claude Monet, Enrico Caruso, Pierre-Auguste Renoir, André Gide, Paul Valéry, Cécile Sorel, Mistinguett, Gabrielle Réjane, Sarah Bernhardt, Maurice Chevalier, Colette, Louis Bleriot, Mary Gardens, and Buffalo Bill.[11] Many French politicians are also featured, along with ironic commentary on their contribution to the social

Figure 4.1 Védrès includes fashion designers, dancers, and models from *La Belle Époque*.

fabric. The president, M. Faillières is repeatedly said to be "content," until finally, he is no longer content, and is succeeded by M. Poincaré, who is seen traveling on a series of diplomatic missions that unspool into a series of events leading up to the assassination of the Austrian archduke in Sarajevo.

Most strikingly, the film is punctuated at the three-quarter mark by the so-called birdman, Franz Reichelt, leaping to his death from the Eiffel tower in 1912, witnessed by Pathé newsreel cameras. The sequence begins with the birdman preparing himself at the top of the tower, balancing on the rail, while the musical score trembles softly. The narrator is momentarily silent before the leap into the air (figure 4.2). The suspenseful pause before the birdman's jump is perhaps the film's longest, making us suddenly aware of the passing of time. "He hesitates. Finally he jumps." Cut to a second camera on ground level to capture the fall. The narrator describes the six-inch hole at the bottom of the tower. "They carry away the remains of this premature birdman. But others have been luckier in conquering the skies," and without missing a beat, the compilation moves on to Bleriot's successful flight across the English Channel. The sequence is typical of the film's style in the way that the narrator and the music are intermingled on the soundtrack, and in the way that the narration facilitates a flow from one incident to another. The images of Bleriot's successful flight across the English Channel begin before the narrator has completely finished the story of the premature birdman.

Figure 4.2 The silent moment before the birdman's leap into the air.

Both André Bazin and Siegfried Kracauer commented on the film when it was first released, noting its implicit discourse on historical time. For Bazin, it indicated that, "cinema is a machine to recover time, only better to lose it. *Paris 1900* marks a tragedy that is peculiar to cinema: that of time twice lost," while Kracauer describes it as marking "a border region between the present and the past. Beyond it the realm of history begins."[12] Bazin also comments on *Paris 1900* in his essay on *The Bullfight* (*La course de taureaux*, 1951), directed by Pierre Braunberger and "Myriam" (a.k.a. Myriam Borsoutsky), the producer and editor, respectively, of *Paris 1900*. In this key essay, "Death Every Afternoon," Bazin claims that the filming of death is cinema's great obscenity, and emblematic of its specificity because it marks the finitude of the singular moment in time.[13] This observation is also a place where Bazin's views on cinema link up well with Benjamin's, both of them working from the Bergsonian theory of time as *durée*.[14] Benjamin recognized the privileged relationship of cinema to modern time in its ability to extract and freeze a moment from the continuum in its articulation of shock.[15] Kracauer's comments on *Paris 1900* stress the doubleness of images drawn from the past that are at once familiar and unfamiliar.[16]

Archiveology is indeed an uncanny discourse, as old images are given new meanings in new contexts. For Benjamin, the act of collecting is a practice of allegorization in which objects are detached from their use value and exchange value and given new meaning within the terms of a private archive. This means that they are effectively "dead." For Benjamin the rags and refuse

67

of the Paris arcades are richly allegorical as ruins of the past. For the collector "the world is present, and indeed ordered, in each of his objects."[17] Védrès's act of collecting fragments from the "dust-bin" of history in the 1940s was an innovative and radical act that challenged more conventional views of history, exposing its gaps and its forgetting alongside what Paula Amad describes as the "historicist illusion of total recall" created by newsreels.[18]

Paris 1900 embraces the cinema as an aspect of modernity with the potential to appropriate the era's impulses toward collecting and construct a different history of the future. It is a remarkable illustration, in my view, of Walter Benjamin's hopes for the transformative possibilities of film. Benjamin's dialectical and non-linear concept of history is particularly appropriate to archiveology as a critical mode of image recycling. In "On the Concept of History," for example, Benjamin describes the materialist historian as "brushing history against the grain."[19] History is not a question of recognizing the past "the way it really was," but as it flashes up in a moment of danger.[20] He also notes that, "the only historian capable of fanning the spark of hope in the past is the one who is firmly convinced that *even the dead* will not be safe from the enemy if he is victorious."[21] The enemy in this passage is the danger of conformism and capitalist exploitation.

To return to the birdman, who is made to look pathetic in his failed and deadly experiment, his role in *Paris 1900* is precisely to underline the vulnerability of the past to teleological narratives of success in which an aviator such as Bleriot is a hero and poor old Reichelt is forgotten. If Védrès manages to redeem him as a hero of an earlier age of the spectacle, her film is arguably consistent with Benjamin's utopian hope for a flash of something transformative to emerge from the ruins of the past. By drawing out the affinities between Benjamin's work and Védrès's film, I hope to underline the significance of archiveology to historical thought. Benjamin's cultural criticism urges a focus on the present and the ongoing "catastrophe" of commodity capitalism. After the "end of cinema," the digital turn, and the archival turn, we are indeed facing an onslaught of montage-based media practices comprising found images and sounds: recycled, remixed, and reframed. The return to 1947, via Benjamin, may help to recognize the present media culture of appropriation as a means of rethinking the histories of image-culture, which is to say, rethinking history through its visual manifestation in moving images.

I first became aware of *Paris 1900* through Paula Amad's book on what she calls the "counter-archive." Through a study of Albert Kahn's unusual film archive produced in the first decades of the twentieth century, Amad argues that motion pictures posed a fundamental challenge to the notion of the archive that had previously dominated historical methodology in the humanities. The cinematic counter-archive is, in her words, "a supplementary realm where the modern conditions of disorder, fragmentation, and contingency came to haunt the already unstable positivist utopia of order, synthesis, and totality."[22] In *Paris 1900* one can readily see the effect of the counter-archive as a challenge to history

"as it really was." This is history as it was filmed, in which the trickery and fantasy available to the camera is flaunted and celebrated, alongside the spectacle of troop inspection, mass demonstrations in the streets, and the posing of politicians.

Paris 1900 includes one clip from Albert Kahn's archive: a scene of men using a sidewalk urinal (*vespasienne*). The men exiting the urinal pause to return the camera's gaze. This *vespasienne* footage was the first time in thirty-five years that the Kahn footage was "brought to life" or exhumed from the archive (figure 4.3).[23] Amad analyzes this scene of everyday life in Paris as an example of the "penetration of the animate by the inanimate." The human and the camera meet, crystallizing a moment in which habitual action is transformed. We laugh at the sequence because we witness "the deflection of life towards the mechanical," says Amad, following Bergson. The disclosed witnessing of the returned gaze evokes the dialectics of mobility and fixity that rendered cinema, for Bergson, an intimation of mortality. Transfixed by the camera's gaze, the men exhibit a sense of guilt, recognition, and curiosity, as if they were transformed into "lifeless automata."[24] Kahn's archive included many images, such as the *vespasienne*, of everyday life. One of the counter-archival principles of motion pictures was its indiscriminate capturing of the trivial and the inconsequential. In *Paris 1900* "everyday life" is, however, endowed with a spectacular sense of newness and display. The camera is the democratic everyman; the archiveologist therefore digs through the strata of amnesia to better learn about the possibility and potential of everyday life in modernity.

Figure 4.3 The *vespasienne* footage from the Albert Kahn archive.

For viewers in the early twenty-first century, *Paris 1900* points to the potential of film fragments to create alternative cultural histories based in moving images.[25] Védrès's particular use of special effects from the cinema of attractions makes the film especially provocative as the construction of a memory of a forgotten future. It is more than evident from our perspective in the early twenty-first century that the film is less a "recreation" of Paris, but a remaking of its self-image, and an appropriation of its energies and hope for a future that ultimately failed it. Digital media has made it easier to retrieve and replicate the imagery of the past, but it is important to put these practices into perspective. In an era when it has become commonplace to use images and sounds to create historical narratives, when sampling and mashups are everyday techniques of media arts, it is instructive to return to a moment when the potential of this practice for new forms of historical knowledge was just being realized.

the essayistic mode

Timothy Corrigan claims that the essay film emerged as a form in post-war France, and he highlights the films of Resnais, Marker, and Varda in the 1950s. But the first film he mentions is Resnais's *Van Gogh* (1948), which was produced by Pierre Braunberger and narrated by Claude Dauphin.[26] Resnais is credited as assistant supervisor on *Paris 1900*, Braunberger produced it, and Dauphin narrated. Védrès worked on the film in 1945 and '46, it premiered at Cannes in September 1947, and won the French *Prix Louis Delluc* in the same year. An English version was released in 1948, and in 1950 it was awarded fifth prize in the foreign film competition by the National Board of Review in the United States. So, although *Paris 1900* has been largely neglected since then, it was recognized as an innovative project when it first appeared. The density and complexity of the found footage, furthermore, anticipates Guy Debord's subsequent work in France in the '50s; but where Debord enacted a systematic critique of image culture, Védrès indulges in the phantasmagoria—the world of images—and in many ways anticipates the more archival modes of found footage and essayistic film practices of the early twenty-first century.

The tone of the narration, in both French and English, remains distanced from the images, as if the narrator were watching them unspool along with the viewer. Given the kind of research that went into the film and its incomplete, slightly off-kilter approach to truth, *Paris 1900* unquestionably evokes the essayistic mode. As archiveology, it indicates how the historical evidence available to the filmmaker is unique in its capacity to produce historical knowledge that includes the trivia of everyday life alongside global politics. One critic was particularly critical of the film's crude use of humour, and points out that while the narration "mentions the socialist politician Jean Juarez, it completely fails to mention his final words: 'I blame Germany.

I blame France. I blame Russia. I blame England. I blame Austria. All are to blame and all will suffer.' "[27] The film seemed to some critics to lack depth, as its historical analysis was replaced with what another critic in 1987 described as an excess of vitality "that simply leaps from the screen."[28] It now seems to be a haunted film, as its excess masks a failure of modernity to make good on the promise of its technological novelties.

For Bazin, the film marks a second level of tragedy, which is "the impersonal gaze man now directs towards his history."[29] The death of the birdman points to the role of public memory embedded in the compilation film, as if the camera had no soul. Kracauer notes how the film separates the self from history, marking a discontinuity of the past thrown up in objective, detached form. The habitual fashions of the past suddenly seem ridiculous, and it is laughter that summons up a more acute sense of the present as historical time.[30] Indeed, the shock of the birdman's death, caught by an anticipating camera, is black comedy, pointing up the way that *Paris 1900* is self-conscious about its own superficial ironies.

Benjamin's theory of allegory, which he developed in his work on the Baroque mourning play, notoriously links it to ruins: "That which lies here in ruins, the highly significant fragment, the remnant, is in fact, the finest material in baroque creation."[31] When he adds that in Baroque literature, fragments pile up "ceaselessly, without any strict idea of a goal," the relation to the montage and collage practices of his own time (*c.* 1924) becomes evident. As Susan Buck-Morss argues, the notion of temporal transience in Baroque allegory is central to Benjamin's critique of commodity culture: "The other side of mass culture's hellish repetition of 'the new' is the mortification of matter which is fashionable no longer."[32] In archiveology, the fictional fragment is "mortified" as documentary and the newsreel fragment is "mortified" as spectacle; they thus become allegories of their former mystique. Moreover, the absences, gaps, and incompletion that become evident in this process of mortification lend themselves to irony. If in Baroque allegory, "Death digs most deeply the jagged line of demarcation between physical nature and significance," in archiveology, this "death" is precisely the unfixing of meaning, the loss of certainty and truth.[33] But, at the same time, the image contains a trace of "physical nature" in its profilmic materiality, a trace of time inscribed for example in the birdman's death. If the "significance" is up for grabs, archiveology is a film practice that enables the image to retain its allegorical doubleness as at once meaningless and meaningful. The defamiliarization provoked embarrassed laughter in the 1940s; now it is recognizable as pastiche, in its ability to elicit "a specific emotional or affective response."[34]

Recontextualized images refer back to their origins in time and space, and they also acquire a new form of address to a viewer who will, in turn, understand themselves to be historical. In the late 1940s, Kracauer felt a personal attachment to the period in question as a distant memory. He

laughs at himself for what he remembered as being "modern." A century removed from these images, our perception is more likely to be framed by public images of history. *Paris 1900* in this sense is strikingly familiar to cinephiles who may recognize clips from Méliès, and typical scenes from actualities, newsreels, comedies, and melodramas in the style of the era. We have no personal memories of this period, but we have become somewhat familiar with its imagery as an archival discourse. As Bazin noted, the archive is ruined twice over, and in this receding view of history, it may produce new insights into the potential for archival film practice to produce knowledge in essayistic form.

Paris 1900 recalls Benjamin's view of history as non-linear, imagistic, dialectical, and always undergoing construction, reconstruction, and retrieval in the interests of an ever-changing future. The film begins a few decades after the *Arcades Project* ends, and it ends a decade or so before Benjamin began living in Paris and writing about the city, filling in the gap between the two eras. The nineteenth-century phantasmagoria that he was so fascinated by, has, by the early twentieth century, become a full-fledged dream world. After World War II, the nightmare concealed within this dream becomes legible as a function of the dream itself. The architectural marvel of the Eiffel tower, a landmark to which Védrès repeatedly returns, is the climactic monument to the iron construction that housed the shopping concourses of the arcades. Some of Benjamin's twentieth-century heroes appear in person, such as Valéry and Apollinaire, exemplary poets of the so-called *Belle Époque*. Moreover, the film arguably dramatizes the dialectics of the phantasmagoria that Benjamin addresses in his sprawling opus.

Benjamin's fascination with the nineteenth-century phantasmagoria recognized the way in which it presented an illusion predicated on its own ruination, and he found keys for its undoing—the potential of awakening—within its very fabric. The essayistic flow of *Paris 1900* creates a seamless sense of historical time, as if it were a kind of monument to the period, and in this sense, it exhibits all the traits of historicism that Benjamin denounced. At the same time, its archival composition, its fragmentariness and contingency, its montage of disparate sources and styles, along with its implicit sense of mortality, show the cracks in the edifice of history. The tone of the narration, and its slightly impersonal flavor, renders history as a dream time. But most importantly, everyone and everything subsists in the "second nature" of cinema. There is no everyday life, and there is no "realism." The men outside the urinal, for example, are no longer men, but are produced by the cinema, which has essentially rendered them as elements of the city. The celebrity artists are highly self-conscious about performing for the camera. A few of them, including Sarah Bernhardt, are accompanied by voice recordings from the period, awkwardly synched to their images. In this form, subsumed entirely by mechanical

reproduction, they seem even further removed from experience, from humanity, and from life.

Everyone in this film is definitely dead, especially the birdman. Bazin suggests that if the cameras had not been there, "a sensible cowardice might have prevailed."[35] The stakes were raised by the camera's presence, and the astonishing footage constitutes one of the earliest snuff films. By including this "modern Icarus" within her compilation, Védrès allows its critical effects to undermine the film's otherwise whimsical celebration of the era. In keeping with Benjamin's theory of allegory as a process of mortification and loss, the birdman's death proclaims the failure of *La Belle Époque* to save itself, and the world, from devastation. Made just after the liberation of Paris from Nazi occupation, *Paris 1900* speaks of the decadence underlying the flourishing of the arts. The phantasmagoria Védrès depicts is not one of consumer culture, but of a national, urban culture that integrated cinema into itself so thoroughly that the image came to stand in for reality.

magic: the special effect of the archive

In *Paris 1900*, Presidential appearances, society ladies, parades, and circuses are interspersed with trick films from the period in which special effects are smoothly integrated into the flow of everyday life. This casual undermining of the realism of the cinematic document aligns the film closely with the Surrealists' distortions of reality. Benjamin's interest in Paris was explicitly inspired by the Surrealists, and Margaret Cohen has argued that his unorthodox Marxism was informed by Breton's surrealist analysis of Paris. She describes Benjamin's "gothic Marxism" as an analysis of how the "expressive character" of the Parisian environment shapes Marx's thought, alongside Baudelaire's:

> Benjamin constructs the expressive character of the Parisian environment with appeal to aesthetic products, certainly, but also with appeal to representations across the ideological spectrum cutting through the boundaries of institutionally separated genres.[36]

The parallels between *Paris 1900* and *The Arcades Project* include practices of collage and juxtaposition in which strange bedfellows are brought into conversation with one another, and in the process, materialist history is threaded with poetic "magical" eruptions made possible by technologies of representation.

The "marvelous disorientation" provoked by random cinema-going described by Breton, dropping in and out of movie theatres, is an important precursor to the shifting perspectives provoked by archival film practices

such as *Paris 1900*.[37] For Benjamin, Paris was their "most dreamed-about" object and even a "little universe": "That is to say, in the larger one, the cosmos, things look no different. There, too, are crossroads where ghostly signals flash from the traffic, and inconceivable analogies and connections between events are the order of the day."[38] Even more importantly, Benjamin refined his critical notion of the phantasmagoria, or the image-sphere of nineteenth-century modernity, through surrealist tropes of the unconscious dream world. "Profane illumination" is his term for the surrealist experience although he also found that the Surrealists were not quite equal to the job they set out to do. *The Arcades Project* is intended, through a more rigorous form of inquiry, to open "the long-sought image space."[39]

If, for Benjamin, "image" was a metaphor for the visuality and display culture of nineteenth-century Paris, for Védrès it is very literally the ruins of that culture. As Cohen describes it, Benjamin was interested in "how social facts manifest themselves primarily in the world of forms, in a world of forms that is not aesthetic but rather the realm of social fact."[40] Recorded on film, these "social facts" become expressive fragments of memory, ripe for discursive play in their recycled form. Védrès accesses film not only for its images and representations, but also for its status as a social practice and process that is never fixed or static, but always incomplete, transformative, and transitory. Through techniques of collection and collage, moreover, she has arguably "blasted the epoch out of the reified continuity of history," as Benjamin puts it, precisely by "interspersing it with ruins—that is, with the present."[41] Most significantly, by borrowing the magical properties of the cinema of attractions, the documentary status of *Paris 1900* is rendered radically unstable and unfixed.

In the opening sequence of *Paris 1900* documentary and fiction are thoroughly blended in a segue from a series of generic shots of the city, including Montmartre and the Place de la République, into a chase film set on the streets of Paris. The narrator says, "out of the morning mists, some questionable characters emerge. If they are thieves, the gendarmes will be in hot pursuit," and the soundtrack music abruptly shifts from an orchestral celebration to the familiar piano music accompaniment of silent film, preceded by a police whistle. A scene from a Keystone cops style chase film unfolds, complete with stop-motion special effects. A rogue criminal leaps up out of frame and after a second, falls on the cops, scattering them so he can make his escape—a classic stop-motion effect of early chase and comedy films.

By including sequences from trick films such as this into the compilation, Védrès borrows a specific style of editing from the period. As Tom Gunning has argued, the stop-motion effects by Méliès and other cineastes of the era are borrowed and adapted from nineteenth-century popular entertainments staged in magic theatres, often using screens, such as magic lantern shows and phantasmagorias.[42] The special effects of the cinema of attractions privilege a continuity of framing over spatio-temporal

unity, producing discontinuities that are superhuman and a display of magical transformations.[43] The attraction is always, in part, the technology itself, which produces such magical results as the metamorphosis that takes place in the clip from *The Brahmin and the Butterfly* (Méliès, 1901). The magical effect of early film tricks is produced by various forms of collage, either in the frame or between frames.

The most sustained example of a trick film in *Paris 1900* is Védrès's inclusion of the entirety of Ferdinand Zecca's short film *The Moon Lover* (1905). It is the only fragment to be introduced specifically as a film, complete with accreditation and attribution: "Its admirers call it innovative," we are told, and indeed the film features a drunkard flying through the stars to land back in his room with dancing bottles (figure 4.4). This trick film, which follows a sequence of music hall entertainers and *café-concerts*, takes us deep into the dream world of the *Belle Époque* and its chaotic diversions. The camera enters the frame of the film by zooming in over the audience and the orchestra. The falling man is the third such descent in the film, including the birdman and the falling criminal.

By 1947, trick effects were probably regarded as quaint relics of a primitive cinema, but we can recognize them now, in the context of Védrès's compilation, as a form of media archaeology. She has included not only faces and images of the past, but technological processes and effects of early cinema. Media archaeology is a field that tends to skirt around Foucauldian discourse analysis and applies more directly to the technologies

archiveology and the compilation film

75

Figure 4.4 An excerpt from Ferdinand Zecca's short film *The Moon Lover* (1905).

of representation, such as the techniques of magic and surreality from early cinema appropriated in *Paris 1900*. As Paula Amad points out, the film archive never really fit into Foucault's critique of the archive as a system of knowledge. Its counter-positivist thrust, for her, may lie behind his theory of the archive as a system of power in the first place.[44] The counter-archival properties of cinematic temporality, contingency, and excess, as well as the resistance of film to classification and cataloguing, align the cinema more with Foucault's notion of a heterotopia.[45]

Jussi Parikka has described media archaeology as a discursive return to archaic, obsolete, and redundant communications technologies in the interests of "discovering new material aspects from our digital cultural past."[46] Although he does not discuss found footage film practices specifically, Parikka acknowledges that artistic methods are ideally suited for such a project. His sense of the archive as having become a "mode of transmission," rather than simply a means of storage and preservation, is very relevant to the rich history of archive-based filmmaking.[47] Benjamin points to the same conclusion in his discussion of memory as a "medium of that which has been experienced."[48] In the form of film footage, memory remains linked to models of storage but in a counter-archival way, given the excess of contingency that explodes from those rediscovered film cans in garrets, attics, and deep in the recesses of the library. When the archival image becomes a medium of communication, its discursive effect includes expressive and sensual effects as well as the historicity of its original production.

The trick films and magical effects that are incorporated into *Paris 1900* ripple through the montage as a kind of counterweight to the doomed birdman. They enable us to recognize what Parikka refers to as the "imaginary" of technology. From the nineteenth-century phantasmagorias of supernatural life-forms, to the "fantastic" underbelly of screen, broadcasting, and telecommunications media discussed by Jeffrey Sconce, new technologies harbour their own imaginary, unrealized possibilities for social transformation.[49] Parikka is interested in imaginary media, but also the imaginary of media, pointing out that Foucault's conception of archaeology does not seek origins, but is interested in "rewriting practices." Archaeology seeks the conditions for discourse, working outside disciplinary boundaries; archiveology produces a language of history from media archives through practice. "Media archaeology," according to Parikka, does not need oedipal terms of analysis; and yet archiveology, as a discourse of specific images from the past, will continue to cry for such analysis insofar as the contents of the twentieth-century visual archive are always implicitly gendered and racially coded (*Paris 1900* includes one quick shot of African soldiers, plus a brief reference to the Dreyfus affair).[50]

The integration of fiction and *actualités*, newsreels and the various styles that we associate with the cinema of attractions, do not compromise the film's documentary value, but instead, they establish a level playing field for

the status of film as document. The narration plays freely with these documents, making them work with whatever story the narrator chooses to tell. The slippages of meaning are especially playful in the charting of time. Although the film covers a period of fourteen years, it is also structured somewhat like a prewar city-film, such as *Man with a Movie Camera* (Vertov, 1929) or *Berlin Symphony of a City* (Ruttman, 1927) with the city rising as a living, breathing organism. It ends with the outbreak of the war and the assassination of the socialist Jean Juarez. The narrator says, "The sun sets for the last time on a peaceful Paris" over a shot of the Seine at dusk.

Despite the structure of a day-in-the-life of the city, *Paris 1900* is explicitly compiled from footage covering fourteen years. The flooding of the Seine is clearly historical in the sense of marking a fairly specific moment in history, linking the epoch to a date, and the birdman's demise underscores this specificity; but shots of the Eiffel tower, like shots of the Seine at dusk, and many of the activities and shots of celebrities, are impossible to periodize with any accuracy. The challenge of film to the archive is precisely this instability and incoherence. Once it is removed from its can—its archival prop—the film clip can mean anything one wants it to mean. As Védrès herself explains, "One must go [. . .] through the first appearance of the selected shot to feel and, without insistence, *make felt* that strange and unexpected 'second meaning' that always hides behind the plain and superficial subject."[51] In the context of historical compilation, these second meanings go well beyond denotative and connotative significations to register the typical, the habitual, the everyday, and also the once-only event, which anchors the image in history. The birdman's death shudders through the film to remind us of this duplicity, and thus the whole evidentiary system is ever so subtly compromised.

In *Paris 1900* the sensual, affective aspects of the culture of the period are incorporated into the city film in such a way as to bring us closer to its transformative potential, and its failures. Certain moments in the film, such as the Méliès and Zecca films and the stop-motion effects in the chase film, suggest how the cinema participated in the transformative effects of modernity. It may even have led the charge. Hardly anything has not been staged in some way for the camera. If the cut in the birdman's fall signals the failures of the era and the lost promise of modernity that Benjamin wrote about so eloquently in the *Arcades Project*, its failure is all the more melancholy because of its alliance with the magical properties of cinema demonstrated elsewhere in the compilation.

collecting and compilation, past and future

Benjamin describes his method in the *Arcades Project* as being that of a collector, of whom he says, "the collector lives a piece of dream life."[52] The collector strips things from their use and exchange values to allow them

to enter new relations that remain unfixed, ungoverned, and incomplete.[53] In his essay on Eduard Fuchs, a contemporary of Benjamin in the 1930s, Benjamin makes a crucial link between collecting and historical materialism. Fuchs collected items of mass culture and popular arts, provoking Benjamin to recognize the particular configuration of historical thought entailed in the collection. Detached from its original context, the collected item harbours its own relations of production.[54] The past is incomplete, and can take on new meanings in the context of its afterlife. Objects and artworks do not need "appreciation," but can be valued for their material character, and for their dialectics of history, insofar as they carry the trace of entire cultural networks into the present.

Likewise, in the *Arcades Project*, Benjamin says that in the method of montage rags and refuse "come into their own" by being shown, not inventoried. He need not "say anything."[55] This is very much true of contemporary compilation films such as *The Clock* (Marclay, 2010), *Artist* (Moffatt, 2000), the works of Matthias Müller and Christophe Girardet, and Thom Andersen's *Los Angeles Plays Itself* (2003). These filmmakers do not offer inventories, and often include no credits at all, but access the archive according to patterns of movement, location, gesture, sounds, and other nondiscursive elements of the moving image archive. In the early twenty-first century, archiveology is only just coming into its own as a means of thinking about cultural history.

Benjamin saw Fuchs's practice as a fundamental challenge to the disciplinarity of the humanities, pointing out that "cultural history presents its contents by throwing them into relief, setting them off. Yet, for the historical materialist, this relief is illusory and is conjured up by false consciousness."[56] This leads Benjamin to the famous statement, "there is no document of culture which is not at the same time a document of barbarism."[57] The collected fragments of material history will always have a lineage within a history of production relations, just as film clips necessarily speak about conditions of media production. Fuchs's collection offers a dialectical passage out of this conundrum insofar as his objects, excerpted from the continuum of history, lack any signs of genius, appreciation, or "aura." Cultural history is for Fuchs, "the inventory which humanity has preserved in the present day."[58]

The collection of images Nicole Védrès compiles in *Paris 1900* is by no means devoid of the concepts of cultural heritage of which Benjamin was so sceptical. In fact, the parade of famous faces is perhaps the antithesis of the mass arts that Fuchs collected. Nevertheless, the effect created by Védrès's montage subtly undercuts the aura of these geniuses through decontextualization and historical retrospect. The film evokes Benjamin's notion of materialist historiography as radically discontinuous despite its final accumulation of events leading up to the war. Dates are literally "given their physiognomy," but they are nevertheless dissolved into the teleology of industrial modernity.[59]

In the last twenty minutes of the eighty-minute film, the collection of imagery begins to spiral out to include aerial shots of mass protests as labour unions are formed. A group of city councillors visit "a part of Paris that tourists never see"—the slums—to which their response is to build a new morgue and to have garden parties for starving children. The deeper we go into the political history of the era, the more cynical the narration becomes, as the details of weaponry are assembled and troops are paraded on city streets across Europe. Finally, "the happy times are over," and the socialist Jean Jaurés, who defended Dreyfus, is assassinated. By creating a series of events from such a wide assortment of figures, places, imagery, angles, and information, discrete historical facts are made to speak to each other and against each other, on the multiple levels that Benjamin describes as the fore-history and after-history of collected works.[60] Benjamin's notion of an afterlife of cultural artefacts ruptures the linearity of teleological history and nostalgia. The dialectics of now and then are integral to *Paris 1900*, and render the work infinitely incomplete, and always in flux, according to the historical conditions of reception. No amount of self-serving cultural celebration can offset the subsequent history of two devastating world wars, the second of which handed Paris over to the worst "barbarism" imaginable.

Benjamin's key insight, that "it is another nature which speaks to the camera as compared to the eye," is exemplified in *Paris 1900*.[61] As I have argued, the integration of fiction films, trick films, and other "attractions" of the era, effectively renders the newsreel imagery as playful, dialectical documents that are fictive in their own right. The compilation style—rushed, flowing, light, and breezy—interrupted only by the catastrophic death of the birdman, is very much in keeping with a false consciousness of historicism, and yet this phantasmagoria is only the surface of a roiling sea, an excess of images. It is clearly constructed from the flotsam and jetsam of a haphazard archive. Benjamin describes his own method in *The Arcades Project* as one of carrying over "the project of montage into history."[62] He also develops a nascent theory of the dialectical image as a point where the past and the "now" form a constellation in the form of an image that flashes up quite suddenly. Archiveology, in embryonic form in 1947, is precisely a means of shocking the past into attention, awakening its latent technologies from their preoccupation with the allegorical novelty of commodity fetishism. Benjamin was writing at a crucial moment in European history, and he was undoubtedly inspired by the specific conjunction of technology, propaganda, capitalism, and fascism, a configuration that points in crucial ways to the politics of the image-archive which has become the *lingua franca* of digital culture. The contemporary landscape of image recycling is vast and uneven, as media convergence and remediation become standard practice, demanding new critical tools to trace the implications for historical imagination. The dialectics of future and past implicit

in archiveology, and the ability to recognize the future in the remembered dream world, may provide such tools.

Paris 1900 provides an instructive point of reference between Benjamin's moment and our own, because Védrès was working with an image-bank that was remarkably close to Benjamin's study of nineteenth-century Paris. The viewer becomes a historian such as Benjamin describes, one who "takes up, with regard to [the image], the task of dream interpretation."[63] The history in this film, like the history in *The Arcades Project*, challenges all disciplinary bounds and respects no scientific laws. Moreover, the techniques of cutting, extracting, and fragmenting evoke the destructive edge of technology that finally brought the city to its knees, just as the absence of an auteur behind the camera evokes the terrifying role of the machine. The film exemplifies Benjamin's observation that "Overcoming the concept of 'progress' and overcoming the concept of 'period of decline' are two sides of one and the same thing."[64]

Film studies in the early twenty-first century has seen the "death of cinema" segue into the rise of digital media, which as Benjamin indicates, is not necessarily a rupture but a shift in perspective. New technologies offer new forms of historical imagination, and indeed, coincident with the transformation of moving image media, we have seen what Emma Cocker has described as a "paradigm shift" in the arts of archival media. She argues that the use of archival material in artists' film and video should be understood as a form of "borrowing" in which cultural memory is re-animated to produce critical subjectivity and a more empathetic relation to history.[65] The notion of archiveology as articulated here might further help to illuminate the potential of image recycling within digital media culture.

Because *Paris 1900* constitutes a transitional zone between nineteenth-century practices of art, poetry, and fashion, and twentieth-century image-culture, it provides a particularly evocative insight into the transformative effect of this shift in historical imagination. The transition of digital culture has many implications, one of which is the transformation of the archive into an accessible database, searchable by algorithms, textual tags, and non-linguistic indexes. As Jussi Parikka points out, "The archive is no longer simply a passive storage space but becomes generative itself in algorithmically ruled processuality."[66] His notion of "archivology" [sic], drawn from Wolfgang Ernst, is less about culture and more about "the techno-archive itself."[67] And yet, if we are concerned about culture and historiography, including the histories and cultures of technologies—such as those of early cinema—Benjamin's method is particularly useful. In fact, the digital archive is in many ways a remediation of the film archive, for which it has provided valuable new platforms for expansion, so that "the cinema" is not only growing more accessible, it is also growing deeper and wider.[68]

Benjamin's dialectical method provides a way of tracing the future as a reconfiguration of a "constructed" past, and while montage is the most

well-known technique of this mode of construction, equally important is the technique of collection. His theory of collecting implies a crucial transition in the relation between people and things. For Benjamin, "living means leaving traces," and the detective is the figure who collects those traces. But, as Stanley Cavell points out, if "the collector is the true inhabitant of the interior," then "the collector himself is without effective or distinctive interiority."[69] This returns us to the filmmaker-archiveologist who makes films without a camera. Indeed collecting has become a function of the modern administrative apparatus, which assembles traces in its various systems of registration and filing. The material traces of fingerprints and imprints in plush upholstery rendered the nineteenth-century interior a self-enclosed shell, which began disintegrating, according to Benjamin, with the introduction of *Jugendstil* (art nouveau), which turned the interior inside out.[70] The interactivity of digital media enables any computer user to dismantle the phantasmagoria and re-assemble it from the inside by breaking it up into object-like files. Thus the essay form of archiveology constitutes the critical side of the culture of remix and mashup. In digital culture, the compilation model has taken on new dimensions that may align it with the essayistic mode, constructing histories from fragments of other histories. As a form of archiveology, the research function of compilation media is paramount, even if this research is increasingly performed by search tools that find images in the form of systematically compiled data. Images are found and compiled specifically as images, and not as things, people, or places. The correspondence with the "real world" is to a real world of fiction, in which images are assembled from a limitless image-bank.

Paris 1900 is thus an important moment in the process by which the image-bank in its fundamental contingency and instability becomes a means by which history can speak back to the present. The dialectics of the film image are mobilized for the ongoing rewriting and reconstruction of history as a materialist practice. Once we recognize that images, media, and moving pictures are part of history and the "real world" there can be no discontinuity between images and reality. The compilation takes us into the interior of a dream world that has put itself on display for viewers in the future, which is precisely the effect of contemporary compilation media. The archival excess enables us to look beyond the "evidence" of the past to the failed promise of the future.

Like the collector's collected objects and the philosopher's collected thoughts, dialectical images bring us close to the world of the past, while the history of the profilmic remains somewhat mysterious and unknown. In *Paris 1900* we get a definite sense of the incompleteness of the total picture; we are acutely aware that all we are seeing is that which was filmed. As a counter-archival discourse, film gives us only the sensory elements of the experience of history, bringing us closer to the dream life and imagined

futures of the past. *Paris 1900* is not only one of the first essay films, it indicates how the fall of the credibility of the image opens up a rich new means of representing history as, quite literally, a dialectical process.

notes

1. Jay Leyda, *Films Beget Films* (New York: Hill and Wang, 1964), 79.
2. Nicole Védrès, quoted in the Toronto Film Society program notes for 8 February 1954.
3. Bosley Crowther, "Snows of Yesteryear: Paris 1900 Has Faults of Most Album Films," *New York Times* (29 October 1950); Anon., *Monthly Film Bulletin* Vol. XIX, No. 216 (1952): 100.
4. Védrès, Toronto Film Society program notes.
5. As Stella Bruzzi explains, the difference between newsreel and "documentary" begins with the "creative treatment of actuality." Stella Bruzzi, *New Documentary* (London and New York: Routledge, 2006), 28.
6. Quoted in Védrès, Toronto Film Society program notes.
7. See Arthur Knight, "Woman in a Masculine Movie World," *New York Times* (23 November 1952): X5; Parker Tyler, "Four Million Dollars Worth of Magic," *Theatre Arts* (January 1953): 83–84.
8. Védrès, Toronto Film Society program notes.
9. The first person to use the term "archiveology" was Joel Katz in his article "From Archive to Archiveology," *Cinematographe* No. 4 (1991): 96–103. I first used the term myself in: "Archiveology," *Public 19: Lexicon 20th Century A.D.* Vol. 1 (2000): 22. The suffix "ology" can refer to the study of something, but also to a form of language or discourse.
10. See William C. Wees, *Recycled Images: The Art and Politics of Found Footage Films* (New York: Anthology Film Archives, 1993), 45.
11. Many of these portraits are borrowed from Sacha Guitry's 1915 film *Ceux de chez nous* (*Those of Our Land*).
12. Siegfried Kracauer, *Theory of Film: The Redemption of Physical Reality* (Princeton: Princeton University Press, 1997 [1960]), 57; André Bazin, "A la recherche du temps perdu: *Paris 1900*," *Qu'est-ce que le cinéma?* Vol. 1 (Paris: Éditions du cerf, 1962), 41–43.
13. André Bazin, "Death Every Afternoon," in *Rites of Realism: Essays on Corporeal Cinema*, trans. Mark A. Cohen, ed. Ivone Margulies (Durham, NC: Duke University Press, 2003), 27–31.
14. Monica Dall'Asta has provided a more comprehensive comparison of Bazin and Benjamin, concluding that while Bazin may or may not have been familiar with Benjamin's writing, there are several remarkable points of contact. See her "Beyond the Image in Benjamin and Bazin: The Aura of the Event," in *Opening Bazin: Postwar Film Theory and Its Afterlife*, ed. Dudley Andrew (New York: Oxford University Press, 2011), 57–65.
15. Walter Benjamin, "On Some Motifs in Baudelaire," in *Selected Writings Volume 4, 1938–40*, ed. Michael W. Jennings (Cambridge, MA: Harvard University Press, 2003), 328.
16. Kracauer, *Theory of Film*, 57.
17. Walter Benjamin, *The Arcades Project*, trans. Howard Eiland and Kevin McLaughlin (Cambridge, MA: Harvard University Press, 1999), 207.
18. See Paula Amad, *The Counter-Archive: Film, the Everyday, and Albert Kahn's Archive de la Planète* (New York: Columbia University Press, 2010), 123.

19. Benjamin, "On the Concept of History," in *Selected Writings Volume 4*, 392.

20. *Ibid.*, 391.

21. *Ibid.*

22. Amad, *Counter-Archive*, 21.

23. *Ibid.*, 114.

24. *Ibid.*

25. *Paris 1900* was listed among seventy-five important and neglected films in 2007. See Nick James, "75 Hidden Gems," *Sight and Sound* Vol. 17, No. 8 (August 2007).

26. Timothy Corrigan, *The Essay Film: From Montaigne, After Marker* (New York: Oxford University Press, 2011), 67.

27. Robert Griffith in the *Saturday Review*, quoted by Douglas S. Wilson in Toronto Film Society notes from 1987 on the occasion of a screening of the film at the Royal Ontario Museum (28 May 1987): 11.

28. *Ibid.*

29. Bazin, "A la Recherche du temps perdu," 241.

30. Kracauer, *Theory of Film*, 56–57.

31. Walter Benjamin, *The Origin of German Tragic Drama*, trans. John Osborne (London: New Left Books, 1977), 178.

32. Susan Buck-Morss, *The Dialectics of Seeing, Walter Benjamin and the Arcades Project* (Cambridge, MA: MIT Press, 1989), 159.

33. Benjamin, *German Tragic Drama*, 166.

34. Emma Cocker, "Ethical Possession: Borrowing from the Archives," *Scope* No. 16 (February 2010): 96.

35. Bazin, "A la Recherche du temps perdu," 42.

36. Margaret Cohen, *Profane Illumination: Walter Benjamin and the Paris of Surrealist Revolution* (Berkeley: University of California Press, 1993), 224.

37. André Breton, "As in a Wood," in *The Shadow and its Shadow*, ed. Paul Hammond (San Francisco: City Lights Books, 2000), 42–43.

38. Benjamin, "On Surrealism," in *Selected Writings Vol. 2: 1927–1934*, trans. Rodney Livingstone, eds. Michael J. Jennings, Howard Eiland, and Gary Smith (Cambridge, MA: Harvard University Press, 1999), 211.

39. *Ibid.*, 217.

40. Cohen, *Profane Illumination*, 225.

41. Benjamin, *Arcades Project*, 474.

42. Tom Gunning, "'Primitive' Cinema: A Frame-Up? Or, The Trick's on Us," in *Early Cinema: Space, Frame Narrative*, ed. Thomas Elsaesser (London: BFI, 1990), 100.

43. *Ibid.*, 101.

44. Amad, *Counter-Archive*, 20.

45. *Ibid.*, 35.

46. Jussi Parrika, *What is Media Archaeology?* (Cambridge, UK: Polity Press, 2012), 39.

47. *Ibid.*, 123.

48. Walter Benjamin, "Excavation and Memory," In *Selected Writings Vol. 2*, 576.

49. Cited in Parikka, *Media Archaeology*, 44. See also Jeffrey Sconce, *Haunted Media: Electronic Presence from Telegraphy to Television* (Durham, NC: Duke University Press, 2000).

50. Parikka, *Media Archaeology*, 47, 58.

51. Védrès, Toronto Film Society program notes.

52. Benjamin, *Arcades Project*, 205.

53. *Ibid.*, 211.

54. Walter Benjamin, "Eduard Fuchs, Collector and Historian," in *Selected Writings Vol. 3: 1935–1938*, trans. Edmund Jephcott and Howard Eiland, eds. Howard Eiland and Michael W. Jennings (Cambridge, MA: Harvard University Press, 2002), 269.
55. Benjamin, *Arcades Project*, 460.
56. *Ibid.*, 267.
57. *Ibid.*, 276.
58. *Ibid.*, 267.
59. *Ibid.*, 476.
60. *Ibid.*, 261.
61. Walter Benjamin, "The Work of Art in the Age of its Reproducibility" (Second version) in *Selected Writings Vol. 3*, 117.
62. Benjamin, *Arcades Project*, 461.
63. *Ibid.*, 464.
64. *Ibid.*, 460.
65. Cocker, "Ethical Possession," 92.
66. Jussi Parikka, "Media Archeology as a Transatlantic Bridge," in *Digital Memory and the Archive*, Wolfgang Ernst, ed. and trans. Jussi Parikka (Minneapolis: Minnesota University Press), 29.
67. *Ibid.*, 28.
68. For more on this, see Catherine Russell, "New Media and Film History: Walter Benjamin and the Awakening of Cinema," *Cinema Journal* Vol. 43, No. 3 (Spring 2004): 81–85.
69. Stanley Cavell, "The World as Things: Collecting Thoughts on Collecting," in *Cavell on Film*, ed. William Rothman (Albany: SUNY Press, 2005), 250.
70. Benjamin, *Arcades Project*, 220–221.

after life, early cinema

remaking the past with hirokazu

kore-eda

j o n a h c o r n e

In 1896, the French married couple Victor and Catherine Henri published what would become a landmark paper on early childhood memory, a captivating subject that had received strangely little sustained attention within the domain of professional psychology. Titled "Enquête sur les premiers souvenirs de l'enfance" (Investigation into First Memories of Childhood), the paper focused on the 123 submissions to a questionnaire that the Henris had circulated the previous year in a handful of scholarly journals from France, Russia, England, and the United States. Reprinted in full at the beginning of the paper, the questionnaire contained requests for such ineluctably impressionistic information as: "What is the first memory that you have of your childhood? Describe it as completely as possible, indicating its clarity, the manner in which it appears, and the age to which it corresponds." "Did someone perhaps speak to you about the first event that you remember, or have you remembered it spontaneously, without anyone having told you about it?" "What is your second childhood memory? What do you remember? Is there a big gap in between your first and second memories?" "Do you remember the objects and people close to you

better than you can remember yourself? Can you remember your own voice?" "From what age do you begin to have memories of the continuous flow of your life?" "Do you remember your childhood in dreams, and if so what are these memories?"[1] Plentifully recounting and quoting from their respondents' answers, the Henris' paper instituted a new sort of archive, a first-of-its-kind first-memory bank, from out of which could be extracted inevitably preliminary but nonetheless "highly suggestive results," to borrow the estimation of Freud, whose essay "Screen Memories" (1899) pays an extended, appreciative debt to the paper (figure 5.1).[2]

At the same time the Henris were amassing and evaluating early childhood memories, another French family duo, the Lumières, were, of course, engaged in their own kind of memory research. The *cinématographe*, the Lumières' new machine, could memorialize—that is, photographically preserve—whatever was taking place in front of its lens, which frequently in the case of the Lumières' first films turned out to be scenes close to home, domestic scenes, with their inevitable stress on early childhood. Given this uncanny set of parallelisms, watching the Lumière childhood films in conjunction with the Henris' paper compels me into a strange sort of confabulation: could I be witnessing not merely scenes of early childhood memorialized, but rather scenes of early childhood *memories*, as if the Lumières had furtively dipped into the "Enquête" and decided to adapt, to translate across media, the recollections (or at least the *kinds* of recollections) collected there? Archiving the Henris' archive, as it were? "Another person recollects when he walked for the first time. He knows he was less than a year-and-a-half old. He represents himself as walking from one lady to another, holding on to a chair, and very much pleased with his exploit," relate the Henris.[3] The fit is hardly exact, but a Lumière film—included in the "Enfances" section of the centenary compilation *The Lumière Brothers: First Films (1895–1897)* (1996)—presents a highly similar scene. A girl of around a year-and-a-half, dressed in a gown as if for a special occasion, walks down the vista of a sidewalk accompanied by a hovering, nanny-like figure, and falls over in the final seconds just before she is able to make a full, Ciotat-style arrival. One detail of the film in particular arrests me: a doll, forlornly splayed out on the pavement in front of the camera. Why is it there? Obviously, to try to encourage what is expected of the child, to

jonah corne

86

6 mois	8 mois	1 an	1 an 1/2	2 ans	2 ans 1/2	3 ans	3 ans 1/2	4 ans	5 ans	6 ans	7 ans	8 ans
1	2	4	9	23	20	19	14	12	6	5	2	1

Figure 5.1 Date du premier souvenir (Date of first memory), a chart from Victor and Catherine Henri's study of childhood memory.

offer her a reward at the end of her attempted solo walk and luringly keep her on course. The film, in other words, contains subtle elements of staging, as if indeed there were a kind of rough script, a template reminiscent of the reminiscences of the "Enquête," involved.

Those familiar with *After Life* (1998), the second feature by the renowned contemporary Japanese director Hirokazu Kore-eda, will likely recognize my fantasy of a collaboration between the Henris and the Lumières as a camouflaged, roundabout way of describing what Kore-eda's film constitutes in fact: namely, a mass survey about memory carried out with the tools of filmmaking. As if a stray bonus question of the "Enquête," the tag-line on the cover of the North American DVD release of *After Life* reads: "What memory would you take to eternity?" Although switched from the subjunctive to the indicative, it is the question around which the entire film turns. Set in a sort of way station—a ruinous institutional complex that might once have been a school or orphanage or hospital—the film begins as a crowd of the dead slowly, scuttlingly filters in from out of an obscure, depthless haze. Assembling in a waiting room, these people are then assigned special caseworkers who inform them that while they are, indeed, dead, they now have the opportunity to choose a single memory with which to take with them into eternity. (As we later learn, the caseworkers, along with all the people employed at the facility, are also dead, but have been so for a while; unable to choose, they have been consigned to linger at the facility indefinitely at an aging standstill, assisting others.) Beginning on a Monday and lasting a week, the taking process consists of three fluidly interconnecting phases: (1) the selection of the memory, which occurs over the course of a few days in which the person talks out the past with his or her caseworker in sessions that irresistibly recall a kind of lay analysis; (2) the recreation of the chosen memory on film by a small, on-site movie crew, which occurs over the course of another few days; (3) the screening of the film in a communal screening ceremony on Sunday—an event with a progressively dwindling audience, since as the spectators watch their films, they relive their memories, and are thereby transported to a place where they keep reliving the memories forever.

Although obviously deeply fantastical, the film in many ways feels connected to Kore-eda's early work as a documentarian, to the series of searching, socially trenchant non-fiction films that he originally made for broadcast on Japanese television.[4] As he writes in his "Director's Statement" for *After Life*: "When we were developing the script we asked more than 500 people to recount the one memory they would take with them to heaven. I was intrigued by how often people chose upsetting experiences. The first half of the film uses actors working from scripts, actors recounting their own experiences, and real people telling true stories. Of course, as they tell real stories for the camera, people inevitably fictionalize aspects of them, consciously or not, because of pride or misunderstanding."[5] To make

matters even more suitably confusing, Kore-eda shoots the interviews with the three types of subjects in exactly the same way: via a static, frontal camera placed on the opposite side of a bare wooden table (figure 5.2). Indeed, if shown an only mildly abridged version of the first half of *After Life*, which consists largely of such uniform, stripped-down medium shots assembled in crudely jump-cutting montages, one could be forgiven for mistaking the film for an actual documentary on the intrinsically non-documentary topic of how people remember, or else as a patchwork, testimony-based oral history or "people's history" of Japan in the twentieth century.

Made around the time of the centenary, however, the film also functions as a vehicle for cinema to remember and re-examine itself. Allusions to old movies abound. *Wandafuru raifu*, the film's Japanese title, a transliteration of "Wonderful Life," openly courts a comparison with Capra's 1946 Christmas classic, which revolves around a similarly high-concept, supernatural premise that concerns looking back on life from the vantage of (near-)death. During a conversation about movies, a character who professes her love of Joan Fontaine mentions by name a pair of films starring the actress, Hitchcock's *Rebecca* (1940) and William Dieterle's *September Affair* (1950).[6] As David Desser points out, Kore-eda at one point includes an unmistakable "straight-on shot from Ozu's vaunted 'tatami-level,'" and models an important character, Ichiro Watanabe, on the terminally ill bureaucrat protagonist of Akira Kurosawa's *Ikiru* (1952).[7] Further, in a casting decision with irresistibly intertextual implications, the film features in a small but critical role the legendary actress Kyoko Kagawa, from *Tokyo Story* (1953) and *Sansho the Bailiff* (1954), among a host of movies by Ozu, Mizoguchi, Naruse, and Kurosawa.

Figure 5.2 Kore-eda shoots the interviews with the three types of subjects in exactly the same way.

These evocations, largely culled from the respective Golden Eras of Hollywood and Japanese cinema, however, tell only part of the story of Kore-eda's engagement with film history. What goes oddly unremarked in the insightful essays on the film by Desser and Jonathan Ellis—the major statements I can find in English—is the role of early cinema. Analogous to all the Henris-esque, early remembering that goes on in the interview sessions, this gesture of reaching way back to the beginnings of the medium manifests itself not strictly, but most strikingly, via the cinematic memory recreations. Like early films, they are "shorts." Like early films, they are produced on a low budget, in great abundance, within a very short amount of time. Like early films, they are screened one after another in what might be described as a mixed program. And like early films, they embody a type of non-narrative, moment-based cinema, comparable with certain dimensions of what Tom Gunning has famously described as a "cinema of attractions," a cinema that assumes the form of a "sudden burst of presence" or "jolt of presence," evincing a temporality "limited to the pure present tense of [the attraction's] appearance."[8] Indeed, emphasizing such a temporality of singularity, the dead must choose, if they are going to choose, *one* memory to be filmed to take with them into eternity.

This essay thus seeks to offer an account of *After Life*'s early cinematic relations, which, as I see it, recast some of our most entrenched ways of understanding early cinema, including the "cinema of attractions." Reflecting on matters of the senses, the DIY, the physical aging of film and video, and the metaphysics of presence/absence, I continually come back to the ways that the film implicates loss into its far-reaching memory work. Remembrance for Kore-eda, as we'll see, turns out to be mixed up with an idiosyncratic, complex form of renunciation.

un repas en famille au japon: attractions beyond the visual

In Gunning's conceptualization of the cinema of attractions, it is sight that takes pride of place among the senses. Differentiating attractions, whose roots lay in the fairground, the amusement park, and vaudeville, from the narratively driven movies that displaced them as cinema's dominant mode around "1908 or so," he writes: "Attractions' fundamental hold on spectators depends on arousing and satisfying visual curiosity through a direct and acknowledged act of display, rather than following a narrative enigma within a diegetic site into which the spectator peers invisibly."[9] Brazenly exhibitionist while encouraging an avid, symbiotic scopophilia in the spectator, the attraction appears to operate within a fairly closed circuit of the senses, even while its "peculiarly modern obsession with violent and aggressive sensations (such as speed or the threat of injury)" and affinities with "the sensational press" work to induce a destabilizing sensory

overload.[10] What might this emphasis on visuality and shock—or more specifically, shock-visuality—miss or reduce about the play of the senses in early cinema?

In an interview quoted in Ellis' review-essay, reflecting on the challenges of approaching memory through film, Kore-eda remarks:

> People remember a touch, a taste, something that brushed their skin. In the 100 years since cinema has been around I feel it has constantly been straining against the limitation of being a largely visual medium; there's something about the way we watch films that push the boundary.[11]

What jumps out in this comment that casts a synoptic glance back over the "100 years" of cinema is the word "constantly," which implies that right from the beginning cinema's marshaling of spectactularity has not always been for strictly spectatorial ends. Kore-eda anticipates scholars like Vivian Sobchack who have attempted to rethink a reigning ocularcentrism in film studies. Sobchack writes:

> Our fingers, our skin and nose and lips and tongue and stomach and all the other parts of us understand what we see in the film experience. As cinesthetic subjects, we possess an embodied intelligence that opens our eyes far beyond their discrete capacity for vision, opens the film far beyond its visible containment by the screen.[12]

Kore-eda's comment challenges the idea of early cinema as necessarily structured around a sensory hierarchy in which the eye rules solitary and unchallenged. Accordingly, what sorts of possibilities might there be for touch-attractions, taste-attractions, smell-attractions, sound-attractions, indeed all manner of sensorially hybridized attractions?

A scene early on in *After Life* offers some direction. Gathered around a boardroom table in a dimly lamp-lit room, flipping through dossiers on the new arrivals, whose identifying, passport-like headshots are blown up on a portable screen by a clanking slide-projector, a group of facility staffers discuss plans for the work-week ahead of them. We are in the equivalent of a pre-production meeting. As they turn to the case of a man referred to as Bundo san—a man who, according to his file, claims to possess memories of when he was less than a year old—the conversation suddenly, digressively veers into territory distinctly recalling the "Enquête." "How far back do people remember?" asks an inexperienced staffer who looks to be in his mid-thirties. "Typically, four years old," the veteran sitting next to him answers, offering a figure that conforms with the far end of the range proposed by the Henris. As several begin exchanging their own first memories,

the curious novice volunteers his: a memory of kindergarten. Pointing with growing exultation at his tongue, he remarks:

> They used to give us all hot tea... The taste of that hoji tea...
> I remember eating my box lunch and drinking the tea. My
> tongue remembers. It's the memory of a certain taste.

As I have mentioned, the facility staffers became staffers because they were unable—or unwilling—to choose a favorite memory with which to move on; and so this nonvisual memory is not one of the several nonvisual memories that we see taken through the process of cinematic recreation. Nevertheless, one can get an idea of what such a recreation might "look" like from the memory's uncanny resonance with a key film from the Lumières' corpus of Japanese films.

The name Katsuatro Inabata (1862–1949) is inextricably tied to the beginnings of cinema in Japan. Sent abroad to study at La Martinière, the technical college in Lyon, where he was a fellow student of Auguste Lumière, Inabata returned to Europe in 1896, reestablished contact with his former schoolmate, and acquired the exclusive Japanese rights to the *cinématographe*, subsequently mounting the first public film screening in Japan, at the Nanchi Theatre in Osaka, on 15 February 1897.[13] At some point during that same year, Inabata himself was filmed by Constant Girel, the operator whom the Lumières sent to assist him, and who took the opportunity of being overseas to shoot the Lumières' first films of Japan. Today catalogued under the generic title *Repas en famille (Family Meal)*, the film more specifically shows Inabata (dapperly dressed in a dark robe with amply hanging sleeves, smoking a traditional kiseru pipe) amidst his family in his upper-class Kyoto home taking tea.[14]

One of the most striking things about the film is, at the center of the slightly angled frontal tableau image, the repeated attempts of Inabata's plump-faced, kimono-ed niece Natsu to coax the ornately collared infant she is holding (Inabata's daughter Noriko) into looking at the camera by puppeteeringly waving the latter's arm in the direction of the machine; a ploy that repeatedly fails, and thus alternates with the niece giving the infant sips of tea out of one of the grown-up cups, perhaps as a pacifying inducement for cooperation, or else as an improvised substitute performance.[15] Watching these actions, I begin to ask myself: does *my* sense of the tea end with the look of it? Not entirely, since from watching the infant accept the proffered cup once without wincing, and then greedily over again, I get a taste of tea that has almost certainly cooled, and been steeped to a point before bitterness; a "taste," that is, that does not feel entirely right to lodge within scare-quotes, attesting to Sobchack's observation that "it is only in afterthought that our sensual descriptions of the movies seem metaphorical."[16] As well, such an experience of sensory crossing

seems somehow intensified by the fact that it is an infant, rather than one of the adults, whose tasting I zero in on. As Sobchack remarks, citing research on the neurology of synesthesia: "It has been demonstrated that young children—not yet fully acculturated to a particularly disciplined organization of the sensorium—experience a greater 'horizontalization' of the senses and consequently a greater capacity for cross-modal senso-rial exchange than do adults."[17] In a kind of atavistic identification, tasting through my eyes, I feel obscurely keyed into the relative democracy that obtains within the child's sensorium. Reinforcing the situation, too, is the specific form of the Lumière film: the one-shot tableau, which allows so much, and so many different, sensory phenomena to occupy the frame all at once. Whereas one could imagine a later film giving the tea, the smoke of Inabata's pipe, and the encradling arms of the mothering niece, each a discrete, "juicy" close-up (echoing strategies in advertising), here taste, smell, and touch are compelled to interfuse with one another within a shared temporal horizon.

Of course, like many such early films taken outside of Europe by Lumière personnel and others, the film was originally intended to exude an aura of exoticism, which we might wonder to what extent would have tampered with, even negated, the intimacy upon which haptic and other powerful cross-sensory elicitations depend (or at any rate would seem to depend). As indicated by the lengthier title under which it was screened in Lyon on 9 January 1898—*Un repas en famille au Japon*—the film would have been presenting to its European audience not just any family sitting down to eat (or drink) together, but a specifically Japanese family, and beyond that a generalized distillation of "Japaneseness," conveyed by the habitual, ritual nature of the scene.[18] What could be more Japanese than this elabo-rate taking of tea on the tatami? At the same time, however, what are we supposed to do with those factors that seem to militate against an absolute, hard-and-fast separation between Girel's camera-gaze and what it records? Here I am referring not only to the obvious and apparent circumstance that the film was taken with the awareness of its subjects—something that other "ethnographic" early films share—but also to the more buried (too extra-textual and thus intransmissible?) fact of Inabata being an agent within the larger Lumière enterprise, a partner in the global dissemina-tion of the *cinématographe*. Especially with that connection in mind, the film captures an encounter that is hardly fully alien. Indeed, when projected on screen back in Lyon, Inabata would have been *returning* to the city for no less than the second time since his extended residence as a student.[19]

Mostly, however, I wonder how the staffer in *After Life* would respond to the film. Might it not serve as an exemplary model from deep out of the past persuading him of cinema's ability to capture something of his exhila-rating first memory's nonvisual character, and thus emboldening him to choose? Indeed, the infant in the film, spurning the gaze of the camera, as

if to direct the attention of the apparatus out beyond the field of the visible, seems to be the very encapsulation of "my tongue remembers." "Don't look, or don't stop with your looking," she seems to be gesturing, "what this is about is something beyond what's merely shown or on display here: namely, the tinglings of my tongue."

falling leaves: the DIY and death

If the memory recreations in *After Life* underscore an excess in early cinema—that poly-sensory excess that has been a feature of the medium since its beginnings—they also speak to a condition of dearth that, too, relates to early cinema. As Thomas Edison reflected in 1921, more than a quarter century after building the Black Maria to house production for films for the Kinetoscope: "They say they are spending a million dollars nowadays to make just one picture. If I had been told in the days of our first movie studio that anybody would spend a million dollars to produce a single film, I don't know whether I would have swallowed it or not. It would have been some effort."[20]

Recalling those earlier days, movie production in *After Life* operates on a conspicuously, almost anorectically low budget. The studio where the majority of shooting happens consists of a single modest warehouse space into which all the sets for the week are tightly crammed, separated off from one another by makeshift partitions. Gear is minimal, basic: a tripod, a few tungsten lights, a few reflectors, some stands and clamps; no discernible dolly or crane; certainly nothing on the order of a Steadicam. Props are scavenged from junk-heaps, or fabricated out of everyday household odds and ends, while scenic backdrops are painted in a manner that clearly aspires (or settles) for evocative suggestion rather than *trompe l'œil* illusionism. On an infrastructural level, the energy source that powers everything is subject to sudden and drastic intermittence, as demonstrated when one of the newly deceased switches on a hair dryer in the dilapidated bathroom of his room and sets off a facility-wide blackout. "The electrical circuits are overloaded. Please refrain from using hair dryers," a voice comes over the intercom system and gently admonishes. Indeed, it is as if the mysterious entity under whose auspices the afterlife runs—an entity that only appears on screen through its wordless logo: two interlocking circles that vaguely recall the reels of a projector—is suffering from some unaccountable cosmic budget crisis, or else is as warily tightfisted when it comes to the funding of highly personal and experimental movies as corporate entities are in the world of the living.

Still, as we glimpse in the second half of the movie, the artisanal, poverty row conditions allow for, indeed copingly engender, a remarkable degree of invention and industriousness. Perched atop ladders, each wielding a long bamboo rod with a basket suspended at the end, two staff

members spill dyed pink snippets of paper onto an enigmatically smiling elderly woman whom earlier we learned spent her last years in a state of social withdrawal, already engrossed in her memories while still alive (figure 5.3). We never hear her say it out outright—she seems to have fallen into a state of mutism—but she has apparently chosen a memory of the end of the celebrated Japanese cherry blossom season. Another of the current week's arrivals, a man who looks no older than forty, chooses the memory of when he got to fly solo for the first time when he was a pilot in training. (Not only first memories, but memories *of* firsts—the first time I did, felt, discovered X—recur in people's reflections on the past, exerting an understandable force of attraction, marking time.) Unable to track down the exact model of Cessna in the man's memory, the crew nevertheless manage to source a fuselage that comes close enough, and graft on to it a lone wing, leaving the other merely to be implied beyond the frame. Playing his younger self himself, the man sits in the cockpit, and is given a relativistic, rear-screen-like perception of motion by looking out the window and seeing clouds drift past—what in the reality of the studio are agglomerated clumps of cotton conveyed along a squeaky system of wires and pulleys. Incidentally, with this blissful moment of floating among the clouds, *After Life* comes as close as it does at any point to a conventionally "heavenly" iconography.

These films, pulled off on such scarce means, find uncanny analogues in the archives of early cinema. The ex-pilot trainee's recreation brings to mind *Filibus* (Roncoroni, 1915), an early Italian feature about a piratical aviatrix who roams the film's painted canvas, studio skies in an eccentric zeppelin whose cockpit (a topless steel dingy suspended from the bulbous envelope by a mess of tackling) contains a pulley-operated system

Figure 5.3 Staff members spill dyed pink snippets of paper onto an elderly woman.

of its own: a drop-down pod for stealthy air-to-earth commuting.[21] The elderly woman's recreation evokes Alice Guy Blaché's *Falling Leaves* (1912), a film produced by Guy Blaché's Fort Lee-based company Solax, in which a child named Little Trixie movingly attempts to rescue her elder consumptive sister, whom the family doctor has pronounced will die before "the last leaf falls," by going out into the yard in her nightie one blustery night and tying the leaves back on to the trees one by one with string.

The connection between the elderly woman's cine-memory of falling cherry blossoms and *Falling Leaves*, indeed, presents itself for reasons that go far beyond a mere conjunction of low-budget environmental effects. Crucially, both films are the product of a female's directorial vision. Wherein "more women worked at all levels inside and outside the Hollywood film industry in the first two decades than at any time since," one of the fascinating implications of the premise of *After Life*, which calls up that bygone, superior gender breakdown, is a radical democratization of movie-making: in Kore-eda's afterlife, everybody makes movies.[22] Further, and perhaps most strikingly, both films situate DIY (re)construction within a context of death. Acting out her fantastic, child (il)logic, Little Trixie remakes the unfallen leaves in response to the doctor's prognosis of her sister's fatal illness. Acting within the hardly less fantastical organizational logic of the facility, the elderly woman remakes the memory of the falling cherry blossoms in response to her own unfolding death.

Interestingly, this intersection of the DIY and death in the two cases produces similar results, or rather similar recognitions of mortality. While Little Trixie is out reattaching the leaves, she happens to be met by a nocturnal stroller, a bacteriologist named Earl Hedley, who has recently discovered a "wonderful cure for consumption." Informed by Little Trixie of her antic intentions, he thus takes her sister into his care, treats her successfully with the breakthrough serum, and the movie ends happily and seemingly tidily. A crucial causal question, however, lingers: who or what exactly is responsible for bringing about the "miraculous" conclusion of the film? Whereas it would have been easy for Guy Blaché to omit Hedley (first introduced at the beginning of the film in a separate, parallel line of action), and thus have the consumptive sister recover as an apparent one-to-one consequence of Little Trixie's intervention, Guy Blaché instead insists on incorporating a scientific, materialist dimension to the recovery. Of course, one could point out that it is Little Trixie's reattachment of the leaves that *leads* to the chance meeting with Hedley, thus participating indirectly but critically in the recovery; but that is exactly the rub: her actions are insufficient on their own as an effective thwarter of death. Consequently, the film retains a sense of the poverty of her pathetically dangling, knotted-back-on leaves.

The elderly woman's memory recreation, too, doesn't quite give a picture of the transcendence of death, if we pay attention to the content of

the memory. Famously short-lived, falling within a week of blooming, cherry blossoms are traditionally taken in Japanese culture to epitomize the Buddhist idea of *mono no aware*, associated with a wistful, pathos-tinged appreciation of the impermanence of things. "If man were never to fade away like the dews of Adashino, never to vanish like the smoke over Toribeyama [both places are graveyards], but lingered on forever in the world, how things would lose their power to move us! The most precious thing in life is its uncertainty," writes the Buddhist priest and poet Kenko in his classic fourteenth-century *Essays in Idleness*. And: "People commonly regret that the cherry blossoms scatter or that the moon sinks in the sky, and this is natural; but only an exceptionally insensitive man would say, 'This branch and that branch have lost their blossoms. There is nothing worth seeing now.' "[23] What the elderly woman evokes through her fragile, DIY reconstruction, in other words, is such loss itself.

video vintage 1943: historicity and media decay

Despite everything I have said about the poverty of movie-making in *After Life*, there is at least one theoretically avoidable expense that the facility refuses to skimp on, to subject to retrenchment: namely, celluloid, the medium on which the memory recreations are elected to be shot. I say "elected" to indicate a situation of choice, of options, since video—recognizably cheap, mass-produced video—not only exists in the world of the film, but is directly tied to the larger recreation process.

In the event that a new arrival cannot come up with or settle on a memory to choose, the assigned caseworker may take recourse by going to retrieve a cache of carefully ordered, neatly stacked VHS tapes. Containing a shot-on-video record of the client's life in the ratio of "one for each year," such supernaturally long-playing tapes are meant to be used strictly "for reference," not as a replacement for memory, but as a kind of *aide-mémoire*. Intriguingly, *It's A Wonderful Life* provides a similar, more or less benign vision of celestial panopticism, of what we might think of as a sort of Book of Life transmedially updated to the era of the moving image. While recounting George Bailey's past, the film suddenly freeze-frames on him with his arms demonstratively out-stretched in a luggage shop, prompting his guardian-angel-in-training Clarence to ask an elder angel in voice-over, "Why did you stop it?" The implication, of course, is that the cinematic record of George's life that we are watching actually exists inside the film, as if "it" is a reel that has been plucked off the shelves in some heavenly archive, and is being projected by an angel capable of exerting playback control over it.

In *After Life*, one of the characters requiring the assistance of his videotapes is the previously mentioned Watanabe, a retired steel company executive who lived the last five years of his life as a widower (figure 5.4).

When shown in interview for the first time, he instantly betrays his blockage, clearing his throat in an almost comically long drawn out way. Watanabe's trouble, as we discover as he watches his tapes, relates to his forty-year marriage to a woman named Kyoko, played (with Kore-eda's characteristic blurring of fiction and non-fiction) by Kyoko Kagawa. "It may sound odd, but it's not as though we were united by burning passions," Watanabe explains to his broodingly handsome caseworker, Mochizuki, an (outwardly) young man in his early twenties who turns out to have been Kyoko's fiancé, a soldier who died in World War II before they could be married.

Tacitly making the identification between Mochizuki and this prior lover whom he was always dimly aware of, Watanabe hardly escapes feelings of jealousy. Yet he nevertheless finds a way of affirming his life in his marriage by reflecting on the long-lasting relationship's small, ordinary pleasures. Watanabe signals his choice with a loaded press of the pause button on the VCR. He chooses a memory corresponding with a moment on the videotapes where he and Kyoko are sitting serenely, silently on a park bench in Tokyo's Ginza district. It is an image that subsequently returns to the film over and over again, although in severally mediated forms. For following Watanabe's departure from the facility, Mochizuki makes a trip with his assistant Shiori—a caseworker-in-training (shades of Clarence) who is secretly in love with him, thus quadrangulating the already complicated transontological love triangle—to the facility's film archives to track down the recreated memory that Kyoko would have made after her death. Shot in 1993 (according to the label on the dusty canister) and corresponding with a moment in 1943 (according to some accompanying

Figure 5.4 Watanabe, a retired steel company executive, requires the assistance of videotapes.

paperwork), the film shows Kyoko sitting on a similar bench next to a young man, whom we can only see from the rear, dressed in an immaculately white sailor's uniform. To corroborate the man's identity, the two then turn to the video archives and dig up a tape from 1943, one of the last Mochizuki would have appeared on before his death. And here again we see the park bench, though this time shot from the front and clearly showing Mochizuki (played by the same actor, Arata Iura, who plays Mochizuki in the present tense of the film) in the sailor's uniform sitting beside Kyoko (this time played by a younger Kyoko, not Kyoko Kagawa) (figure 5.5). Coming to the tenderly devastating realization that he was "part of someone else's happiness," and that Kyoko never stopped loving him, never stopped grieving over him, Mochizuki is thus compelled to choose a memory of his own. Like both Watanabe and Kyoko, he settles on the park bench. In his version, however, shot with special permission outside of the usual production schedule in the not-yet-dismantled set of Watanabe's recreation, he sits by himself on the bench, staring intently into the camera, which is then pictured, surrounded by Shiori and the rest of the small crew, who stare back at him. In this densely layered meta-cinematic image—involving not only the whole web of archived tapes and films but no less than three cameras: the one pictured on-screen, the one shooting that one, and Kore-eda's—Mochizuki thus takes with him what could be read as *the recreation itself* of the park bench, a kind of condensation of earthly and limbo memories that reflects his unique predicament in which his half-century of "afterlife" has exceeded his young "life" by nearly three times.

At any rate, Kore-eda shows us in total four mediations of the park bench, among which the material differences between the two shot and

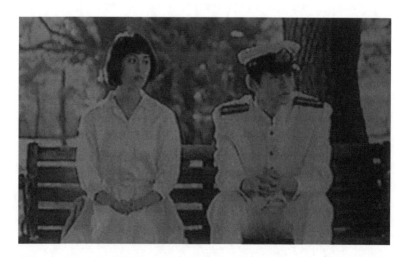

Figure 5.5 Kyoko and Mochizuki on the park bench.

screened on video and the two shot and screened on film are not just noticeable, but flagrant. Exacerbated by being filmed off the television screen on which they are being watched, the two video versions possess a picture quality of in-your-face "badness," exhibiting a range and multitude of blips and glitches. Indeed, all of the videotape footage that Watanabe watches—not only of the park bench, but of an early date with Kyoko and of a domestic scene during their newlywed years—erratically pulses, vibrates, quivers, and flashes, as if it were being transmitted from another planet.[24] Conversely, the two celluloid versions of the park bench vividly pop, are pristinely, almost grainlessly clean: an effect accentuated by Kore-eda's presentation of the images not rephotographed off the screen in the facility theater, but, as it were, outright, permitting them to take over for his own film in which they are theoretically enframed, and thus divesting them of a secondary layer of mediation.

Of course, as the videos are necessarily older than the films, it makes sense that they should appear comparatively more ragged. A gulf of over fifty years, recall, separates the moment of Kyoko and Mochizuki on the park bench captured on video and their (semi)corresponding recreations of the same moment on celluloid; indeed so old is the video, of mid-World War II vintage, that it even *precedes* the actual, earthly technological emergence of video. So, albeit in an anachronistically surreal way, the comparative decrepitude of the videos speaks to a certain hypothetical verisimilitude concerning the aging of images of over time. Then again, one might wonder if *After Life*'s stress on video abjection combined with the caseworkers' insistence on the medium's merely supporting role in the facility's memory operations is symptomatic of that ingrained prejudice against video that views the medium as necessarily inferior to celluloid: colder, less indexical, tarnished by association with television, etc. While acknowledging the intuitive sense it makes for the memory recreations to be shot on celluloid as part of the project of returning to early cinema, that is, as a way of adhering to the materiality of early cinema, I want to try to explain why I think *After Life*'s attitude toward celluloid-video relations is significantly more complicated than a traditionally cinephilic favoring of celluloid.

Take the blips and glitches on the videos, which Kore-eda and his cinematographer have doctored with what must have been great care. The trembling of the image, the bars of fuzz intermittently migrating across the frame, the desaturated colors redolent of countless rounds of copying: so extreme and exaggerated are many of these phenomena that a process not only of imitation but of experimentation and invention appears to be at work. All of which is to say, Kore-eda is quite clearly fascinated by video degeneration—as fascinated, I would say, as Peter Delpeut and Bill Morrison are by celluloid necrosis in their respective compilations of spectacularly damaged nitrate found-footage, *Lyrical Nitrate* (1991) and *Decasia* (2002).

Indeed, I want to suggest, insofar as early film has come to acquire and be associated with a "look" of ravagement, the videotapes in *After Life* perform an uncanny medial displacement. Exhibiting effects of decay specific to video, they also conjure up an image of early film as it appears, a century on, through the lens of the late twentieth century.

Hence the division between celluloid and video written so dramatically across the four park bench mediations begins to seem that much less of a division. And aptly, I would add. For it would be odd for the film to balk at the privations of the videos when it offers such a keen embrace of failure and fragility in the context of the low-budget production of the filmic recreations. Rather than siding with one medium over the other, the film with its incorporation of decaying video makes a larger point about media ecology. Namely, that celluloid does not hold a monopoly on conveying a deep sense of age. As Marita Sturken remarks in an essay on video history written in 1988:

> Videotapes made in 1973 (a mere sixteen years ago), with their blurred, grainy images and muffled sound, seem like distant aesthetic antecedents to contemporary work. These tapes (those that are not already irretrievable because of image deterioration or because their equipment format is now obsolete) appear to be strange and elusive artifacts of another era; in other words, they seem much older, and much more evocative of a past, than, for instance, 16 mm films from that time.[25]

Indeed, the impossible tape from 1943 explicitly performs this defamiliarizing inversion. On the question of film and video, decay, and historicity, one might say, *After Life* can't quite make up its mind.

recreation as decreation: emptiness attractions

In line with such blurred boundaries between film and video, I want to conclude with a far-reaching suggestion, one that concerns the facility's main ostensible result and *raison d'être*: namely, spending all eternity with a single memory, a fate that depends most immediately medium-wise on the materially immaculate celluloid recreations. What I want to suggest, simply, is that what goes by the name of eternity in the film is far from stable, far from immune from immanent, mortal pressures. For it is crucially worth noting that we are never given so much as a glimpse or even an oblique transmodal hint of what, if anything, lies on the far side of the world of the facility. In one of Kore-eda's drollest sight gags, the seats in the screening room are draped with headrest covers that make them look like commercial airplane seats; and yet whatever metaphysical flight is

happening as the spectators relive their memories occurs not only in the dark but off-screen. As the audience settles in to watch their recreations during the regularly scheduled screening ceremony, the film elliptically cuts away to a scene taking place some time later in which Mochizuki discovers a letter left for him by Watanabe; and as the houselights go up after Mochizuki's recreation, which we do get to oversee, the film cuts back to a shot of his seat after he has already disappeared from it (figure 5.6). How are we to know that he, and the others watching and reliving their memories, disappear from the theater *to* anywhere at all?

Talk of eternity at the facility is largely couched within promissory rhetoric, within a register of speech that fundamentally invites skepticism, that leaves room for doubts. "The moment you relive your memory, you'll move on to a place where you can be sure of spending eternity with that memory," one of the senior caseworkers, Sugie, reiterates in a farewell speech that he delivers (notably, from a stage) at a luncheon held prior to the screening ceremony. Such statements are further compromised as truth claims by their coming from people who inevitably make them on a second-hand basis, never having themselves chosen a memory and moved on. Of course, one might object to this whole line of argument, accusing it of misguided literalism: what business does skepticism have in the realm of openly acknowledged fantasy, in a film set in a strange shoe-string movie-making facility beyond death? "The entire premise of the film is allegorical, as it is in Ernst Lubitsch's film, *Heaven Can Wait*," Kore-eda writes, adding yet another thread to the film's intertextual web.[26] Certainly, to have the new arrivals continually pressing the facility workers if eternity "really" exists would undermine this figurative quality, while

Figure 5.6 Mochizuki missing from his seat.

doing collateral damage to the pacing of the film. Significantly, the most recalcitrant of all the new arrivals—Iseya, an unemployed, free-spirited, tousle-haired twenty-one-year-old who looks like he could have died in a daredevil snowboarding accident—disputes not the reality of what the caseworkers say about eternity, but rather the presupposed benefits of such a realm. At first questioning if he might choose a dream instead of a memory, he declines to make any sort of choice by the end of the week, remarking: "This looking back at the past, living with a single moment from my past, would be too painful for me. It's your whole set-up here that needs rethinking." For Iseya, a reconsideration of the set-up is needed because the pain of living within a single moment would be all too real, all too unbearably real.

Without belaboring skepticism regarding eternity, however, Kore-eda unignorably incorporates such a stance into the film by refusing to represent the place where the deceased are alleged to spend forever with their chosen memories, keeping the realm stringently screened-off, unknown and unverified. Even as an allegorical entity, the place is shrouded in uncertainty, in ontological tenuousness. Consequently, we are invited to entertain the unspoken, yet extremely live and vertiginous, possibility that the place has no existence; that the rundown facility, where people arrive after they have died and perdure for (usually) another week, is all there is of the afterlife. Viewed in this way, at least from one perspective, everything suddenly becomes sinisterly absurdist: the dead going through all these motions, expending vast amounts of mental and emotional energy in order to make this momentous decision, all, as it were, for nothing. Such a scenario lends Kore-eda an unmistakable air of Kafka, which he certainly deserves. Yet it is also possible that the dead are quietly tapped into the prospect of nothing existing beyond the world of the facility, are on a certain level aware that what they might be preparing for is something other than, even the opposite of, everlasting self-preservation, thus transforming all their motions into a process of vigilant renunciation, of premeditated divestment and severance from an existence whose finitude there is no way out of. Take Mochizuki's recreation. Why does he choose to sit alone on the park bench rather than next to Kyoko, or rather a stand-in for Kyoko, when it would be easy enough to arrange for such casting, even under the exceptional circumstances of his belated, out-of-schedule shoot? Exacerbating the already radically spare quality of the recreation, which in itself gives the impression of an undoing, he effectively "empties" her from the scene, as if to explicitly acknowledge the recreation as a disavowal.

Each of the cine-memories, we might say, throbs—bursts—with *absence*, which brings us around to our second despectacularizing variation on Gunning's cinema of attractions. Absence, of course, is intrinsically implicated in a "burst of presence," given the instantaneous nature of a burst. Now you see it, *now you don't*, goes the saying Gunning borrows for the title

of his essay. Indeed he goes on to clarify the temporality of attractions as an "alternation of presence/absence that is embodied in the act of display," and as a "flicker of presence and absence," cleverly reading such oscillation as emblematized in the profusion of sudden, magical appearances and disappearances in the cunningly edited trick films of Méliès.[27] Yet what we find in Kore-eda is a cinema that, differently, seems to highlight absence unrelieved for the span of its moments. To come back to Mochizuki's recreation, Kyoko does not suddenly materialize by the force of some mnemonic prestidigitation. Or consider the penultimate shot of the film. As off-screen we hear Shiori, now promoted into an official caseworker, rehearsing her lines about the protocols of the facility *sotto voce* to her first client who has yet to arrive, Kore-eda gives us a long, lingering frontal shot of the empty interview chair: fifteen seconds of its unobstructed, spindly wooden slats.[28] At such moments, we are confronted by what might be called emptiness attractions, or, to adapt the term coined by twentieth-century French mystic Simone Weil to describe her recondite practice of self-negation, attractions recreated under the sign of "decreation."[29] Bursting with absence, such moments send us back to the historical attractions attuned to their voidlike, alternative metaphysical possibilities, as well as remind us that our returning to them—in their surviving paucity, in their distance—is a venture inescapably pervaded by loss.

conclusion

After Life is a relatively understated instance of what might be expected from a "new silent cinema." Nowhere in the film, nor in the films-within-the-film, for instance, do we find such caricature-prone traits of early and silent movies as voiceless speech, emphatically gestural acting, or black-and-white images. Yet once we recognize that Kore-eda is pursuing a Henris-style enquiry on a film-historical level, the tendency starts to be bristlingly noticeable everywhere. Indeed, it is remarkable just how many issues and questions surrounding "*les premiers*" films he manages to incorporate into a single film. Going back to cinema's beginnings with enticingly rich subtlety and diffusion, *After Life* necessitates its own untold returning.

notes

1. Victor and Catherine Henri, "Enquête sur les premiers souvenirs de l'enfance," *L'Année psychologique*, Vol. 3 (1896): 184–185. The translations are my own. The English version of the article from *Popular Science Monthly* that I cite below is abridged, and neglects to reproduce the questionnaire.
2. Sigmund Freud, "Screen Memories," *The Standard Edition of the Complete Psychological Works of Sigmund Freud: Volume III (1893–1899)*, ed. and trans. James Strachey (London: The Hogarth Press, 1962), 304.

3. Victor and Catherine Henri, "Earliest Recollections," uncredited translation, *Popular Science Monthly* Vol. 53 (1898): 110.

4. Of these films, the one most relevant to mention in relation to *After Life* is the thematically allied *Without Memory* (1996), which chronicles the day-to-day life of a man who, as the result of medical malpractice in the aftermath of major brain surgery, lost his ability to form short-term memories.

5. Hirokazu Kore-eda, "Director's Statement." New Yorker DVD.

6. In Dieterle's film, Fontaine and Joseph Cotton play "fellow ghosts" who start a new, clandestine life together after they are believed to have died in a plane crash.

7. David Desser, "History, Memory, Trauma, and the Transcendent," *Film Criticism* Vol. 35, No. 2/3 (Winter 2010/Spring 2011): 46–65.

8. Tom Gunning, " 'Now You See It, Now You Don't': The Temporality of the Cinema of Attractions," *The Velvet Light Trap* No. 32 (Fall 1993): 6–7, 10.

9. *Ibid.*, 4, 6.

10. *Ibid.*, 8, 6.

11. Quoted in Jonathan Ellis, Review of *After Life*, *Film Quarterly* Vol. 57, No. 1 (Fall 2003): 37.

12. Vivian Sobchack, *Carnal Thoughts: Embodiment and Moving Image Culture* (Berkeley: University of California Press, 2004), 84.

13. See Peter B. High, "The Dawn of Cinema in Japan," *Journal of Contemporary History* Vol. 19, No. 1 (1984): 23–25.

14. *La Production cinématographique des Frères Lumière*, eds. Michelle Aubert and Jean-Claude Seguin (Paris: Editions Mémoires de cinéma and la Bibliothèque du Film, 1996), 354.

15. These identifications are courtesy of *La Production cinématographique des Frères Lumière*, 354, and the online resource *Catalogue Lumière: L'oeuvre cinématographique des frères Lumière: catalogue-lumiere.com/repas-en-famille-2*.

16. Sobchack, *Carnal Thoughts*, 80.

17. *Ibid.*, 69.

18. See *La Production cinématographique des Frères Lumière*, 354.

19. My reading of the Inabata film traces similar lines as Katherine Groo in her analysis of a different *Repas* Lumière film taken abroad: *Repas d'Indiens*, shot in Mexico in 1896 by Gabriel Veyre. See Katherine Groo, "The Maison and Its Minor: Lumière(s), Film History, and the Early Archive," *Cinema Journal* Vol. 52, No. 4 (Summer 2013): 42–46.

20. Thomas Edison, "Moving Pictures and the Arts," in *The Diary and Sundry Observations of Thomas Alva Edison*, ed. Dagobert D. Runes (New York: Philosophical Library, 1948), 63.

21. For inspiring me to track down this last film, I am indebted to Angela Dalle Vacche's "Femininity in Flight: Androgyny and Gyandry in Early Cinema," in *A Feminist Reader in Early Cinema*, eds. Jennifer M. Bean and Diane Negra (Durham, NC: Duke University Press, 2002).

22. Jane Gaines, Radha Vatsal, and Monica Dall'Asta, eds., *Women Film Pioneers Project*, Center for Digital Research and Scholarship (New York: Columbia University Libraries, 2013). For more on Guy Blaché, see Alice McMahan's *Alice Guy Blaché: Lost Visionary of the Cinema* (New York: Continuum, 2003); and Gaines' "First Fictions," *Signs* Vol. 30, No. 1 (Autumn 2004): 1293–1317.

23. Kenko, *Essays in Idleness: The Tsurezuregusa of Kenko*, trans. Donald Keene (New York: Columbia University Press, 1967), 7, 115.

24. It is in the footage of the early date that Kyoko professes her Fontaine fandom, and mentions *Rebecca* and *September Affair*. The footage of the domestic scene provides the opportunity for Kore-eda's reproduction of the Ozuvian "tatami" shot.
25. Marita Sturken, "Paradox in the Evolution of an Art Form: Great Expectations and the Making of a History," in *Illuminating Video: An Essential Guide to Video Art*, eds. Doug Hall and Sally Jo Fifer (New York: Aperture in association with the Bay Area Video Coalition, 1990), 104.
26. Kore-eda,"Director's Statement."
27. Gunning, " 'Now You See It,' " 6, 11.
28. A clear parallel to Clarence getting his wings at the end of *It's A Wonderful Life*.
29. See *Gravity and Grace*, trans. Emma Crawford and Mario von der Ruhr (London: Routledge, 1952), 32–39.

playback, play-forward

anna may wong in double exposure

y i m a n w a n g

In the wake of the digital turn, remixing and reenactment have emerged as two important methods of creating media works that privilege media archeology, intertextuality, and inter-mediality. Such practices hinge upon discovering and assembling archival materials, subjecting them to reappropriation, recontextualization, and resignification. As such, they lead us to reexamine the shifting cultural politics of authorship, media historiography, canon (re)formation, media specificity and convergence, and ultimately, the ramifications of remediation. These shifts become more prominent when the digital turn brings back into light a long obscured silent film or a marginalized performer originating from the silent era. This process of recovery and remediation telescopes multiple spatial and temporal layers, media forms, representational strategies, and author positions, bringing them into meaningful friction and mutual implication, challenging us to assess the generative function of jarring juxtaposition, even incompatibility (as opposed to unproblematic convergence).

My essay addresses these issues by studying the contemporary remediation of Anna May Wong (1905–1961), a Chinese-American screen and stage performer who ventured into screen acting in 1919, established a

transnational reputation by the 1920s, and played most of her leading roles in the 1930s. To fully grasp Wong's significance in film and theater histories, however, one must first wrestle with two major challenges. First, her tireless international traveling and performance in many European countries and Australia between 1928 and 1939 means that the sites and content of her performances were widely dispersed, hard to trace, and the reception of her performances significantly varied. Second, her perceived exotic value as an ethnic performer led to her frequent appearance in decorative yet uncredited roles in the margins of a large number of films. Obscured by the main cast and left out by publicity materials, much of Wong's screen performances are yet to be identified. The Wong we know today thus largely depends on her lead roles and major supporting roles, combined with her published interviews and writings, newspaper and magazine coverage, and the large amount of memorabilia that have been made available by international collectors, libraries, and archives. Yet, given the vast amount of her lost and not-yet-identified screen and stage performances, our knowledge of Wong inevitably registers the anxiety of lack, which we try to redeem by investing intensely in her more prominent or identifiable roles.

In this context, digital remixing and the multimedia method offer a productive approach to reassembling Wong's legacy and re-envisioning her significance. Facilitated by easily accessible digital technology and editing software, digital remixing mines and eclectically incorporates oftentimes fragmented, unrelated, and decontextualized audiovisual as well as print materials, recontextualizing them, and resequencing them into a new, multi-layered narrative. The multimedia method, similarly, harnesses digital as well as other media technologies to generate an open-ended and oftentimes multi-channel spatio-temporal structure. This structure reframes and juxtaposes the found or custom-created materials so as to stimulate refreshing processes of meaning-making, affective address, and audience engagement. Both digital remixing and multimedia presentation encourage rediscovering materials and traces, the goal of which is not simply to restore their original meanings and contexts, but, more importantly, to place them in a new medial, spectatorial, and social context so as to tease out their multivalence, and contemporary relevance. In this sense, the plethora of memorabilia and primary materials related to Wong—fragmented and oftentimes found out of context—make for perfect foraging among fans, critics, and media makers seeking to revive and reactivate Wong's legacy.

In this essay, I will focus on three media works that resignify Wong's performances and performative strategies. My first example is Yunah Hong's *Anna May Wong: In Her Own Words* (2013), an hour-long documentary featuring an actress, Doan Ly, ventriloquizing (i.e., vocally reenacting) Wong's correspondences and interviews. The second is Celine Parreñas Shimizu's short documentary, *The Fact of Asian Women* (2002), which similarly deploys reenactment, but focuses on the disjuncture between Wong and her contemporary

impersonator. My third example is Patty Chang's two-channel video instal-
lation, *The Product Love* (2009), based on material shot in Hangzhou, Los
Angeles, and Berlin. Among the three works, *The Product Love* foregrounds
the representational conundrum embodied by Wong, as the actress is spe-
cifically figured in an essay by Walter Benjamin, which was based on an
interview he conducted with Wong in Berlin in 1928. Channel One shows
three native English speakers' failed attempts to translate the essay, whereas
Channel Two stages a quasi-pornographic encounter between Wong and
Benjamin, as dramatized by two Chinese performers. By mocking and vul-
garizing the Wong-Benjamin encounter, Chang's *The Product Love* reimagines
Benjamin's befuddled fetishization of Wong. It further probes the possibility
and the form of Wong's performative identity and agency vis-à-vis her con-
strained space as determined by European Orientalism.

In all three instances, Asian-American women makers/critics/artists
explore the position of ethnic female performers in the mainstream film
industry. Together, they intersect in the iconic figure of Anna May Wong,
revisiting her photos, films, and other primary materials, reenacting,
repurposing, and even detouring them through a spectrum of contempo-
rary media formats. Here, the media practitioner, critic, historian, and con-
sumer converge to bring to the fore the question of how the present-day
media ecology contributes to reinterpreting Wong's celebrity. Do digital
technology, multimedia proliferation, and the correlated expansion of
netizen-ship offer us more leverage than what the early twentieth-century
monopoly of motion picture technology could allow in reshuffling social,
cultural, and political inequities? In the process of rediscovering, reviving,
and recreating Wong's work and experience, what kind of afterlife do we
generate for the pioneering Chinese-American performer half a century
after her passing? Conversely, how do we imagine the cosmopolitan Wong
addressing new-millennium, international communities composed of
media makers, critics, audience, and fans?

My analysis of the three media works outlined above addresses these
questions. I devote more attention to Chang's *The Product Love* due to its
textual complexity, intervening recontextualization, and the result-
ing multi-layered engagement with the fantasy surrounding Wong. By
explicating the ways in which *The Product Love* interweaves different loca-
tions, temporalities, media forms, and modes of presentation, I unpack
the mise-en-abyme of the Wong fantasy that emerges from its continuous
media deconstruction and reconstruction.

from ventriloquism to the archive effect

My first example, Yunah Hong's *Anna May Wong: In Her Own Words*, differs
from the first feature-length Wong documentary—Elaine Mae Wong's
Anna May Wong, Frosted Yellow Willows: Her Life, Times and Legend (2007)—in

important ways. Hong's film goes beyond the conventional documentary strategies of voiceover and talking heads by refocusing on Doan Ly's vocal and costumed reenactment of Wong's correspondences, interviews, and stage performances. Hong explains that a contemporary actress's reenactment facilitates the audience's "sense of Anna May Wong."[1] That is, Doan Ly's voice and body mediate and embody the long-deceased Wong and her long-silent voice. Her posing as a concrete proxy serves a heuristic purpose of leading the audience into the past and the multiple countries where Wong traveled. In so doing, it facilitates the audience's engagement and identification with the absent Wong.

By interweaving Ly's vocal reenactment with the talking heads commentaries and voiceovers excerpted from the filmmaker's interviews with historians, critics, Asian-American actors, Wong's family friends, and a tenant in Wong's Santa Monica residence, the film appears to shuttle seamlessly between the present and the past. Moreover, the reenacted past is visually indistinguishable from the present, as the reenactment sequences from the past and the interviews conducted in the present are shot in the same style: full color with high-definition resolution. Thus, Ly's reenactment contributes to the illusion of a complete and readily available past. On closer analysis, however, the film yields to an imaginary dialogue between the present and the past, and the dialogue is staged with heightened consciousness of the technological conditions of the present moment.

This phantasmatic dialogue is necessitated by the intractable gap between the past and present, or what Jaimie Baron calls "temporal disparity."[2] We may find such disjunctive temporality in the film's juxtaposition of the full-color footage with black-and-white footage and photos, including Wong's feature film excerpts, documentary footage of her China trip and social activities, publicity photos, and news coverage of her travels, public appearances, and other occasions. Such black-and-white, grainy images visualize Wong's life and career elliptically. They point the viewer's attention to the archive effect of the archival document as such. That is, despite the apparent ease of re-presenting the past through full-color reenactment, the inevitable lacunae in the archive document cue an emotional effect of absence and irretrievability. To that extent, the film cannot re-present the past without reinforcing the archive effect of loss. The "real" past thus remains as "temporal disparity," disconnected from the reenacted past and the full-color present; it is evoked as a ghostly receding horizon that refuses to disappear, yet also defies redemption.

Contrary to the plenitude and accessibility promised by the digital episteme undergirding the interviews and reenactment sequences, the archive document adheres to the engrossing esotery of a different temporality. This is manifested in the overwhelming silence of the archival photos and film footage that punctuate and ultimately conclude the documentary. In a final shot, the camera freezes on Wong walking up to the camera,

smiling silently—a moment lifted from the documentary footage of her 1936 China trip, when she is strolling in a flower market in Shanghai. This concluding silent freeze frame forms a strong contrast with the film's eloquent opening, which showcases historians and critics' ready comments on Wong, followed by Ly's effortless vocal reenactment of Wong's Chinese song, "A Pretty Jasmine Flower," which Wong originally performed as part of her vaudeville repertoire in Europe.

Wong's silent smile echoes the silent photos and film footage that punctuate the entire film. Some of the films excerpts are replayed with Wong's truncated spoken lines only to be overlaid by the commentators' voiceovers. The jarring, almost violent juxtaposition of the silent archive document with the superimposed sound imported from the present time gives rise to a form of digitextuality, one accentuating the gap between different media technologies. On the one hand, as Anna Everett argues, the digital framework "has introduced new visual and aural media codes that draw extensively from the medium specificities of film, video, and radio while introducing new characteristics and imperatives that are properties of digital technologies alone."[3] On the other hand, digitextuality by no means guarantees the merging of different media technologies and formats, the digital subsuming of all previous media formats. Instead, digitextuality must accommodate, and sometimes even foreground, the divergences between media technologies, particularly when it compresses them into a single space.

Given the intractable media divergences and persistent silence that characterize the archive material in her documentary, Hong's professed goal of bridging the past and the present by reenacting Wong's voice necessarily takes on a more complex twist. Due to the unvoiced nature of Wong's letters and interviews and the lack of audiovisual recording of Wong's stage performances, Wong's voice, via Doan Ly's ventriloquism, is more imaginary than re-presented. In other words, Ly's vocal reenactment does not inherently refer to Wong's voice, but rather becomes possible and desirable precisely because of the *absence* of Wong's original voice. In implying this absence, Hong's strategy of vocal reenactment forfeits "its indexical bond to the original event," and instead goes through the motions, with the result of producing a "fantasmatic" "mise-en-scène of desire" to animate the past, as Bill Nichols argues.[4] This desire is articulated from the position of the present, embodied by Hong, a first-generation Korean-American female documentary maker. By deploying "fantasmatic" vocal reenactment facilitated by digital technology, Hong seeks to evoke a long-deceased third-generation Chinese-American performer who blazed the trail for later generations of Asian-American women participating in mainstream entertainment.

This imaginary transhistorical dialogue points to a dynamic interaction between Wong's silent beckoning and contemporary filmmakers' strategies

of response. Hong's response in the form of reenactment ostensibly prof-
fers the illusion of re-presenting the original voice as is. Yet, the entrenched
"temporal disparity" displayed in the film and the fantasmatic nature of the
past-present dialogue draw attention to the film's own historical moment
and conditions of (re)mediation. The film ultimately signals a post-Civil
Rights Asian-American standpoint, which recuperates Wong as a woman
warrior persevering through Euro-American racial and gender prejudices.

To convey this woman warrior image to a contemporary audience,
the film deploys two layers of mediation. First, it draws on verbatim the-
ater, casting a contemporary actress, Ly, rehearsing Wong's interviews
and correspondences. The difference is that the accent and body language
that Ly adopts are not based on Wong's original presentation (which is
absent), but rather derive from contemporary imagination. Second, Ly's
reenactment and Hong's film both depend upon contemporary digital
technology. The easy affordability and accessibility of digital technology
significantly extends authorship to disfranchised social sectors tradition-
ally excluded from or marginalized in resource-intense filmmaking.
Thus, Hong's film grows out of the current media ecology, which prom-
ises unprecedented empowerment for the disadvantaged and transforms
media consumers into active connoisseurs, makers, historians, and crit-
ics. Such differences between past and present, suggested by Baron's con-
cept of "temporal disparity," find more self-conscious expression in my
next example, Celine Parreñas Shimizu's short documentary, *The Fact of
Asian Women*.

the metaprocess of reenactment

Inspired by Frantz Fanon's *The Fact of Blackness*, *The Fact of Asian Women*
presents a self-reflexive intervention into Hollywood stereotyping of
Asian-American femininity. Shot in 2001 in San Francisco with a crew of
independent women of color, the film uses camerawork and lighting to
demystify the conventional Hollywood techniques used to portray Asian
female characters. By doing so it deconstructs the hypersexualized Orien-
tal femininity in American film and popular culture.[5] To work through
(rather than simply against) Orientalist stereotypes, the film casts three
contemporary Chinese-American actresses to reenact emblematic scenes
from three films: *Shanghai Express* (1932), *The World of Suzie Wong* (1960), and
Charlie's Angels (2000). These films originally feature Anna May Wong,
Nancy Kwan, and Lucy Liu, respectively. The contemporary actresses
also vocally reenact Wong, Kwan, and Liu's interviews. Furthermore, the
film stages them in full costume on San Francisco streets, walking and
displaying themselves the way they think Wong, Kwan, and Liu would do
in their own contexts, creating a disjunctive performative provocation in
present-day San Francisco. Finally, the film invites the actresses to reflect

upon the filming experience and, more specifically, on their strategies of reenactment. These interview sessions take place in retail stores of their own choice.

Lena Zee, who impersonates Wong in a scene from *Shanghai Express* and then acts out her imaginary Wong on a downtown street in San Francisco. Her retro Oriental costuming and hairstyle, heavy makeup, stiff and mechanic gait, cold and unwavering stare, and utterly expressionless face make her a walking curiosity that both attracts the pedestrians' attention and mystifies (even repulses) them. In her interview, Zee describes her portrayal of Wong's stiffness, fully clad asexuality, and constrained body language as a self-defense necessitated by hostile environs. Zee's interpretation of Wong's asexuality contradicts the common discourse of Wong as an icon of Oriental sexuality.

However, the point is not which interpretation of Wong is historically accurate. What is important is that Zee's conception of Wong, along with the other two contemporary actresses' understanding of Nancy Kwan and Lucy Liu, dwells on the performative process of re-presentation. This process brings out layers of discursive, visual, vocal, and inter-generational mediation as necessitated by the younger actresses' circumstances, experiences, and their understandings of racial politics in popular media. Furthermore, Shimizu's own Filipino background, often marginalized in the American popular media imaginary of Asia, and her feminist stance lead her to deconstruct the American mainstream media. Her small-budget documentary forcefully affirms the importance of renegotiation, mediation, and transformation of the past in the present, especially during reenactments of the past on the streets of contemporary San Francisco.

These processes of renegotiation and mediation take place at the very sites in which the contemporary actresses perform in public. Not only do they drastically reshape their physical appearance and adopt mannerisms in accordance with their understanding of their respective characters, but their reenactments also lead to their own bodies being perceived by contemporary pedestrians as puzzling spectacles. In other words, their performances subject the actresses to real-life compromise and vulnerability. As Shimizu puts it, "moving like Anna May Wong constitutes a kind of pathological asexuality for Lena Zee; strutting like Nancy Kwan results in a particular kind of sexual availability for Angelina Cheng that leaves her shaken on the streets; and Kim Jiang's donning dominatrix gear to evoke Lucy Liu reveals the caricature quality of contemporary Asian female roles."[6] In staging and exposing the dramatic incongruity of hypersexualized Asian females in the real-life environment, the film highlights the awkward mediation of the past and the ways in which this kind of embodied performance compromises contemporary actresses. The film also critiques the Hollywood-produced mystique of Asian(-American) femininity.

Yet, the film goes beyond demystification to argue that spectators who encounter oftentimes hypersexualized Asian-American femininity in mainstream cinema do not "simply learn and accept these images," but rather "converse with and challenge them in a dialectical process."[7] To parse out the dialectical conversation, the film aims to "recognize not only the pain but also the pleasure provoked by these images," a pleasure that "may be available for viewers even in the most unexpected representations."[8] Furthermore, Shimizu argues not only that spectators can derive pleasure from hypersexualized imagery, but also that Asian female performers may find pleasure in authoring themselves as sexual beings.[9] This situation constitutes what she describes as the "messy morass of power that is sexuality and film."[10] It envelops the Asian female performers and their characters as well as Shimizu herself. It "repress[es] our experience but also compel[s] our film practice and our speech."[11] In *The Fact of Asian Women*, both authorship and spectatorship become sites of negotiation, contestation, and articulation. Interacting both with the screen and amongst each other, filmmaker, performer, and spectators are able to develop a kind of agency. Shimizu describes the interaction as the metaprocess of relational filmmaking.[12]

Whereas Shimizu shares Hong's strategy of reenactment, her emphasis and agenda differ drastically. Hong strives for approximation between the present actress and past Wong so as to revivify Wong for the contemporary audience. Shimizu, on the other hand, uses reenactment to physically inscribe the discrepancy between the past and the present. Ultimately, whether the past is lost or recoverable is beside the point, for her emphasis is to promote the metaprocess as a method of bringing the filmmaker, the performer, and the spectator into vigorous inter-play in their performative reconstruction of Asian(-American) femininity. And the ways they inter-play with this racial-gender dynamic are contingent upon the "messy morass of power" of their times. The reenactment thus becomes a means of articulating the voice of the contemporary filmmaker and the performer.

In focusing on the ability to intervene on the part of the filmmaker, the performer, and the spectator, Shimizu's film registers what Bill Nichols calls "the documentary voice"; yet, it also expands this voice from "the embodied speech of a historical person—the filmmaker" to that of the performer and the spectator as well.[13] It is through this interaction of "documentary voices," combined with their "affective engagement," that "meaning arises from what had seemed to lack it or to be already filled to capacity with all the meaning it could bear."[14] In Shimizu's film, it is the overcharged, stereotypical hypersexuality of Asian(-American) femininity that is cracked open for new and pleasurable interpretive possibilities.

Different from Shimizu's endeavor to instill agency and new meanings into the performers' self-authored "sex act," Patty Chang's installation work, *The Product Love*, probes the difficulty, if not impossibility, of meaning-making and agential claims in the "messy morass of power." In this forty-five-minute, two-channel installation work, Chang juxtaposes two video streams. One video documents the strenuous efforts of three native English speakers—one Asian female, one white female, and one white male—to translate into English Walter Benjamin's German essay based on his 1928 meeting with Anna May Wong in Berlin.[15] The other video shows two Chinese actors made up as Wong and Benjamin, engaged in a soft-core pornographic encounter under the direction of a diegetic Chinese crew. The whole process is staged for and documented by Chang's camera. Additionally, *The Product Love* includes a three-minute film loop and photographic installation in an adjacent gallery room. Entitled *Laotze Missing*, the film loop, projected from a reel-to-reel projector, is a transfer from video documentation, which transforms a key scene from Wong's first German film, *Song* (a.k.a *Show Life*) (Eichberg, 1928).

The complexity of *The Product Love* consists not only in the multi-channel and cross-media format, but also in its layered intertextuality and juxtaposition of apparently unrelated imagistic and linguistic references. The title, *The Product Love* (*Die Ware Liebe*), evokes Bertolt Brecht's play *The Good Person of Szechwan*, originally entitled *Die Ware Liebe* (or "love as commodity"), which puns on "Die wahre Liebe" (or "true love"). This intertextual reference secures the installation work's German connections while highlighting the treacherous irony besieging inter-racial and cross-cultural intimacy: it is simultaneously "true" and a product for sale. Furthermore, the "Translators" video references Benjamin's essay, especially its tortuous syntax and impenetrably florid language forged to comprehend the enigmatic Wong, "the Chinese from the old West."[16] In the "Actors" video, the two Chinese actors are made up in imitation of Wong and Benjamin's photographs, which constitute an additional layer of visual intertext. Wong's photo shows her in a medium framing, clad in a black velvet dress with a low neckline adorned with a long white necklace, a white flower covering the left side of her pitch black hair, while her eyes gaze from under her trademark China doll bangs at the camera with a brooding look. Benjamin's photo, on the other hand, is the one that graces the cover of one of his best-known books, *Reflections: Essays, Aphorisms, Autobiographical Writings*. The photo shows him in medium close-up, wrapped in thoughts, his well-groomed facial hair and glasses enhancing his high forehead and meditative pose. Despite their close attention to details (e.g., making sure that the Chinese actor's wig and fake moustache are groomed and attached in a manner that closely replicates Benjamin's photo), the

114

make-up artists' attempt to pass a Chinese actor off as Walter Benjamin as depicted in a photograph is comic at best. For this act of translation (or racial masquerade) focuses on surface visual resemblance while failing to recognize the actor's apparent non-knowledge of Benjamin, or the heavily mediated quality of the Benjamin photo that is necessarily different from the historical figure himself.[17] Yet, through Chang's framing, such decontextualization enables the "whiteface" attempt to reference, reverse, and implicitly mock the equally decontextualized and ideologically driven yellowface practice that prevailed in American cinema and theater, severely hampering Wong's career in her time.

Finally, the film loop, *Laotze Missing*, engages with two more intertexts— Wong's silent film, *Song*, and a fragment from Benjamin's manuscript on Bertolt Brecht, in which he first wrote "Laotse fehlt" (Laotze missing), then crossed it out. The precise connection between "Laotze missing" and the reworked sequence from Wong's silent film, or between the erased writing of Benjamin and the projected film loop, remains to be discerned by the audience.

In addition to this thick layering of inter-lingual (mis)translation, intertexuality, and intermediality, *The Product Love* also stages multi-local and hetero-temporal encounters. Shot in Los Angeles, Berlin, and Hangzhou in southeast China, the work yokes together Wong's birth city, the city where she met Benjamin and started her European career, and a Chinese city she visited in 1936. All three cities are pictured in the present time, far removed from Wong's historical moment. The present-day China is presented as industrial, glamour-less, and completely devoid of the Oriental mystique touted in many of Wong's films. The resulting incongruity necessitates multiple perspectives in negotiating the encounter and confrontation between mutually unintelligible racial, gender, and cultural positions and expectations.

In the destabilizing confrontation between the two video channels and *Laotze Missing*, Wong occupies a position of being probed, described, circumscribed, filmed, and puzzled over. Her status is revealed as an *outline* that is simultaneously and stubbornly present yet conspicuously empty (or emptied out) both in the West and in China, in past and present. The film loop encapsulates Wong's haunting yet invisible presence by reworking a crucial scene in *Song*. *Song* stars Wong playing a homeless girl who is eventually ruined by her unrequited love for a Caucasian knife thrower. Patty Chang specifically re-works a scene in which the man forces the homeless girl to stand against the door, and then limns her figure with white chalk on the door. He then pushes her to screen right, and proceeds to throw knives at the chalk outline. As she watches the knives accurately land right on the edge of her outline on the door, the terrified girl turns to the man with an admiring gaze.

In Chang's film loop, we see the original moment of the man outlining her figure on the door. Yet, instead of having him push her away, the projector pauses, makes clicking noises for a few seconds, then rewinds the film at a much slower speed, so that the frames flicker in reverse order; between the flickering, we see the man slowly, almost lovingly, erase the chalk outline around the girl (figure 6.1). Once the chalk marking is completely erased, the projector pauses for a split second, then replays the original film footage so that Wong's character is once again forcefully encased in the chalk outline. Just as the man lays his hand on her shoulder to push her away, the projector again pauses and makes clicking noises for nearly twenty seconds as if it were jammed. When the film finally resumes, showing the girl pushed to screen right, looking back in terror at her outline on the door, the projector "jams" again for twenty seconds, prolonging her gaze and his gaze at her emptied-out outline (figure 6.2). After dwelling on this suspenseful moment, the film resumes, showing the terrified girl watching the man poised to throw the knife. The camera then cuts to show her seeing the knives land accurately just on the edge of her outline, one after another, which literally circumscribes her figure once again (this time with knives). Upon witnessing the knife thrower's flawless marksmanship, her facial expression changes from terror to admiration in a luminous close-up; her expression quickly reverts back to terror as she reacts to the knife thrower off-screen. Here the loop stops, leaving the audience to speculate about the next moment of crisis.

In the original film, what ensues is the girl's masochistic agreement to become the man's business partner. Dragging her back to the door, thrusting her into the knife-studded outline, with two knives flanking her head just above the shoulders, the man asks, "Are you afraid?" She

Figure 6.1 The man erases the chalk outline around Wong's Chinese girl.

Figure 6.2 A long pause shows the man and the Chinese girl staring at the chalk outline for a prolonged period of time.

hesitates between nodding and shaking, and eventually accepts his proposal to become a human target in his sensational knife-throwing game. This marks the beginning of her "show life."

The original film sequence emphasizes a sadomasochistic tension and pleasurable suspense for both the diegetic and film audiences. It teeters between two sets of possibilities: either the white man really cuts her *or* cuts out her figure with knives; either the homeless girl is terrified of being hurt *or* takes pleasure in being almost-hurt-but-not-quite. Chang's film loop differs from the fluency of the original film sequence, which exploits and naturalizes the sadomasochistic pleasure. The loop disrupts and jams this fluency: it not only reverses, pauses, and repeats the original sequence, but also demystifies the image flow with the loud projector noise, the clicking jamming sounds, the flickering low-resolution quality, and the crude framing as seen in the wall projection. All these strategies force us to focus on and reread details, fleshing out multiple meanings originally marginalized as flitting moments in the film's sadomasochistic narrative. For instance, the reverse of the original footage produces the illusion of the man erasing the chalk outline and thereby suggests a surprising effect of liberation, as if he set Wong's character free, which is impossible in the original film. The long pause dwelling on his laying a hand on her shoulder before pushing her away makes one ponder the possible intimacy in that touch before the movement resumes again, turning the touch into a brutal shove. The suspenseful stillness introduced by the pause also transforms Wong's character from a panicking victim to a semi-expecting playmate. The second long pause, arresting the couple in a prolonged act of

117

looking at the chalk drawing, foregrounds the central significance of the latter's empty outline.

Contrary to a flitting image in the original film, now the outline is singled out as the object of attention, forcing both the characters and the audience to reflect on its relationship with Wong (and with her character). The outline contains a space Wong and her character once occupied. It also suggests the white man's symbolic imprisonment of her. When she is pushed away, the outline is emptied out, alienated, yet not entirely disconnected from her. In fact, its very emptiness suggests her absent presence. Or, the empty outline takes on her embodied presence, suggesting an apparition despite her elimination from the space. The couple's prolonged gaze testifies precisely to an enigmatic and uncanny emptiness that is not just empty, but *emptied out*, ineluctably evoking what it now lacks. Thus, the chalk outline becomes a quasi-doppelgänger of Wong and her character. When the knife-thrower aims at the outline, the terror Wong's character feels is no less than if her real body were targeted. The heightened emotional investment in the chalk outline renders the emptied-out form pregnant with new meanings. As the trace of Wong and her character, this chalk outline constitutes an uncanny doubling that alienates her while also intensifying her fantasmatic existence. Her trace or outline serves to mediate the Euro-centric sadomasochistic desire, making it image-able and justifiable (after all, it is the outline, not her, that is knifed). To the extent that her value hinges upon the fantasy existence, Wong's interstitial position and agency as a historical subject becomes obliterated. Consequently, she is both hypervisible and conspicuously absent, analogous with the chalk outline that attracts prolonged attention, but only as an emptied-out space to be signified by external projection—in the dual sense of being the target of the white man's projectiles and the vehicle of the colonial Orientalist fantasy.

The accompanying photo installation of Benjamin's writing, "Laotse fehlt," constitutes another rendition of this theme of "Wong is missing." Furthermore, "Wong is missing" underlies the "Translator" video installation that shows three native English speakers tasked with translating Benjamin's German essay on his meeting with Wong. Shot in three different interior settings in Los Angeles, the three translators bend over their tables, painstakingly plod through the printed lines of the German text, and haltingly render the German words into barely sensible English equivalents, with much back and forth revisions. At one point, one translator feels compelled to explain Wong's answer—written as "touch would" (in response to Benjamin's question of how she would express herself if she were no longer doing film) in the original text—as a misspelling for "touch wood." Another translator pores over the page, then simply lets out a helpless sigh, and gives up. The juxtaposition of their belabored translations (sometimes of corresponding phrases and passages) demonstrates glaring discrepancies between the different versions.

These discrepancies, combined with the translators' oftentimes puzzled facial expressions and awkwardly visualizing hand gestures, suggests that Benjamin's rhetorical contortion defies easy, lucid translation. Benjamin's writing, which borders on the non-sensical, indicates the extent to which his encounter with Wong revealed his epistemological limit.[18] Facing the "walking contradiction to existing stereotypes about Chinese women," Benjamin, like his contemporaneous German media publicity, tended to acknowledge Wong's modernity "only to reinforce those very stereotypes [about Chinese femininity] in the same characterization."[19] Unsurprisingly, when language and its accompanying conceptual framework fail, visual tracing came to the rescue. The article, which originally appeared in *Die Literarische Welt*, includes a sketch of Wong's profile from the left. As Benjamin indicates in his article, Wong was sketched by both an illustrator and an American journalist during the meeting. The visual tracing is reminiscent of the chalk tracing in the *Show Life* sequence reworked in the film loop. Together, they reinforce the importance of the outline as a placeholder, an absent presence that allows imaginary projection when cross-cultural understanding is blocked by prejudicing categories and stereotypes. When Benjamin's text is reenacted in three failed versions of English translation in contemporary Los Angeles, Chang rehearses an Orientalist imaginary, one that spotlights Wong only to render her conspicuously absent.

To enhance the disjuncture in the translators' linguistic and vocal performance of Benjamin's text, still shots are inserted into the translation scenes, showing unidentified interior and exterior locations in China. The shots include ambient sounds, but they are largely unpopulated. The exterior scenes are post-industrial, cluttered with concrete buildings, construction debris, a gray sky, and wet road. The interior scenes show a mixture of styles in furnishing, interior design, and architectural features. Additionally, we see shots through the window, vertical shots of the steep stairwell, shots of shelves in the Walter Benjamin Archive, and a shot of Benjamin's 1928 article (complete with the sketch of Wong), cut from the magazine, *Die Literarische Welt*, and pasted into a scrapbook.

All the interior and exterior still shots inserted into the translation sequences are eerily depopulated, with the traffic frozen, the furniture abandoned, and the floors covered with dust, evoking the inhabitants who used to be there in a different historical fold, but long since vanished. The last shot of this "Translators" channel is a static framing of the wall of a bedroom, focusing on the empty trace left behind by the bed that used to be there. The empty space echoes the chalk outline on the door and Wong's sketch in Benjamin's article, suggesting not simple absence, but rather absence charged with spectral presence, which points to not only past history, but also an alternative history—one that may be made-up, yet nonetheless compelling in how it captures historical possibilities

through the plasticity of artistic creation. A made-up, speculative history is precisely what happens in the "Actors" channel of the installation.

In this channel, the empty trace left by the bed gives way to a long take, with a fixed camera holding on a large window covered with black drape. This long take precedes scenes of two Chinese TV actors being made up as Wong and Benjamin, who subsequently enact an impassive sexual encounter. Following up on the shot of the absent bed, this bedroom scene presumably re-presents what could have happened in 1928 Berlin, with a significant twist that the enacted sex scene now takes place on a bed surrounded with retro "Oriental" decor, and the actress is dressed in a bright yellow cheongsam with fake buttons, contradicting Benjamin's description of her attire as a blue coat, a skirt, a light blue blouse, and a yellow tie. In the sex scene, the clichéd image of the pre-1949 China and Chinese femininity is reinforced by the diegetic male Chinese crew filming the scene and who, in turn, were filmed by Chang for her installation project.

Facing Chang's camera, the two-man crew state their understanding of Benjamin's sexual desire for Wong. One man opines that Benjamin lacked self-confidence and inevitably felt attracted to the Oriental woman, and that the Oriental woman entertained, even encouraged his desire out of maternal generosity. He further states that Benjamin's desire for Wong symbolized his flirting with Eastern culture by touching its sensitive spot. The other man strives to translate the East-West hetero-erotic economy into awkward English for Chang, echoing the (failed) efforts of translation in the first channel. His inadequate English makes the description of the sexual encounter comically blunt. As a result, we are presented soft-core pornography conceived and shot by Chinese male filmmakers, yet instigated by and filtered through Chang's project.

Both the "Translators" channel and the "Actors" channel converge on a crisis of communication and interpretation, one provoked by absent presence and emptied outline. Yet, they differ in one significant aspect. Whereas the "Translator" channel emphasizes the trace from the past, or the effort of visual tracing when comprehension fails, the "Actors" channel takes the strategy of filling in the trace through enactment and embodiment. The medium in question shifts from the language to the body, especially the actors' bodies, as mocking supplement of the historical figures (Benjamin and Wong) who have disappeared, but have left indelible (if befuddling) traces. By placing a contemporary proxy body in the leftover trace from another historical moment, the embodiment does not simply revivify what happened previously, but rather reimagines what could have happened. It bodies forth a possibility of what Benjamin calls the "afterlife" (*Nachleben*) of "prehistory" (*Urgeschichte*). According to Benjamin, this afterlife indicates necessary disruption as well as continuity. Only when prehistory falls into disarray can it be rewritten or re-versed. And it is only through this process of reversing that that which remains embryonic in

prehistory can be fulfilled as the afterlife.[20] The generation of the afterlife, therefore, is predicated upon the dual act of evoking the prehistory while subjecting it to rupture and critical pressure.

This rupture becomes even more palpable when reversal is staged via the contemporary actor's body. As the location and the history-specific physical body becomes the very medium used for embodying and bearing out the past trace, the clash between what is remembered and what is presented as a new manifestation becomes most obvious. In this process, prehistory is evoked only to be reversed, even perverted, so that the original power is simultaneously questioned and given an unexpected afterlife. As much as the makeup professionals diligently reference Wong and Benjamin's pictures for maximal resemblance, the result inscribes inevitable distance between the historical figures and their contemporary impersonators.

To have a Chinese actor made up as Benjamin ostensibly mimics the practice of yellowface by taking it in a reverse direction. However, unlike yellowface performance celebrating a white entitlement to racial masquerade and a white ability to freely cross between racial/ethnic identities, the Chinese actor's whiteface performance accentuates the improbability of such masquerade. In the impersonation sequence, and especially in the deliberately farcical sex scene, we see the jarring distance between the Chinese actor and Benjamin not only in their looks, but also in their body language. Sporting the Benjaminian moustache and hair, the actor undresses the actress and proceeds with the sex scene under the Chinese crew's instructions. During the intermission, the actor un-self-consciously and vigorously fans himself and the actress's half-covered, motionless body laid out on the bed. This action suggests the humid, hot summer weather typical in southeast China where air conditioning is not always available. This elaborate mise-en-scène forces the viewer to reflect on the distance between the contemporary Chinese actor and Benjamin in 1928 Berlin. It prevents us from identifying with the characters or believing their sex scene. This alienation effect problematizes the white celebratory discourse regarding racial masquerade, and specifically challenges the yellowface practice that deprived Wong of many well-deserved screen opportunities.

Such a counter-illusional gap between the actor and the character, the past and the present, similarly obtains in the Chinese actress's relationship to Wong. A television actress and a restaurateur, the actress's dual identity raises for Patty Chang the ethical question of how one may stay "good" in China's "market-driven economy," with the "good" referencing Brecht's play *The Good Person of Szechuan*.[21] I argue that the issue here is not simply the possibility of being ethically "good," but rather the inevitability of becoming the "product" labeled as "love." Brecht's wordplay in the original title—which exchanges the term "Ware" meaning "product" or "commodity" for "wahre" in the common phrase "Die wahre Liebe" or "true love"—already indicates the slippery linkage between the "true"

121

and the commercial. Brecht's self-conscious skepticism regarding "love" is further amplified in Chang's installation work, which translates Benjamin's linguistic efforts to grasp Wong into his carnal desire to touch Wong. This remediation then slides into a perverse staging of "love" as "product." Wong's impersonator as the "product love" is, unsurprisingly, passive, tepid, and irresponsive to the touch. Posing as an inanimate prop in the entire sex scene, she barely encourages the Benjamin-impersonator's desire (contrary to the Chinese crew's projection).

At one moment in the "Actors" channel, the actor is instructed to raise one of the actress's legs in a fetishistic manner. To get the best angle, he tries out different positions and heights of the leg until the Chinese crew is satisfied. What make the scene awkwardly dehumanizing yet hilarious is that the camera frames the actor adjusting the actress's leg position very diligently to get the best camera shot, while the actress's subjectivity completely collapses. Her value is distilled into one trophy-esque leg that is unconditionally subjected to external force. The manipulation of her leg resembles a shop clerk's posing of a mannequin to best display a piece of clothing. The relationship between the two performers, and between their corresponding characters, thus becomes perverted as the impossibility of a relationship between the manipulator and the mannequin, or the actor and the prop.

The actress's prop-like inertia is further signaled by her lack of language. She speaks not a single word during the entire video, contrary to Wong's witty eloquence, which both teased and undermined Western Orientalist assumptions. Thus, the contemporary Chinese actress's presence in the sex scene consists purely in her corporeality, first clad in the faux-pre-modern cheongsam, then stripped down to naked flesh. The emphasis on the actress's corporeal existence echoes Patty Chang's trademark style of placing her own body at the center of many of her works. However, there is a significant difference. Chang's works featuring herself emphatically challenge her own (and, vicariously, the viewer's) physical comfort and normality by documenting her own body performing highly contrived and iconoclastic actions. They include kissing her parents while chewing and passing an onion in between mouths; doing Chinese acrobatic contortion; donning Bruce Lee's yellow jumpsuit to feebly imitate his fighting choreography; and subjecting her body to an eel squirming around under her clothing. In foregrounding the visual and tactile details of her involuntary physical revolt despite her physical constraint (e.g., crying from chewing the onion while kissing, twitching under the eel's slimy "touch"), her work positions her body as a medium at a limit point, literally struggling and channeling between self-restraint and excess, strength and vulnerability, the subject and the object, the norm and the abject. Thus, her corporeal presence exercises a high degree of creativity and self-determination precisely when she subjects her body to surprising forms of micro-violence.

Using herself as a performer, Chang deploys a strategy similar to what Celine Shimizu calls the "metaprocess," which approaches the directing relationship "as a classroom where actors learn for themselves and discover their own power within the creative process."[22] Herein lies the significant difference between Chang's deployment of her own body as opposed to the Chinese actress's body in the "Actors" channel. While her own body commands agency and power in determining the type, extent, and degree of self-imposed micro-violence, her calculated physical reactions, and the correlated purpose of such performances, the Chinese actress serves more as raw material (or materiality) that exists merely for the male-driven sex fantasy, deprived of a name, language, and a responsive or active body language.

This raw corporeality extracted from the Chinese actress is pregnant with meanings; yet they are kept dormant so that the apparently subject-less and emptied corporeality can be made amenable to external projection. It evokes the chalk outline highlighted in the film loop of *Lao-tze Missing*. In the latter instance, the form of Wong is contoured, dwelled upon, and subjected to the knife-thrower's projectiles and sadistic fantasies. When the Chinese actress impersonates Wong, her body apparently serves to fill Wong's contour, especially when it is reshaped to fit with Wong's photo. However, her passive corporeality in the sex scene ends up as another outline, subjected to another round of imaginary projection, this time originating from layered (re)mediation of the male actor, the diegetic Chinese crew, and Chang herself.

conclusion: performing comparative media ecology

Yunah Hong's *In Her Own Words* seeks to re-present Wong through vocal reenactment only to produce an archive effect, namely, the visual and temporal divergence between the lost black and white past and the color-saturated present. Celine Shimizu's *The Fact of Asian Women* takes a more performative and relational approach by constructing a meta-representational structure in which contemporary Chinese-American performers not only reenact Anna May Wong, Nancy Chan, and Lucy Liu, but also reflect upon the meanings and impact of their reenactment. This metaprocess allows Shimizu to explore the difference between the contemporary performers and the performers they reenact, while also emphasizing the gap between her own marginalized Filipino heritage and the hypervisibilized Chinese-American femininity in the American mainstream popular culture. Shimizu's documentary understands filmmaking as a relational process in which the makers, the actors, and the spectators interact with each other, and mutually constitute their respective agency and position of enunciation.

Unlike Hong and Shimizu, Patty Chang's *The Product Love (Die Ware Liebe)* mobilizes strategies of remediation, enactment, linguistic performance,

and rhythmic multi-loci spatial tableaux shots to highlight and problematize the trans-cultural Orientalist erotic charge that underpins Benjamin's befuddled experience of encountering Wong. In this process, Wong's film is reworked not to figure out what or who the real Wong was under the guise of the image, but rather to enhance the image itself as an opaque, sometimes inert, construct. This construct takes on different forms, such as the chalk outline doubly outlined by the knives, the empty space indelibly marked on the wall by the missing bed, the contemporary Chinese actress's mute body, and the sketch in Benjamin's essay that stimulated his contorted linguistic performance and subsequently difficult (if not impossible) translations. Chang's video installation evokes and re-performs Wong's image to accentuate her opacity as absent presence.

In each case of reworking, re-enactment, and re-presentation, Wong's figuration experiences double exposure in the past and the present, resulting in palimpsest configurations that scramble and redraw temporal and spatial boundaries, prompting us to consider border-crossing and trans-medial movements on the one hand, and to interrogate the entrenched schema of historic, geopolitical, and medial differentiation on the other. Through the gyrating lens that refracts Wong and her work in the digital age, we—contemporary critics, makers, and spectators—explore new approaches to transmedial production and consumption of an opaque, interstitial performer. As Wong re-encounters us in different media assemblages, we are summoned to reflect upon the potentials and perils of our own media ecology—in connection with and contradistinction to that characterizing Wong's age of segregation.

acknowledgment

I thank the editors, Katherine Groo and Paul Flaig, for their constructive suggestions and studious editing of my essay. All remaining errors are my sole responsibility.

notes

1. Steve Su, "Interview with Filmmaker Yunah Hong," *Alt Magazine* http://www.asianloop.com/article/100/Interview_with_Filmmaker_Yunah_Hong. Accessed 25 February 2015.
2. Jaimie Baron, "The Archive Effect: Archival Footage as an Experience of Reception," *Projections* Vol. 6, No.2 (Winter 2012): 105, 109.
3. John Thornton Caldwell and Anna Everett, eds., *New Media: Theories and Practices of Digitextuality* (New York: Routledge, 2003), 5.
4. Bill Nichols, "Documentary Reenactment and the Fantasmatic Subject," *Critical Inquiry* Vol. 35, No.1 (Autumn 2008): 74, 76.
5. Celine Shimizu, "Theory in/of Practice: Filipina American Feminist Filmmaking," in *Pinay Power: Feminist Critical Theory*, ed. Melinda L. De Jesus (New York: Routledge, 2005), 319–320.

yiman wang, university of california

124

6. *Ibid.*, 322.
7. Celine Parreñas Shimizu and Helen Lee, "Sex Acts: Two Meditations on Race and Sexuality," *Signs* Vol. 30 No.1 (Autumn 2004): 1386.
8. *Ibid.*
9. *Ibid.*, 1387.
10. *Ibid.*, 1388.
11. *Ibid.*
12. Nichols, "Documentary Reenactment," 79.
13. *Ibid.*, 78, 88.
14. Walter Benjamin, "Gesprächt mit Anna May Wong: Eine Chinoiserie aus dem Altern Westen," in *Die Literarische Welt* (6 July 6 1928): 213.
15. Interestingly, Benjamin's famous essay, "The Task of the Translator," originally written in 1921 as the introduction to his translation of Baudelaire, already foregrounds the difficulty of translation, especially given his understanding that translation is an art that must not simply convey the original meaning, but more importantly, creatively fulfill the kinship between languages and facilitate the rebirth of "pure language" in the translation. The model of translation Benjamin maps out in his essay becomes especially difficult when his own writing on Wong is subjected to translation. As Chang's installation work demonstrates, to engage with and to foreground the difficulty per se instigates creative reinvention, even when the translation attempt fails or takes on an unexpected direction.
16. I thank Katherine Groo for urging me to consider the iconification of Benjamin through his widely circulated images.
17. When the original text's problematic meaning-making is duplicated in the failed attempts of translation, this process bears out Benjamin's postulation that translation opens up the target language, allowing it to be estranged by the source language (in this case, English is estranged by Benjamin's German). Meanwhile, however, failed meaning-making stems from Benjamin's ideological limitations. This dimension completely falls out of his theorization of translation as the birthing of a "pure language."
18. Such self-contradiction was prevalent in German media coverage of Wong, according to Pablo Dominguez Anderson. See his " 'So Tired of the Parts I Had to Play': Anna May Wong and German Orientalism in the Weimar Republic," in *Crossing Boundaries: Ethnicity, Race, and National Belonging in a Transnational World*, eds. Brian D. Behnken and Simon Wendt (Washington, D.C., Lexington Books, 2013), 265.
19. The terms *Urgeschichte* (primal history) and *Nachleben* (afterlife) are used by Benjamin in Convolute N of his *Arcades Project* (Cambridge, MA: Belknap/Harvard University Press, 1990), 463, 460.
20. The press release for the exhibition of *The Product Love* in Germany can be accessed online: http://www.arratiabeer.com/index.php?template=press_release&id=PC_TPL#. Accessed 25 February 2015. *The Good Woman of Bangkok* (Dennis O'Rourke, 1991) also comes to mind. This documentary chronicles a Thai prostitute's day-to-day experience, including her sexual transactions with the Australian documentary maker himself. As such, it replays, albeit with a twist, the scenario of the white man/Asian woman encounter, which oftentimes entails sex trade and the "white knight" complex, as overdetermined by the imperialist and Orientalist fantasies and power economy.
21. Shimizu and Lee, "Sex Acts," 1387.

the living nickelodeon

and silent film

sound today

a n i n t e r v i e w w i t h p r o f e s s o r r i c k
a l t m a n

Rick Altman is Professor Emeritus of Cinematic Arts at the University of
Iowa. He has written widely in film and literary studies, contributing semi-
nal texts on film genre, movie musicals, theories of narrative, and silent
cinema. His 2004 monograph, *Silent Film Sound*, challenged long-standing
assumptions about early cinematic soundscapes, approaching a diverse
range of archival material through a historiographic method emphasizing
multimedial exchange and historical contingency. Altman has animated
this research by creating and performing "The Living Nickelodeon," a play-
ful resurrection of diverse exhibition practices from film's first two decades.
Acting as erudite lecturer, singing pianist, and schmoozing showman, Alt-
man has performed The Living Nickelodeon at conferences, festivals, and
cinemas around the world. Intended as a pedagogical demonstration of the
hows and whys of silent film sound prior to the feature film's dominance,
The Living Nickelodeon also points to the oft-forgotten necessity of cre-
atively engaging music, sound effects, and silence during contemporary
exhibition, dissemination, or re-mixing of early films. This interview was

conducted by Paul Flaig via email between June and December 2014. It has
been condensed and edited.

At the 1998 Domitor Conference you and several colleagues involved
in the Sound Study Group at the University of Iowa debuted The Liv-
ing Nickelodeon. At once a pedagogical extension of your research
on the complex soundscapes of early cinema, The Living Nickelo-
deon is also an entertainment, featuring short films and illustrat-
ed songs with which you perform as pianist, singer, and, not least,
scholar. What was the initial motivation for translating your work
on silent film sound into an interactive exhibition and, specifically, a
re-animation of the Nickelodeon? How was this initial performance
first conceived?

The Living Nickelodeon began as a collaborative project involving my
University of Iowa Film Studies colleagues Lauren Rabinovitz and Corey
Creekmur. Together we came up with the idea of recreating early film
performances, in all their performative variety and splendor. We talked
the Library of Congress into furnishing 16mm copies of films in the
Paper Print Collection. I provided the illustrated song slides (from the
Marnan Collection in Minneapolis) and the piano part, along with pre-
sentational prose and commentary. Lauren took care of projection (and
active schmoozing), while Corey handled the sound effects. When we
scheduled a Living Nickelodeon performance at the 1998 Domitor meet-
ing in Washington, D.C. we pressed my Washington area niece, Anna
Lamond, into service. She turned out to be the perfect singer for the heav-
ily lyrics-oriented early Tin Pan Alley illustrated songs that provide the
backbone of our program.

For several years, we performed as a quartet, often varying the film and
song slide selection, but always concentrating on the multimedia nature
of early film programs, and always exemplifying several of the many ways
in which early films were accompanied by (and surrounded by) differing
types of music and sound effects. For the better part of a decade we alter-
nated between high-profile venues (Museum of Modern Art in New York,
Detroit Institute of Arts, Chicago Art Institute, Bologna Cinema Ritrovato
Festival) and more modest locations (several American universities, as well
as a handful of local retirement facilities—the easiest places, as it turned
out, to get people singing).

For the last several years I have been performing The Living Nickel-
odeon as a solo routine, with the piano playing and singing interwoven
with films, commentary, and schmoozing in the audience. From Mel-
bourne, Australia, to the Louvre Museum in Paris, by way of the Brussels
Cinematek, a handful of German venues, and several US universities, this
is the way that The Living Nickelodeon is currently presented.

Through the efforts of archivists, collectors, scholars, and restorers, there has been an increasing availability of documents and films related to cinema's first decades. As a scholar long engaged with the study of film, how has the field transformed in relation to this availability, which includes DVD releases, archival resources, events like The Living Nickelodeon, or increasingly multimedial conferences like Domitor? Beyond the sheer dissemination of information or images, how do digital means of restoration or circulation affect contemporary approaches to the study of silent film?

This is a more complicated question than might at first seem to be the case. In one sense, it is obvious that archival finds and digital technology have expanded our access to the early film scene. But just because we have multiplied by a factor of ten the list of available early films doesn't mean that there will automatically be similar progress in accompaniment techniques. I admit to being somewhat frustrated that early films continue to be accompanied in the same style as later "silent" films. To be sure, there are exceptions, including the wonderful work done by such groups as the Mont Alto Orchestra. But by far the majority of DVD musical settings for films offer a single style of accompaniment. One of the important missions of The Living Nickelodeon is to draw attention to the variety of approaches used during the 1895–1915 period.

The Living Nickelodeon addresses much more than film. I sometimes fear that increased access to films, often in more complete and better copies, may blind us to the importance of considering neighboring and complementary media such as sheet music and song slides. If we want to understand the visual landscape and audio soundscape of early cinema, then we have to reach farther than increased access to films. We need to recognize the importance of work done by such organizations as the Magic Lantern Society, as well as the archival endeavors of such illustrated song pioneers as Nancy and Margaret Bergh.

How have audiences responded to the information it presents or to the interactive elements of performance, such as singing along with illustrated songs? Have these responses, in turn, affected your own thinking, theoretical, or historiographic, about early cinema and its exhibition?

As important as increasing access to early films might be, the film itself can never tell us how it was projected, played, or received. This is why we need active performances to serve as a model and to initiate discussion about early performance standards. One of the important insights that grew out of developing The Living Nickelodeon is presented in my article on "Film Sound: All of It," where I insist on considering all the events surrounding a film performance.[1] When you actually attempt to recreate an earlier style

of performance you find yourself obliged to consider many, many questions that are not obvious when you're simply inserting a DVD into a computer. What kind of piano should be used? Where should it go? Does it need to be in tune? Or should we use an organ? Or is an orchestra more appropriate? What music should be used? In what order? Matching films how? Through title and lyrics or according to the music's emotional content?

It has been a special pleasure to get people around the world to sing. We have gone out of our way to make sure that audiences would have every incentive to sing along. We have produced lyrics in French, German, and Italian. We have varied accompaniment strategies according to local practice and local musical knowledge. What a kick to have 300 French spectators singing, in French and in English, under the pyramid of the Louvre!

Of course, The Living Nickelodeon is more than just a series of film accompaniment examples, complemented by illustrated songs. The Living Nickelodeon tries also to provide an experience that differs radically from the twenty-first-century film theater experience. In order to liberate audiences from their prejudices regarding appropriate audience conduct, I often enlist several audience members, asking them to make boisterous comments, to indulge in rowdy behavior, and to engage other audience members in active participation. When the opportunity arises, I encourage audience members to carry on conversations out loud in multiple languages. Of course, just as early audiences often did, today's spectators sometimes get out of hand. I recall especially a performance at a conference in Australia where I enlisted the active participation of two academic cronies. Taking his responsibility all too seriously, a theretofore respected colleague spat on the equally respected colleague sitting in front of him. For several minutes the resulting skirmish in the audience overshadowed the image on the screen. Unless you actually participate in a live audience situation, you are unlikely to learn the lessons that active participation offers.

The name "Living Nickelodeon" seems a fitting moniker for the goals you have mentioned, not least re-animating the multimedial soundscape of early cinema. It also implies one potential model for thinking about the resurrection of forgotten or deceased media forms, what the accompanist Philip Carli has called "the sense of seeing 'how it was done'—an extinct format brought forward for public view again."[2] This might include performing original scores, approximating period music and effects in contemporary compositions and performances or, as in the case of festivals like the Crazy Cinématographe in Luxembourg, recreating the looks, feels, and sounds of early cinema. How far can or should exhibitors or performers go in their resurrections of early cinema? How important is it to maintain this model in approaching the authenticity or accuracy of exhibition, live or otherwise, in light of early cinema's "performance standards"?

One of my pet peeves is the all too common imbalance between carefully reconstructed silent film images accompanied by ill-chosen sounds. I have no problem with new soundtracks, ranging from rock to minimalist "classical" music and beyond. What worries me is the less-than-desirable matching of the latest and best copy of an early film with an accompaniment borrowed from a period totally different from the film itself. From reading the period professional press we know that films were often accompanied by songs matched with the images—not by sound but by words. If the images show an empty glass, the accompaniment might be built around the song lyrics for "How Dry I Am." As common as this verbal approach was during the late aughts and early teens, we rarely hear this accompaniment strategy at today's festivals or in the increasing number of one-off silent film presentations. The result is predictable: spectators get the wrong idea about how early films were accompanied. They quite reasonably assume that a presentation touted as the "Recently Reconstructed Film X" includes an equally carefully reconstructed accompaniment.

The Living Nickelodeon is meant to serve as a modest corrective to this situation. It is built around four different accompaniment approaches that are under-represented in current silent film presentations. After a first program where the pianist accompanies the illustrated songs, but takes a break during films, we move to a second program featuring sound carefully matched to on-screen action—but only as long as the sound continues to be justified by on-screen activity. So when an on-screen pianist disappears from the screen, the accompaniment goes silent until the pianist reappears. The third program involves films built around songs, while the fourth depends on humorous matches between on-screen activity and the lyrics of the songs selected for the accompaniment. All four of these approaches were common during the nickelodeon era, but they are virtually never included in today's accompaniment schemes.

So, to return to your question: is The Living Nickelodeon dedicated to giving audiences "the sense of seeing 'how it was done' "? In one sense the answer must be in the affirmative: The Living Nickelodeon certainly does offer several different examples of "how it was done." But in another sense the notion of "seeing" how it was done misses the mark. What I am aiming at, first and foremost, is to give audiences the sense of *feeling* how it was done. This involves much more than just seeing and/or hearing. It includes, for example, a wide range of relationships among spectators, which can be appreciated only when the full experience is taken into account. The illustrated songs featured in The Living Nickelodeon are essential to this overall experience, because they help to create an active audience, with virtually continuous audience participation. This is why, during the minutes before the show, I often enlist the participation of selected audience members, exhorting them to be noisy and boisterous, and to talk to each other during moments that might otherwise be

silent. When The Living Nickelodeon works as designed, it gives audiences a chance to experience early movies in a new and fascinating way. Is my way the only way? Certainly not. Is it the best way? Who's to say? In any case, I don't pretend to be offering an exact reconstruction of a nickelodeon-period audience experience. But I do claim to be opening a new avenue to understanding the variety of audience experiences characteristic of the nickelodeon era.

For better or worse, digital formats of sound and image have had an extraordinary impact on the ways silent films might circulate. These include transformations like DJ Spooky's *Rebirth of a Nation* (2007), electronic scores ranging from Giorgio Moroder's *Metropolis* (1984) to live soundtracks by DJs and CD soundtracks by bands (Air's *A Trip to the Moon*), and the many local performances linking various musical styles (rock, bluegrass, classical, etc.) to any number of exhibition sites: rooftops, opera houses, former film palaces, etc. How do you understand these efforts, which are less resurrection and more re-mix? In these cases can the film itself indicate to musicians how it might be exhibited or do potential freedoms from copyright or film print encourage freedoms in styles of accompaniment or modes of exhibition?

I love what you characterize as the "re-mix" approach. Even though my Living Nickelodeon show falls more on the "resurrection" side, I am very much in favor of ANY approach that increases spectatorship for early films. This is why I regularly pass out to my students sound makers of all sorts (bells, whistles, keyboards, drums, etc.), encouraging them to use them whenever they choose. The ensuing discussion about why and when they chose to use their noise makers always engenders fascinating new hypotheses about the various ways in which film accompaniment can be approached. Likewise with the carefully confected scores produced by an increasing number of individuals and groups around the world. The way I figure it, only good can come from time spent on silent films.

Of course, there is a big difference between Giorgio Moroder's *Metropolis* and The Living Nickelodeon. You ask whether it's possible for "the film itself [to] indicate to musicians how it might be exhibited." Certainly, all films do give some indications regarding potential accompaniment strategies, but by and large it is not so much the film, but rather the contemporary press, that provides clear (and yet often contradictory) indications about the range of acceptable accompaniments. Because the contemporary press bears witness to a wide range of accompaniment strategies, it seems to me important to range widely in our approach to silent film accompaniment. But there's no sense in confusing "resurrection" and "re-mix" approaches.

In *Silent Film Sound* you argue for a "crisis historiography" in approaching early film culture, but also suggest such an approach "may usefully be applied to a wide range of cultural phenomena."[3] One of the central assumptions of *New Silent Cinema* is that cinema's present crisis, largely provoked by digital media, might be understood in light of past crises, including those during cinema's initial development and later synchronization with sound. What lessons, if any, can we learn about the current crisis vis-à-vis cinema as a former "new media"?

I love your characterization of cinema as "a former 'new media'"! Perhaps the most important aspect of my work on "crisis historiography" involves recognition that all media are historically contingent and in a constant situation of flux. We tend to treat all successful media as if they were either permanent or the expected result of a predictable (even if only retrospectively recognizable) teleological progression. But the minute we start to think of cinema as "a former 'new media'" then we have to engage in some serious analysis to understand what cinema is/was and how it got that way.

In my book on *Silent Film Sound* I make the point that all "new" media are initially defined as versions of "old" media. Cinema, for example, was once a form of photography, an instance of theater, a type of "views," or a form of "advanced vaudeville." In order to understand cinema, we need to understand the multiple ways in which the new mode was defined. Same thing today. Does anyone really compute with that thing we call a computer? Is there a board (or a key) in today's keyboards? Is the primary purpose of our desktop computer screens really to serve as a monitor? No to all the above, yet our understanding of the new technology must pass through these early definitions, now become transparent language.

You have written widely on silent film sound, musicals, theories of genre and narrative and many other topics in film and literary studies. Do you have a view of potential future paths for early and silent film studies? Looking retrospectively, what crucial changes in method, object or theory have, in your estimation, been most important in those studies? Looking forward, what questions might be asked in developing scholarship or pedagogy?

When I began the research that eventually led to my book on *Silent Film Sound*, I thought I was collecting material for the opening chapter of a general history of film sound. Since virtually everything I had read about silent film sound was of a piece, in full agreement about the kinds of accompaniment that characterized cinema during its first three decades, I expected rapid preparation of my opening chapter, on silent film sound. But as

I turned away from secondary sources to look more closely at primary evidence, I was shocked to find out that accepted notions about silent film sound were not systematically backed up by easily available newspaper and magazine articles, film catalogs, contemporarily published books, and archival collections of film programs, broadsides, sheet music, and many other categories of material. In short, I received my comeuppance because I had expected to base fundamental claims on secondary sources. I hope that my experience will serve as a warning for others who might be tempted to take received knowledge for granted. Just as my student Michael Slowik has radically revised our understanding of early sound scores—because he insisted on looking closely at a domain that others had neglected—I expect that future scholars will turn over many a stone previously unturned, and we will learn that all too much of our knowledge is nothing other than a mirage produced by the faulty research of earlier scholars.[4]

It would be easy and comforting to say that the internet will contribute substantially to this progress. Actually, I believe that the opposite may be true. Yes, some of our research on early cinema has been made easier. Students who might never have trundled off to the library to consult the microfilm might very well take advantage of online versions of such periodicals as *Moving Picture World*. So, to be sure, the internet can simplify the teaching process and make it more rewarding. But ask yourself this: What materials get digitized and posted on the internet? By and large, in order to be worthy of internet posting, materials must be known, available, and of potential interest to a large group of users. But for in-depth research, something quite different is necessary. Instead of appealing to the broadest possible audience, serious research requires us to unearth and exploit hidden resources, precisely the materials that are NOT posted on the internet. As more and more researchers come to the same conclusion regarding the object of their research, I expect many breakthroughs based on consultation of newly discovered resources.

So, in what areas can we expect new discoveries? Some of the breakthroughs to come, I would predict, lie in neglected and thus under-researched areas—band music, film music libraries, evolving sound technology, rural exhibition, and many others. Often, new knowledge will be generated by archivists rather than academic historians. (Indeed, it is worth noting that the last two decades have witnessed increased communication between these two groups, a connection that is bound to grow in the decades to come.) Other developments that we are destined to witness, I am convinced, relate to increasing expansion of the borders of film studies. Once upon a time, cinema study was restricted to cinema. Now, more and more, film scholars understand the importance of broadening our research to neighboring media: photography, theater, vaudeville, the concert hall, music-related technology, and much more.

notes

1. Rick Altman, "Film Sound: All of It," *IRIS* No. 27 (1999): 31–48.
2. Philip Carli, "Musicology and the Presentation of Silent Film," *Film History* Vol. 7, No. 3 (Autumn 1995): 299.
3. Rick Altman, *Silent Film Sound* (New York: Columbia University Press, 2004), 22.
4. *After the Silents: Hollywood Film Music in the Early Sound Era, 1926–1934* (Durham, NC: Duke University Press, 2014).

intertext as archive: méliès, *hugo*, and new silent cinema

eight

c o n s t a n c e b a l i d e s

> With Méliès's films, especially the hand-colored ones, it's like illuminated manuscripts come alive.
>
> (Martin Scorsese)

> Time has not been kind to old films.
>
> (René Tabard)

> Let us not begin at the beginning, nor even at the archive.
>
> (Jacques Derrida)

To begin, three statements about the archive. In an interview in *The New York Times*, Martin Scorsese compares the intertextual presence of the early films of Georges Méliès in *Hugo* (Martin Scorsese, 2011) to "illuminated manuscripts come alive."[1] By invoking an analogy between medieval documents with densely colored, hand-painted images and silent film intertexts, Scorsese suggests a venerable—if anachronistic—provenance for his digital 3D film. This oblique characterization of *Hugo* as an archive is supported

by the inclusion of shots from a restored tinted version of *A Trip to the Moon* (Méliès, 1902, 2011) in the film. Held in the Filmoteca de Catalunya in Barcelona, the 1902 nitrate print used in the restoration is the only known tinted version of the original film by Méliès and was so badly deteriorated it was presumed lost. This tinted version was used by Lobster Films as the basis for a lengthy and laborious frame-by-frame digital reconstruction. For spectators who know this story, the presence of colored shots from the digital print of *A Trip to the Moon* in *Hugo* constitutes something of an archival moment.[2] More broadly, for a popular audience the numerous clips from various silent films in *Hugo* make silent cinema visible as so many historical documents.

René Tabard, the fictional historian and curator of a collection of Méliès's artifacts, comments on the problem of loss associated with the silent film archive to Hugo and Isabelle, the film's young characters: "Time has not been kind to old films." Tabard meets the pair when they are consulting his book, *The Invention of Dreams: The Story of the First Movies*, which is held in the vast Film Academy Library; he shows them the Méliès collection in his office *cum* museum; and he emphasizes the tragedy for film history of the loss of Méliès's films. Tabard's statement on the ravages of time on old nitrate film resonates with the actual loss of the Méliès oeuvre, which consisted of approximately 520 films of which 214 (including fragments) have survived.[3] An authoritative report by the Library of Congress (2013) estimates that seventy percent of American silent films from 1912–1929 are completely lost.[4]

Finally, Jacques Derrida complicates the desire to return to original documents or memory as a straightforward project of recalling or retrieving past events. Like Tabard, Derrida is concerned with the problem of time in relation to archival documents. However, Derrida links the historical problem of the archive to a psychoanalytic understanding of the past. He foregrounds the compulsion to repeat inherent in any project of returning to a beginning and characterizes archivization as a conserving of the past that is also the projection of a future, one that necessarily changes the archived document. In keeping with this approach, Derrida enacts a recursive sense of time when he begins his book, *Archive Fever*, with a cryptic statement of intention, namely, "Let us not begin at the beginning nor even at the archive" and then goes on to effect a reversal, "But rather [let us begin] at the word, 'archive.'"[5]

A contemporary cinephile filmmaker who is optimistic about *Hugo*'s potential as a "living" archive of silent cinema history. A fictional film historian who comments on the difficulties for film historiography of lost origins and the incomplete film archive. And a deconstructionist who begins a discussion of the archive with a return to the beginning, even though he repudiates the possibility of doing so. In this chapter, I analyze *Hugo* in relation to the conceptual space of the archive, historiography,

and temporality suggested by Scorsese, Tabard, and Derrida. This conceptual space points to the dilemma of historiography as both a desire to restore origins in the return to the archive and the impossibility of that desire given lost documents, the inevitable translation of documents in the process of archiving, the migration of texts across different mediums (nitrate and digital film) and time periods (early and contemporary cinema), and the overdetermined nature of memory itself. This dilemma informs the question this chapter asks, namely, how does *Hugo* write film history?

At its most straightforward, the film is about remembering silent cinema. It is the story of a fictional orphaned boy, Hugo Cabret, who meets the now forgotten filmmaker, Georges Méliès, during the late 1920s in the Montparnasse Railway Station in Paris where Méliès is the proprietor of a candy and toy booth. Hugo along with Méliès's goddaughter, Isabelle, his wife, Mme "Mama" Jeanne Méliès, and Tabard conspire to help the former filmmaker remember his past in a positive light. Through their efforts, a commemorative screening of Méliès's films at the Salle Pleyel secures the filmmaker's place in film history. Key factual elements such as the toy booth and the Salle Pleyel screening invite a reading of the film as an historical reenactment of actual events.[6] Myriad silent film clips encourage film spectators to incorporate unknown or forgotten early films into their memory of cinema.

At the same time, the film complicates history as a straightforward project of restoring origins or retrieving archival documents. As I will argue, *Hugo* enacts a complex historiographical project as an allusionist text, as a performative history lesson, and as a particular kind of archive of silent cinema. Allusion in this context is a textual strategy that refers to silent film history through the incorporation of film clips and other quoted references. As a performative lesson, *Hugo* engages the experiential present of film spectating. And as a collection of silent film intertexts, *Hugo* invokes the archive as a database, that is, an unstructured grouping of documents on a specific topic subject to various future uses.[7]

More generally, the investment in silent film intertexts as archival documents places *Hugo* within a cycle of mainstream and experimental contemporary films that thematize and comment on the archive as a system of organizing knowledge, a cycle I call "archive films."[8] A dominant stylistic feature of archive films is the incorporation of archival material—such as intermedial references, broadcast television, and, in the case of *Hugo*, cinema artifacts, "old films," and historical photographs—in ways that foreground a complicated temporality and an inherent translation in the use of archival material. Stated otherwise, silent films are present in *Hugo* in a way that enacts a strategy of then and now. In keeping with other chapters in this volume, *Hugo* as an archive film addresses the curious temporal oxymoron of "new silent cinema."

film history as allusionist practice

Hugo and Isabelle are characters who learn about silent film history, a narrative conceit that extends to the film's address to contemporary spectators. This project is formally expressed in a dominant textual strategy of making allusions to silent cinema. Allusionist intertexts include actual footage from a number of films by Méliès including *The Melomaniac* (1903), *Kingdom of Fairies* (1903), *Impossible Journey* (1904), *Spider and the Butterfly* (1909), *The Conquest of the Pole* (1912), and the legendary *A Trip to the Moon*. Other clips include canonical Lumière brothers films such as *Workers Leaving the Factory* (1895) and *Arrival of a Train in Ciotat Station* (1897); Thomas Edison's actuality films; American feature films including Charlie Chaplin's *The Kid* (1921), *The Four Horsemen of the Apocalypse* (Ingram, 1921), and Buster Keaton's *The General* (1926); and the German Expressionist film, *The Cabinet of Dr. Caligari* (Wiene, 1920). References extend to photographs of silent stars and frame enlargements in Tabard's (fictional) book including two metonyms for the origins of cinema, namely, the train moving into the foreground of the shot in *Arrival of a Train* and the "shell" or rocket ship hitting the face of the moon in *A Trip to the Moon*.[9] French film posters for *Le Gaucho* (Jones, 1927) with Douglas Fairbanks; *Pour quoi les hommes travaillent* (*Why Men Work*) (McCarey, 1924) with Charley Chase; and *Judex* (Feuillade, 1916) along with Keaton's *The Cameraman* (1928) are placed throughout the setting of a cinema theater running a silent film festival; a historical poster for *Fantômas* (Feuillade, 1913) is pasted on the side of a building; and another for the Lumières' *cinématographe* is positioned near the projector showing *Arrival of a Train* in a fairground side show. When Hugo and Isabelle go to the silent festival they watch the classic scene in *Safety Last* (Newmeyer and Taylor, 1923) in which Harold Lloyd hangs from a clock on the side of a skyscraper. This scene is later recreated when Hugo hides from the station inspector by hanging from the arm of a large outdoor clock on the side of Montparnasse Station.

These references illustrate a strategy identified by Noël Carroll in his canonical essay from 1982 on the development of allusion to film history as a "major expressive device" in New Hollywood cinema of the 1970s and early 1980s. Carroll conceives allusion as "an umbrella term covering a mixed lot of practices," and his list of examples is a *de facto* playbook for *Hugo*. It includes:

> quotations, the memorialization of past genres, the reworking of past genres, *homages*, the recreation of "classic" scenes, shots, plot motifs, lines of dialogue, themes, gestures, and so forth from film history [. . .] [as well as] the outright imitation of film-historical references; the insertion of classic clips

into new films; the mention of illustrious and coyly nonil-
lustrious films and filmmakers in the dialogue; the arch play
of titles on marquees, [. . .] posters, and bookshelves in the
background of shots.[10]

Carroll links these practices to a new group of directors in the 1960s and
1970s, cinephiles who valorized film as art following auteurist debates
of the 1950s. He notes, "the boom of allusionism is a legacy of American
auteurism," and aptly characterizes Scorsese of the period as "an addicted
allusionist" whose film, *New York, New York* (1977) is "a whirligig of allusions
that requires a viewer with the knowledge of a film historian."[11] As sug-
gested by my description of *Hugo*, its sheer quantity of film historical refer-
ences constitutes an intensification of the 1970s allusionist style described
by Carroll. In places, this intensification tips into a *mise-en-abyme* of auteurist
self-referentiality. For example, Scorsese reprises his cameo role as a period
photographer in the *Age of Innocence* (1993) in *Hugo* as the photographer
who documents the opening of Méliès's new film studio; and he reiter-
ates an elaborate signature tracking shot in *Goodfellas* (1990) in the opening
sequence in the train station.

Hugo also complicates 1970s allusionism described by Carroll, in part,
by foregrounding the fact that film history comes from books and other
historical documents. That is, allusionism in *Hugo* is not only an histori-
cal strategy; it is a historiographical strategy that foregrounds the writing
of film history. This sense of history as writing is literalized in the motif
of the automaton.[12] Once Hugo repairs the broken automaton, it makes
a drawing of the rocket ship embedded in the face of the moon from *A
Trip to the Moon* and signs the name, Georges Méliès. On the one hand, the
automaton invokes historical memory as a curative return to origins both
for Méliès, who once owned it, and for Hugo, whose father found it aban-
doned in a museum. On the other hand, the automaton is a machine that
engages the past through writing. The drawing also becomes a clue that
leads Hugo and Isabelle to the archive, the Film Academy Library, where
they discover Tabard's *The Invention of Dreams*.

Once there, Hugo and Isabelle experience silent film history as a mon-
tage of film clips that seemingly emerge from the book. The sequence pro-
gresses by intercutting between Isabelle and Hugo—who are turning the
pages of the book—and brief clips from an eclectic range of silent films.

The opening montage, for example, begins with *Workers Leaving the Fac-
tory*, followed by other actualities, namely, a London street scene from 1903;
Dickson Experimental Sound Film (Edison, 1895) and *Corbett and Courtney before the
Kinetograph* (Edison, 1894); the staged *The May Irwin Kiss* (Edison, 1896); and a
shot form the chase film, *The Great Train Robbery* (Porter, 1903). The sequence
continues with clips from a number of American silent features includ-
ing *Intolerance* (Griffith, 1916); *Tumbleweeds* (Baggot, 1925) with William S.

Hart; and *The Thief of Baghdad* (Walsh, 1924) with Douglas Fairbanks. It also includes a clip from the German film, *Pandora's Box* (Pabst, 1929). The entire sequence ends with the still of the rocket hitting the face of the moon. In this scene, the archive delivers the secret that opens up the past of silent cinema in the form of a book.

Historical photographs of Méliès are also sources for allusion in the film. One period photograph shows an older Méliès in the booth at Montparnasse. He is seated below a large sign, "Confiserie and Jouets," surrounded by a counter full of dolls, sweets, and wooden toys; rackets, drums, and fishing tackle baskets hang below the counter and rubber balls and hoops dangle from above. The same shot in the film is an almost direct match in composition and mise-en-scène with Méliès framed by the booth and positioned in the cluttered setting surrounded by merchandise (figure 8.1). This resemblance gives the shot historical authenticity; it also makes the point that historical accounts are constructions of events drawn from historical documents. A second historical photograph is of Méliès painting flats with co-workers in the Star Film studio in Montreuil. This photograph of the real Méliès is a framed artifact in Tabard's collection; it is later recreated as diegetic action in Méliès's flashback to his filmmaking days. By first appearing as an archival document in the film and then as a recreated action, this photograph makes the stronger point that archivization involves a translation of original documents. In both cases, the shots carry narrative implications not present in the photographs; namely, Méliès appears isolated and trapped in the first shot (figure 8.1) and exuberantly setting about his task in the Montreuil studio in the second shot, whereas in the original photographs Méliès respectively adopts an informal but posed portraiture and straightforwardly documents his working practices. These allusionist references to photographs thereby invoke Derrida's sense of the archive as a place that not only "conserv[es] an archivable content *of the past*" but also structures archival material "in its relationship to the future."[13] The presence of the photographs in archive collections in the Museum of Modern Art and La Cinémathèque Française already implicates them in a logic of preservation for future uses, which is literalized by photographs in various history books and in their "re-archivization" as shots in *Hugo*.[14]

The film also re-enacts Méliès's filmmaking practices as "outright imitation[s] of film-historical references," including his artisanal mode of production and techniques such as tinting, stop motion substitution, and the substitution splice. In his flashback to the Montreuil studio, Méliès's voiceover comments, "I wrote, designed, directed, and acted in hundreds of movies." While he reminisces, the image track shows the filmmaker drawing an image of a woman as a butterfly, painting a flat, giving instructions on the set to the actors, and playing the role of a devil in a green cape who performs a vanishing trick through a trap door. This

Figure 8.1 Méliès in his booth as authenticating allusion. *Hugo* (Scorsese, 2011).

characterization dovetails with Méliès's description of his working prac-
tices in a 1906 essay, namely, "the author must know how to work out
everything by himself on paper, and consequently he must be the author
[scriptwriter], director, designer, and often an actor if he wants to obtain
a unified whole."[15] Lines of dialogue refer to the practice of tinting. For
example, Mme. Méliès explains to Hugo, "But of course we tinted the
film. We painted it by hand, frame by frame." *Hugo* also stages the process
of stop-motion substitution or as Méliès called it in 1906, "the substitu-
tion trick called the stop-motion trick."[16] This trick gave the effect of the
sudden disappearance or transformation of a character or prop by stop-
ping the camera, rearranging an aspect of the profilmic scene, and then
restarting the camera; Méliès's discovery of it is a well-known anecdote.[17]
In the Montreuil flashback, Méliès directs the profilmic event to achieve
this trick. He verbally instructs actors playing the role of knights to stop
wielding swords against acrobatic skeletons ("Knights, 3, 2, 1, freeze");
tells the skeletons to leave the profilmic space ("Skeletons, that's great;
you can go") and calls for explosives to be placed on the set ("Pyrotech-
nics in please") and triggered to explode ("Action"). When filming recom-
mences, the skeletons will have disappeared.

Carroll argues that 1970s allusionism involved a reciprocal relationship
between the new breed of auteurist directors and a new film literate specta-
tor, namely, "works were greeted by an expanding cinema-learned coterie,
constantly reinforced by the influx of film-school critics and college-bred
film-appreciation and film-society audiences."[18] This address is part of "a
two-tiered system of communication" according to which the films are
comprehensible both as "an action/drama/fantasy-packed message" to
uninitiated spectators and on a "hermetic, camouflaged and recondite"

level for those who are knowledgeable about film history.[19] Allusion in *Hugo* works in a similar way. While the narrative is comprehensible without a knowledge of silent film history, myriad film historical references provide the occasion to play the "game of allusion." But this game in *Hugo* is a complicated one. Beyond its cinephile/auteurist implication and the pleasure of recognizing allusionist references, *Hugo* asks film literate spectators to be informal film historians, an address that includes children as film historians *in potentia*.

This address is illustrated in a notable recreation of the substitution splice coupled with stop motion. The film cuts from Méliès directing the profilmic scene described above to working on the negative film strip in close-up shots of film frames. Méliès cuts the negative film strip in two places, namely, when the skeletons hold up their hands and when the explosion occurs, and he conjoins the pieces together with tape, which is shown in a close-up shot of the spliced film (figure 8.2). This shot illustrates Tom Gunning's observation that the substitution splice "alter[ed] filmic reality through the act of cutting and splicing" associated with editing.[20] By showing this technique in the film, Scorsese enters into an implicit conversation with film historians like Gunning, John Frazer, and Jacques Malthête, who analyzed physical prints of Méliès's films. As Gunning argues, this technique was a way of enhancing the continuity of the action across the trick of stop motion as distinct from editing aimed at achieving classical continuity. Its use reverses an earlier view of Méliès as a theatrical illusionist who only filmed his stage magic tricks.[21] The shot of the frame as a "recondite" detail in figure 8.2 serves as evidence for the revisionist historiographical argument that Méliès's used a complicated set of techniques and had a sophisticated understanding of film as a medium.

Figure 8.2 Spliced filmstrip as revisionist historiography. *Hugo* (Scorsese, 2011).

The film also makes a finely tuned historical reference to tinting, or the application of color to developed film. In contrast to the earlier profilmic scene in which the knights wear brightly colored costumes, Méliès looks at frames of the skeletons and the knights in a close-up of a positive monochrome film strip and then imagines those frames as projected action in black and white. The contrast between the colored costumes and imagined film reinforced by the monochrome film strip makes the point that color was applied later.[22]

This address to film spectators as historians is linked to a recursive strategy in the film involving a return to originary moments in film history. Versions of the rocket hitting the face of the moon appear as the drawing by the automaton, the still in Tabard's book, another drawing by Méliès, and in the moving picture itself at the Salle Pleyel screening. A twice-repeated scene of the historical audience watching *Arrival of a Train* further nuances this strategy. The commonplace story about this film is that the movement and large scale of the projected image of the train moving toward the foreground of the shot caused early spectators to leap from their seats in fear as if mistaking the representation for reality. Martin Loiperdinger and Bernd Elzer analyze the historical reception of *Arrival of a Train* and argue that this "founding myth of the medium" was actually exploited for the sake of publicity, which suggests a knowing rather than naïve audience.[23] More broadly, Gunning's characterization of an "aesthetics of astonishment" associated with the cinema of attractions emphasizes an "awareness" and "delight" in "film's illusionist capabilities" on the part of early audiences who were already predisposed to respond in a sophisticated way given their experiences with fairgrounds, amusement parks, and other nineteenth-century illusionist entertainments.[24]

The first version of this incident takes place in the library. While Isabelle is reading from Tabard's book, the image track cuts from the page, which contains text and a still of the train pulling into the station from *Arrival of a Train*, to the moving film where the shot of the train takes up the entire frame. As the train moves to the foreground, the camera pulls back to show the historical audience's reaction of gasping and ducking for cover. This action confirms the book's commentary, which repeats the founding myth, namely, "When the train came speeding toward the screen, the audience screamed because they thought they were in danger of being run over." The children exchange quizzical glances. The second version of the incident occurs in Méliès's flashback when Jeanne and Georges enter the side show *cinématographe* screening of the same film. In this version, the entire exhibition space is shown in long shot including the screen and projected film, the historical audience seated in rows, and Georges, Jeanne, and the projectionist looking on. The audience's reaction is held for a longer time enabling the contemporary spectator to see individuals first gasping with fright or surprise and then laughing at having been caught out by the film.

In the first version, the historical audience is naïve and fearful; in the second version, astonished and aware. Through this contrast, the film enacts a revisionist analysis of the early cinema audience, a strategy reinforced by framing. In the first version, the contemporary spectator is positioned as a historical participant who experiences the full frame of the film just like the historical audience; in the second version, the spectator is more like a witness to the entire scene who observes the developing response of the historical audience as it unfolds. This contrast also makes a point about the logic of revisionist historiography as re-seeing historical events in order to develop new interpretations. In the second version in the fairground side show, the spectator is positioned as a historian whose interpretation of the meaning of the event has changed.

Allusionism as a formal strategy in *Hugo* addresses a cross-generational and differentiated film-literate audience. As a PG-rated film adapted from Brian Selznick's children's novel, *The Invention of Hugo Cabret*, *Hugo* draws on an already established child audience. The visual design of the film is heavily influenced by the illustrations in *Hugo Cabret*, which adds another level of expert knowledge for children, and the history lesson quality of the film is supported by secondary material for children including Selznick's *The Hugo Movie Companion*. In the case of adults, the film addresses various constituencies of film-literate spectators, namely, general interest spectators who could easily discover many of the silent films or the historical photographs of Méliès in Google searches; adults as amateur film historians already familiar with those references and invested in taking their knowledge further; and film scholars, who recognize the most "hermetic" and "recondite" historical details.

As I will go on to discuss in the last section of this chapter, allusionism in *Hugo* and in 1970s New Hollywood occur in different historical periods and distinct social formations. The context of debate in film theory in these two periods is also different. In 1982, Carroll criticized certain allusionist films that were too indebted to contemporary film theory in keeping with a critique of 1970s theory associated with a neo-formalist strand in his analysis. He argued then that an over-reliance on theory made those films too didactic compared with many New Hollywood films, which integrated allusionism in an expressive manner as part of their overall design. My own interest in allusionism in *Hugo* is related to the current re-evaluation of indexicality in film theory. These recent debates are concerned with analyzing the specificity of historical films in their relationship to the past, complicating the relationship between photographic cinema and digital cinema, nuancing the indexical sign itself, and moving beyond reflectionism or ideology as ways of assessing the relationship between film representation and reality.[25] Theorists analyzing these issues draw on Charles Sanders Peirce, who characterizes indexicality in terms of the "physical connect[ion]" between the sign and its referent including "anything which focuses the attention."[26]

Peirce also distinguishes between the indexical sign and the iconic sign, which is based on resemblance or "likeness" between the sign and its referent; and the symbolic sign, which is based on "usage" or convention.[27]

Paul Willemen, for example, rethinks indexicality to complicate an understanding of how films encounter the real. He expands a sense of the referent of indexical signs to include broad aspects of the social formation and he complicates how signs function in practice. In this project, Willemen emphasizes two key features of signs discussed by Peirce; namely, they are multivalent, that is, actual signs often combine sign-types of index, icon, and symbol; and they are multi-temporal, that is, all signs variously engage relations between past, present, and future. This emphasis on the complex functioning of signs supports a useful distinction by Willemen between a film's "construction of reality" and its "construal of reality," a distinction that is in line with the shift in theoretical agendas in film studies. While the "construction of reality" is associated with a 1970s focus on ideology as a distorting filtering mechanism and the critical project of exposing that construction, the "construal of reality" invokes the contingent and nuanced processes through which cinema negotiates the real in keeping with a critical reconsideration of indexicality. As Willemen states, "A construction of reality implies the building of a rigid model whereas a construal of reality changes and is adjusted in the process of its encounter with the real."[28] While it might appear that the more nuanced "construal of reality" only applies to particular filmmaking traditions such as Italian neo-realism, which engages the real in a less formulaic manner than classical Hollywood cinema, Willemen argues that Hollywood cinema, too, involves the "construal of reality" through a complex functioning of signs. In making this point, he argues against restrictive views of Hollywood cinema as simply character-based narration involving a trajectory of characters' actions and reactions. Indeed, the multi-temporal aspect of signs leads Willemen to foreground the fact that all signs "leave traces, all connecting bits of optical-aural images to various history-streams."[29] Thus, films, even conventional narrative films, can be palimpsests of various periods of time that negotiate different historical realities. His provocative analysis suggests a way of understanding the connection between allusionism and indexicality in *Hugo*.

Clearly, *Hugo* is a narrative film in the classical sense of a tight causal chain of events based on characters' actions and reactions. At the same time, a number of Hugo's allusionist references involve complex signs that engage "the process of [their] encounter with the real." The shot of the Saint-Geneviève Library in Paris used for the Film Academy Library, for example, symbolically invokes the archive as a labyrinth, a key narrative implication, but as a location shot, it also indexically refers to a real place that houses books. In doing so, the shot also authorizes the archive as a real place for historical inquiry. The colored shots of *A Trip to Moon* are iconic

in their resemblance to the tinted nitrate film, symbolic given their status as digital images, and indexical as the (only) trace of the former existence of the historical tinted print of the film. The shots based on the photographs of Méliès (for example, figure 8.1) are iconic in their resemblance to the originals but their iconicity also serves as an indexical reference to the once-present Méliès who posed for the original photographs. Citing Laleen Jayamanne, Willemen foregrounds an important aspect of indexicality, namely, that "little bits of time arising to the surface are not just bits of empty time, but bits of historical time."[30] These "bits of empty time" are associated with films that do not have a strong narrative drive, for example, Italian neo-realist films, as noted earlier, or certain avant-garde films. However, they also exist in gestures to earlier historical moments and the present time in Hollywood films that would otherwise appear to eschew indexicality, for example, action effects driven blockbusters. To be sure, the tight narrative structure of *Hugo* mitigates against "empty" moments; however, the inclusion of so many film clips in the montage sequence in the library or later at the Salle Pleyel extend beyond their narrative purpose and function like "bits of historical time." Philip Rosen's work on a variant of indexical signs that signify the pastness of the referent, which he calls "indexical traces," is useful here. These myriad clips from silent cinema in *Hugo* are "indexical traces" which have a "referential credibility" by calling up "a different when from that of the spectator."[31] When the clips appear in these sequences as fragments of the past and "bits of historical time," moreover, they engage the past in a way that conceives of historical memory as non-linear and disjointed.

performing film history

Hugo's allusionist intertexts have a complex relationship to the past but they also engage the spectator in a complicated relationship to the present time of film spectating. In the library scene, the children's history lesson is a history lesson directed at the spectator. *Hugo*'s use of 3D digital effects, which are associated with the 1950s, not only alludes to film history, but also performs it. As a result, the film enacts a complex layering of temporality in which it references two past times of cinema—the silent era and the 1950s—while it engages the spectator in the ongoing present of the film experience.

Following the opening shots from *Arrival of a Train* in the library described in the last section, a contemplative Hugo looks up at the ceiling at a painted mural of a mythological figure, Hyperion, whose pointing finger transforms the light of the sun into a beam of light of a film projector. As Hugo's glance follows this beam of light, the camera pans to the right to focus on a transparent curtain with the projected *Workers Leaving the Factory* (1895) visible behind it. The curtains then part to reveal the film

(figure 8.3). While this shot is associated with Hugo's interiority as if he is imagining the moving pictures described in the book, a frontal camera position on the Lumière film and the parting curtains direct the spectator's attention to the historical stage of early cinema. This address to the spectator is reinforced by a didactic quality in the sound track. During the first montage of clips that begins with *Workers Leaving the Factory* and ends with *The Great Train Robbery*, Hugo's voiceover describes the transformation of early films from a "side show novelty" to "something more when the first filmmakers discovered they could use the new medium to tell stories." The sound track emphasizes the lesson of the visual track as an illustration of the transition from actualities to the chase film.

While the montage of film clips visualizes the book as moving images, it also foregrounds the transformation from still to projected moving images, a key intervention of cinema in an era that included photography, projected lantern slides, and optical toys. A frame enlargement in Tabard's book of Buster Keaton sitting on the wheels of his train holding his hat in *The General* cuts to a matched shot of Keaton in the actual film. This shot is followed by Keaton placing his hat on his head as the train begins to move and then, still seated, Keaton moving up and down with the wheel. While these shots reinforce the joke of Keaton's comical deadpan response, they also make a point about the specificity of cinema as moving images. This point is repeated with similar shots of Louise Brooks in *Pandora's Box* and Douglas Fairbanks in *The Thief of Baghdad*. The motif of still to moving images also makes a recondite point about early exhibition practices. The Lumières' films in particular were screened using a hand-cranked projector. A screening would begin with a stilled projected image to adjust the framing before cranking commenced, a practice that enhanced the

Figure 8.3 Workers leaving the Factory as history lesson. Hugo (Scorsese, 2011).

spectacle of movement.[32] As movement, moreover, the motif makes a comment about cinema as a particular medium. For Christian Metz, a key element in cinema's strong impression of reality is movement, which is always experienced as existing in the present time. Whereas the still photograph is "the trace of a past spectacle" experienced as "the trace of a past motion," "the spectator always sees movement as being present."[33] Moreover for Metz, "the movie spectator is absorbed, not by a 'has been there,' but by a sense of 'There it is.' "[34] By performing the distinction between still and moving images, *Hugo* reinforces the meta-cinematic point that (all) movement in film is experienced in the present tense. In Peircean terms, both the parting curtains on *Workers Leaving the Factory* and the motif of enacting movement engage the present time of spectating by indexically focusing the spectator's attention in gestures that indicate "there it is."

Sound works in a similar way. Accompanying the tinted shot from the Babylon courtyard scene in *Intolerance*, a layered sound track refers to different time periods. Sounds include an offscreen mechanical noise of a hand-cranked projector, which signifies the past of the cinema; the rustling pages of the book that Isabelle and Hugo are reading, which suggests the diegetic present of the characters; and non-diegetic background music, which reinforces the present time of the spectator watching the film. A temporal layering at the service of a didactic point about film history occurs in another scene in which Tabard screens *A Trip to the Moon* in the parlor in the Méliès home. Tabard elaborately threads the film in the projector and, as he hand cranks it, the noise of the projector is audible. When Georges enters the room, he comments, "I would recognize the sound of a movie projector anywhere." The now unfamiliar sound of a projector is also a signifier of the past experience of cinema, which is reinforced by the dialogue.

3D effects in *Hugo*, in particular, perform film history in a way that acknowledges the present time of spectating and implicates the past in the present. *Hugo* was the first venture into 3D by Scorsese and various interviews and articles foreground the director's biographical, cinephile, and auteurist investment in the special effect and in Méliès's films more generally.[35] Scorsese's first experience of *A Trip to the Moon* was when Edward R. Murrow introduced it in 1956 as part of a gala screening of *Around the World in Eighty Days* in Todd-AO widescreen format; and Scorsese recounts his later exposure to Méliès's films in the Village in the 1960s in screenings organized by Jonas Mekas.[36] Adam Cook underscores a key point illustrated by these anecdotes, namely, "Scorsese sees cinema history as equally intertwined with world history and personal history. [. . .] Cinephilia [. . .] is inextricably part of his identity and how he relates to the world."[37]

While 3D contributes to Scorsese's auteurist vision, the 3D of the 1950s period is an important historical reference point for discussions of *Hugo*'s stereographic design. A key feature of 3D in the 1950s involved objects and

people who appear to emerge from the screen into the space of the audience, an effect produced by negative parallax.[38] William Paul elaborates on this aesthetic of protrusion with its spectacular gimmicks describing the style as an "aesthetic of emergence," a sensationalist aesthetic that competed with the more legitimate immersive strategies of new wide screen formats such as Cinerama and Cinemascope. More broadly, immersion is associated with illusionist classical Hollywood narration and the spectator's absorption in the diegesis. Paul stresses how 3D during the 1950s assumed illusionism as the norm in order to break with it, namely, "moving beyond the frame demands some notion that there is a frame to move beyond: emergence depends on a sense of violation for its effect."[39] By contrast, recent uses of 3D are more narratively integrated and use positive parallax, which gives the impression of depth behind the screen. Discussions of these contemporary uses stress the difference from the sensationalist variant in the 1950s. James Cameron, in particular, argues for a narratively integrated approach to 3D, which he views as a key strength of *Hugo*.[40]

Barbara Klinger, however, complicates an understanding of how *Hugo* uses both positive and negative parallax effects. Negative parallax effects, in particular, "work across a spectrum of possibilities," all of which have different narrative implications.[41] While *Hugo* does use overt protruding effects associated with negative parallax of the 1950s, Klinger notes, they are limited to shots involving comic relief, for example, with the station inspector and his dog. Other instances of negative parallax are projective effects in which "the prop, an often overlooked aspect of narrative, emerges from the mise-en-scène to come literally to the fore"; floating elements such as snow falling which tend toward a "lyricism and awe" rather than a shock effect; and "covert negative parallax," which enhances screen depth by "plac[ing] a character or an aspect of mise-en-scène just in front of the screen plane (or zero point of parallax)."[42] Klinger's analysis of covert negative parallax effect, which enhances depth but does not break the illusion, is similar to Scott Higgins's characterization of Scorsese's stereoscopic visual style as an "amplified dimensionality." As Higgins notes, "Scorsese demanded strong dimensionality from his stereographer, but his film handles out-of-screen effects with restraint. Rather, *Hugo* offers exaggerated volume, roundness, and depth within the screen."[43]

Both Klinger and Higgins argue for a 3D design in *Hugo* that charts a path between emergence and immersion. Rooted in classical Hollywood cinema, *Hugo*, as Klinger notes, is "both tethered to classical tradition and invests in a heightened visibility and often kinetic frontality [which] makes a spectacle out of norms, while embracing them."[44] As such, she suggests, it illustrates David Bordwell's characterization of an "intensified" classical style in contemporary films. For his part, Scorsese describes 3D in the film

149

as adding an "extra element," "something special," and "an enhancement" to the story. As he elaborates, "Every shot was special and every one we pushed as far as we could to fit into the nature of what we were trying to do within the story."[45]

Klinger's enhanced depth and "kinetic frontality," Higgins's "amplified dimensionality," and Scorsese's "extra element" are suggestive for thinking about Hugo as a performative text. 3D effects amplify the presence of reconstructed historical scenes thereby enhancing the status of the film as a "living archive" of the past. In Méliès's flashback, for example, the camera fluidly weaves through the Star Film Studio where Jeanne is dressed in a striped leotard with gauze wings resembling a butterfly. The choreography of characters as they move about the space coupled with the camera movement heightens the visibility of characters and props and situates characters within an amplified depth that enhances the feeling that you are there in the historical scene. A similar effect of depth is achieved during Tabard's flashback to the Star Film studio, which he visited as a boy. The flashback shows Méliès filming the underwater Court of Neptune in *Kingdom of Fairies*. Multiple painted flats are positioned on different planes in the profilmic space along with lobsters and fish, which are in sharp focus in the extreme foreground of the shot. The film deftly refers to Méliès's filmmaking practices when the camera tracks back to show a stage hand placing lobsters in a fish tank in the foreground. John Frazer describes the effect in *Kingdom*, noting that, "the scene was shot through an aquarium with live fish behind which painted flats are successively lowered to simulate the forward movement of travelers over the ocean floor."[46] While the historical film uses these strategies to simulate depth along with the movement of living fish, the reconstructed scene heightens this effect by using a "kinetic frontality" and "amplified dimensionality," thereby giving the spectator a stronger experience of depth. That is, the film hyperbolizes the original effect.

Higgins explains a complex example of 3D in the final appearance of the rocket in the face of the moon during the screening at the Salle Pleyel. As he notes, the "moon floats out of the screen-plane, well into the negative parallax but it is ostensibly on a screen located at the far end of a deep shot over the heads of the fictional audience."[47] The shot hovers between the space of the historical spectator in the theater watching the film and the diegetic space of the represented film being screened. The use of 3D also has the effect of a direct address to the contemporary spectator linking the actual theatrical space and the diegetic space. As Higgins elaborates, "the moon appears in a space outside of the diegesis, directly addressing the viewer while it is resolutely anchored to and placed within the film's world."[48] Higgins's analysis supports my argument about a performative historiography in *Hugo*. The film retains a sense of the historical past by finally delivering the shot "as seen" by historical spectators. It also



restages the historical effect as a contemporary 3D effect thereby acknowledging the present time of its own spectators in the theatre. Like the fish tank in *Kingdom*, the spectator simultaneously experiences the shot as an historical and a contemporary special effect.

This performative historiography also engages another aspect of indexicality. Mary Ann Doane moves beyond the more commonplace discussion of the index as a physical trace of a referent to include signs like shifters in language, which Peirce discusses in some detail.[49] Shifters are context dependent and they are linked to the present time. Referring to Roland Barthes, she comments on the temporal difference in two aspects of the indexical sign, namely, the sign as physical trace aligned with "historicity, the 'that has been' of Barthes' photographic image" and the sign as "deixis, the pointing finger, the 'this' of language [. . .] ineluctably linked to presence" for example, "the here and now of speech."[50] In Doane's terms, the 3D effects described above as well as the shot of the curtains parting are deictic (figure 8.3). Nanna Verhoeff picks up on this aspect of the index in Doane's analysis to emphasize the importance of context for the indexical sign, which is linked to immediacy and presentness. An installation piece entitled *Zoomscape* (2010, Eye Film Institute), which was situated on a railway platform in Amsterdam Central Station, illustrates the point. The installation incorporated archival films including *Arrival of a Train*, which it showed *in situ* in the station. As Verhoeff notes, "deixis frames the statement in temporal ('now') and spatial ('here') terms." This exhibition strategy resulted in a "layered temporality" associated with an "archival performance that brings about a particular *liveness* to early films as archival objects."[51] While *Hugo* is not equivalent to this self-reflexive installation, its performative use of 3D as enhanced volume acknowledges the present situation of film spectating (the spectator is here now) as much as it references the past through archival intertexts. In its use of 3D, moreover, the film amplifies volume in its diegetic space giving its historical scenography an added quality of "liveness."

This understanding of indexicality as deictic has epistemological implications for historiography more generally. Raphael Samuel argues that informal modes of history writing, for example, historical re-enactments in which participants dress up in period costumes, have something important to say about history more generally. He notes, "we are in fact constantly reinterpreting the past in light of the present, and indeed, like conservationists and restorationists in other spheres, reinventing it." These practices challenge proper histories, whose aim is to let the evidence speak for itself, and historians who view themselves "not [as] masters, but as servants of the evidence."[52] Like popular practices of history, *Hugo* and its historical intertexts are in a conversation with the spectator in the present. The film makes a larger point that the past is imbricated in the present through a continual reinterpretation and reinvention of the past.

the archive as database

Hugo also gestures to the present time of its social formation, especially changes in how information is accessed and organized and how knowledge figures in the contemporary archive as a database. This new archival paradigm associated with the digital age is also implicated in changes in contemporary film reception associated with DVDs and their supplementary materials as well as assorted online resources (for example, film websites, blogs, forums, and digital collections). Information about *Hugo*, for example, exists on countless databases that can be accessed and used in myriad ways. The greater accessibility of this material blurs formerly circumscribed boundaries of knowledge, between publicly authorized archives such as the Library of Congress and informal archives such as earlycinema.com or thebioscope.net. These blurred boundaries also exist between scholarly peer-reviewed journals, popular articles, and informal commentary; as well as between formal interviews in newspapers and film magazines and informal conversations on blogs. Individual websites themselves exhibit this elision. A non-peer-reviewed article on Méliès in Wikipedia contains extensive hyperlinked endnote references and bibliographic sources for future scholarly and amateur work. An IMDb posting on *Hugo* entitled "Connections" lists thirty film references in the film, which could also serve as a viewing list and collection guide for the cinephile-spectator-historian. More generally, new technological and epistemological conditions for cinephilia and the study of film open up possibilities for amateur and informal historical inquiry. While corporate marketing strategies for films are now explicitly tied to DVD supplements and websites, the internet also opens up other possibilities for refiguring cinephilia along democratic lines.

Lev Manovich describes the database as a "structured collection of data" which "appear[s] as a collection of items on which the user can perform various operations: view, navigate, and search"; and he makes a distinction between narrative as a cause and effect logic that orders items and the database as a "list of items" that "refuses" an ordering or opens up the possibility of subsequent orderings.[53] The trope of the database as archive informs a number of contemporary installations that employ a "database aesthetic."[54] *Hugo* symptomatically engages with the archive as a database; or as Willemen says, "the pressure of the real striates [the text's] substance of expression [. . .] by anchoring the text's relation to an actual moment in the history of a social formation."[55] While *Hugo* is not a literal database that viewers interactively use and it does not develop a radical database aesthetic or intervene in the narrative/database binary in the manner of experimental installations, the film invokes the archive as a database in key ways. Moreover, in Willemen's terms, the archive as a database in *Hugo* bears the trace of real historical conditions.

The montage of film intertexts in the library scene is an important example. The sequence refuses a coherent syntagmatic ordering of clips

even though the clips adhere to key paradigmatic categories (for example, tinting, genre, director, nation). The narrative logic of these intertexts as a lesson for the characters notwithstanding, film clips function like so many textual invitations to further inquiry. The montage of clips from Méliès's films at the Salle Pleyel, which ends with *A Trip to the Moon*, is another case in point. It is not ordered chronologically but functions like so many examples of the director's work. Potential future uses of the clips are reinforced by end credits in *Hugo* which list film titles and archives under headings, "footage from films by Georges Méliès," "silent films," and "recreated sets, props, and drawings from films and works by Georges Méliès." While the credits satisfy copyright requirements, they also serve as *de facto* footnotes or suggestions for further viewing. This potential use is facilitated by the availability of comprehensive DVD collections of Méliès's films based on restored prints and a DVD box set of the restored tinted version of *A Trip to the Moon* by Lobster Films. Other films that appear in *Hugo* can also be viewed on websites as diverse as the Library of Congress's American Memory site and YouTube.

The most explicit instance of the archive as a database in *Hugo* occurs when Hugo and Isabelle find a hidden wooden box full of paper remnants of Méliès's filmmaking career in a secret compartment in the large armoire in the bedroom of Georges and Jeanne. To begin, the scene invokes the trope of the archive as a labyrinth. The compartment hides a box that contains the remaining secret documents of Méliès's past as a filmmaker, and the children find the box by observing indexical clues, namely, Mme Méliès's glance at the armoire, a gap in the wooden panel, and a hollow sound when Isabelle knocks on the panel's facade. When the chair that Isabelle is standing on breaks and the contents of the box spill out, swirl around the room, and land on the bedroom floor in random piles, the changed scene suggests a different trope of the archive, that is, the archive as a database (figure 8.4). This unordered collection of items includes sketches, drawings, and water colors of shots from Méliès's films, a detailed line drawing of the rocket in the face of the moon with handwritten instructions to the side, a sepia version of the same shot, postcards with stamps and postmarks, handwritten letters, and invoices. While the drawing of the rocket in the face of the moon has a greater narrative resonance than other items, and the animation effect of a series of twirling colored images of a woman dressed in a butterfly costume is a spectacle in its own right, each piece of paper moves around the room as so many pieces of information. Each item could be the starting point of a future ordering of knowledge. The shot of the swirling documents that land on the floor suggests the different ways of approaching knowledge that is associated with online databases, namely, as trajectories of inquiry traversed in a serendipitous way.[56]

Moreover, like the 3D scenes already discussed, the swirling drawings with their "kinetic frontality" reinforce the present time of spectating.

Figure 8.4 Méliès and his paper archive as database. *Hugo* (Scorsese, 2011).

The drawing of the woman as a butterfly whose colors intensify as the drawing moves toward the zero parallax point and a fire-breathing dragon that gives the impression of movement as multiple pages unfurl are both spectacles that directly address the spectator. The drawing of the rocket in the face of the moon similarly moves to the foreground of the shot and hesitates briefly in midair to give the spectator a better view before it falls to the ground. For the spectator, the 3D spectacle of the archive as a database is coupled with the experience of the "liveness" of its archival documents.

In commenting on a fundamental paradigm shift from scarcity as a ruling logic of the traditional archive to abundance in the digital archive, Roy Rosenzweig raises the issue of the distinction between the professional and the amateur historian. During the early twentieth century, he notes, membership in the American Historical Association was more inclusive, which is to say it included archivists, local historians, and "amateurs" in addition to university scholars. He further observes that this paradigm shift toward abundance "may lead us 'back to the future'" as a result of all kinds of materials on the internet and an expanded audience for scholarly articles as a result of their presence online.[57] While the analysis of fan film cultures over the past decade has altered notions of authorship and the autonomy of the original text, the boundary between academic and amateur film history, with notable exceptions, has not received the same amount of attention.[58] The archive as a database suggests the importance of rethinking this boundary, a rethinking that an archive film like *Hugo* invites.

In this chapter I have argued that *Hugo*'s recursive, performative, deictic, and complexly indexical strategies trouble a seemingly obvious view of the film as a narrative linear project of retrieval and remembering.

The film doubles back to earlier scenes and shots, repeats historical references so that they take on new meanings, performs textual strategies that simultaneously position spectators in a present time and a past time, and symptomatically refers to new conditions of knowledge and history writing. *Hugo* invites a further reflection on history writing associated with the desire to return to the beginning even in the knowledge that this return is impossible. When memory is conceived as a linear return to a past, for example, in empiricist modes of history writing, or as a straightforward narrative retelling, it has already undergone significant revision in the psychoanalytic sense of repression and overdetermination. This is the kind of memory Derrida problematizes when he reflects on the archive. The process of archivization, moreover, inevitably changes the nature of the original content since it becomes "codetermined by the structure that archives."[59]

The document that grounds all other film intertexts in *Hugo* is the tinted version of *A Trip to the Moon*, which is first glimpsed in Méliès's parlor when the rocket lands on the moon and the scene turns from black and white to color. For film-literate spectators, this transition to color involves an archivist's frisson in the recognition of the back story of the original tinted print thought to be lost. But the story is more complicated. The damaged nitrate tinted print of the film was dismantled frame by frame in order to digitize each frame. The original was then reconstructed as a new digital film in a process of matching frames in the damaged print with two other black and white archive prints in order to fill in missing frames. While a digital coloring process respected the original tints and variations of density in the colors, it also replaced the original hand tinting and the indexical marks of brush strokes used in the process. This archive story, like *Hugo*, involves the story of lost origins, which brings us back to Derrida's injunction not to begin at the beginning or even at the archive. In the end, *Hugo*'s intertexts as archival documents point to another problem with historiography construed as a linear return. The tinted nitrate print of *A Trip to the Moon* is now "archived" in a digital film. *Hugo* highlights the challenge of history writing as a desire to return to the archive in the knowledge that this return involves a translation of the original document.

155

Acknowledgments

A version of this chapter was delivered at the annual conference of the Society for Cinema and Media Studies in Seattle, Washington in 2014. I would like to thank Katherine Groo and Paul Flaig for organizing the panel and the Carol S. Levin Fund for Faculty Research, Tulane University, for financial support to attend it. I would also like to thank Katherine and Paul for their smart editorial suggestions.

notes

1. John Bowe, "Martin Scorsese's Magical 'Hugo,'" *The New York Times* (2 November 2011): http://www.nytimes.com/2011/11/06/magazine/martin-scorseses-magical-hugo. Accessed 19 November 2012.
2. For a discussion of this restoration, see the documentary, *The Extraordinary Voyage* (Bromberg and Lange, 2011).
3. This fictional book is possibly a reference to Georges Sadoul's first volume of *Histoire Générale du Cinéma* entitled *L'Invention du Cinéma 1832–1897*. For the number of made and extant films by Méliès, see Matthew Solomon, "'Georges Méliès: First Wizard of Cinema (1896–1913)' and 'Georges Méliès Encore: New Discoveries (1896–1911)'" in *The Moving Image* Vol. 12, No. 2 (Fall 2012): 187.
4. See David Pierce, *The Survival of American Silent Feature Films: 1912–1929* (Washington, D.C.: Council on Library and Information Resources and the Library of Congress, 2013), 1.
5. Jacques Derrida, *Archive Fever: A Freudian Impression*, trans. Eric Prenowitz (Chicago: University of Chicago Press, 1996), 1.
6. As a fictional narrative film, *Hugo* takes license with its handling of certain facts. See helpful remarks by Kristin Thompson on David Bordwell's blog (7 December 2011) "Hugo: Scorsese's Birthday Present to Georges Méliès": http://www.davidbordwell.net/blog/2011/12/07/hugo-scorseses-birthday-present-to-georges-melies/. Accessed 19 November 2012.
7. See Lev Manovich, *The Language of New Media* (Cambridge, MA: The MIT Press, 2001).
8. This chapter is part of a larger book project on archive films, which includes *Sherlock Holmes* (Guy Ritchie, 2009) and *Dial H-i-s-t-o-r-y* (Johan Grimonprez, 1997).
9. The term "shell" is used in the original scene list and synopsis for the film. See Appendix, "A Fantastical . . . *Trip to the Moon*," in *Fantastic Voyages of the Cinematic Imagination: Georges Méliès's Trip to the Moon*, ed. Matthew Solomon (Albany: SUNY Press, 2011), 227–232.
10. Noël Carroll, "The Future of Allusion: Hollywood in the Seventies (and Beyond)," *October* No. 20 (Spring 1982): 52.
11. *Ibid.*, 54, 69–70.
12. The reference in the film to Méliès as the maker of the automaton comes from Brian Selznick's novel, *The Invention of Hugo Cabret* (New York: Scholastic Press, 2007).
13. Derrida, *Archive Fever*, 16–17.
14. The photographs of Méliès are housed in both of these archives. They are also reproduced in various books and websites. For example, the photograph of Méliès in the toy booth is reprinted in John Frazer, *Artificially Arranged Scenes: The Films of Georges Méliès* (Boston: G.K. Hall and Co, 1979), 55; Brian Selznick, *The Hugo Movie Companion* (New York: Scholastic Press, 2011), 86–87; and Thompson on *Hugo* on David Bordwell's blog.
15. Georges Méliès, "Cinematographic Views," in *French Film Theory and Criticism: A History/Anthology, 1907–1939*, Vol. 1, trans. Stuart Liebman, ed. Richard Abel (Princeton, New Jersey: Princeton University Press, 1988), 41.
16. *Ibid.*, 44.
17. *Ibid.* In the anecdote, Méliès recalls filming at the Place de l'Opéra when his camera jammed and by the time filming began the result looked like the Madeleine-Bastille trolley had turned into a hearse.

18. Carroll, "The Future of Allusion," 55.
19. *Ibid.*, 56.
20. Tom Gunning, "Primitive Cinema, A Frame-Up? Or the Trick's on Us," in *Early Cinema: Space, Frame, Narrative*, ed. Thomas Elsaesser with Adam Barker (London: BFI Publishing, 1990), 98.
21. Gunning makes the point that Malthête examined the positive prints of Méliès's films and declared that, "there is never any trick of substitution which does not make use of splicing." *Ibid.*
22. See Méliès, "Cinematographic Views," 41–42.
23. Martin Loiperdinger and Bernd Elzer, "Lumière's Arrival of the Train: Cinema's Founding Myth," *The Moving Image* Vol. 4, No. 1 (Spring 2004): 89–118.
24. Tom Gunning, "An Aesthetic of Astonishment," in *Viewing Positions: Ways of Seeing Film*, ed. Linda Williams (New Brunswick, NJ: Rutgers University Press, 1994), 129.
25. See especially Philip Rosen, *Change Mummified: Cinema, Historicity, Theory* (Minneapolis: University of Minnesota Press, 2001); Mary Ann Doane, "Indexicality and the Concept of Medium Specificity," *differences* Vol. 18, No. 1 (Spring 2007): 136; and Paul Willemen, "Indexicality, Fantasy, and the Digital," *Inter-Asia Cultural Studies* Vol. 14, No. 1 (2013): 110–135.
26. Charles Sanders Peirce, "What is a Sign" in *The Essential Peirce*, Vol. 2, ed. Peirce Edition Project (Bloomington: Indiana University Press, 1998), 8.
27. *Ibid.*, 5.
28. Willemen, "Indexicality, Fantasy, and the Digital," 111.
29. *Ibid.*, 113.
30. *Ibid.*, 112.
31. Rosen, *Change Mummified*, 20.
32. Loiperdinger and Elzer, "Lumière's *Arrival of the Train*," 97.
33. Christian Metz, "On the Impression of Reality in the Cinema," in *Film Language: A Semiotics of the Cinema*, trans. Michael Taylor (Chicago: University of Chicago Press, 1974), 8.
34. *Ibid.*, 6.
35. See, for example Bowe, "Martin Scorsese's Magical 'Hugo.'"
36. See Richard Brody, "Martin Scorsese on 'Hugo,'" *The New Yorker* (15 December 2011): http://www.newyorker.com/online/blogs/movies/2011/12/martin-scorsese-on-hugo.html. Accessed 19 December 2013.
37. Adam Cook, "Past/Not Past: A Tale of Two Cinemas" (25 February 2012): http://mubi.com/notebook/posts/pastno-past-a-tale-of-two-cinemas. Accessed 12 December 2013.
38. As Scott Higgins explains, negative parallax is when images appear to converge in front of the screen. See Higgins, "3D in Depth: *Coraline, Hugo*, and a Sustainable Aesthetic," *Film History* Vol. 24, No. 2 (2012): 198.
39. William Paul, "The Aesthetic of Emergence," *Film History* Vol. 5, No. 3 (1993): 335–336.
40. "James Cameron and Martin Scorsese on *Hugo*'s 3D Special Effects," uploaded 11 November 2011: http://www.youtube.com/watch?v=DFJZ1HKybZA.
41. Barbara Klinger, "Beyond Cheap Thrills: 3D Cinema Today, The Parallax Debates, and the 'Pop-Out,'" *Public* Vol. 24, No. 47 (Spring 2013): 198.
42. *Ibid.*, 190, 191–192.
43. Higgins, "3D in Depth," 207.
44. Klinger, "Beyond Cheap Thrills," 192.
45. Quoted in "Cameron and Scorsese on *Hugo*'s 3D Special Effects."
46. Frazer, *Artificially Arranged Scenes*, 117.

47. Higgins, "3D in Depth," 207.
48. *Ibid.*
49. On shifters, see Charles Sanders Peirce, "Of Reasoning in General," in *The Essential Peirce*, Vol. 2, ed. Peirce Edition Project (Bloomington: Indiana University Press, 1998), especially 14–16.
50. Doane, "Indexicality and the Concept of Medium Specificity," 136.
51. Nanna Verhoeff, "Pointing Forward, Looking Back: Reflexivity and Deixis in Early Cinema and Contemporary Installations," in *A Companion to Early Cinema*, eds. André Gaudreault, Nicolas Dulac, and Santiago Hidalgo (Chichester, UK: John Wiley and Sons, Ltd, 2012), 572.
52. Raphael Samuel, *Theatres of Memory: Past and Present in Contemporary Culture* (London: Verso, 2012 [1994]), 430.
53. Manovich, *The Language of New Media*, 218, 225.
54. See Victoria Vesna, ed., *Database Aesthetics: Art in the Age of Information Overflow* (Minneapolis: University of Minnesota Press, 2007).
55. Willemen, "Indexicality, Fantasy, and the Digital," 120.
56. Mike Featherstone uses the suggestive term, serendipity, in this context. See Mike Featherstone, "Archiving Cultures," *British Journal of Sociology* Vol. 51, No. 1 (January/March 2000): 167.
57. Roy Rosenzweig, "Scarcity or Abundance? Preserving the Past in the Digital Era," *The American Historical Review* Vol. 108, No. 3 (June 2003): 738.
58. For an important exception, see Steve F. Anderson, *Technologies of History: Visual Media and the Eccentricities of the Past* (Dartmouth: Dartmouth University Press, 2011).
59. Derrida, *Archive Fever*, 18.

cross-medial afterlives

the film archive in contemporary

fiction

j o s h u a y u m i b e

> The old idea had been to see each film once. Now I saw them
> many times, and instead of visiting an archive for just a few
> hours, I stuck around for days, running the films on flatbeds
> and Moviolas [. . .] winding and rewinding the prints until my
> eyes wouldn't stay open anymore. I took notes, consulted
> books, and wrote down exhaustive commentaries, detailing
> the cuts and camera angles and lighting positions, analyzing
> all aspects of every scene down to its most peripheral ele-
> ments, and I never left a place until I was ready, until I had
> lived with the footage long enough to know every inch of it
> by heart.
>
> (Paul Auster, *The Book of Illusions*)

To know the material contours of a film, frame by frame, is a cinephilic
ideal growing more distant as increasingly films are not measured spa-
tially in inches or millimeters, nor in split-reels and thousand-foot cans,
but as data counted in gigabytes and digital time codes. Nostalgic longing,

however, is not the only register through which to face these technical changes, for much is also gained in terms of digital access for those films, old and new, that have made the transition. What can now be viewed, paused, and looped on one's various screens was unimaginable only a short time ago, from the silent serials of Louis Feuillade to Kenneth Anger's *Magick Lantern Cycle* to the films of Ousmane Sembène. We are swimming in access of varying quality as digital codecs replace emulsion and competing streaming services vie for prominence, but in the midst of this digital re-encoding, analog film has made a comeback of sorts. In the face of its apparently pending obsolescence, analog film—both the material print and the viewing apparatus—has become a renewed object of fascination. As Erika Balsom has argued, this began in the 1990s when film infiltrated art galleries and museums during the digital transition, "appearing there as something of an old medium to be commemorated and protected."[1] In a parallel move, I trace here another symptomatic reaction within our present media culture to the digital transformation of moving image technology, specifically how these changes have been registered in contemporary fiction, at points not only to commemorate the medium but also to examine the archival allegories and eschatologies of analog media in our growing digital ecology.

Over the past two decades, a significant number of novels have turned to cinema as a guiding topos, often referencing silent and experimental cinemas and also the film archive, both as a site and structuring concept. One can see this, for example, in Theodore Roszak's *Flicker* (1991), David Foster Wallace's *Infinite Jest* (1996), W.G. Sebald's *Austerlitz* (2001), Paul Auster's *The Book of Illusions* (2002), Don DeLillo's *Point Omega*, (2010), and Susan Daitch's *Paper Conspiracies* (2011). This is nothing new exactly, as since its inception film has been a reference point in literature, at times denigrated as a vulgar competitor in the field of cultural production while also being appropriated in literature as a trope and stylistic influence, particularly in modernist literature.[2] Yuri Tsivian for instance has traced the cultural reception of early film in Russia by focusing in part on its reverberations in Symbolist literature. The exploding and disappearing characters of early trick films by Georges Méliès and others were an influence on the eschatological, literary visions of Andrei Bely, as Tsivian notes: "The cinema with its flickering, vibrating, unstable image was a perfect symbol for such a representation of the world."[3] As a site of mediation and reflection, the cinema has made dramatic appearances in a variety of novels throughout the twentieth century, including Frank Norris's *McTeague* (1899), Richard Wright's *Native Son* (1940), and Walker Percy's *The Moviegoer* (1961) to name only a few.[4] However, with the contemporary literary interest in film, the medium functions as more than just a cross-medial reference. Instead, it is used as a structuring principle in which cinema's materiality is interrogated in light of recent technical transformations, and through this process

it is used to explore both central thematic concerns within the novels, and reflexively, literature's own fate in the era of digitization.

For instance, in the texts focused on in this essay by Roszak, Sebald, and Daitch, film's historicity is examined through the archive. Respectively, these works depict the Museum of Modern Art, the Imperial War Museum, and the Library of Congress as key sites in which the novels' generic, detective-like plots become entwined with the workings of film history. To unravel the mysteries of the narratives, their protagonists resort to archival research, examining fragile prints of long-forgotten films on rewind tables and Moviolas. Often the secrets found in these works—lost artifacts, missing people, hidden and occult meanings—are on the verge of disappearance, as the celluloid in which they are embedded has warped and the emulsion decomposed. Renovating the generic conventions of detection through the medium of film, the novels elaborate the delicate frame-by-frame inspection required to trace out the mysteries hidden in the films' fragile images. Through a shared emphasis on archival decay, these secrets are shown to be transient, underscoring that film's material promise to embalm time is itself governed by the withering of time. In contrast, the novels themselves are able to preserve and playfully remediate these transformations, even as the works are also reflexively aware of their own fragility as texts.

Laura Marcus has recently discussed a similar series of contemporary novels that engage with film in relation to the "death of cinema" trope found in recent film theory—that is, the medium's impending loss of analog materiality.[5] This trope informs the fictions examined here as well, though with different valences, particularly in light of how each uses the physical instability of analog film to refract, as we will see, the traumas of World War II. *Flicker* crafts a far-reaching eschatology of the ends of film that is grounded in key ways on the violence of the War, whereas *Austerlitz* uses filmic decomposition to meditate on the politics of the modern archive after the ruins of the Holocaust, a subject that *Paper Conspiracies* also returns to as it uses film's material instability to examine the ethics of preservation. These differing novelistic emphases usefully outline specific aspects of the contemporary cultural reception of film and in particular of the film archive. The temporality of these literary instances of intermedial engagement is significant for what it refracts about the current moment in media archaeology when new technologies are shifting both the materiality of films and texts and our historical and theoretical approaches to them. While the death-of-cinema trope is inherent to these transformations, as these novels also show, nostalgic allegories of loss are not the only outcomes of the digital transition. At a historical juncture when medial boundaries are in flux, these novels usefully question not just the end of celluloid film, but also what its afterlife might be in the era of the digital archive. Their interrogation of the current analog transition has broader

implications beyond film, for these novels also use these questions to alle-
gorize the cross-medial future of the text in the era of digital convergence.
As such, they critically outline the creative and material play across media
that digitization enables, even in the face of loss.

medial eschatologies

Flicker (1991), the earliest of the novels surveyed here, marks an emerging
interest in the archival history of film that informs all of the literary works
examined in this essay. Millennial unease undergirds these texts, which ret-
rospectively examine the uncertainty of archival knowledge in the midst
of growing concerns over digital instability.[6] Disquiet over these transitions
is a topic that Roszak has discussed at length in his critical work *The Cult of
Information*, which examines the displacement of ideas by digital information.
It was first published in 1986 and revised in 1994, thus bracketing the pub-
lication of *Flicker*.[7] Replete with millennial dread, Roszak's novel follows
the investigations of UCLA film professor Jonathan Gates into the fictional
lost films of Max Castle, and the text poses as Gates's archival research and
cinephilic coming-of-age memoir, written like the novel at the end of the
twentieth century. The memoir looks back primarily to events in the 1960s
and 1970s in order to trace Gates's development from young cinephile to
graduate student to professor as he examines Castle's work. Castle was
a brilliant Weimar UFA director, who immigrated to Hollywood in the
mid-1920s, where he became stuck directing low-budget, B-movie horror
films until his presumed death in 1941 in the midst of World War II. Over
the course of the novel, Gates discovers that Castle was an orphan raised
and educated by a Gnostic cult, the "Orphans of the Storm," descended
from the heretical Cathars who were nearly exterminated by the Albig-
ensian Crusade of the thirteenth century. In the novel's imaginary, the
cult had begun developing moving-image technology shortly before the
crusade—flip-books and magic-lantern devices, culminating in the nine-
teenth century with the cinematic apparatus and later with VHS. The
Orphans deployed these devices as a subversive, visual means of spreading
their religious beliefs subliminally within the flicker of the media, for the
flickering alternation of the projector embodied and preserved the dualis-
tic core of their beliefs: the struggle of light and shadow. Based upon this
precept, they conspired to embed secretly within films a subliminal pen-
chant for violence amongst spectators, which would culminate in a final
apocalyptic war, annihilating the world in 2014. Traumatic violence thus
ripples through the archival history of the book, superimposing the geno-
cides of the crusades with those of World War II and projecting forward
through post-war nuclear anxieties to our contemporary moment.

In the course of this eschatological conspiracy plot, as Gates discovers,
Castle was the cult's most gifted pupil, a Frankenstein-like amalgam of

Edgar G. Ulmer, William Castle, Harry Smith, and Slavko Vorkapich. In the process of combing through a host of private and public archives (including MoMA, with the assistance of a stand-in for Eileen Bowser), Gates is able to unearth much of Castle's lost work, in some cases in pristine condition and in others mutilated ruins.[8] Repeated reflections by Gates upon the "terrible fragility" of analog film are worked into the novel's archival investigations:

> Movies are the most delicate of all human works. Paper
> and parchment can be cheaply replaced; sculpture lasts
> for centuries, architecture for millennia. But the plastic
> to which a movie clings so precariously is vulnerable to a
> hundred lethal hazards; to restore or reshoot is too costly
> except for the few films that can still earn the price of their
> survival at the box office.[9]

Yet even in the fragile and time-ravaged state in which he finds much of Castle's work, its occult power still resonates. Indeed, the fragmentary state of the films is vital for the novel's eschatology of the medium for how it elicits cinephilic desire within Gates. As Paul Willemen has noted, the cult of cinephilia evokes "overtones of necrophilia, of relating to something that is dead, past, but alive in memory."[10] In this way, the death-of-cinema trope evoked through Castle's devastated films creatively motivates Gates's cinephilic work, to unravel the mysteries of Castle's work and revivify what has been ravaged by time.

Beyond the archival ruins of Castle's oeuvre, the play of desire and death are also embedded within the films themselves. Through the training of the Orphans, Castle learned and went on to perfect their techniques of working within the material contours of the filmic image. As Gates discovers through close, repetitive inspection of the films both on screen and on rewind tables, Castle's occult techniques involved manipulating the flickering, shadowy elements of the frames, where he inserted hidden, polarized imagery structuring a secret palimpsestic film buried beneath the surface of the visible film. This might entail recycled newsreels of warfare and riots, or pornographic scenes and occult rituals. Destructive, perverse, highly erotic yet not arousing, this secret imagery ensconced in the flicker of Castle's work was, according to Gates, "Unclean, [...] so indelibly sullied that the flesh itself would have to be peeled away to remove the stain."[11] Inherently dualistic, Castle and the Orphans aimed to incite the purification of the world, destroying the very materiality of the fallen earth with the explosive nitrate power of film, a medium as unstable as the physical world itself.

In the course of his academic research that leads him across the U.S. to Europe, Gates comes to the attention of the Orphans, and before he

can expose their conspiracies, they kidnap and exile him to an inescapable desert island in the western Indian ocean. There, to his shock, he finds Max Castle, who after falling out with the Orphans, had been exiled since 1941, some thirty-five years by the time Gates arrives in 1976. As a preserved, if ragged, artifact of a distant media era, Castle is thus juxtaposed with Gates, a film scholar of the next generation who is now confronted with the long-thought-dead object of historical inquiry. The prison island itself becomes an archive, staging a primal confrontation between generations and also with film. Well-stocked not only with food, but also regularly supplied with scrapped film equipment and desert-island films, Castle had continued his work over the decades, creating one final epic and ongoing production named *The End*. Though supplied with old film prints and broken projectors and Moviolas, Castle did not have access to cameras and raw stock, so instead of filming new material, he recycled old footage for the work, explaining to Gates:

> I have become the world's first cannibal moviemaker. My
> movie eats their movies. It is the survival of the fittest [. . .]
> I think of it as pruning. As in the orchard. I prune away
> the excess until only the essence remains. Even in the
> best movie there is excess; even in the worst, there is an
> essence—something humorous, something mysterious,
> something uncanny. Perhaps it is only a single shot: an eye,
> a smile, an actor's instinctive gestures, light reflected from
> a jewel. In my own films, there was often no more than a
> few seconds that really mattered.[12]

Castle's notion of cinematic autosarcophagy here is archivally grounded and resonant with Jean Epstein's cinephilic theorization of *photogénie*, "a spark that appears in fits and starts," and through this fragmenting impulse, cinephilia and necrophilia are again entwined.[13] This final work of Castle is a silent, found-footage film based upon his orphaned archive, but pared to the bone and then layered and reworked at the editing table.

Castle's archival sensibility is vital for what it elaborates about the nature of film's archival eschatology in the novel:

> I had at my disposal all that the motion picture has to
> offer. The work of the very best, as well as the very worst.
> All of it mine. Through the films, I can treat myself to a
> kind of animated museum of modern times [. . .] the way
> our barbaric forebears salvaged the ruins of Rome to make
> their barns, pigsties, churches. And yet, I have come to see
> my work as the film of the future. I imagine the French

would call it *cinéma brutal*, the way movies will have to be made if there is any future at all for us.[14]

The animated museum of modern times is thus imagined as a prison island beyond the edge of civilization, and its contents are the withering ruins of an ancient filmmaker, an aging scholar, and the decomposing objects of their affection. Though devised as an apocalyptic narrative about the end of the world, *Flicker* provides a cross-medial eschatology of the late twentieth-century archive—of film at the apocalyptic end of analog film. This plays out not only in the cannibalistic nature of *The End*, but also in the film's very materiality. Working largely with homemade and unstable splicing glue and whatever bits of Mylar tape he could beg from his captors, Castle's crowning masterpiece was itself a crumbling wreckage devoured by time. Castle invites Gates to be the first and final viewer of the work, for given its fragile splices, it would almost certainly not hold up through the projector gate at the moment of its illuminated fulfillment, fated simultaneously to be its destruction—an amplification of Paolo Cherchi Usai's insight that every projection of an analog film is a unique event that "progressively dissolve[s]" the materiality of the print.[15]

Through Castle's invitation, a reflexive pun is embedded in the text, playing on Gates's name. In effect his memoir of the experience becomes the reader's cross-medial projection *gate* of the film, providing an entryway into the *castle* per se, which following the generic trope of detection grants the reader narrative access through the restricted perspective of the detective. In this sense, the film's only viewing is a unique event within the island archive of the novel, distanced from the reader as cinema becomes an ekphrastic experience filtered through Gates's subjective description. The novel performs what Françoise Meltzer has described as the "dance of writing" in which literature flaunts the mimetic power of writing over the ephemerality of the visual.[16] Yet even within the subjectively filtered archive of the text, the film remains unattainable, for as Gates discovers upon opening the film cans, the material was in even worse condition than he had feared:

> I quickly pried open the dusty, mold-enshrouded box. It was like opening a coffin expecting to find a corpse . . . and finding a corpse. Not shocking, just sickening. [. . .] I continued opening cartons. Each revealed a new plastic pathology. Film reduced to crumbs, to jelly, to dust. Film melting into goo, cracked into splinters, shredded into black spaghetti. I was learning all over how fragile this greatest of all art forms is, a dream drawn by light on an evanescent polymer ribbon.[17]

Amidst these nitrate ruins, some scraps do still survive (for instance, Betty Boop disturbingly spliced over Nazi death camps), but going over the material frame by frame on a Moviola, the footage also disintegrates as it passes through the apparatus.

At last in his rummaging, he finds a reel that was made more recently and is still projectable. Similar to Bruce Conner's *A Movie* (1958), it begins with a title card of "The End" and then lurches forward, tracing an apocalyptic ending through found footage. Eventually, this culminates in a marching, nonfiction mass of wartime streetwalkers moving in extreme slow motion into an entrance of an underground tunnel. The image then begins to split, slowly opening a chasm from within, engulfing Gates's mind with the thought that "we live on film, on *a* film, the skin of a bubble, what is real lies behind, waiting to push through, swallow us up, reclaim us."[18] The material instability of analog film thus stands in apocalyptically for the Cathar abyss of existence. What emerges from beneath is a nuclear cloud, engulfing the image and screen in the pure light of the projector bulb through emulsion-less film, only to be followed dualistically a short time later by a black raven, animated and growing to engulf the pulsing white nuclear void with the dark shadow of its breast. The film then comes to its provisional end, shredded on the floor beneath the projector. Castle subsequently enlists Gates to assist with its ongoing production, winding down the clock towards the world's prophesied end in 2014.

Amidst Castle's archival refuse, the end of the medium thus figures eschatologically in this creative and simultaneously destructive play of light and shadow—a cinema that eats itself, along with the world. Written at the beginning of—but set earlier than—the digital transition, these archival insights into the material ruptures of film provide an afterimage of the medium's digital future. In the face of the mythic plentitude of media access and storage that digital preservation promises ("data glut," as Roszak has called it elsewhere), *Flicker* presents a vital, if hyperbolic, corrective.[19] In the unfolding chaos of the novel, the act of representation is depicted as being inherently conflicted, both textually and visually, and medial transitions in the text, as films consume films, lead to more, not less, chaos and degradation. This results in an archive where the death of the medium is ever present and replete with traumatic loss. Despite this, nostalgia is not the dominant register of the text, for its prison-island archive is a site of creative play in which cinematic ruins are recycled into flights of fancy at multiple levels: by Castle making his film, and then with Gates both working on the film as well as his memoir, and finally through the novel itself, which remediates these various layers within the archival folds of its pages. Textuality, however, is not portrayed as being more stable, at least within the novel, for at its end, Gates sits down to write the first sentences of chapter one on paper that, like *The End*, has also been cannibalized. It is made from old newspapers, scrubbed and bleached in the sun. If our warehouse

of images is destined to dissolve, their textual afterlife also stands precari-
ous like Gates's memoir—he contemplates bottling the pages, like Castle's
corpse-reels, and setting them adrift in the salty sea.

eureka

The material limits of the moving image also feature prominently in
Sebald's *Austerlitz* (2001), though, as we will see, filtered through a cri-
tique of the alienating effects of archives in general, for how they mediate
knowledge and power. The novel is set in the late 1990s, and retrospec-
tively traces Jacques Austerlitz's attempt to reconstruct his parents' his-
tory, decades after his separation from them during World War II. Born in
Prague, Austerlitz was sent as a young, four-year-old child into exile abroad
via the Kindertransport to Wales in 1939 to protect him from the German
advance. Over the course of the novel, he discovers that his mother Agáta
was a Jewish opera singer who was interned after his departure in the
Theresienstadt ghetto outside of Prague.

Upon finding that the Nazis had made a documentary of the camp and
after much research, letters to archives, and waiting, Austerlitz procures a
video of the film through the British Imperial War Museum from the Fed-
eral Archives in Berlin. With the hope of catching a glimpse of his mother,
he recounts how he sat in the museum, watching the video, only to discover
that the film was merely a fourteen-minute fragment of cobbled-together
footage: "I remember very clearly . . . how I sat in one of the museum's video
viewing rooms, placed the cassette in the black opening of the recorder with
trembling hands, and then, although unable to take in any of it, watched
various tasks being carried out at the anvil and forge of a smithy."[20]

Providing an account of the film that echoes the discontinuous style of
some of the earliest exhibitions of silent film, Austerlitz continues:

> I saw an unbroken succession of strangers' faces emerge
> before me for a few seconds, I saw workers leaving the huts
> when the siren had sounded and crossing an empty field
> beneath a sky filled with motionless white clouds [. . .]. At
> first I could get none of these images into my head; they
> merely flickered before my eyes as the source of continual
> irritation or vexation, which was further reinforced when,
> to my horror, it turned out that the Berlin cassette [. . .] had
> on it only a patchwork of scenes cobbled together and last-
> ing some fourteen minutes, scarcely more than an open-
> ing sequence in which, despite the hopes I had entertained,
> I could not see Agáta anywhere, however often I ran the
> tape and however hard I strained to make her out among
> those fleeting faces.[21]

In these fourteen minutes of transient images, Austerlitz could find no trace of his mother—the images seemed on their surface fractured and unapproachable, refusing to give up the aura of the past. But this gave him an idea—one in keeping with Ernie Gehr's experimental film *Eureka* (1974), which similarly stretches a 1906 phantom ride down San Francisco's Market Street, filmed only days before a devastating earthquake and fire, from nine-and-a-half minutes to thirty. Austerlitz explains:

> In the end the impossibility of seeing anything more closely in those pictures, which seemed to dissolve even as they appeared [. . .] gave me the idea to have a slow-motion copy of this fragment from Theresienstadt made, one which would last a whole hour, and indeed once the scant document was extended to four times its original length, it did reveal previously hidden objects and people, creating, by default as it were, a different sort of film altogether, which I have since watched over and over again.[22]

By slowing down the film, transferred to VHS from twenty-four frames per second to approximately six, an unseen world appears—what Walter Benjamin troped as the optical unconscious of the photographic image.[23] Another, previously unknown nature speaks to the camera, unfurling a secret life within photographic emulsion that the unaided eye cannot otherwise perceive. For Benjamin, the revelatory optics of the image have the potential to restructure temporality for the spectator, colliding past with present to explode the "prison-world with the dynamite of the split second" and open new, possible futures.[24]

If Sebald motions in this direction through Austerlitz's video experiment, the text simultaneously remains suspicious of the actual results, for in this stretched footage, hidden objects and people are not the only things uncovered. Like the patterns of grain and dirt in Gehr's *Eureka* and Max Castle's *The End*, the decay of Austerlitz's film erupts in the decomposing emulsion transferred to video:

> The many damaged sections of the tape, which I had hardly noticed before, now melted the image from its center or from the edges, blotting it out and instead making patterns of bright white sprinkled with black which reminded me of aerial photographs taken in the far north, or a drop of water seen under the microscope.[25]

While the language of filmic decomposition that Sebald uses parallels the descriptions of the other novels discussed here, the imagistic tropes he invokes of aerial photography and macrophotography are unique for how

they connect decomposition to the optical unconscious. Macrophotography in particular is a key reference for Benjamin regarding the "other nature" that speaks to the camera-eye.[26] Here, though, Sebald pushes the trope against the grain, in that these aspects of the image are not produced photographically but rather through decomposition. Instead of revealing a hidden history buried in the layers of the image—such as the abyss of nuclear light in Castle's *The End*—history itself scars the image, and these indexical wounds pressed into the emulsion testify to the ruins of time rather than to a substrate of meaning.

Yet amidst this slowed-down medial decay, a figure that was indecipherable before now stands out from the damage like the corpse in *Blow-Up* (1966):

> She looks, so I tell myself as I watch, just as I imagined the singer Agáta from my faint memories and the few other clues to her appearance that I now have, and I gaze and gaze again at that face, which seems to me both strange and familiar [. . .] I run the tape back repeatedly, looking at the time indicator in the top left-hand corner of the screen, where figures covering part of her forehead show the minutes and seconds, from 10:53 to 10:57, while the hundredths of a second flash by so fast that you cannot read and capture them.[27]

Uncanny and fetishistic, Austerlitz's quest for his mother crystalizes in this moment of archival fever.[28] But what is it that speaks from this fugitive image—that survives in its scarred, optical trace? It could be the image of Agáta, but as Sebald is quick to point out, it very well might not be—the image here, transferred and stretched from decomposed film to video, is anything but reliable, just as is Austerlitz's distant memory of her face. And even if it might be her, these four seconds of black-and-white muteness are but a shadow, and as such, the passage is indicative of Sebald's ongoing revisionist meditation on Proust and Benjamin, regarding the impossible recovery of lost time, be it through memory, literature, the archive, or the photographic arts.[29] This impasse necessitates, for Sebald, an ethics of remembering: of sifting the ruins of the optical unconscious—textual, photographic, and filmic—for the traces they might hold, while simultaneously uncovering and documenting the ongoing erasure of history to which images such as this film as video in its fragmentary state testify.[30]

Such a labor of remembering, however, faces larger issues when dealing with the modern archive. As J.J. Long has argued regarding Sebald, his work is engaged broadly in an interrogation of the role of the archive in the nineteenth and twentieth centuries, specifically in Foucauldian terms of how the archive structures the relation of knowledge, power, and

discipline.[31] While Austerlitz's experience at the Imperial War Museum's film archive was productive—and inflected consciously or intuitively by the reverberations both of early cinema and of experimental cinema's later back-and-forth negotiations with it—Sebald's general reflections on archival power are worth foregrounding in view of the current and ongoing digital transformations of the archive. At the end of the novel, Austerlitz is carrying out futile genealogical research in the then new, hi-tech facilities of the Bibliothèque Nationale de France in Paris, and he reflects on the way in which the failure of the library's "electronic data retrieval system" that presents him with a dead-end to his research relates to the overall alienating, architectural structure of the facilities. He comes to the acerbic conclusion that:

> in any project we design and develop, the size and degree of complexity of the information and control systems inscribed in it are the crucial factors, so that the all-embracing and absolute perfection of the concept can in practice coincide, indeed ultimately must coincide, with its chronic dysfunction and constitutional instability.[32]

In other words, the more elaborate and totalizing the archive, the more susceptible it is to failure—to digital loss and the inaccessible opaqueness of the data.

This opaqueness, for Austerlitz, is part of a system that paradoxically alienates history through the very archive it builds to preserve it, as the ideology of archival progress is, in his words, "to break with everything which still has some living connection to the past."[33] As Long argues, Sebald's overarching critique of archival power is informed not only by the historical cataclysm of the Holocaust, but also more broadly by the traumatic ruptures of modernity, with its representational technologies that connect the disciplinary functions of media in the nineteenth century with those in the twenty-first.[34] In *Austerlitz* and in Sebald's other work, the archive is as institutionally fissured and unreliable as the very medium of film represented through the Theresienstadt video. Still, as Sebald's writings delineate, the work of historiography is not then to dismiss the archive but rather to engage critically with the fissures and unconscious wounds of time that it reveals.

For the contemporary moving image archive, faced with the ongoing decomposition of analog film and its migration from celluloid to digital, the stakes that *Austerlitz* raises are high. In the face of shrinking budgets and analog obsolescence, coupled with increasing costs for digitization and storage, there is a conjoining will to create ever-more-complex storage systems that promise to grant digital access to history in its totality. Lev Manovich has theorized this impulse as our contemporary "database

complex," which betrays "an irrational desire to preserve and store every-thing."[35] The unchecked results of such a drive are the dysfunction and instability that Austerlitz encounters at the Bibliothèque Nationale. If in some ways its database is a counter example of the refuse heap of *Flicker*'s island archive, the results are similar: the fractured loss and the degradation of materiality—part of an inherent death drive that, according to Derrida, always haunts and shapes the archive.[36] To face the material decomposition of the past is the difficult historiographic task posed to the moving image archive by *Austerlitz*. In Sebald's media ecology, just as in Roszak's novel, writing also is subject to the degradations of time through, for instance, notebooks that are crossed-out and erased and documents made inaccessi-ble in the modern archive.[37] *Austerlitz* along with Sebald's other works con-front these gaps through their layering of histories, images, and sources, as they articulate a mode of archival knowledge that recognizes medial rup-tures and loss as a necessary counterbalance to myths of digital plentitude. In contrast to these myths, such ruptures are the very marks that provide us with history in film as well as text.

millennial archaeologies

If confronting loss is the historiographic challenge that Sebald sets for the archive at the beginning of the new millennium, it is useful to turn to Susan Daitch's *Paper Conspiracies* to trace in brief the cultural reception of the film archive a decade after *Austerlitz* and two past *Flicker*. Over this period, the significance of the archive has become increasingly pronounced within the contemporary media landscape, theorized by some as an archival turn in cultural production that has emerged in response to the digital trans-formation of archival data.[38] Significantly, the specificity of film archival knowledge exhibited in *Paper Conspiracies* is the most detailed of all of the novels discussed here. Set like *Austerlitz* and *Flicker* (when Gates writes his memoir) obliquely at the turn of the present century, *Paper Conspiracies* simi-larly distances itself from the contemporary frame to examine the turn of the last century as it moves from the contemporary restoration to the orig-inal production and aftermath of Georges Méliès's controversial *The Dreyfus Affair* (1899), with frame enlargements of the film illustrating the text.[39]

Méliès's film examines the scandalous, trumped-up court marshal and punishment of Alfred Dreyfus, a Jewish captain in the French army in the 1890s. Upon discovering that a spy had been selling state secrets to the Ger-mans, French military intelligence convicted Dreyfus in 1894 on falsified evidence—elaborately forged letters supplied by the real spy, Colonel Wal-ter Esterhazy. The court then banished Dreyfus as a political detainee to the Devil's Island prison colony in French Guyana. As news of the case spread through France and around the world, controversy erupted, splitting the French violently between pro- and anti-Dreyfusards: that is, between the

largely secular liberal Socialists who saw the case as anti-Semitic scapegoating and the Catholic and generally xenophobic conservatives who supported the military power. Due to the outcry, Dreyfus was returned to France for retrial in 1899, found guilty of treason yet again despite the clear evidence to the contrary in a face-saving maneuver by the French military, only to be pardoned by the French president and released later that year, and then fully exonerated at last in 1906.

Méliès's film (or more correctly, his ambitious eleven-part through twelve tableaux film series) was produced in the context of the 1899 retrial, and it was also one of his earliest reconstructed actualities, as opposed to his magical trick and fairy films, and "preconstructions" (which aimed to project imagined futures rather than reconstruct past events).[40] For Méliès, both the actuality and the preconstruction aimed similarly, through different styles, to reveal fantastic realities, bringing as the motto of Star Film declared "the world within reach." As a character within Daitch's novel explains, Méliès "offered escape hatches, transformations, jokes. No one wants to see what they can see every day [. . .], they want to see what they can't see. Then he began to think about filming what everyone looked at but didn't really see."[41] In a sense, Daitch's account of Méliès's films taps into the realm of Benjamin's unconscious optics in a more straightforward sense of revealing the fantastic that is normally unseen, as opposed to *Austerlitz*, which uses such imagery to show what is lost and not recoverable. Turning this optical sensibility to the case of Dreyfus, Méliès reconstructed the facts in such a way that the truth of the case, amidst all of the forgeries and lies, would be evident. As such, according to Daitch, he "resisted the temptation to change the fantastic verdict into the correct verdict: innocent. He let the unbelievable conclusion stand. He shot the actuality, as improbable as it was."[42] This editorial maneuver, of letting absurdity negatively outline the obvious, apparently turned out to be explosive: riots are said to have erupted at the film's premier, between the pro- and anti-Dreyfusards, and the police were called in as the theater was torn apart. The accounts of these conflicts, however, from Madeleine Malthête-Méliès come later and have not been verified historically.[43] Eventually, the French government politically censored films about the Dreyfus affair in 1915 in the midst of the War, forbidding films about Dreyfus from being screened (though earlier, local bans may have been in place in France), and also banning the exhibition and production in France of Dreyfus films, which remained in place until 1950 for exhibition and 1974 for production. The film itself circulated beyond France and has survived, though two of its tableaux are missing (the second and the final scenes chronologically), which provides space for Daitch to play with fictional alternatives, thus appropriating Méliès's own creative approach to the reconstruction of actuality.

It is out of the context of political scandal and censorship arising from a trial based upon lies, fakes, and textual and photographic forgeries that

Daitch interrogates film and the film archive's problematic relationship to history. The novel is constructed from a series of layered and interconnected narrative accounts set in the 1890s, 1930s, 1960s, and 1990s (primarily structured in reverse in the novel) and ranging from the conspirators who assisted in the framing of Dreyfus, to Méliès's assistant at Star Film during the film's production and disastrous premier, to the most developed character who frames the novel at beginning and end in the 1990s, Frances L. Baum (a play on L. Frank Baum, likely alluding to his interest in Méliès's trick effects).[44] She is a young film archivist, in her twenties, working in a private New York lab in the late 1990s on the restoration of a long-lost complete print of *The Dreyfus Affair*, rumored to have a secret ending.

Like Austerlitz, Baum is apparently the child of Jewish Holocaust victims, but in her case survivors living in exile in upstate New York. This backstory, though, must be surmised, for as Baum explains, "all those unspoken histories were packed away, little signifiers of identity ready to burst out uncontrollably."[45] Accordingly, the family's history is only alluded to through fleeting references to relatives who disappeared during the War, her parents' traumatic aversion specifically to tattoos and more generally to the past, and the apparent post-war anti-Semitism that cost Baum an eye when, as a young girl, she opened a letter-bomb addressed to her family—violence which echoes the conspiratorial anti-Semitism rampant in the Dreyfus case. These buried traumas of history grounded in World War II—as well as its precursors and aftermath—motivate Baum's cinephilia in ways parallel to Jacques Austerlitz and Jonathan Gates, as she, too, is fascinated by archival ruins. She eventually takes a paid internship after college at the Library of Congress to work on a film restoration project, which leads to a job at the New York lab, Alphabet Film Conservation. As traced through these novelistic examples, the archival instability of film thus recurs as a motif to explore the traumas and lacunae of the twentieth century.

Baum's narrative voice opens *Paper Conspiracies* with an uncanny reflection on the work of a film restorer, faced with an ancient print and its long-past inhabitants: "How many stories could begin, 'What are you doing here, you're supposed to be dead?'"[46] This invocation of film's ability to revive the past (cinema's mummy complex) is, however, tested by the novel's related emphasis on the medium's material contingency and instability. As Baum describes her initial inspection of the Méliès reels:

> Inside were long shreds of film, glutinous and flaked. Single reels looked like hockey pucks, gummy sweat exuding along the edges. These were rare films whose footage was almost obliterated, yet they continued to cling to life. Old silent films are the most difficult to preserve or restore. They are brittle, shrunken; images are distorted

as if burned, or figures appear drowned under a bubbled, warped surface.[47]

If film can revive the dead in images, materially it too is a dead object in need of resuscitation. What is of interest is how the trope of film's decomposing materiality leads in *Paper Conspiracies* to a discussion of the ethics of film preservation, one which is relevant for today's broader medial context. Throughout the narrative, Daitch depicts arguments between Baum and her boss, Julius Shute, who demands a restored image "with as little visual static as possible," achieved through a thorough application of wet gate printing that makes the scratches in the source material disappear. However, for Baum, the resulting images are "too perfect and too sharp, as if photographed yesterday" and thus untrue to the source.[48] Instead, she prefers what she calls "the archaeology of [. . .] crappy prints, and when making a copy of a film [she] photographed the whole surface, preserving whatever was there, including the dust and fingerprints," so that the images would "reflect the original with all its granularity and visual static."[49] In line with what Paolo Cherchi Usai has argued regarding the unique specificity of individual prints, it is these indexical marks of time for Baum that give analog prints their unique and contingent historicity, which can enable the unspoken past to burst forth uncontrollably.[50]

It is such investment in the material grain of film that the novel emphasizes in its conclusion. In its brief final section, the text returns to Baum's opening story and ties the novel's disparate temporal threads loosely together. Historical conspiracies circulate through all of the sections, reverberating from the Dreyfus affair and Méliès's cinematic account of it to the film's contemporary restoration. Desperate for cash, Shute, the owner of Alphabet Film Conservation, had accepted the restoration project from a wealthy unnamed source who commissioned him to give the film a happy (and false) ending: that Méliès's filmed trial, when restored, should find Dreyfus innocent, thus whitewashing the French military who in fact conspired to convict him despite his innocence in order to save face. Upon discovering that Shute had actually carried out this conspiracy to falsify the restored film, "perhaps by copying, drawing, and splicing many bits together," Baum slices off his faked work with a guillotine splicer, a device "though harmless to live humans its blade is oddly sharp and lethal to filmed ones."[51] For Baum, it is the absurd and deteriorating granularity of Méliès's original that she defends through her filmic execution, hearkening back to the guillotine of the French Revolution. She slips the splicer into her pocket as she exits the novel, as "there are always other stories that need to be preserved," especially now within our digital ecology.[52]

However, the novel's conclusion also offers a cautionary tale about guillotines. Curiously, in this process of historical preservation, Baum also

seems to have destroyed a secret original ending, following Shute's re-edit, to the film, which according to the novel was inserted into *The Dreyfus Affair* by Méliès as a postscript to the twelve tableaux. In it a riot breaks out, restaging the fights that supposedly erupted at the film's premier, and in the midst of the chaos, a death occurs: one of Méliès's employees is trampled, and possibly stabbed by anti-Dreyfusards seeking to punish those involved with the film production. This footage itself bears the dust and fingerprints of time, for as it passes through the flatbed viewer, it dissolves into an indecipherable fog, all but disintegrating under the light of the machine. In the novel's fictional retelling, the killing did actually occur in 1899, and through the visual static of the decomposing footage, this past crime flashes up for Baum. Whether or not Méliès's restaged *j'accuse* of these events survives, though, is ambiguous in the novel—Baum seemingly destroys it with Shute's false ending, although it is not certain that she cuts it out with the rest. This ambiguity, however, points to the precarious nature of the archive of films, which like texts and literature, can be faked, forged, and destroyed. The novel performs all of these possibilities, bearing the visual marks of film in its inserted frame enlargements, as it stages the obliteration of the past and its mediated afterlife.

creative receptions

What are we to make of these contemporary accounts of the fragile materiality of film as remediated through literature? Digital convergence is only obliquely referenced in these novels, given their settings in the 1990s and earlier. Sebald and Roszak fleetingly reference VHS rather than digital media, and Daitch only mentions in passing that analog film restoration is in decline as the insolvent lab Baum works for shuts by the end of the novel. However, what emerges in these contemporary fictions, laden as they are with historical research and archival detail, is a turn in reference and valorization of analog film—one that is fully aware of its material fragility. In the face of a crumbling filmic medium, the novels perform deep archival work, as their characters sift through both paper sources and film prints on Moviolas and rewind benches, uncovering the material traces of history. Through this approach, these works provide a nuanced cultural reception of recent historiographic and archival transformations—one which is not just exhibited through the characters' fictional investigations but is ingrained in the very writing of the texts, as each of the authors have also carried out extensive archival research that threads their narratives together. Sebald, with his erudite wanderings through our recent ruins, is the epitome of this archival approach to fiction, and as noted earlier, Roszak carried out his work on *Flicker* in the midst of his research on the rise of digital culture, *The Cult of Information*. For her part, Daitch conferred about Méliès with historian Tom Gunning and critic David Kehr, while

also consulting a variety of research archives and libraries, as detailed in her acknowledgements.[53] Beyond these archival approaches, each of the authors has also internalized cinematic and photographic modes of representation in their texts, not just through the illustrations that illuminate *Austerlitz* and *Paper Conspiracies* but also formally in the writing. As Daitch has noted regarding her approach to fiction, "I spend a lot of time at the movies, and parts of the books are cinematic as if I was looking at the characters through a camera."[54] Within the concerns of these particular, archivally oriented novels, however, the ekphrastic doubling of text and image does not provide photographic clarity to the works but rather a disintegrating collapse of representation, as the filmic images each novel strives to preserve and remediate break down into visual static. They thus offer an image not of film triumphant for its indexical powers of historical resurrection, but instead, a "cinema in ruins," to borrow a phrase from Erika Balsom's work on film in the contemporary art gallery.[55]

Such a medial interest in ruins is apt for these works of contemporary fiction, as literature and the publishing industry have also been in transition, if not exactly crisis, with the expansions and contractions wrought by digital technologies that are altering reading behavior as well as purchasing habits through eBooks, Kindles, and iPads. Like film archives, paper archives and funding for them are also shrinking, and have been for some time, as Nicholson Baker has pointed out.[56] Digitization imperatives predominate now at the expense of analog objects—a hasty archival transition exacerbated by the recent economic crisis. In these fictions' cross-medial attention to film and its material transformations, one can read a displaced concern with the printed word's own vulnerability, as also documented in these novels with their emphases on recycled, palimpsestic memoirs, opaque paper trails of World War II, and caches of incriminating forgeries. For a cross-medial perspective on contemporary literature, film—aesthetically as a register of historical contingency, and functionally as the twentieth century's mass-cultural medium par excellence—offers a telling lesson of the lifespan of analog media in the era of digital convergence. Having displaced the popularity of the printed word at the turn of the last century, analog film's own vulnerable dissolution at the turn of the present century opens it as a creative site in contemporary fiction for cultural reflection on medial afterlives.

In these literary accounts, we find a fractured, decomposing medium that is valorized under erasure, auratic only in its material obsolescence. Based on the contingent and unconscious meanings found in the unearthed films in these novels, literary value accrues to these analog objects at the same time that their mass cultural use breaks down. The imperative that emerges then, for the archive in these fictions, is to think through an afterlife of film in the digital age, one which preserves the medium's ruined connection to its dissolving past.

notes

1. Erika Balsom, *Exhibiting Cinema in Contemporary Art* (Amsterdam: Amsterdam University Press, 2013), 11.

2. See Julian Murphet, *Multimedia Modernism: Literature and the Anglo-American Avant-Garde* (New York: Cambridge University Press, 2009), in particular 12–25.

3. Yuri Tsivian, *Early Cinema in Russia and Its Cultural Reception*, trans. Richard Taylor (Chicago: University of Chicago Press, 1998), 120.

4. An exhaustive list is beyond the scope of this essay, but for a useful survey of silent era fiction about film, see Ken Wlaschin and Stephen Bottomore, "Moving Picture Fiction of the Silent Era, 1895–1928," *Film History: An International Journal* Vol. 20, No. 2 (2008): 217–260.

5. Laura Marcus, "The Death of Cinema and the Contemporary Novel," *Affirmations of the Modern* Vol. 1, No. 1 (July 2013): 160–77.

6. Through the 1990s, one can point to the digital anxiety over the exaggerated Y2K bug, whereas in the new millennium, archival concerns about digital platforms have become increasingly complex, faced both with the material problems of long-term data storage and with the increasingly competitive and politically charged domain—and surveillance and security—of global information technologies. On the media landscape of this period, see Kirsten Moana Thompson, *Apocalyptic Dread: American Film at the Turn of the Millennium* (Albany: SUNY Press, 2007), 1–26.

7. Theodore Roszak, *The Cult of Information: A Neo-Luddite Treatise on High-Tech, Artificial Intelligence, and the True Art of Thinking*, Reprint edition (Berkeley: University of California Press, 1994).

8. On these various connections in the novel, see in particular Tom Gunning, "Flickers: On Cinema's Power for Evil," in *Bad: Infamy, Darkness, Evil, and Slime on Screen*, ed. Murray Pomerance (New York: State University of New York Press, 2003), 35.

9. Theodore Roszak, *Flicker* (New York: Summit Books, 1991), 119–120.

10. Paul Willemen, *Looks and Frictions: Essays in Cultural Studies and Film Theory* (Indiana University Press, 1994), 227.

11. Roszak, *Flicker*, 116.

12. *Ibid.*, 561.

13. Jean Epstein, "Magnification," in *French Film Theory and Criticism: A History/ Anthology: 1907–1939*, Vol. 1, ed. Richard Abel (Princeton: Princeton University Press, 1988): 236.

14. Roszak, *Flicker*, 564.

15. Paolo Cherchi Usai, *The Death of Cinema: History, Cultural Memory, and the Digital Dark Age* (London: British Film Institute, 2008), 67.

16. Françoise Meltzer, *Salome and the Dance of Writing: Portraits of Mimesis in Literature* (Chicago: University of Chicago Press, 1987).

17. Roszak, *Flicker*, 571–572.

18. *Ibid.*, 579.

19. Roszak, *The Cult of Information*, 161–165.

20. W.G. Sebald, *Austerlitz*, trans. Anthea Bell (New York: Random House, 2001), 245.

21. *Ibid.*, 245–246.

22. *Ibid.*, 246–247.

23. Walter Benjamin, "The Work of Art in the Age of Its Technological Reproducibility (Second Version)," in *Selected Writings*, Vol. 3 (1935–1938), trans.

Edmund Jephcott and Harry Zohn, eds. Howard Eiland and Michael W. Jennings (Cambridge, MA: Belknap Press, 2002), 117.

24. *Ibid.*, 117. See also Miriam Bratu Hansen, *Cinema and Experience: Siegfried Kracauer, Walter Benjamin, and Theodor W. Adorno* (University of California Press, 2012), 155–162.

25. Sebald, *Austerlitz*, 247.

26. See Benjamin, "The Work of Art," 117, and his discussions of Karl Blossfeldt's macrophotography in "Little History of Photography," in *Selected Writings*, Vol. 2 (1927–1934), trans. Edmund Jephcott and Kingsley Shorter, eds. Michael W. Jennings, Howard Eiland, and Gary Smith (Cambridge, MA: Belknap Press of Harvard University Press, 1999), 510–511; as well as his "News about Flowers," in *Selected Writings*, Vol. 2, 155–157.

27. Sebald, *Austerlitz*, 251–252.

28. Relatedly, see Laura Mulvey's discussions of the uncanny, the fetish, and the mother in Roland Barthes's *Camera Lucida* and in *Psycho*, in *Death 24x a Second: Stillness and the Moving Image* (London Reaktion Books, 2006), 54–66 and 85–103.

29. On Sebald and Proust, see Lauren Walsh, "The Madeleine Revisualized: Proustian Memory and Sebaldian Visuality," in *The Future of Text and Image: Collected Essays on Literary and Visual Conjunctures*, eds. Ofra Amihay and Lauren Walsh (Newcastle upon Tyne, UK: Cambridge Scholars Publishing, 2012), 93–129. Also, see Mattias Frey, "Theorizing Cinema in Sebald and Sebald with Cinema," in *Searching for Sebald: Photography After W.G. Sebald*, eds. Lise Patt and Christel Dillbohner (Los Angeles: Institute of Cultural Inquiry, 2007), 226–241.

30. On Sebald's ethics, see Eric L. Santner, *On Creaturely Life: Rilke, Benjamin, Sebald* (Chicago: University of Chicago Press, 2009), in particular 134–135.

31. J.J. Long, *W.G. Sebald: Image, Archive, Modernity* (New York: Columbia University Press, 2010), especially 7–20.

32. Sebald, *Austerlitz*, 281.

33. *Ibid.*, 286.

34. Long, *W.G. Sebald*, 169–170. Also on the development of the media archive during modernity, see Mary Ann Doane, *The Emergence of Cinematic Time: Modernity, Contingency, the Archive* (Cambridge, MA: Harvard University Press, 2003), 206–232.

35. Lev Manovich, *The Language of New Media* (Cambridge, MA: MIT Press, 2001), 274. Relatedly, see Roszak's critique of data glut in *The Cult of Information*.

36. Jacques Derrida, *Archive Fever: A Freudian Impression*, trans. Eric Prenowitz (Chicago: University of Chicago Press, 1998), 79.

37. Long, *W.G. Sebald*, 125–126.

38. See for example Cheryl Simon, "Introduction: Following the Archival Turn," *Visual Resources* Vol. 18, No. 2 (2002): 101–107; and Randolph C. Head, "Preface: Historical Research on Archives and Knowledge Cultures: An Interdisciplinary Wave," *Archival Science* Vol. 10, No. 3 (1 September 2010): 191–194.

39. On the controversy of the film, see Stephen Bottomore, "Dreyfus and Documentary," *Sight and Sound* Vol. 53, No. 4 (Autumn 1984): 290–293.

40. Susan Daitch, *The Paper Conspiracies* (San Francisco: City Lights Book, 2011), 288. Also see Bottomore, "Dreyfus and Documentary," 290–293; and Luke McKernan, "Lives in Film No. 1: Alfred Dreyfus—Part 1," *The Bioscope* (10 March 2010): http://thebioscope.

net/2010/03/10/lives-in-film-no-1-alfred-dreyfus-part-1/. Accessed 25 February 2015.

41. Daitch, *The Paper Conspiracies*, 279–280.
42. *Ibid.*, 95.
43. Madeleine Malthête-Méliès, *Georges Méliès l'enchanteur* (Paris: Hachette, 1973), 220–221. See Venita Datta, "The Dreyfus Affair as National Theater," in *Revising Dreyfus*, ed. Maya Balakirsky Katz (Boston: Brill, 2013), 50–52.
44. On Baum's interest in Méliès, see Karen Beckman, *Vanishing Women: Magic, Film, and Feminism* (Durham, NC: Duke University Press, 2003), 196.
45. Daitch, *The Paper Conspiracies*, 39.
46. *Ibid.*, 7.
47. *Ibid.*, 24.
48. *Ibid.*, 28.
49. *Ibid.*, 68.
50. Paolo Cherchi Usai, *Silent Cinema: An Introduction* (London: British Film Institute, 2000), 160.
51. Daitch, *The Paper Conspiracies*, 360, 361.
52. *Ibid.*, 361.
53. *Ibid.*, 365.
54. Larry McCaffery, "An Interview with Susan Daitch," *The Review of Contemporary Fiction* Vol. 13, No. 2 (1993): 68.
55. Erika Balsom, "A Cinema in the Gallery, A Cinema in Ruins," *Screen* Vol. 50, No.4 (Winter 2009): 411–427.
56. Nicholson Baker, *Double Fold: Libraries and the Assault on Paper* (New York: Vintage Books, 2002).

supposing that the

archive is a woman

t e n

p a u l f l a i g

> a large part of the mythological view of the world [. . .] is
> nothing but psychology projected into the external world.
> The obscure recognition (the endopsychic perception, as it
> were) of psychical factors and relations in the unconscious
> is mirrored [. . .] in the construction of a supernatural real-
> ity [. . .] One could venture to explain in this way the myths
> of paradise and the fall of man, of God, of good and evil, of
> immortality, and so on, and to transform metaphysics into
> metapsychology.
>
> (Sigmund Freud, *The Psychopathology of Everyday Life*, 1901)

Although it appears only a handful of times in Freud's oeuvre, the concept
of *endopsychic perception* offers a singular way to bridge the theoretical concern
of psychoanalysis with, on the one hand, mythological or anthropologi-
cal origin and, on the other, symptoms and visions endemic to its clinic.
While Freud's many proto-cinematic terms—projection, screen memory,
the Mystic Writing Pad—hint at the ways the unconscious informs or

deforms vision, endopsychic perception occurs in those moments when what is "mirrored" externally takes on a "supernatural" or "metaphysical" shape, screening the modern as if it were ancient, casting the neurotic as Oedipus or Narcissus, the psychoanalyst as Moses. In a kind of time travel, the desires of the unconscious become visible through civilization's earliest myths, in particular those telling of origin and eternity. Freud's interest in antiquities and primitive rituals was thus not only due to finding a source for culture's recent discontents. He also sought to explain how the present can be experienced as past, as if one directly became or encountered the antique, displacing one's finite history onto seemingly timeless myths of self and world.[1] While one might link this concept to a variety of Freudian terms and figures, not to mention numerous texts, films, and images contemporary to or inspired by psychoanalysis, it is in Freud's 1907 reading of Wilhelm Jensen's 1903 novel, *Gradiva*, where endopsychic perception finds its case study.[2]

Gradiva's protagonist, Norbert Hanold, is an archaeologist overwhelmed by the sight of an ancient relief, one depicting a woman walking. Hanold becomes obsessed, naming this woman "Gradiva" and dreaming of her as a Pompeian. He produces a plaster cast of the relief, spies on women's feet, androgynously imitates their walk, and travels to Pompeii to seek the impression of this dead woman's gait. There, Hanold meets the living embodiment of Gradiva in a woman he believes to be her ghost, but who turns out to be, in a ludicrous coincidence, a forgotten childhood friend, Zoe. To explain this intersection of antiquity and childhood, Freud writes, "Once he had made his own childhood coincide with the classical past [. . .] there was a perfect similarity between the burial of Pompeii—the disappearance of the past combined with its preservation—and repression, of which he possessed a knowledge through what might be described as 'endopsychic' perception."[3] *Gradiva*, however, supplements Freud's concept with what Zoe calls "negative hallucination": Zoe and Hanold were not only childhood friends, but they presently live in the same city. Hanold's obsession with Gradiva is only possible because he had displaced Gradiva's own origin, Zoe, onto a lifeless past: the relief as well as all manner of archaeological residue. Hanold "possessed the art of not seeing and not recognizing people who were actually present" and this "not seeing" is what allowed Gradiva's re-animation in the first place.[4] The modern can only take the shape of the primeval if some threatening element of its own reality is repressed and transformed.

As is often the case in such psychoanalytic studies, it is a woman's body that acts as medium for processes of hallucination and displacement.[5] Whether as analyst or archaeologist the male figure reaches the past through the undressing of a woman, her nudity evidence of an origin resurrected, her memory given flesh through the archival collection of reproductions and traces. Yet Hanold, in Jacques Derrida's diagnosis, "suffers

181

from archive fever."[6] He has "exhausted the science of archaeology" so that the more he seeks the moment of Gradiva's footstep in the past, the more she fragments into mere trace. In turn, the more this archive accrues, the more he is haunted by the specter of her reincarnated body. It is not by happenstance that Derrida's *Archive Fever* concludes with Freud's reading of *Gradiva* nor that Hanold would be the eponymous concept's embodiment. In a footnote, Derrida offers his own elusive term, "patriarchive," one which points to this erotic dynamic between a masculine archivist and the feminine body of the archive, where the violence of time passing, of statues dying, is revealed and refused in the perception of an archive become live flesh.[7] If there is no endopsychic perception without negative hallucination, neither seems to function for the patriarchivist without a woman's body interposed as the screen upon which a primordial past might be restored to the present.

In this essay, I will trace this complex of perception, hallucination, and gendered matter within the archives of film history. From *Vertigo* (Hitchcock, 1958) to *La Jetee* (Marker, 1962), *Laura* (Preminger, 1944) to *Paris, Texas* (Wenders, 1984), *Jules and Jim* (Truffaut, 1962) to *Contempt* (Godard, 1963), the history of cinema has no shortage of Hanolds and Gradivas, of films featuring obsessed collectors spurred by the image of an elusive woman, their quest achieving mythological resonance.[8] And there are the many ways cinema has been perceived as descendant of primordial forms of image-making, whether it be cave paintings or Plato's allegory of the cave. I want to focus, however, on film history's own "classical past," its first decades as hallucinated from the vantage of a digital present.

Focusing on two found footage works, each drawing on the early film archive, I argue that the medium of film has often been made to matter through patriarchival projection, an anxious yet utopian attachment to an antique cinema supposed as a lost feminine object. Turning to the works of Bill Morrison, I first discuss his *The Film of Her*, a twelve-minute short from 1996. *The Film of Her* belongs to a genre Derrida describes as "archaeological parabl[e]," merging the contested history of a film archive—the Paper Print Collection in the Library of Congress—with a fabricated passion for its protagonist, a clerk obsessed with restoring the image of a silent stag film actress, remembered from his childhood. I then turn to the Austrian avant-gardist Gustav Deutsch's *Film ist. a girl & a gun* (2009), which also uses early stag films, interlacing their erotic imagery with a range of other silent film genres as well as a series of ancient Greek citations of Hesiod, Sappho, and Plato. Deutsch approaches the birth of cinema through a mythology in which that birth is taken literally, the return to a primordial womb out of which a "female principle" might emerge from the roads not taken in film's subsequent history.

As archive-driven works, *The Film of Her* and *Film ist. a girl & a gun* perceive silent cinema endopsychically, using found footage much in the same way

Jensen's archaeologist perceived Gradiva: as the means for a mythological time travel displacing a contemporary anxiety. As their titles suggest, this anxiety has to do with what film "is" or what it represents when facing its own finitude. Each film negatively hallucinates a present of digital imagery and celluloid ruin so as to reunite with the moment of film's utopian inception. As seen through patriarchival fever dreams, utopia in both films is figured as female body, insulated from time's ruin or masculine holding, but also thereby impossible ever to see in the flesh. Just as Hanold's archaeological science was both lured and exhausted by the plenitudes and absences offered by Gradiva, so too is media archaeology overwhelmed by negative hallucinations and endopsychic perceptions of an explicitly gendered nature. Film's future histories are wrapped up in this exhaustion, where early cinema's very matter is felt and perceived in mythological terms preceding its invention, entangled in a contradictory circuit linking idealist philosophy with a feminine matter repressed, desired, and impossible to hold or behold. In moments of transition or threshold, media matter is conjured as feminine wish-image, the more ancient the hallucination, the more desperate the desire for restoration of a past that never was, but which may be melancholically projected.

dreams made flesh: bill morrison's *the film of her*

The contiguity between the archives of psychoanalysis and early cinema is not merely conceptual, but also literal. Freud's writings lie in the Library of Congress, the very site of the storage of the Paper Print Collection, whose re-discovery is mythologized in Bill Morrison's *The Film of Her*. Just as the controversies surrounding Freud's archive were as much about the patriarch of psychoanalysis as they were about his inheritors, so too is the history of the Collection as much about film artifacts as it is about those in charge of the archive's maintenance.[9] Controversy over who re-discovered these prints in the late 1930s, the inspiration for Morrison's film, is especially fitting given the pre-text for its creation: the desire on the part of another inventor of the *fin-de-siècle*, Thomas Edison, to copyright his films when the format's future was unclear. The Library would go on to accept bromide paper prints of nearly three thousand films made between 1894 and 1912.[10] Its collection became an essential trove for cinephiles and scholars as well as documentarians and avant-gardists. Spurred by Morrison's film, Gabriel Paletz has written the most definitive account of who might be responsible for re-discovering the Collection. However, he emphasizes throughout the difficulty of definition itself, especially regarding the key question raised by *The Film of Her*: how and why one archivist, Howard Walls, was supplanted by another archivist, Kemp Niver, in stewardship and credit of the Collection's re-discovery?[11] Paletz's account is largely concerned with unraveling these questions, but *The Film*

of Her might rather be understood in how it departs from the empirical into the mythic.

The Film of Her transforms Howard Walls into a nameless clerk, one hero-ically responsible for re-discovering the Paper Print Collection, but tragi-cally displaced by official history as he is fired and forgotten, a Niver-esque figure stealing credit and spotlight. This tragedy is made acute through Morrison's invention of a stag film—the eponymous "film of her"—remembered from the clerk's youth, one he seeks and finds in the Col-lection with the hopes of restoring to the present. Sadly, at film's end, the former clerk loses access to the archive's bounty, will never see or touch the image of the nude actress, cause and potential cure of his archive fever. As I will argue, this tragedy of repeated loss, of exile from both past time and archival preservation, encourages this fever to keep burning. Sepa-rated from the film of her, the aging, former clerk can dream of an image stripped of finitude or deception. In *The Film of Her*, the archive takes the form of woman so as to maintain the lure of a timeless return to origin.

Morrison re-tells Howard Walls's story by separating the facts of Walls's account from a fiction the filmmaker has invented. This separation oper-ates on multiple levels of the film's structure and form. It is divided in half by two tellingly named musical pieces, "The Way Home" by guitarist Bill Frisell and Henryk Górecki's "Third Piece in Olden Style." There are two narrators: a first-person ventriloquism of Walls performed by Morrison and an unnamed narrator (Guy De Lancey) telling the clerk's story in a rumi-native third-person. These voices play off both each other's accounts—the clerk only corroborates the narrator's references to the stag actress at film's end—as well as Morrison's image-track. The latter comes from a range of sources, including the Paper Print Collection, documentaries about the Collection, scenes of Morrison's own shooting, and a silent stag film the filmmaker discovered in a flea market.

That film is seen only after the Collection is introduced through an endopsychic perception of early film history, one that begins *The Film of Her*. Morrison's play of music, narration, and found footage first shows an archive containing not only canonical first films by Edison, Griffith, and Méliès, but images containing the entire universe, from primordial soup to planet earth, human infant to vegetation, the latter's cotton and trees eventually converted into cellulose nitrate and paper prints. After this transformation of antique film into ancient fossil, the narrator begins his story of the Collection and its clerk. The latter works in the Library's copy-right department and "dreams of power and of creation. Of making some-thing of himself. And he dreams of his youth spent in his grandfather's movie house. On Saturday night he would sneak down in his pajamas and watch the films. He dreams of the film of her." Among the flood of early cinematic images accompanying this narration, two stand out: Edwin S. Porter's *Uncle Josh at the Moving Picture Show* (1902) and a fragile clip of a naked

woman reclining on a bed. The scene of a rube's primal encounter with cinema, in which Uncle Josh mistakes image for reality, anticipates the clerk's relationship to the second clip, the "film of her." This relationship will be inverted in the stag film itself, later shown sped up as the clerk gives his own account of his childhood, mention of "her" seemingly repressed. The stag actress plays an artist's model, nude but—in another echo of Gradiva—for her headband.[12] Rather than reproducing her figure on his canvas, a horny painter fondles and kisses her. The film slows down as the man unzips his fly, then freezes as the painters looks at his crotch while the woman stares directly at the camera. From early life to early cinema to individual childhood, this first section of *The Film of Her* endopsychically links a world-containing archive with a primal scene of archive fever.

As Morrison moves to the clerk's tragic adulthood, these two dreams—of "power and creation" and of "her"—are mutually implicated, but also mutually destructive. Following a genealogy of male heroes, from first filmmakers to heroic explorers, the clerk will try to rescue among the infinities of "past time" a fragile image of the nude actress. Repressing this finitude, Morrison's elderly-sounding clerk proudly describes his discovery of the Paper Print Collection just as it was to be incinerated for lack of archival space. Narrated in the thrilling terms of a cross-cut finale from a D.W. Griffith film—Morrison shows piano scores for *Broken Blossoms* (1919) and *Orphans of the Storm* (1921) as well as *Thief of Baghdad* (Walsh, 1924)—the archive would take the place of Griffith's passive heroine, but also act as the very means of rescuing the clerk's own (pornographic) version of Lillian Gish. The clerk not only saves the collection just in time, but is the first to realize what it holds: "I felt like Balboa when he climbed over the last hill and he saw the Pacific Ocean [. . .] I felt like I found forever there in that thing. We had the first of everything in that vault."[13] Yet among the infinite space of "everything" and infinite time of "forever," the clerk seeks only the film of her: "The curator searches the vault until at last he finds her. She is frozen in time. He wants only to restore her to the present time [. . .] The film of her is presently being re-photographed. She is as every bit as lovely as he had remembered." This oceanic feeling of re-discovery—of both the Collection's forgotten infinities and the clerk's treasured "her"— dissolves as the coming of World War II establishes other priorities and the clerk loses his job. The narrator describes a now forgotten clerk watching an unnamed, Kemp Niver-inspired figure on television win an Academy Award for restoring the Collection (as Niver did in 1955). No longer in a position of "power and creation," the archivist has no archival trace to call his own or to be his calling.

If "the film of her" is the archive's pre-text it is also its ruin as the curator never sees her again in her perfect state, having lost his job and any access to the promised restoration of his past. There is no moment of rescue or re-discovery. There is no oceanic witnessing and thus no oceanic feeling,

and the birth of his cinephilia can only be imagined. At *The Film of Her*'s climax, the clerk finally acknowledges the narrator's diverging account: "She's still restoring on some shelf somewhere, waiting to be called up, to be born again." At this moment, the film's two stories finally coincide so that the tragedy of misplaced credit is only of a piece with a more personal loss. Removed from the Library the clerk is exiled from the only restoration that ultimately mattered: not patriarchs Edison, Méliès, or Griffith, but rather a nameless "her."

The clerk resonates with other cinematic figures afflicted with endopsychic perception, intent on reanimating a woman from the past, whether *Vertigo*'s Scottie Ferguson or *The Last Tycoon*'s Monroe Stahr. Yet in contrast to these figures, or to the stag film's horny painter, Morrison's protagonist is not "in love" with a woman, but rather with the *image* of a woman and it is this he seeks to restore to the present. This is made clear in the first freeze of "her" during the clerk's description of his childhood, when she fades to black and is replaced by the final punch-line of *Uncle Josh at the Moving Picture Show*: its title character jumps at a dancing couple only to bring the screen and their image crashing down. What's more, this image has no consistency, being equal parts dream, paper print, celluloid copy, and mortal body. As with *Gradiva*'s Zoe, the presence of life becomes indistinguishable from a series of supplements. How can the past simultaneously disappear and be preserved? Does "the past" have the same meaning, identity, or affect from disappearance to preservation or are there rather excesses and elisions interrupting this time-travel?

Similar questions abound in parsing the language of both narrator and clerk: "The film of her is presently being re-photographed. She is as every bit as lovely as he had remembered." An abyssal deferral separates the "is" of each sentence: the film "is presently" not yet present, not yet fully restored but spectral she "is" the same as in the past, the same as in his memory of her. Both tense and reference lose all stability, disjoining not only from each other, but also from their own individual sense. The clerk's climactic acknowledgment of the narrator's story of her suggests a similar aporia: "She's still restoring on some shelf somewhere, waiting to be called up." Excluded from the archive and its bounty, the clerk can still cling to this desire for re-birth. Separated from "her" this fantasy is the pre-condition for his nostalgia, his way of negatively hallucinating the present away in the return to the oneiric world of his childhood. All tension between past and present, origin and copy dissolves, so that the stag film actress is forever "restoring" and "waiting," never decaying, never dying. Yet the price for resolving this tension is for all these divisions to return, as in any repression, with a vengeance so that the former clerk is separated, by both time and space, from the realm of her, the realm without separation, which Derrida calls "the nearly ecstatic instant [. . .] of when the very success of the dig must sign the effacement of the archivist:

the origin then speaks by itself. The arkhe appears in the nude, without archive."[14] This nudity is always spectral, the erotic beauty of its image and the passion both inspire dependent on a finite physicality effaceable only in fantasy. The woman stripped of clothes and the timelessness of a restored filmstrip would be indistinguishable, but the price of such frozen perfection is their removal from the clerk's finite universe of ever-ruining film, career, and life.

In linking the clerk's desire for "power and creation" to the frustrating yet flirtatious film strip of the stag actress as well as a subversive history of first films, *The Film of Her* exhausts a certain archive fever much in the manner of *Gradiva*. Yet through its mythic re-writing of the story of Howard Walls, the film demonstrates a way archive fever finds new fuel through which to burn. That fuel is a fantasy based on the promise of the female body, a patriarchival gambit in which conscious control of the archive is given up to maintain the purity of a "frozen image" denuded of time yet impossible ever to touch or see. Aurally, the clerk is introduced asking an "old philosophical question: If a tree falls in the wood and nobody is there to hear it does it really make a sound?" This existence of a tree falling—or paper print "restoring"—without a spectator to see it is short-circuited by fantasy, which preserves the ideality of an image stripped of time. In allegorizing Walls's story, Morrison asks less a "philosophical" question and more a psychoanalytic one, namely, whether this fantasy can ever be traversed. Will future archivists learn the clerk's lesson or will they rather find his tragedy all the more tempting? At its end, *The Film of Her* returns to where it began, repeating many of its own first images as well as an earlier text, now applied to new clerks who once more dream of "power and creation." Will these dreams carry the promise and peril of a "her"? In alluding to these tales of future archives, whether paper, celluloid, or digital, Morrison's images and voice offer no answer.

the tyranny of greece over the austrian avant-garde

The Film of Her's film of her is at once a perfect and paradoxical instance of Paolo Cherchi Usai's "Model-Image": an image so removed from the ruins endemic to celluloid, it cannot be made present let alone seen. Less an actual image and more an ideal condition for archival labor, the Model-Image is, in D.N. Rodowick's words, "an eternal and Platonic form," unbound by time or matter.[15] Usai echoes the narrator's account of an image "frozen in time," a coldness in tension with a burning passion that might cause the archivist "to fall prey to the illusion that the moving image can be frozen in time, as if it could no longer be affected by history."[16] And what better form for the Model-Image than that of the naked body of an artist's model? Indeed, Usai finds in early pornographic films a "counterpart" to his Model-Image, a way to overcome the distance implied by remove

from time or perception through visceral bodily response and fantasmatic potential.[17] The artist's model, taken for real by the clerk's Uncle Josh, is a perfect simulacrum of the "Platonic" Model-Image since its perfection, stripped of time's ruin or the fashions of history, requires the clerk's exile from its presence.

This endopsychic conjoining of the Platonic and the prurient is a story oft told in the archive. In her essay, "Working in the Archives," Alice Yaeger Kaplan describes an "archival passion," one that encourages the archivist to endopsychically perceive objects sought or found, narrating one's research as:

> versions of epic, Odysseus's travels, Diogenes's search for
> the honest man or the reliable fact. They are redemptive
> detective fictions with their single problem, their crime,
> waiting to be solved at the center of the labyrinth. Archival
> work is an epic, but it is also a dime novel, an adolescent
> adventure story.[18]

In Gustav Deutsch's *Film ist. a girl & a gun* this convergence of Greek, specifically Platonic myth and vulgar fiction is *modus operandi*. Deutsch is a prominent figure in the Austrian film avant-garde and, like many within that world, especially interested in creative recycling of found footage from less recent film history. He is often spoken of in tandem with Bill Morrison and *a girl & a gun*, like *The Film of Her*, hinges its mythological inventions on images from silent stag films. For *a girl & a gun* Deutsch sought out one of the largest collections of such films, held at the Kinsey Institute at the University of Indiana, re-filming numerous un-restored and decaying stag films in high definition and re-deploying them along with footage gathered at several other film archives.[19]

Film ist. a girl & a gun is only the most recent in a series of found footage works Deutsch has been making since the mid-1990s, inspired by film's centenary. To define film's being is for Deutsch always to ask what it was when it first came to be. Deutsch began gathering various definitions of film while simultaneously developing a series of projects expanding understandings of the history and ontology of the moving image. *a girl & a gun* is preceded by the entries, *Film ist. 1–6* and *Film ist. 7–12*, both of which sought to illustrate—through complex montage of silent film citations—Deutsch's crucial point: "Film is infinite, and infinitely meaningful. Film speaks many languages. Film is more than film."[20] Yet *a girl & a gun* breaks with the playful, unbound taxonomy of *Film ist. 1–12*, which focused on the scientific and fairground origins of early cinema. Its title alone imposes a limitation to serial excess. Here film cannot simply be defined as "more than film," open to endless formal or definitional difference. The various techniques of Deutsch's montage now construct one

188

particular definition of film (apocryphally) attributed by Jean-Luc Godard to D.W. Griffith: "All you need to make a film is a girl and a gun."

That film cannot be reduced to a mere number or to a single word implies a movement beyond definition and towards a mythology of cinema. Recalling Kaplan's claim, *a girl & a gun* combines the five-act structure of silent film melodramas (from which many of its images originate) with a mythological arc. These five acts' titles and respective themes are, in order, "Genesis," "Paradeisos," "Eros," "Thanatos," and "Symposium." Each act is organized through a series of citations from ancient Greek texts, specifically the *Theogony* of Hesiod, the poetry of Sappho, and Plato's *Symposium*. Here Deutsch takes the term "birthplace" both literally and mythologically, delivering from the early cinematic archive a re-birth of tales of creation, erotics, and war as old as Western civilization itself. Images from the infancy of cinema give visual illustration of myths from humanity's infancy. Psychoanalysis' own endopsychic perceptions—of Eros and Thanatos driving life on both cellular and civilizational scales—are especially relevant for this Austrian interested, like Freud before him, in the violent pleasures of sex and the sexual pleasures in violence.[21]

Just as film's being is multiple so too are the very definitions that make up this multiplicity, not least potential interpretations of Godard's two terms, "girl" and "gun." As minimal requirements for making a film there is no necessary relationship posited in between, but by the film's end we will see an overwhelming restriction in meaning: the female body is subjected to a masculine control that equates the camera's gaze with the sightline of a gun and the destruction of the earth with rape. At the film's beginning, however, we have a contrary meaning, suggested by Deutsch through a feminist interpretation: "All you need to stop a sexist is a girl with a gun."[22] A woman, dressed in Western fashion, shoots six targets with a rifle before a male assistant throws up several more into the air, which she then shoots, tracking each pigeon before pulling the trigger. The image is taken from William Dickson's 1894 filming of Annie Oakley in Edison's Black Maria, but is here tinted purple and accompanied by stabbing bursts of piano in time with each shot from Oakley's rifle. This scene introduces the archival territory upon which Deutsch maps his mythology: attractions from film's first decade; actualities, including documentary footage of World War I; along with scientific and travelogue films; central European melodramas of the 1920s and '30s, and a mixed bag of sex films depicting scientific examinations, masturbation, queer encounters, nude dancing and gymnastics, and explicit intercourse. It also introduces the means of his own archival play: selection and montage of clips, color tinting, a score composed by Christian Fennesz, Martin Stewert, and Burkhard Stangl, and intertitles culled from ancient texts. The film's alternation of text and image, separated by vast historical distances, works in both directions, re-casting the earliest dramas through eccentric fantasies and tawdry melodramas while

infusing early cinema with antique grandeur, an epic scale that cannot entirely shed its vulgar origins.

As I will argue, Deutsch mythologizes early cinema not on the level of its fragile, seductive materiality, as in *The Film of Her*, but through the images that form its archival corpus and announce its representational and narrative destinies, images that reveal both an ontology of film's being as well as a spectral femininity violently excluded by this ontology. Yet like the clerk and his artist's Model-Image, Deutsch elevates the woman into an ideal realm, a melancholic projection of a masculine principle he would claim to expose and critique.

Though I will focus on "Symposium," it is important to understand what brings *a girl & a gun* to this epilogue. The four preceding acts' visual entwinement of desire with destruction would seem to necessitate a philosophical reckoning with a tragedy at once anthropological and cinematic. This entwinement is clear right from the start: "Genesis" begins and ends with fiery explosion, using passages from Hesiod's *Theogeny* to give lurid image of the world's beginning. "Wide-bosomed earth" is a naked woman fondling her breasts for the camera. Images of cooling, once volcanic matter receive further form from "Eros, fairest among the Gods"—strongman Eugen Sandow, another star filmed in Menlo Park—who gives birth to "starry Heaven, equal to herself": a man, tinted blue, in close-eyed ecstasy, a woman's feet revealed behind him as he lifts up her legs for penetration. "Paradeisos" goes on to show an earth that is habitable, ready for human exploration and play. Hesiod's origin story gives way to Sappho's poetry just as Deutsch's montage shifts from the mythological figures of theatrical attraction to bourgeois tourists and nude gymnasts discovering a peaceful Eden full of blooming flora and fauna. In "Eros," paradisical landscapes disappear as Deutsch moves into the claustrophobic interiors of 1920s and '30s melodrama, an exile from Eden that makes nudity itself visible for the first time, a desirable object beneath fashion's second nature. With men become seductive voyeurs and women objects of their gaze, "Eros" consistently shows a desire defined by distance, masquerade, or lack. Covered by clothing, separated by the obstacles of the bourgeois interior, or lost to time, men seek women in films, photographs, stolen glances and, all these being insufficient, violent possession. "Thanatos" transforms artificial floridity into sexual combat and battlefield, both premonitions of human-made death rather than nature-endowed life. Linked across dozens of films, women and men are condensed into allegorical expressions of gendered destiny. No longer simply spied on or seduced, women are reduced to found objects, subjected to invasive examination, or pinned down for violation. So too is "wide-bosomed earth" destroyed, the conflation of nature and feminine flesh made clear by their mutual destruction. The archive of World War I footage consumes *a girl & a gun*, girl giving way to gun just as more female-focused archives of melodrama and pornography

give way to overtly phallic images of cannons, bombs, and charging or mutilated soldiers.

In concluding his film with an explanation of how the erotic and thanatological conspire to exile humanity from paradise, Deutsch turns to a related myth of humans reaching for the divine only to suffer punishment from the gods: Aristophanes's allegory of human desire in Plato's *Symposium*.[23] In this he recalls Freud, linking the libidinal life drives of Eros and death drives of Thanatos to an origin story the psychoanalyst discusses in *Beyond the Pleasure Principle*. Citing Aristophanes, Freud examines how these drives have their "origin" in "an instinct [Trieb] to *a need to restore an earlier state of things*."[24] If Deutsch, in his own archival drive, returns to cinema's "earlier state of things," he does so to suggest the ways these moments of cinematic birth explains the patriarchal violence that would dominate the twentieth century on film screens and battlefields alike.

The conclusion of "Thanatos" anticipates the myth central to "Symposium," with bursting reconnaissance balloons anticipating Deutsch's citations from Aristophanes's fable, specifically the circular shape of humans before their division. Three genders—male, female, and the "union of the two"—are modeled after three spherical bodies—sun, earth, and moon—but are split in half by Zeus as punishment for human rivalry with the gods. As Deutsch moves through the text of the fable, a range of images associate with these three classes of humans, from scenes of explicit or implicit copulation to soldiers carrying tires to microscopic images and cartoons of human reproduction on a cellular scale. After a series of images of scientific collaborations between men and women, Aristophanes's definition of Eros appears: "the desire and pursuit of the whole is called Eros." The sequence culminates in an image of Conrad Veidt from the gay rights film, *Different from the Others* (Oswald, 1919), sitting beneath a figure of male scientific (or perhaps psychoanalytic) authority. Veidt's eyes close and we see, in a dissolve initiated by Deutsch, his implied memory: a baby sucking at a woman's breast, tinted in golden yellow. Pairing stag and scientific imagery, Deutsch implies a libidinal basis for the preceding four acts, all-consuming male desire seeking not merely feminine objects to conquer, but as remedy for its own lack, one that might move time backwards to a primal scene of wholeness connoted by the womb.

In *a girl & a gun*'s final passage this reunion with maternal flesh becomes explicit. The conflation of Aristophanes's "whole" with a return to infancy—the hole of the nipple or birth canal and the whole of maternal reunion—reaches its apotheosis. This climax follows the conclusion of Aristophanes's fable: "we must praise the god Love for he will restore us to our original state, and heal us and make us happy and blessed." Recalling the clerk's only acknowledgment of "her" in Morrison's film—"She's still restoring on some shelf somewhere"—the desire for restoration also points to Usai's "Platonic" Model-Image. Deutsch moves to a doctor

191

manipulating, stretching, and massaging an infant on an examining table and then presenting to the camera, in an idyllic outdoor setting, the perfect form of the human infant.[25] An abrupt cut takes the viewer to a battlefield where a soldier, framed in the same dimensions as the doctor, shows a bomb to the camera. After a series of clips of sexualized interaction with military hardware, we see a soldier's hands unpack an explosive, each bag of munitions placed around a hole in their container's center. Deutsch dissolves from this hole to a pair of hands crudely exposing a woman's vagina. A triptych of holes is established in the film's concluding image, as Deutsch dissolves to an iconic image from early cinema: a hand-tinted shot from *The Great Train Robbery* (Porter, 1903) in which that film's villain faces the camera, lifting up a revolver to shoot straight at the camera, the pistol's barrel falling over a location previously occupied by the empty center of a bomb and violently exposed vagina. The film fades to black as the words "to be continued" conclude this latest entry in Deutsch's *Film ist.* series.

From Annie Oakley to "Barnes, leader of the outlaw gang" shooting at his audience, *a girl & a gun*'s final sequence suggests how far it has come from its feminist promise—"All you need to stop a sexist is a girl with a gun." Bookends for less known, less reputable genres in silent cinema, these images suggest the misogynist resonance of Griffith's Godard-attributed maxim as confirmed by film history. Indeed, paired with other Godardian definitions of cinema—"The history of cinema is boys photographing girls," "Cinema is truth twenty-four times a second," or Sam Fuller's statement in *Pierrot le Fou* (Godard, 1965), "Film is a battlefield"—*a girl & a gun*'s final sequence suggests an equation between the camera's truth-conferring gaze, industrial violence, and masculine agency, all at the expense of feminist film histories or ontologies. Pairing Porter's image, which, in Noël Burch's words, connoted for viewers "fascinated aspiration and forcible rape," with those of bombs and battlefields, the film's visual accent shifts from the nudities of paradise and the fashionable seductions of "Eros" to the warfare of "Thanatos."[26] Civilization's discontents are also cinema's, seemingly destined by the play of loss, desire, and aggression played out in both psychoanalytic and visual terms. "Symposium" suggests that all the viewer has seen is destined by desire itself and above all by the unique kind of desire that film has elicited within its chosen mythologies and archetypes. To seek a primordial wholeness against the deferrals of lost time, fashionable masquerade, or the resistances put up by the object of desire is no different from a will to destruction. Eros and Thanatos are not opposed as life and death drives, but rather they demand each other. The former's end, possession or consummation, is no different from a frustrated, resentful annihilation. Placing agency and action entirely in male hands and eyes, the feminine becomes associated with an impossible perfection equal parts femme fatale and maternal flesh. As the film's final triptych makes clear, one cannot have one without the other and this ambivalence extends to

the "wide-bosomed" earth as the ultimate object of male competition and conquest. Deutsch effectively offers a montage merging of feminist accounts of male gaze and feminine masquerade with the claims of theorists like Paul Virilio and Friedrich Kittler, for whom "The history of the movie camera [. . .] coincides with the history of automatic weapons."[27] To say "all you need to make a film is a girl and a gun" is to not only announce a generic destiny for cinema, but is to define film's being as inherently violent. The camera's eye meets the hole of a barrel's gun meets the (w)hole of the birth canal. Birth and murder overlap, through Deutsch's dissolve, to give an image of desire nostalgic only for the perfection of life's before and after: death.

Inspired by Aristophanes's fable Deutsch has suggested a potential escape from this equation between film and violence. Insisting that male and female principles operate in all humans, Deutsch has said that,

> when we learn as human beings to put more power and more energy into our female principles and in our female ways of living, then maybe something can change in the world [. . .] I can't find this vision in film footages, especially in the time of the footage with which I am working, the first four and half decades of filmmaking. The way scenes were dramatized, characters were developed, was male orientated."[28]

There is an underlying tension in Deutsch's statement, which might be dismissed for its naïve opposition. He suggests the possibility of an alternative principle based on femininity, but admits that in early cinema's archive, this principle is not visible. What images would this vision offer, what ways of seeing and being would it entail beyond the violent impulse of the camera's gun aimed at its seemingly destined and always passive target, girl? Convinced of this absence, what scenes does Deutsch miss or mis-read, those films where the relation between women and men complicate the conjoined destinies of "girl" and "gun"?[29]

Deutsch does not or perhaps cannot say and that is because, I would argue, his very notion of a female principle is no different from the ideal object of Aristophanes's circle, the circle of the maternal womb necessitating both nostalgia and violence in the form of the gun's own circular barrel. Feminist philosophers have tracked the many links between femininity and matter drawn by modern philosophers of misogyny like Freud's contemporary, Otto Weininger, as well as ancient philosophers like Plato, where the feminine is associated with finite matter and deceptive simulacrum.[30] Yet like Deutsch's impossible "female principle" there is another femininity one might discover among philosophers and psychoanalysts, less a denigration of the feminine body and more that body's elevation

into an impossible object dreamt by patriarchivists. What if there is a secret complicity between this ideal image and the seductive, dissembling, and maternal matter of women's bodies seen throughout *a girl & a gun*? In this case, the female principle would be only supplement—desired when ideal, denigrated when present—to a male principle critiqued, but also seemingly destined.

To understand this ideal femininity, I will conclude by returning to my starting point. Beyond Hanold's interest in Gradiva and her double, Zoe, there is another apt account of the desire underpinning both Morrison's eternal, yet unreachable "film of her" and Deutsch's invisible "feminine principle": Freud's 1912 essay "On Narcissism." There, Freud posits a "complete object-love" on the part of the "masculine type" "derived," he argues, "from the child's original narcissism."[31] To resurrect this wholeness no object works better than a narcissistic woman, who, rather than being a figure of masquerade or castration, attracts in the "self-contentment" she evinces.[32] Sarah Kofman describes Freud's dynamic in terms reminiscent of both Morrison and Deutsch's approaches to cinema's infancy:

> What is attractive in woman is that she has managed to preserve what man has lost, that original narcissism for which he is eternally nostalgic. It may thus be said that man envies and seeks that narcissistic woman as the lost paradise of childhood (or what he fantasizes as such), and is condemned to unhappiness: for if such a woman loves to be loved, she loves only herself, she is sufficient unto herself.[33]

Kofman perceives this dynamic between the obsessed male and the narcissistic female in terms both modern and ancient, connecting her allure to Greek terms like Aletheia, a name for truth "represented as a naked goddess" but more often relegated by philosophers to "an intelligible sky in which she can no longer be reached."[34]

Deutsch's montage of film archives violates this ideal image, critically conjuring the male principle and its misogynist vision. But, in doing so, it elevates a female principle to an ever-distant time/space, a version of desire no different from that offered up in Aristophanes's fable. Or, one might add, in the archaeological parable of *The Film of Her* where a "Platonic" Model-Image of the nude artist's model can be dreamed, but never touched. This assimilation of cinematic childhood to mythological childhood, an endopsychic return to the maternal flesh of first images, recalls an aside in Kaplan's essay, "Working in Archives," a rule of thumb the patriarchivist might well have to learn: "there is no mother lode."[35]

Another of Sarah Kofman's examples—Nietzsche's affirmative woman—allows me to return to my own beginning, the title "Supposing that the Archive is a Woman," a play on the first words of *Beyond Good and Evil* where it is truth supposed as woman.[36] There, Nietzsche mocks philosophers who have tried to woo this woman, Plato above all. Both *The Film of Her* and *Film ist. a girl & a gun* cannot help but recall, given their own Platonism, an aporia underlying this affirmative woman, one pointed out by Derrida: "A woman seduces from a distance. In fact, distance is the very element of her power. Yet one must beware to keep one's own distance from her beguiling song of enchantment. A distance from distance must be maintained."[37] This aporia between distance and a distance from distance structures Morrison and Deutsch's montages of erotic early cinema, where archive and woman play off each other in a game of presence and absence. They each shift from the "distance" of a woman lost to the past or "female principle" impossible to see and a "distance" from that distance, overcoming loss through the dream of perfect restoration or violent reunion. Rather than supposing that truth be a woman, both films suppose that the archive is a woman, a necessary mediation that might flirt with the presence of a primordial past, but which defers any becoming whole.

In concluding, I'd like to focus on the digital present hallucinated away by Morrison and Deutsch's endopsychic perceptions of the early cinematic archive. Mary Ann Doane has argued that this archive offers crucial resources for combating fantasies of timeless immateriality in the virtual age, so as to make media "matter," her key example Morrison's better-known *Decasia* (2002).[38] Yet, in a preceding text, Doane implies that the same fantasy was at play when film was a new media, connecting the desires it first elicited to a contemporary case study, none other than Jensen's novel, *Gradiva*: "It is the movement of Gradiva that activates Hanold's obsession and fuels his dream of presence. Chronophotography is the scientific sublimation of this fascination and the cinema the reactivation of its desire."[39] From the "dream and delusion" Freud diagnosed in Jensen's archaeologist to the film scholar's application of "dream" and "fantasy" to celluloid and pixel alike, making media "matter" begs a prior question: what does matter itself mean in light of the perceptions and hallucinations attracted to its presence, memory, or archiving? As we have seen, matter is often the stuff of patriarchival projection, one seeking a woman unveiled, possessed, or transcended as both embodiment and obstacle of desire.[40] Before approaching either present pixel or ruined celluloid it is worth asking what it means for images, whether analog or digital, paper prints or dreams, to matter, what matter itself might mean, archive, or represent across media and media histories.

This would require taking seriously André Bazin's suggestion to place "plastic arts" "under psychoanalysis," thinking how and why more recent but less obviously plastic arts, not only preserve the past, but compulsively attract fantasies of rescue and re-birth.[41] Moving to his next sentence, making media "matter" would also require a feminist account of the link between Bazin's "psychoanalysis" and the "mummy complex" the former would claim to "reveal."[42] This is Bazin's own endopsychic perception of cinema, linking ancient archiving, modern cinephile, and a maternal desire punningly disavowed. Feminist and psychoanalytic critique have much to contribute to the media archaeology often in dialogue with Bazin's ontology, approaching media's matter by interlacing the technological, the somatic, and the libidinal. Recalling another archaeologist, Norbert Hanold, these intersections might disrupt the tidy sedimentation or linear development of media regimes, finding uncanny returns across antique, modern, or post-modern epochs.

What remains disavowed in "The Ontology of the Photographic Image" is directly stated across the canons of film theory. These range from Bazin's mourning of film's ceaseless historical change, embodied by anachronistic-looking actresses who no longer seduce, to Jean-Louis Baudry's analogy between the cinephile's "blind" "passion" for movies and "those lovers who imagine they love a woman because of her qualities or because of her beauty."[43] A more recent analogy between film and female can be found at the start of D.N. Rodowick's *An Elegy for Theory*: "Film is historical in an archaeological sense: an object lost to history that cannot be recovered [. . .]. Consequently, one seeks in digital images an experience that cannot be fully replaced, like widowers who have not yet learned to admire a worthy and seductive lover."[44] Here the mournful cinephile is an explicitly male figure while film is cast as a dead woman, one who might be imagined, but never resurrected by digital masquerade. Like Morrison's clerk or the archaeologist turned fetishist Hanold, the indexes of past life are desired both despite and because of the very distance these frozen impressions mark.

This male melancholic look at the past through an archive supposed as woman has its inversion in the dreams cinema offered early on, when it was once new media. On the other side of the endopsychic image of Pompeiian ghost or antique film strip, there are male projections resisting elegy or archive fever through a techno-philic utopia, woman and medium conflated and controlled by genius men. Writing in the decade prior to cinema's debut, Villiers de l'Isle-Adam would, in his novel *Tomorrow's Eve*, cast Thomas Edison as a romantic savior, inventing a perfect machine-woman, Hadaly, for a heart-broken aristocrat. As a replacement for a superficial woman of flesh and blood, the figure of Hadaly suggests the complicity between the elegiac and the utopian, as well as the misogyny of idealizing women at the expense of their existence, their mattering. The strongest indication of this

complicity is the title, "Tomorrow's Eve," a dream of a future femininity as ideal as that of primordial mother. Hadaly has been seen by many as a harbinger not only of cinema, but of a certain fantasy of the medium and its obsessions, one linking mass culture, technology, and gendered bodies, stretching from Siegfried Kracauer's "The Mass Ornament" and Fritz Lang's *Metropolis* (1927) to Donna Haraway's "A Cyborg Manifesto" and *Ghost in the Shell* (Oshii, 1995), not to mention one of media archaeology's supposed patriarchs: Marshall McLuhan and his early essay, "Love Goddess Assembly Line."[45] The title of the collection containing that essay, *The Mechanical Bride: Folklores of Industrial Man*, likewise points to a whole range of texts, images, and objects mingling technological means with female bodies, including Marcel Duchamp's brides, Alan Turing's imitation game for distinguishing men from women, and Edison's phonographic dolls, unwitting contemporaries of his fictional Hadaly.[46] As we think about cinema's antique-utopian past, about Yesterday's Hadaly, as it were, we must work through the fantasies projected on that past through the vantage of our digital present, to read Morrison's celluloid "Her" with the eponymous Operating System of Spike Jonze's *Her* (2013), *Tomorrow's Eve* alongside Ava, the fembot singularity in Alex Garland's *Ex Machina* (2015). To make media matter one must ask how such matter is dreamt, whether by cinephilic scholars, digital effects specialists, fevered avant-gardists, or by media themselves, those means by which bodies and machines, epochs and ideals are supposed.

notes

1. On the "endopsychic," see Laurence Rickels, "Musicphantoms: 'Uncanned' Conceptions of Music from Josephine the Singer to Mickey Mouse," *Sub-Stance* Vol. 18, No. 1, Issue 58 (1989): 10–14.
2. On Freud's famous interest in archaeology, see Peter Wollen, "Freud as Adventurer," *Paris Hollywood: Writings on Film* (New York: Verso, 2002), 105–122.
3. Sigmund Freud, "Delusions and Dreams in Jensen's *Gradiva*," in *Writings on Art and Literature*, trans. James Strachey (Stanford: Stanford University Press, 1997), 45.
4. *Ibid.*, 59.
5. These include "Medusa's Head" and "Fetishism" in Sigmund Freud, *Sexuality and the Field of Love*, ed. Philip Rieff (New York: Touchstone, 1997), 202–209.
6. Jacques Derrida, *Archive Fever: A Freudian Impression*, trans. Eric Prenowitz (Chicago: University of Chicago Press, 1998), 98.
7. *Ibid.*, 4. On Derrida, *Gradiva*, and the relationship between the feminine and philosophy, see Catherine Malabou, "Woman's Possibility, Philosophy's Impossibility," in *Changing Difference*, trans. Carolyn Shread (Cambridge: Polity, 2011), 90–141.
8. There is also Roberto Rossellini's *Voyage to Italy* (1954), where modern marriage is given relief through a Pompeiian couple, the instant of their death frozen and preserved. See Raymond Bellour, "The Film Stilled," *Camera Obscura* Vol. 8, No. 3 24 (1990): 109–110.

9. See Janet Malcolm, *In the Freud Archives* (New York: Knopf, 1984).

10. See Kemp Niver, *Early Motion Pictures: The Paper Print Collection in the Library of Congress* (Washington D.C.: Library of Congress, 1985).

11. Gabriel Paletz, "Archives and Archivists Remade: The Paper Print Collection and *The Film of Her*," *The Moving Image* Vol. 1, No. 1 (Spring 2001): 68–93.

12. See Wilhelm Jensen, "Gradiva: Ein Pompejanisches Phantasiestück," in Sigmund Freud, *Der Wahn und die Träume in W. Jensen's "Gradiva"* (Frankfurt-am-Main: Fischer, 2009), 129.

13. Tom Gunning begins his study of Griffith's early Biograph films with the story of Walls's discovery, describing it in terms anticipating Morrison's film. See his *D. W. Griffith and the Origins of American Narrative Film* (Champaign: University of Illinois Press, 1993), 1–2.

14. *Ibid.*, 92.

15. D.N. Rodowick, *The Virtual Life of Film* (Cambridge, MA: Harvard University Press, 2007), 20.

16. Paolo Cherchi Usai, *The Death of Cinema: History, Cultural Memory and the Digital Dark Age* (London: BFI, 2001), 101.

17. *Ibid.*, 81.

18. Alice Yaeger Kaplan, "Working in Archives," *Yale French Studies* Vol. 77 (1990): 103–104 and 107.

19. Linda Williams has written about this collection in " 'White Slavery' Versus the Ethnography of 'Sex Workers': Women in Stag Films at the Kinsey Archive," *The Moving Image* Vol. 5, No. 2 (Fall 2005): 107–134.

20. Quoted in Alexander Horwath, "Kino(s) der Geschichte: Dark Rooms, Speaking Objects, More than Film: Gustav Deutsch as a Museum Maker," in *Gustav Deutsch*, eds. Wilbrig Brainin-Donnenberg and Michael Loebenstein (Vienna: Austrian Filmmuseum/SYNEMA, 2009), 124.

21. See Beate Hofstadler's "All you need to make a movie is a girl and a gun—All you need is love: Film ist. Seen Through Psychoanalytic Eyes," in *Gustav Deutsch*, 200–206; Tom Gunning, "From Fossils of Time to a Cinematic Genesis: Gustav Deutsch's *Film ist*," in *Gustav Deutsch*, eds. Brainin-Donnenberg and Loebenstein, 173–180.

22. Scott MacDonald, "A Conversation with Gustav Deutsch (Part 2)," in *Gustav Deutsch*, eds. Brainin-Donnenberg and Loebenstein, 159.

23. Tom Gunning has written about this myth's manifold relationship to cinema in "The Desire and the Pursuit of the Hole: Cinema's Obscure Object of Desire," in *Erotikon: Essays on Eros, Ancient and Modern*, eds. Shadi Bartsch and Thomas Bartscherer (Chicago: University of Chicago Press, 2005), 261–277.

24. Sigmund Freud, *The Standard Edition of the Complete Psychological Works: Volume 18*, ed. James Strachey (London: Hogarth Press, 1960), 57 (hereafter cited as SE). See also *Three Essays on the Theory of Sexuality*, SE: 7, 136. Emphasis in original.

25. This footage shows pediatric physical therapist Detleff Neumann-Neurode and was shot during the Third Reich. The same sequence is cited in *Sweet Movie* (Makavejev, 1974).

26. Noël Burch, "Porter, or Ambivalence," *Screen* Vol. 19, No. 4 (1978): 101.

27. Friedrich Kittler, *Gramophone, Film, Typewriter*, trans. Geoffrey Winthrop-Young and Michael Wutz (Stanford: Stanford University Press, 1999), 124.

28. Brandon Harris, "Interview: Gustav Deutsch, *FILM IST. a girl & a gun*": http://cinemaechochamber.blogspot.com/2009/12/interview-gustav-deutsch-film-ist-girl.html. Accessed 8 June 2012.

29. Over the last several decades, early film scholars have provided a range of images, texts, and analyses that undermine Deutsch's claim. For a selection of this scholarship see *A Feminist Reader in Early Cinema*, eds. Jennifer Bean and Diane Negra (Durham, NC: Duke University Press, 2002).

30. See Luce Irigaray, *Speculum of the Other Woman*, trans. Gill (Ithaca: Cornell University Press, 1985); Judith Butler, *Bodies that Matter: On the Discursive Limits of "Sex"* (New York: Routledge, 1993), 21–92; Elizabeth V. Spelman, "Woman as Body: Ancient and Contemporary Views," *Feminist Studies* Vol. 8, No. 1 (Spring 1982): 109–131. On Weininger, see Slavoj Žižek, *The Metastases of Enjoyment: On Women and Causality* (New York: Verso, 2005), 137–164.

31. Freud, SE: 14, 88–89.

32. *Ibid.*

33. Sarah Kofman, *The Enigma of Woman: Woman in Freud's Writings* (Ithaca: Cornell University Press, 1985), 52.

34. *Ibid.*, 95.

35. Kaplan, "Working in the Archives," 116.

36. Friedrich Nietzsche, *Beyond Good and Evil*, trans. Walter Kaufmann (New York: Vintage, 1989), 1.

37. Jacques Derrida, *Spurs: Nietzsche's Styles*, trans. Barbara Harlow (Chicago: University of Chicago Press, 1979), 49.

38. Mary Ann Doane, "The Indexical and the Concept of Medium Specificity," *differences* Vol. 18, No. 1 (2007): 146.

39. Mary Ann Doane, *The Emergence of Cinematic Time: Modernity, Contingency, the Archive* (Cambridge, MA: Harvard University Press), 220.

40. Doane has written of this intersection of gender and media in "Technology's Body," *differences* Vol. 5, No. 2 (Summer 1993): 1–23.

41. André Bazin, *What is Cinema?*, trans. Hugh Gray (Berkeley: University of California Press, 1967), 9.

42. *Ibid.*

43. Bazin's complaint is cited in Brian Jacobson's "Found Memories of Film History" in this volume. See Jean-Louis Baudry, "Author and Analyzable Subject," in *Apparatus*, ed. Theresa Hak Kyung Cha (New York: Tanam Press, 1980), 68.

44. D.N. Rodowick, *An Elegy for Theory* (Cambridge, MA: Harvard University Press, 2014), 1.

45. Among the many texts on *Tomorrow's Eve*, see Raymond Bellour, "Ideal Hadaly," *Camera Obscura* Vol. 5, No. 3 15 (1986): 110–136; Marshall McLuhan, *The Mechanical Bride: Folklore of Industrial Man* (London: Routledge & Kegan Paul, 1967), 93–106.

46. On Turing's test, see N. Katherine Hayles, *How We Became Posthuman* (Chicago: University of Chicago Press, 1999), xi–xiv. On Edison's dolls, see Julie Wosk, *Women and the Machine: Representations from the Spinning Wheel to the Electronic Age* (Baltimore: Johns Hopkins University Press, 2001), 76–77.

the life cycle of an analog

medium: tacita dean's *film*

eleven

jennifer lynn peterson

> Today, hardly anything happens in the world [...] that is not
> swiftly captured on film and shown to a cinema audience in
> the whole world.
>
> (Emilie Altenloh, 1914)[1]

Although it is a work of silent film made using analog processes, Tacita
Dean's *FILM* (2011) is a resonant intervention into contemporary digital
media culture. A celebration of 35mm on the eve of its apparent demise,
FILM is a wondrous feast for the senses, displaying a masterful deploy-
ment of film's most basic formal elements such as composition, color,
montage, and movement. A large-scale vertical projection running in an
eleven-minute loop, *FILM* was commissioned as part of the high-profile
Unilever Series for the Turbine Hall at the Tate Modern in London, where
it was installed for five months in 2011 and 2012 (figure 11.1). *FILM* is
entirely non-narrative, devoid of characters and the trappings of fiction
that define the cinema for the majority of its spectators and fans. But the
work offers a rich series of visual attractions that render it accessible to a

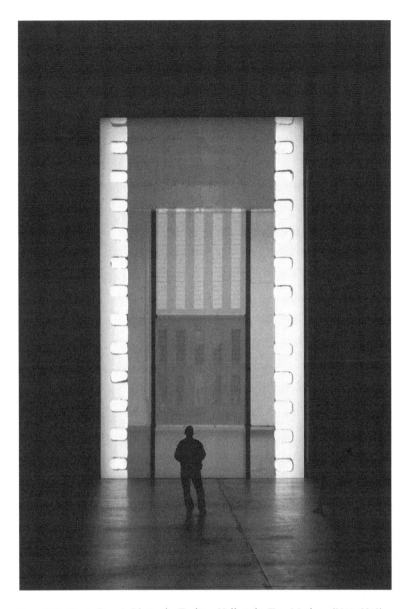

Figure 11.1 Tacita Dean's *Film* in the Turbine Hall at the Tate Modern (2011–2012).

generalist audience as well as a specialist audience of seasoned avant-garde filmgoers. It is hardly an exaggeration to call it a smash hit: the piece received largely rave reviews and was widely covered in the art media and the general press (receiving coverage in major British newspapers such as the *Guardian* and the *Telegraph*, along with a feature story in the *New Yorker*).[2] Hugely popular, the piece was dubbed a "stunning success" by no less than Rosalind Krauss.[3]

FILM was conceived and designed specifically for the Turbine Hall, a vast space that runs the entire length and height of the Tate Modern building. During the course of its eleven-minute loop, *FILM* presents a series of seemingly unrelated images: waterfalls, an escalator, tomatoes, a watch, an eye. *FILM* uses a widescreen format that has been turned on its side, so that it appears tall and thin, like a monolith. Some images emphasize verticality while at other moments *FILM* breaks the vertical frame into smaller units to create a split-screen effect.[4] One of *FILM*'s major visual motifs is the exterior wall of the Tate Modern itself, whose narrow vertical windows form a prominent design feature of the historic building. (The building was originally the Bankside Power Station which opened in 1952; it was redesigned by architecture firm Herzog & de Meuron in 2000.) Within the space of the Turbine Hall, these windows are located directly behind where the large thirteen-meter screen was placed for the *FILM* projection (on the east wall of the hall), creating a doubling effect in which spectators frequently saw a film image of what literally existed behind the screen. This architectural image of a wall with vertical windows gestures toward the historical and industrial significance of the original building. At one point, a large bubble floats down in front of this wall-window image. Later, a large egg is superimposed in front of it. At another point, the wall-window image is divided into eight different geometrical shapes that pulse with different colors, giving the heavy industrial wall a dynamic stained glass effect. *FILM* also features a repeated image of a mountain—yet another reference to verticality, as well as a signifier of the natural or analog world. The mountain image is inspired by *Mount Analogue*, an allegorical novel by René Daumal about climbing a difficult-to-perceive mountain. The mountain appears superimposed in front of the wall-window image; then a second image of the mountain appears, upside down and underneath the first; then a third mountain. At some point, the mountain appears enshrouded in fog at its base. This mountain image—also a wry reference to the Paramount Pictures logo—lends *FILM* an allegorical dimension that separates it from Dean's other work.

In the press coverage of *FILM*, along with its companion exhibition book, the piece is understood to be about Dean's anachronistic use of 35mm in the twenty-first century and her defense of photochemical film as a medium that should continue to exist in the digital era. However, *FILM* is not simply a plea for an analog medium in the digital age, as it has been characterized. For despite its deeply materialist exploration of the filmic medium, and despite its polemical plea for the continued manufacturing of analog film stock, the digital nonetheless has emerged as a significant side effect of *FILM* as it continues to live online in the form of spectator videos posted on YouTube, Vimeo, and other sites. While the piece does indeed demonstrate the persistence and even resilience of the analog, *FILM* is also a meditation on historicity that revives the seemingly obsolescent technology of cinema

even while it helps us imagine a new multimedia future in which the digital is one of many technologies. This is a work about the death and renewal of a medium. Perhaps counter-intuitively, the life cycle of *FILM* actually makes a case for the co-existence of the analog and the digital.

FILM's five-month run at the Tate, from 11 October 2011 to 11 March 2012, coincided with a crucial period in the history of photochemical film.[5] 2012 was the year that a majority of movie theaters worldwide converted from 35mm to digital projection. Just a few years later, 35mm has been almost completely phased out of commercial theaters worldwide.[6] This change, which has major implications for exhibition, access, and preservation, was marked by many stories in the popular press, with one writer proclaiming that, "The year 2011 is the most important one for cinema since 1927" (the year of the transition to sync sound).[7] In February 2012, a few weeks before *FILM*'s Tate exhibition closed, a large "Celebration of Film" event was held at the Turbine Hall with 800 invited guests from the British film industry. This event was staged in part to support a campaign (still underway) asking UNESCO to recognize photochemical film as a significant world cultural heritage artifact.[8] *FILM* is thus a portrait of a medium at a particular moment in time: an endangered species facing possible extinction. For Dean, who has become an outspoken defender of photochemical film, the issue is one of "grieving the potential loss of my medium."[9]

I would like to suggest that while *FILM* fits into the category of the experimental or artist's film (and its concomitant exploration of cinematic medium), it can actually be better understood in the context of its singular invocation of historicity. More precisely, *FILM*'s resonance with early cinema (as image, technology, and experience) allows us to view the medium of film *in the present moment* against the backdrop of its long history as a complex intermedia technology. *FILM* contains images that seem to have time-traveled from early cinema such as giant mushrooms, waterfalls, industrial smokestacks, and waves lapping at the seashore. Moreover, many of *FILM*'s analog production processes can be traced back to the techniques of Georges Méliès and Norman Dawn, including extensive use of multiple exposures and glass matte painting. A favorite early cinema technique—in-camera masking—is used throughout *FILM* to create the image of sprocket holes running down the left and right of the frame. One section was colored using the silent-era process of color tinting. Finally, as a museum installation, *FILM*'s simulation of a "cinematic" mode of address recreates the space of film in its historical dimension, emphasizing cinema as a public experience in which a large moving image is projected before a group of strangers gathered in a darkened room. But *FILM* adds something new to this experience of "cinema," and this is a mark of its timeliness: *FILM*'s monumentality, its looming vertical frame resembling a monolith or a gravestone, transforms cinema spectatorship into an experience

of reverence and mourning. *FILM* is, in sum, a grand experience of plenitude and loss, pitched with an understated yet fundamental sensitivity to historical time.

FILM asks us to consider nothing less than the materiality of film as a historical subject: its photochemical base, the camera, special effects, editing, the projector, and how these technologies have different meanings in different eras. The cinematic *dispositif* or apparatus that once seemed so iron-clad to film theorists of yore (projector/light/screen) has been vanquished, and is put on display not for its ideological effects (à la Jean-Louis Baudry) but for its historical resonance. In fact, despite its evocation of early cinema and the long history of photochemical film, the piece is entirely contemporary; not only has it been shaped by concerns about the materiality of analog media, but these very concerns are a product of the digital age. While it uses only analog material and processes—and indeed, it would not have the same visual quality or power if it had been made using digital techniques—*FILM* is resolutely a work of the digital era.

As a kind of requiem for film, *FILM* explores what it might mean to mourn the passing of a medium. But what is surprising and perhaps unexpected is *FILM*'s digital afterlife. For *FILM* has, ironically enough, found a robust online presence in spectators' videos posted online. These videos have been shot on smart phone cameras and feature the familiar poor technical qualities associated with amateur video. And yet these digital forms of *FILM* provide *access* to a work that is no longer viewable, and which, as a site-specific installation, was never accessible to everyone in the first place. *FILM* is thus a work that is both *about* history and a work that already *has* a history of its own. *FILM* provides us with a singular opportunity to think through shifting perspectives on film history, as well as the significance of the analog, at this transitional moment in the so-called digital age.

analog work/digital circulation

Here I must fess up: I myself have only experienced *FILM* online. I have watched the many digital copies of *FILM* that have been posted on YouTube, Vimeo, and other sites, and I have looked at numerous ancillary and related images and texts in art magazines, blogs, and other sources. But I was unable to travel to London during the five months it was installed at the Tate. I am familiar with the Turbine Hall from other visits before and after *FILM*'s exhibition, and I have discussed the piece with friends and colleagues who saw it when it was installed there. I have seen a number of Dean's other films in person, including two works that immediately followed *FILM*: *JG* (2013) and *Buon Fresco* (2014). I have also been fortunate to interview Dean in person and I shall quote from that interview here. But I have not experienced *FILM* in its analog form, as an installation with a material presence in a specific time and place. Rather, I have looked at

digital versions of the piece on small two-dimensional screens, rather like sketches or documentary fragments. I have experienced *FILM* as a collection of mostly digital traces.

The issue of writing about an artwork one has not experienced in person has been a topic of discussion in performance studies. Amelia Jones argues that, "while the experience of viewing a photograph and reading a text is clearly different from that of sitting in a small room watching an artist perform, neither has a privileged relationship to the historical 'truth' of the performance."[10] Jones's larger point is that "there is no possibility of an unmediated relationship to any cultural product," including even live performance.[11] The problematic of writing about analog films that one has viewed digitally is somewhat different. Since the dawn of the video era in the 1980s, film scholars have regularly analyzed films they have not seen in the theater. Nobody remarks at this, and in fact scholars almost never make note of the exhibition contexts in which they viewed the films they write about. This is because film's relationship to concepts of presence and originality is always already fraught: as a mechanically reproduced art form, analog film's status as auratic has always been questionable in the first place. But analog film's position has changed with the shift to digital; since digital media lack the materiality of analog film, photochemical film prints have come to take on the character of originals. Theatrical distribution prints of films are not originals, of course, but copies. A work made for museum exhibition such as *FILM*, however, contains an element of site-specificity and "liveness" that theatrical films do not have. *FILM* is not live in the way that performance art is live, but neither is it reproducible in the way a theatrical film print is reproducible. What is lost when one views *FILM* online is not only the materiality of analog film—its quality of light, color, grain—but also the large-scale presence of the work in a particular space.

Changing the reception context of *FILM* quite obviously changes the experience of *FILM*. But nobody would claim that watching *FILM* on YouTube is equivalent to having seen the piece in the Turbine Hall. These digital copies are documents of the original installation, and they function like other traces—photographs, reviews, descriptions—to provide an account of a work that can no longer be seen in its original form. More importantly, these digital copies call attention to the mediated nature of film as an aesthetic experience in the first place. When one stands (or sits) before a projected film print, what is there to verify that one is experiencing the true "essence" of the work anyway? All of these issues circle around the well-trodden Benjaminian concept of aura, of course, and I will not rehearse a discussion of that concept here.[12] This much is clear, however: the digital copies of *FILM* facilitate new ways of experiencing the work that are less about authenticity and more about circulation, hybridity, and even (potentially) futurity. As any historian knows, historical traces are always

fragmentary; what is interesting here is to observe the fragments at the moment of their emergence. While I share Dean's sense of loss about the phasing out of photochemical film, I am grateful for the digital media that have enabled me to see some version of *FILM* when I could not otherwise do so, and I am grateful for *FILM*'s continued digital presence now that it no longer exists as an installation. Even Dean herself told me that she doesn't mind the YouTube versions of *FILM* because now, "that's the only way *I* can see it."[13] Ironically, it is the digital that has enabled the circulation of this analog piece, and digital media that have amplified the cause for saving analog film through various petitions and campaigns making the rounds on social media.

As film grain has been transformed into digital pixel, the debate about the ontology of cinema has been revisited by a number of scholars and artists who have been exploring questions of indexicality and materiality in analog and digital media. From one perspective, media convergence across digital platforms threatens to dissolve not only the specificity of cinema as a medium but to render the very experience of cinema itself a historical relic. From another perspective, however, the shift to digital is just another transition—albeit a radical one—in an ongoing history of screen practice. As recent scholarship in new media and archival studies has argued, moving image media have always been transitional in nature. David Thorburn and Henry Jenkins write, "to focus exclusively on competition or tension between media systems may impair our recognition of significant hybrid or collaborative forms that often emerge during times of media transition."[14] Rather than a one-sided story in which digital cinema marches to its inexorable triumph over photochemical film, which lies vanquished and abandoned in the scrap heap with other so-called dead media, *FILM* and its digital afterlife can help us to see the transition to digital as a complex and unpredictable example of different media coexisting and overlapping. If we adopt the long view of film history from a media archaeology perspective, 35mm film is but one iteration in an ongoing history of screen practice. As film archivist Giovanna Fossatti has observed, "Old media never disappear completely."[15]

I argue that *FILM*, for all its celebration of the rich sensorial pleasures of photochemical film, actually demonstrates the compatibility of the analog and the digital. *FILM*'s digital afterlife facilitates new kinds of experience that may be diminished from the perspective of medium specificity, but these experiences are valuable in their own right. Viewing *FILM* online, one experiences a different sense of plenitude and loss. What has been lost is not only the aesthetic density of 35mm, but also the presence of the original installation. However, *FILM*'s digital afterlife enables one to transcend the limitations of geographical, physical, and temporal embodiment. The abundance of digital copies currently available feels like a kind of plenitude—but this digital plenitude is not without its own set

of problems. Digital media are notoriously ephemeral. Users can delete their videos at any time. YouTube (owned by Google) and Vimeo (owned by IAC/InteractiveCorp) are both corporate-owned commercial entities, and could change their policies, reorganize, or even vanish, which would put an end to *FILM*'s online afterlife. Ultimately, the dance of the analog and the digital enabled by *FILM* calls attention to the fact that the kinds of reciprocity and engagement spectators have with film has been caught up in a paradoxical dynamic of absence-presence since film's inception. As this essay's epigram by Emilie Altenloh attests, even in the 1910s filmic documentations of events were already "swiftly captured on film" and circulated around the world. And as film historians are well aware, photochemical film prints from the silent era also proved largely ephemeral. What has changed is the nature of this absence-presence in the digital age. A larger consideration of these stakes is beyond the scope of the present essay. For now, I turn to a close examination of *FILM* for what it can reveal about film history, mourning, and renewal.

an historical interest in sinking ships

Dean is a British artist, based in Berlin. She has been working with film since the early 1990s, producing over forty films on 16mm. Her work also encompasses drawing, collage, photography, and sound recordings. Dean's reputation has been well established in Europe for some time (she was nominated for the Turner Prize in 1998), and she has been the focus of increasing attention in North America in the past several years, although to date she has not had a major retrospective in the U.S., and there has been only limited scholarship published on *FILM*. Dean is known for her steadfast commitment to analog modes of visual representation.[16] Indeed, her solo retrospective in 2006 at the Schaulager in Basel, Switzerland was called "Analogue." Dean's work might best be described as portraiture, although that term sounds too conventional to encapsulate what her work achieves. Her films are characterized by a patient observational style manifested in long takes and a stationary camera. She has made a number of portrait films of artists; her 2012 show at the New Museum in New York, "Five Americans," included works about Merce Cunningham, Cy Twombly, Claes Oldenburg, Julie Mehretu, and art historian Leo Steinberg, for example.[17] Her most recent film, *Buon Fresco* (2014), closely depicts the frescoes of Renaissance painter Giotto di Bondone in the Upper Basilica of St. Francis in Assisi. Dean also makes portraits of places, architecture, and industrial processes. *Fernsehturm* (2001) depicts the interior of the rotating restaurant inside the Fernsehturm television tower in Berlin, and *Darmstädter Werkblock* (2007) was filmed in the seven rooms of Joseph Beuys' installation "Block Beuys" as it was being refurbished at the Hessian State Museum in Darmstadt, Germany. *Kodak* (2006), which functions as an

important precursor to *FILM*, documents the last days of 16mm film production at the now-defunct Kodak manufacturing plant in Chalon-sur-Saône, France.

As almost every commentator has noted, Dean returns to themes of anachronism, obsolescence, and loss throughout her work.[18] In a chapter from her recent book *Exhibiting Cinema in Contemporary Art*, Erica Balsom analyzes Dean's work (produced before *FILM*) as a form of "cinematic ruins."[19] As Dean herself has jokingly remarked, "I [have] had a historical interest in sinking ships."[20]

I would like to suggest that we might think of Dean's work not only in terms of its focus on obsolescence—the interest in sinking ships—but also in terms of its historicity: this interest is specifically (if obliquely) historical. (The word "historical" in Dean's phrase doubly refers to her own history and to history in general.) The historicity in Dean's film work can be found most simply as a series of references, but also appears as a deep engagement with concrete actuality in specific times and places. Some of the references are obvious: Dean's film *The Green Ray* (2001) recalls Eric Rohmer's film *The Green Ray* (1986); the music playing in the restaurant at one point in *Fernsehturm* is Strauss' "Blue Danube Waltz," which is famously heard in Stanley Kubrick's *2001* (1968). A number of Dean's film works also resonate with early film subjects (nature, landscape, industrial production), a reference point that is not likely to be noticed by the majority of viewers who are unfamiliar with early cinema. *Pie* (2003) depicts the magpies outside Dean's Berlin studio; *Baobab* (2002) depicts the fantastically shaped trees of Madagascar; and *Banewl* (1999) depicts a Cornwall farm landscape with cows during an eclipse of the sun. All three of these films echo early cinema's abundant nature study subjects such as birds, trees, and farming. While these shared interests with early cinema may not be deliberate, the resonance gains relevance when one considers that Dean's films confront the world as a landscape of endlessly fascinating material details, just as early cinema discovered in the world an endless list of phenomena to document. The historicity in Dean's work is in keeping with what has been dubbed the "temporal turn" in contemporary art. As art historian Christine Ross argues, much contemporary art works to free "the three categories of time (past, present, and future) [. . .] activating the past in the present and allowing it to condition the future in that very process [. . .] [in order] to remove the future from its modern role—the role of initiator of change—and make room for the reimagining of the future."[21] *FILM* looks back to early cinema as a way of arguing for a different future for art.

As an artist working in the realm of "white cube" exhibition in galleries and museums, Dean's work can be difficult to see. Her work eschews the many distribution platforms available in the digital age. Unlike the theatrical circuit that exists for experimental film (including film festivals and a small number of cinematheque theaters), Dean's films are unavailable for

theatrical screenings and unreleased on DVD. As with many artists work-
ing in film, Dean's films are printed in limited editions, which are then sold
to museums or art collectors. As Balsom puts it, "It becomes a privileged
experience to be present before a Tacita Dean film, to share a room with it
for a particular duration of time, and an even more privileged experience
to purchase one of four editions in existence at a cost of €80,000."[22] The
closely guarded scarcity of the prints is what gives them their economic
value as art objects. If a regular viewer misses the gallery run of a Dean
exhibition, that viewer is basically out of luck if she wants to view it else-
where. Dean's films are almost entirely unavailable online, and only acces-
sible to the public when installed (temporarily) in gallery and museum
settings. (One exception is *The Green Ray*, which is available on Vimeo in an
official video produced by Tate Media. *The Green Ray* is a silent film, how-
ever, and this digital version appears with a related but separately recorded
voice-over narration read by Dean, much to her chagrin.)[23] These gallery
installations, moreover, produce a specific spectator experience that is dif-
ferent from a theatrical experience. According to Dean, only a few of her
films such as *The Uncles* (2004), *Craneway Event* (2009), and *Edwin Parker* (2011)
are allowed to be shown in a cinema. She has said, "Generally I don't show
my films in cinemas because I cannot control the way they are shown, the
scale of the screen, the light, the height, and to some extent the audience.
My works are installed as one installs a sculpture or painting."[24]

Exhibition and circulation constitute a hugely important dimension
of contemporary avant-garde film practice, and it is crucial to understand
the distinction between works exhibited in the "black box" of the theater
versus works shown in the "white cube" of the gallery or museum space.
In a useful article, Jonathan Walley has elaborated upon this distinction
to trace what can be thought of as two distinct modes of avant-garde film
practice: experimental film versus the artists' film. According to Walley,
experimental film tends to be personal and artisanal and relies on the dis-
tribution network of film rentals (through distribution organizations such
as Canyon Cinema and the Filmmaker's Cooperative). The artists' film, in
contrast, is often collaborative, and eschews theatrical distribution in favor
of the art gallery or museum.[25] Walley's article however does not consider
how experimental filmmakers variously utilize the internet as a distribu-
tion platform. Many (though by no means all) experimental filmmakers
who show their films in cinematheques (whether the works originate on
analog or digital) maintain pages on Vimeo or other sites, for example,
where their works can be accessed for free, often in their entirety. Many
artists exhibiting film works on the white cube circuit, in contrast, do not
make their work available online; when such artists' films occasionally do
crop up they are quickly taken down, presumably by the galleries who
work to police the boundaries of the artists they represent. This is clearly
an effect of the different economies of black box and white cube exhibition:

experimental filmmakers do not generally make a profit from showing their films in theaters, while artists who sell limited editions of their film prints via the gallery system are able to make significant sums of money. Controlling online circulation is one way of ensuring the "scarcity" of film prints that are sold in limited editions. Again, there are exceptions to this rule—Sharon Lockhart, for example, is one artist who both sells her work via the gallery system and allows her work to be shown online. But Dean is an artist whose work has not circulated in this way—until now, with the phenomenon of *FILM*.

FILM uses 35mm, unlike Dean's other films, which are shot, edited, and projected on 16mm. In fact, *FILM* is quite unlike any other film Dean has made. Its pace of editing is quite fast, compared with her usual contemplative long takes. It marks the first time Dean used her patented aperture gate masking system (to be described below), which she subsequently used in *JG*. And its vertical portrait format is unlike the landscape format that characterizes a number of her other films (*Banewl*, *JG*). Moreover, its spectacular nature, while still contemplative, is quite unlike the sensibility of Dean's other films, which are marked by a tone of quiet observation. As Dean states in *FILM*'s exhibition book, "The artist Matt Mullican [. . .] described the Turbine Hall to me as a space with a big ego, and he was right."[26] This was a big public artwork that reached a wider audience than Dean's previous films, and it was designed for that purpose. As such, it was an excellent platform for engaging in public discourse, and Dean seized the opportunity for activism in support of photochemical film. Understood in the context of the accompanying exhibition book, which sounds a battle cry for photochemical film stock, *FILM* is argumentative in a way that Dean's other works are not.

Dean makes carefully crafted analog representations, but her work is not only about obsolescence. Dean's work explores the meaning of the analog with a resolutely contemporary sensibility. Several months before *FILM*'s debut, Dean published a widely read manifesto in the *Guardian* newspaper, "Save Celluloid, for Art's Sake," in which she explained,

> Many of us are exhausted from grieving over the dismantling of analogue technologies. Digital is not better than analogue, but different. What we are asking for is co-existence: that analogue film might be allowed to remain an option for those who want it, and for the ascendency of one not to have to mean the extinguishing of the other.[27]

This statement is crucial, for some have misinterpreted Dean's activism for photochemical film—and *FILM*'s elegy for the medium—to mean that she and this work are opposed to the coexistence of film and digital media. In

fact, Dean has steadfastly and consistently asserted that she is not opposed to all things digital. As she said in an interview at the time of the original exhibition, "It's not that I'm a Luddite—I'm not. My sound is digital [. . .]. For some reason if you love film people think you hate digital. The point is digital is a separate medium it's also a fantastic medium. It's got massive potential. I'm in no way anti-digital, I'd like to make that clear."[28] And as Dean said more recently when I asked her directly what she thinks of the videos of *FILM* posted on YouTube and Vimeo:

> I don't mind about that, because it's always in context. You know, [*FILM*] defies your normal telecine. I mean, I can't make a telecine of that. So I've only got those [videos] . . . I don't mind at all, because as I say it's alive. People are walking in front of it. And actually when the Tate documented it, they did it without anybody in it, which was a shame.[29]

So how does *FILM* activate the past in such a way that it looks forward to envision a future for film? Upon close analysis, *FILM* reveals itself as a work that is not only about materiality and historicity, but also death and renewal.

film and early cinema

Dean has explicitly referred to early cinema as a source of inspiration for *FILM*, not only for its technology, but for its sense of excitement about the new medium. "I wanted to go back to the time of invention of early cinema," she has said.[30] In fact, although *FILM* could never be mistaken for a work of early cinema, its strong resonance with early cinema renders it a kind of requiem for film. *FILM* is filled with nature imagery, common in the world of early cinema, such as insects, plants, and bodies of water. Its images of waves at the seashore resemble early "rough seas" films such as *Rough Sea at Dover* (Acres, 1896) and *Rocks and Waves* (Gaumont, 1911). *FILM*'s giant image of mushrooms, tinted green at one point, bears an uncanny resemblance to a 1911 Pathé film called *Mushroom Growing*. Water flows over a waterfall and water spouts from a fountain in *FILM*, just as countless early scenic and travelog films depicted waterfalls, water fountains, and other images of moving water, from *Waterfall in the Catskills* (Edison, 1897) to *Picturesque Waterfalls of France* (Eclipse, circa 1910–1915). Architectural shapes and structures also predominate. A tall factory smokestack belches steam, in an image reminiscent of early industrial films such as *The Concrete Industry* (Kalem, 1913). These similarities are not necessarily a direct reference to specific early films, which are largely unknown and reside mostly in film archives (though more are being made available online).[31] And certainly,

early nonfiction films are not a reference point that many spectators would recognize. But early cinema was a medium of discovery, and *FILM* has recaptured early cinema's sense of discovering the world through a new medium. Bracketing all of this is the piece's signature graphic element: sprocket holes.

In a work that revels in cinematic tricks, *FILM*'s sprocket holes are perhaps the most magnificent trick of all. They function as a major graphic element running down the left and right side of the frame for the duration of the piece. At first glance they seem to be the actual sprocket holes of the film revealed. To anyone with even rudimentary knowledge of analog film and projectors, however, this appears as a bit of a puzzle, for sprocket holes fall outside the area that is projected onto the screen, and are not visible in this way. In fact, these "sprocket holes" are graphic visual elements printed inside the regular area of the frame. *FILM*'s functioning sprocket holes are not visible during projection, and when one looks at a piece of celluloid from the work (an actual piece of *FILM* was included in the exhibition book), one sees two strips of sprocket holes running down the left and right: real perforations next to their graphic representation.[32]

Sprocket holes—otherwise known as perforations—are the mechanism by which film is advanced through the projector. Perforations were an essential component of the flexible film base, or celluloid, that was developed in the late 1880s, onto which projectable moving pictures were first printed. Perforations are an emblematic development of the machine age: they were also an important component of Morse telegraph tape, ticker tape, and the printing of postage stamps. In the very earliest years of cinema, when film gauge was not standardized, several different kinds of perforations existed. Lumière films used one round perforation per frame, for example. Rival companies used other film gauges (and thus rival projector systems), but Edison's 35mm gauge (with four perforations per frame), which had been in use since the 1890s, became standard in 1909 with the formation of the Motion Picture Patents Company.

Square sprocket holes eventually became one of the major signifiers of analog film. The graphic image of a few frames of 35mm celluloid with sprocket holes—let's call it the sprocket hole image—has been used in countless film studio and film festival logos over the years. (Perhaps the most famous example is MGM's classic logo with strips of celluloid spooling out around Leo the Lion.) In fact, one can find this generic sprocket hole image used to signify "film" in an endless array of cinema-related paraphernalia, from small-film-business logos to movie souvenirs and t-shirts. And significantly, the sprocket hole image is still used to signify "moving image media" in many digital contexts: it serves as the graphic icon for "movies" in iTunes, for example. Certainly, the sprocket hole image is

visually striking, but it is also a radically materialistic signifier of what cinema is. This graphic representation of film's material base was once powerfully iconic, signifying a technology, an industry, and a form of media in all its glimmering commercial success. Today that iconic meaning has changed: sprocket holes signify analog media, or rather, old media. But as the iTunes example indicates, in the digital world the sprocket hole image still has the ability to signify any form of moving image media. In this case, the digital has repurposed an analog signifier.

There is a small, prior tradition of experimental filmmakers using sprocket holes as graphic elements, as seen in the work of Owen Land, Paul Sharits, or Peter Tscherkassky. The history of still photography also features sprocket holes revealed starting in the late 1960s; one famous example is the cover of *The Yes Album* from 1970. And today's lo-fi still photography movement is all about exposing the edges of the celluloid so that the sprocket holes become part of the image. But *FILM* seems to be working with the tradition of the sprocket hole image in its generic sense, not so much as an artistic gesture revealing artifice, but rather as a historical gesture invoking the essence of film's material base. *FILM*, then, is a radically materialistic portrait of a medium; it is not about narrative or stars or genres or industry. Rather, *FILM* works almost animistically to inject 35mm photochemical film with a kind of vitality or consciousness, as if it were the lifeblood of an art form. *FILM* reaches to portray film's very spirit, and it locates that spirit in the realm of its material base.

However, the medium of film has always been hybrid in nature, drawing from different media and reliant on the history of technology, and *FILM* exemplifies this hybridity. Although Dean used only analog processes to make the piece, not all of these processes date back to early cinema. The anamorphic lenses used in the piece were developed in the 1950s. An Arri 435 camera (designed in the 1990s) was used to shoot the film. Moreover, while *FILM*'s use of masking hearkens back to early cinema, the actual masks used for this analog production process were made with digital tools. The *concept* dates back to early cinema. As Dean puts it, "Many a keyhole or binocular effect through which we spied in early cinema were made this way, but the edges were never very crisp and the imagery cumbersome."[33] But the *technique* Dean used combines analog camera technology with contemporary digital fabrication. The new masks Dean created for *FILM* were designed by Berlin architect Michael Bölling, working on a computer; the masks themselves were fabricated out of plastic on a 3D printer. The masks, each a different shape, were placed inside the camera's aperture gate, blocking out a section of the film.[34] These masks do indeed produce much crisper edges than those found in early cinema, and the effect is stunning. This aperture gate masking system was used to produce many of *FILM*'s key visual effects,

including the sprocket holes as well as the triangular and circular shaped cut-outs.

The anamorphic lens creates a widescreen aspect ratio of 1:1.73, which Dean exploits to its fullest by composing the vertical image carefully in every corner, especially in parts of the work in which the frame has been divided into many different sections. To achieve this carefully sculpted effect, the film had to be exposed and rewound up to twelve times. As Dean explains it, "I make masks that fit into the aperture gate, which means it's like a stencil. So I . . . rewind the film and then stencil the negative space, and so build up an image on the frame, by putting the film through the camera many times."[35] This process of rewinding and re-exposing different parts of the film is reminiscent of the procedure used by Kurt Kren in his film *31/75: Asyl* (1975), except that Kren used a mask placed in front of the lens, not inside the camera, and Kren's film has the fuzzy edge effect that Dean wanted to avoid.

For the color-blocked sections of *FILM*, color was added to each corner of the frame using the rewinding/masking technique just described, in combination with color filters; the flash frames that were created in this process became colored, and Dean chose to leave them in, creating an unpredictable pulsating color effect. As Dean has said numerous times, part of the value of analog film for her is the mystery of the process; she and her crew did not know what exactly the result would be when they were crafting the piece. Through all these various devices, the work becomes a delightful multisensory spectacle, thanks to the impact of flickering colors and shapes projected on such a large scale. The effect of all these in-camera tricks is magical; *FILM* looks like a wondrous monolith. The Kubrick resonance has been noted by many viewers and by Dean herself, who has said that "we always call it the monolith because it's very like the monolith in Stanley Kubrick's *2001: A Space Odyssey*, which was a cinema screen on its side apparently."[36]

FILM appears to be an elegy for a dying medium; the piece revels in the technology of its creation, and seems to ask its viewers to mourn the passing of this technology. Projected silent, the piece took on the hushed echoes of the Turbine Hall, allowing the sounds of the spectators to become the accompanying soundtrack and giving the piece an interactive, embodied dimension. Dean has stated that the lack of a soundtrack in *FILM* was not intended to be a reference to silent cinema, but this was a connection to film history that many commentators made anyway. In the Turbine Hall, the most prominent sounds (as evidenced in video after video) were those of children squealing, running, and delightedly spinning in front of the screen. At the risk of trivialization, one might dispense with the traditional funerary allegory and instead describe the piece as a celebration of life. This celebratory quality takes on new meaning when one considers *FILM*'s digital afterlife online.

mourning and renewal

In early cinema studies, "cinema" is sometimes defined as moving pictures projected before a public audience, as a way of distinguishing cinema from pre-cinematic peepshow devices such as the Kinetoscope and the Muto-scope (which were not projected and only addressed one spectator at a time). Yet this "cinematic" historical mode of viewing dominated from the 1890s until the dispersal of audiences into home viewing contexts in the 1980s, so it is not specific to early cinema. This is the mode of exhibition that *FILM* recreates in the space of the museum. And it is in the realm of circulation that *FILM*'s digital afterlife takes on significance.

The embodied, site-specific experience of a museum film such as *FILM* is available to a finite number of people who happen to be in the right place at the right time. After *FILM*'s debut run at the Tate Modern, it appeared subsequently at art museums in Melbourne and Seoul.[37] These are all widely accessible venues in major cities, and thus the piece has been seen by a great number of people. As of this writing, however, there are no plans for it to travel further. Theoretically at least (it is impossible to measure for sure), many more people have been able to access Dean's works through online video. There is a great deal of amateur footage of *FILM* online, as well as seemingly endless still images of the piece uploaded to Flickr. There was also a flurry of online media coverage containing clips from the piece. When watching the amateur online footage of *FILM*, one has to contend with the spectators' various framing and camera decisions: some videos are handheld though many are surprisingly stationary, some videos zoom in and out at odd moments, people walk in front of the camera, many of the videos are incomplete, and so forth. The spectators who have posted these videos are mostly anonymous (although one of the Vimeo videos is by filmmaker Phil Solomon).[38] What these videos capture is the experience of standing before the piece, registering both awe and a sense of enjoyment, and also functioning rather like home movies: I was here, I saw this.[39]

While the quality and scale of these online videos are radically different from those of the original piece, these videos nonetheless enable viewers to have an experience of the work, even if that experience is different. The spectator videos of *FILM* at the Tate Modern transform the piece from an imposing installation experienced communally in a landmark public space into a small digital video experienced privately. The online videos evoke a different sense of loss than the installation piece, which asks the viewer to think about the demise of 35mm. Instead, the online videos generate a sense of loss for the embodied experience; the viewer is acutely aware that she is not seeing the piece in person and that the installation has ended.

Photography and film have long been associated with death, from Maxim Gorky's famous account of film at an early Lumière screening as a "kingdom of shadows" to Roland Barthes' account of death as the "*eidos*"

of portrait photography in *Camera Lucida*.[40] Tom Gunning has written of how each recording technology "delivers an uncanny foretaste of death, as a peculiarly modern *Memento Mori*."[41] Indeed, Barthes's account of portrait photography reminds us that in most portraits the sitter is acutely aware of the photo being taken (this self-consciousness has taken on heightened intensity in the age of the selfie). Cinema's "death" has been widely trumpeted and anxiously mourned since the 1990s. And yet the latest phase in the shift to digital—the phasing out of 35mm projection—does indeed signal a new era for motion pictures. Now that photochemical film is an endangered species, its obsolescence entails a narrative of loss. Today, a few years after FILM's run at the Tate Modern, and film's fate seems both more imperiled and possibly more hopeful. Although most filmmakers working in the commercial film industry have embraced digital technology (while remaining silent about or unaware of the larger meaning of this shift), a small but influential few (such as Christopher Nolan, J.J. Abrams, Judd Apatow, and Quentin Tarantino) have rallied to support 35mm film production and exhibition.[42]

FILM can help us think through the contradictions of medium specificity now that the vast majority of media have shifted from analog to digital. *FILM* reminds us that there is an analog culture that persists alongside the digital, and it reminds viewers that they should care about cultivating diverse media environments. Although it uses techniques from early cinema to capture the viewer's attention and to make its point about the importance of photochemical film's persistence in the digital age, it is ironic that the piece is only accessible now via its digital afterlife. In this instance, the digital has enabled the persistence of the analog, at least as a digital trace if not as physical material. Indeed, perhaps one of the only ways the analog can survive at present is when nurtured by the digital habitat that currently dominates. In its larger context as an artwork circulating in the world, *FILM*, a work about the specificity of 35mm as an analog medium, actually makes a case for the continuities and synergies of old and new media. Rather than a model in which digital media destroy analog media, we have in this instance an example of overlap, hybridity, and coexistence.

jennifer lynn peterson

notes

1. Emilie Altenloh, *On the Sociology of the Cinema: The Cinema Business and the Social Strata of Its Audience* (1914), trans. Lance W. Garmer; excerpted in *German Essays on Film*, eds. Richard W. McCormick and Alison Guenther-Pal (New York: Continuum, 2004), 40.
2. See Nicholas Cullinan, "Exhibition in Focus: The Unilever Series, Tacita Dean at Tate Modern," *Telegraph* (21 October 2011): http://www.telegraph.co.uk/travel/destinations/europe/uk/london/8841556/Exhibition-in-focus-The-Unilever-Series-Tacita-Dean-at-Tate-Modern.html. Accessed 27 February 2015; Adrian Searle, "Tacita Dean: Film—Review," *Guardian* (10

October 2011): http://www.theguardian.com/artanddesign/2011/oct/10/tacita-dean-film-review. Accessed 27 February 2015; Emily Eakin, "Celluloid Hero," *New Yorker* (31 October 2011): 54–61.

3. Rosalind Krauss, "Frame by Frame: Rosalind E. Krauss on Tacita Dean's *FILM*, 2011," *Artforum* (September 2012): 419. Accessed 29 April 2015.

4. There has been a groundswell of interest in vertical cinema lately, with a well-received "Vertical Cinema" project emerging out of Rotterdam and touring a small number of venues in Europe in 2014, often with exhibitions in churches. Most of these works were created digitally and transferred to 35mm for projection. *FILM* is not a part of this project, but it certainly anticipated the interest in the vertical exhibition format.

5. "Celluloid" is a misnomer—cellulose nitrate and cellulose acetate have not been used as a film base for years; polyester has been the base for release prints since the 1990s—and yet "celluloid" is still used colloquially as a term that refers to analog film with a flexible film base. The term "photochemical film" is more accurate.

6. On 31 December 2013 the MPAA Theatrical Market Statistics reported that "Over 80% of the world's nearly 135,000 cinema screens are now digital": http://www.mpaa.org/wp-content/uploads/2014/03/MPAA-Theatrical-Market-Statistics-2013_032514-v2.pdf. Accessed 27 February 2015. In 2015, 35mm will be projected in only seventeen percent of global cinemas, according to HIS Screen Digest Cinema Intelligence Service. See http://www.isuppli.com/Media-Research/News/Pages/The-End-of-an-Era-Arrives-as-Digital-Technology-Displaces-35-mm-Film-in-Cinema-Projection.aspx. Accessed 27 February 2015.

7. Ivan Radford, "Don't Keep it Reel: Why There's Life After 35mm," *Guardian* (29 November 2011): http://www.guardian.co.uk/film/2011/nov/29/life-after-35mm-digital-film. Accessed 29 April 2015.

8. http://www.imago.org/index.php?new=604. Accessed 27 February 2015. To learn about the campaign (and sign the petition), go to http://www.save-film.org/. Accessed 29 April 2015.

9. Tacita Dean, *FILM* (London: Tate Publishing, 2011), 16.

10. Amelia Jones, " 'Presence' *in Absentia*: Experiencing Performance as Documentation," *Art Journal* Vol. 56 No. 4 (Winter 1997): 11.

11. *Ibid.*, 12.

12. Erika Balsom discusses Dean's work in relation to Walter Benjamin's concept of "aura" in "Filmic Ruins," in *Exhibiting Cinema in Contemporary Art* (Amsterdam: Amsterdam University Press, 2013), 65–106.

13. Tacita Dean, interview by Jennifer Lynn Peterson, 5 December 2014, Getty Research Institute, Los Angeles, CA, 6.

14. David Thorburn and Henry Jenkins, "Toward an Aesthetics of Transition," in *Rethinking Media Change: The Aesthetics of Transition*, eds. David Thorburn and Henry Jenkins (Cambridge, MA: MIT Press, 2003), 3.

15. Giovanna Fossati, *From Grain to Pixel: The Archival Life of Film in Transition* (Amsterdam: Amsterdam University Press, 2009), 19.

16. On *FILM* see Caylin Smith, "The Last Rays of the Dying Sun: Tacita Dean's Commitment to Analogue Media as Demonstrated by *FLOH* and *FILM*," *NECSUS* 2 (Autumn 2012): http://www.necsus-ejms.org/the-last-ray-of-the-dying-sun-tacita-deans-commitment-to-analogue-media-as-demonstrated-through-floh-and-film/. Accessed 27 February 2015.

17. These films are *Craneway Event* (2009), depicting Merce Cunningham; *Edwin Parker* (2011), depicting Cy Twombly; *Manhattan Mouse Museum* (2011),

depicting Claes Oldenberg, and *GDGDA* (2011), depicting Julie Mehretu. The photo series *Line of Fate* (2011), also included in the New Museum Show, depicts art historian Leo Steinberg.

18. For a sampling of scholarship on Dean's film work (not including *FILM*), see Erika Balsom, "A Cinema in the Gallery, A Cinema in Ruins," *Screen* Vol. 50, No.4 (Winter 2009): 411–427; Beatrice von Bismarck, "Studio, Storage, Legend: The Work of Hiding in Tacita Dean's *Section Cinema (Homage to Marcel Broodthaers)*," in *Hiding Making Showing Creation: The Studio from Turner to Tacita Dean*, eds. Rachel Esner, Sandra Kisters, and Anne Sophie-Lehman (Amsterdam: Amsterdam University Press, 2013), 176–187; Tamara Trodd, "Lack of Fit: Tacita Dean, Modernism, and the Sculptural Film," *Art History* Vol. 31, No. 3 (June 2008): 368–386.

19. Balsom, "Filmic Ruins," 65–106.

20. Hans Ulrich Obrist, *Tacita Dean: The Conversation Series* (Cologne: Verlag der Buchhandlung Walther König, 2012), 55.

21. Christine Ross, *The Past is Present, It's the Future Too: The Temporal Turn in Contemporary Art* (New York: Continuum, 2012), 6.

22. Balsom, "A Cinema in the Gallery," 425.

23. To watch this version of *The Green Ray* (with the added voice-over) see https://vimeo.com/37303919. Accessed 29 April 2015.

24. Andreas Reiter Raabe, interview with Tacita Dean, "Film as Painting," *Spike Art Quarterly* 29 (Autumn 2011): http://www.spikeart.at/en/a/back/back/Portrait_Tacita_Dean. Accessed 27 February 2015. Also discussed in Tacita Dean, interview by Jennifer Lynn Peterson, 1.

25. Jonathan Walley, "Modes of Film Practice in the Avant-Garde," in *Art and the Moving Image: A Critical Reader*, ed. Tanya Leighton (London: Tate Publishing, 2008), 182–199.

26. Dean, *FILM*, 16.

27. Tacita Dean, "Save Celluloid, for Art's Sake," *Guardian* (22 February 2011): http://www.theguardian.com/artanddesign/2011/feb/22/tacita-dean-16mm-film. Accessed 27 February 2015.

28. "Tacita Dean Talks about *FILM* at the Turbine Hall," http://www.phaidon.com/agenda/art/events/2011/october/11/tacita-dean-talks-about-film-at-the-turbine-hall/. Accessed 27 February 2015. Run-on punctuation in original.

29. Tacita Dean, interview by Jennifer Lynn Peterson, 5.

30. Tacita Dean, artist's talk at the Hammer Museum, Los Angeles, 22 January 2014.

31. For a more thorough discussion of these early film genres see Jennifer Lynn Peterson, *Education in the School of Dreams: Travelogues and Early Nonfiction Film* (Durham, NC: Duke University Press, 2013).

32. *FILM*'s exhibition book contains many images from the piece, but these have been somewhat misleadingly cropped to omit the actual sprocket holes from the reproductions, so that only the graphic "sprocket holes" are pictured. It is only when one examines the actual piece of film that comes with the book that the two strips of sprocket holes—real and graphic—are clearly revealed. There is also one reproduction in the book that preserves the edges of the filmstrip so that both strips of sprocket holes are visible; see Dean, *FILM*, 9.

33. Dean, *FILM*, 29.

34. For an image of one of these masks mounted in the camera, see http://www.berlinartlink.com/2011/11/03/tacita-deans-film/. Accessed 29 April 2015.

35. *Art Wednesday*, Interview with Tacita Dean: http://artwednesday.com/2013/02/04/an-interview-with-tacita-dean/. This can be found on the Internet Archive's Wayback Machine (saved 23 April 2014) but it is no longer a live link.

36. Connie Millard, "'The Magic of Mistakes': Tacita Dean on Why Her New Turbine Hall 'Film' Installation is a Plea to Save Cinema," in *ARTINFO UK* (11 October 2011): http://fr.blouinartinfo.com/news/story/749297/the-magic-of-mistakes-tacita-dean-on-why-her-new-turbine-hall. Accessed 6 March 2015.

37. *FILM* was installed at the Australian Centre for Contemporary Art in Melbourne from 10 October to 24 November 2013, and at the Seoul branch of the National Museum of Modern and Contemporary Art in Korea from 12 November 2013 to 28 February 2014.

38. Phil Solomon's video of *FILM* is at https://vimeo.com/30999616. Accessed 29 April 2015. Incidentally, when you hear Solomon saying that the footage is from a science film (at 2:07), he is one of the rare viewers who demonstrates an awareness of early cinema, but in fact he is incorrect: this is not found footage but was shot by Dean and her crew.

39. Incidentally, while *FILM*'s Turbine Hall installation predated the video sharing app Vine (and thus it does not appear there), there are several Vine videos of *JG* as it was installed at the Hammer Museum in Los Angeles from December 2012 to January 2013.

40. Maxim Gorky, "The Lumière Cinematographe," in *The Film Factory: Russian and Soviet Cinema in Documents, 1896–1939*, eds. Richard Taylor and Ian Christie (New York: Routledge, 1988), 25–26; Roland Barthes, *Camera Lucida*, trans. Richard Howard (New York: Hill and Wang, 1980), 10–15.

41. Tom Gunning, "Re-Newing Old Technologies: Astonishment, Second Nature, and the Uncanny in Technology from the Previous Turn-of-the-Century," in *Rethinking Media Change: The Aesthetics of Transition*, eds. David Thorburn and Henry Jenkins (Cambridge, MA: MIT Press, 2003), 48.

42. On July 29, 2014, it was announced that, thanks to lobbying by these four filmmakers, Kodak was about to finalize a deal to continue manufacturing a number of 35mm and 16mm photochemical film stocks. See Saba Hamedy, "Kodak to Keep Making Movie Film, with Hollywood's Support," *Los Angeles Times* (31 July 2014): http://www.latimes.com/entertainment/envelope/cotown/la-et-ct-kodak-hollywood-studios-20140731-story.html. Accessed 27 February 2015.

from silence to babel

farocki's image infoscape

twelve

brianne cohen

In 2006, German filmmaker and artist Harun Farocki created his first instal-lation with twelve screens, *Workers Leaving the Factory in Eleven Decades (Arbeiter verlassen die Fabrik in elf Jahrzehnten)*. It was a tremendous temporal and spatial expansion of his earlier film, *Workers Leaving the Factory (Arbeiter verlassen die Fab-rik*, 1995), which in turn marked the hundredth anniversary of one of the first films shown in public, the Lumière Brothers' *Workers Leaving the Lumière Factory in Lyon (La Sortie de l'Usine Lumière à Lyon)*. The 1895 film is only forty-five seconds long; it captures workers from Louis and Auguste Lumière's pho-tographic products factory as they stream out of the gates at the end of the workday. Farocki's revamped, twelve-screen homage to this watershed film not only includes the Lumière factory footage, but also juxtaposes this footage with filmic sequences of workers exiting factories for every decade since, from Fritz Lang's *Metropolis* (1927) and Charlie Chaplin's *Mod-ern Times* (1936) to Michelangelo Antonioni's *The Red Desert* (1964) and Lars von Trier's *Dancer in the Dark* (2000). The installation's *modus operandi*, in other words, is one of comparison, focusing on the historically shifting semantics of a seminal film shot.[1] Rather than replacing and effacing one image after

another in a single-frame development, Farocki both maintains the gaps and creates seams from one heterogeneous image to another through an encyclopedic visual panoply.

Since 1995, Farocki has increasingly moved from film venues to museum and gallery settings. This changing contextual framework has tested the position of his audiences and allowed him, in turn, to explore new modes of attentive, critical spectatorship. This does not mean that Farocki has relinquished his investment in a filmic visual idiom—quite the contrary. In 2006, he and Antje Ehmann co-curated an exhibition, *Cinema Like Never Before* (*Kino Wie Noch Nie*), which included a number of new cinema-inspired works, including *Workers Leaving the Factory in Eleven Decades* and *On the Construction of Griffith's Films* (*Zur Bauweise des Films bei Griffith*), (2006). Between 2005–2007, a period that included the production of his silent works *In-Formation* (*Aufstellung*), (2005) and *Respite* (*Aufschub*, 2007), his focus turned to an era of early and silent cinema, in order to glean insights from this foundational moment in the broader social-visual field, and to repurpose aspects of this cinema for a rapidly transforming, twenty-first-century viewing public.

Farocki specifically revisited a globalizing, encyclopedic impulse of early cinema in order to address the excesses of information and images that define contemporary screen culture. In his essay, "Early Cinema as Global Cinema: The Encyclopedic Ambition," Tom Gunning boldly proposes "the encyclopedia as an organizing concept for early cinema," as a "textual form of [. . .] global consciousness."[2] He defines this global consciousness of the early era as "the modern Western demand for a world consumed as pictures and information," a new image culture (i.e. early film, World Expositions, a global tourism industry) that could collapse geographical distances through new technologies and create a form of image exchange at once fragmentary and modular, recalling "the universality envisioned by the Encyclopedia of the Enlightenment."[3] Referring specifically to the globe-trotting production, exhibition, and distribution practices of the Lumière, Pathé-Frères, and Gaumont film companies before World War I, Gunning claims that the image-making operations of early cinema offered, conceptually, a system of knowledge production and dissemination that could subject large amounts of information to patterning and organization. Diverse programs of early film attractions introduced women, children, the poor, the proletariat, and the bourgeoisie alike to a larger global consciousness that was emerging through technical innovations—and colonial motivations—in mapping, recording, and measuring various corners of the world.[4] These are broad claims—and intentionally provocative, Gunning insists.[5] For the purposes of this essay, however, I will focus more narrowly on how they reverberate with Farocki's reworking of particular forms and ideas from the early and silent era of film. Above all, Farocki's transition from film to installation art raises questions about how contemporary audiences might equip themselves to apprehend a globally

oriented, Wikipedia-modeled, massive digital infoscape. As I will argue, a number of his recent pieces suggest that such a potentially "globalizing, encyclopedic" moment of early cinema and visual culture resonates in several respects with an expanded visual-symbolic field in the twenty-first century.

This "encyclopedic ambition," as Gunning terms it, might speak to much post-1989 contemporary art, tethered as it is to a new paradigm of the global biennial system and renewed interest in, for instance, forms of the panorama, encyclopedic models, or "universal" visual languages.[6] Farocki's shifting practice, from cinema to the museum-gallery nexus—that is, towards diverse, spatialized displays and new challenging scenarios for spectatorship—serves as one of the more compelling, critical cases of these contemporary permutations of *fin-de-siècle* visual culture. Put more broadly, his return to this earlier artistic era illuminates another moment of tremendous visual-historical transformation, apprehending a twenty-first-century world scaffolded by exponentially proliferating global communication and information technologies. How will the visualization of information evolve on a global scale? How can spectators become actively intelligent readers, interpreters, and participants in a massive, digitally based, Babylonian infoscape? A question of reception in a state of distraction, as Farocki has long attested vis-à-vis the work of Walter Benjamin and Bertolt Brecht, recurs with even greater urgency.

As a filmmaker, Harun Farocki established himself as one of the best audio-visual essayists of the last half-century. With approximately one hundred and twenty works, he trained his lens on the war in Vietnam, prisons, "intelligent" weapons, shopping malls, television, advertising, filmmaking, acting, and workplace training. He utilizes archival resources in order to examine how certain images circulate within broader institutional sites and networks.[7] In order to better understand the stakes of his shift from the film archive to apparently immersive and fragmented, dozen-screen exhibitionary spaces, two lesser-known pieces merit closer attention: *On the Construction of Griffith's Films* and *In-Formation*. Both speak directly to this juncture in his work. Both explore the shifting means of modernist, visual, non-verbal communication and models of spectatorship from early and silent-era cinema as well as museum display. In a comparative, double-screen format, *On the Construction of Griffith's Films* depicts certain tensions of early cinema's transition to classical codes of spectatorship and narration. These tensions include the universality/specificity of, and active/passive reception by, diverse audiences of the time. *On the Construction* showcases how such tensions play out in Griffith's epic *Intolerance* (1916). In turn, Farocki's single-channel video, *In-Formation*, mimics certain organizing principles from *Intolerance* and clearly raises similar questions of universality/specificity and spectatorial engagement. *In-Formation* stages an excessive breakdown in another visual, non-verbal idiom: ISOTYPE, or

the International System of Typographic Picture Education, conceived for spectators of museum displays in the 1930s. Both its founder, Otto Neurath, and Griffith were dedicated to ideas of a pre-Babylonian, hieroglyphic universal language and viewer edification, a fact that seems to bolster Gunning's claim of a globalizing, encyclopedic impulse in much early film and *fin-de-siècle* visual culture. Griffith's and Neurath's utopian aspirations for global visual literacy—ultimately based upon cultural and gender stereotypes—could not adequately serve the heteroglossic complexity of their audiences. Their ambition for "universal" modular systems of comparison and differentiation could not reconcile new models of ideal spectatorship with their historically diverse publics. In *On the Construction* and *In-Formation*, Farocki exposes the historical failures of this type of project, one that would aim to de-babelize its diverse viewing audiences.

In this essay, I will analyze how *On the Construction of Griffith's Films* and *In-Formation* explore earlier historical transitions in popular image-making that foreshadowed pressing contemporary questions concerning the visualization of information. These pieces not only evoke specific cases in early film and visual culture that seem in line with an encyclopedic, globalizing impulse during this era, as Gunning suggests, but they also interrogate problematic constructions of "universal" spectatorship models that arose in conjunction with such an ambition and attitude. I will also investigate a new artistic venture by Farocki and Ehmann, *Labour in a Single Shot (Eine Einstellung zur Arbeit*, 2011–present) that offers a more positive proposition: a contemporary mode of spectatorship that may imagine a cosmopolitan or cross-comparative basis for world-picturing and global-thinking, one that does not efface or override difference through teleologically structured, totalizing narratives. *Labour in a Single Shot (Eine Einstellung zur Arbeit*, 2011–present) has provided amateur filmmakers around the world with the resources to shoot their own films in a single, brief shot, recalling the early example of the Lumière brothers' *Workers Leaving the Lumière Factory in Lyon*. Originally conceived in 2005, the seeds of this project arose side-by-side with *On the Construction of Griffith's Films* and *In-Formation*.[8] Whereas the latter two pieces, however, point to problematic "universal" visual languages that threatened to metaphorically mute and neutralize difference, *Labour in a Single Shot* suggests a more hopeful path for critical, intercultural mediation in a global age of information. Even more than his multi-screen installation displays, it suggests an artistic-epistemic shift in his practice from the model of the archive (historical recuperation, distanciation, and critical re-contextualization) to that of the encyclopedia (cross-comparative, all-encompassing albeit ever-expanding knowledge dissemination), the latter geared towards greater accessibility and public availability. *Labour in a Single Shot* invites simultaneously measured and creative responses to the global infoscape, or rather it countermands and supplants it, *vis-à-vis* one simple condition inspired from the encyclopedic

moment of early cinema: that of attentive engagement by mass, hetero-geneous audiences.

Intolerance, Archetypes, and de-Babelization

Above all, Farocki's methodology insists upon the power of images to com-ment critically on other images. The exhibition *Cinema Like Never Before* was an affirmation of this working mantra: successive images, as in narrative film, threaten to replace previous images for the viewer, but images placed contiguously, as in an art display, may register concurrently and thus insist upon multiple meanings. In this sense, exhibitionary art spaces, accord-ing to Farocki and Ehmann, may act as a "cutting room" or "laboratory" for cinema and offer something that single screen, theatrical-proscenium based cinema may not.[9] Farocki's first video installation, *Interface (Schnitt-stelle)*, (1995), is in fact, an overt exploration of this theme. It is a Benja-minian self-reflexive gesture by Farocki concerning his own films (i.e. "the author as producer"), one that has been unpacked by many film scholars.[10]

On the Construction of Griffith's Films, debuted at *Cinema Like Never Before*, appears, in contrast, as a more modest undertaking. No longer situated directly within Farocki's own "cutting room" and present-day voice, it is a silent, nine-minute double-screen installation that lays out American filmmaker D.W. Griffith's transitional-era use of a narrative grammar, including the shot/reverse shot and close-up. Farocki's piece begins with clips from Griffith's Biograph film, *The Lonedale Operator* (1911), and com-pares them with cuts from his later epic narrative *Intolerance* (1916), detail-ing how Griffith experimented with, and came to alter his form of editing. In *The Lonedale Operator*, for instance, a single shot corresponds to a unique space: Griffith cuts from, and presents frontally, each successive room corresponding to the protagonist's movement. In *Intolerance*, however, he employs shot/reverse shot, pushing the narrative forward by cutting back and forth within the same space, representing a man and a woman in dia-logue. Such basic cuts in space, according to Farocki's intertitles in *On the Construction of Griffith's Films*, creatively evolved in early cinema to portray figurative relationships and scenarios, such as the emotional connection and separation between a man and woman. In other words, the difference in shot/reverse shot viewpoint signifies a shift from presentational to rep-resentational conceptions of space and viewer address, as silent intertitles in the video installation explain, further suggesting that "cinematography constructs its own spaces," "erects imaginary walls," and "opens and closes imaginary doors." Ultimately, through the inventive placement of camera angles and cuts, cinematography may fabricate "parallel worlds."

In the case of *The Lonedale Operator*, Griffith indicates a world of growing social proximity and connectedness through communication and trans-portation technologies. The protagonists are surrounded by an excessive

signification of such technological change: tools of measurement and recording, materials of international business and exchange, and new systems of data management ("wiring" money or messages).[11] The film involves the rescue, in fact, of a woman who is put in charge of operating a telegraph machine and then is able to signal for help when drifters attempt to rob her station. The site of Lonedale epitomizes the small, local village suddenly routed through a much larger cultural and economic network. Moreover, it is Griffith's quite unique, systematic narration via the technology of film, specifically the repetition and alternation of filmic spaces, that throws in high relief such a modern, global interconnection of "parallel worlds," including the spectator's own. The style of narration draws attention to itself, in other words, disallowing an absorbed or removed position by the spectator.[12] Farocki's *On the Construction of Griffith's Films* mimics such techniques—using silence, intertitles, and, particularly in the double-screen format, repetition and alternation of shots—in order to re-explore as much as deconstruct this modernizing, world-making ethos.

Such an invention of "parallel worlds" in nascent cinematic conventions, however, subsequently marked not only a move to codified forms of spectatorship in narrative cinema, but also a disavowal of the differences of audience make-up during this transitional era. As Miriam Hansen outlines in *Babel and Babylon: Spectatorship in American Silent Film*, Griffith played an instrumental role during this shift, from roughly 1907 to 1917, as he assayed new ways of absorbing viewers in film narratives. Through certain strategies of viewer identification and positioning, the illusion of being immersed in the storyline and of leaving behind one's physical self in the theater could be constructed. However, this also concealed "problems posed by the cinema's availability to ethnically diverse, socially unruly, and sexually mixed audiences."[13] The ideal, immersed spectator position, in other words, arose conveniently with the cinema's new availability as a site for mass consumption—film was set forth as a "new universal language" for all those with a disposable income. A ticket to the cinema, if traded in for a successfully absorptive experience, could thus "neutralize" and "equalize" historically non-fungible cultural and sexual positions.[14]

As Hansen argues, this transition occurred neither smoothly nor linearly. Griffith's own *Intolerance*, in fact, exposes a number of underlying paradoxes and tensions inherent to the film industry's attempt at standardization, at branding film as a new universal language for the American masses. Hansen's analysis concentrates on problems of gendered address in silent film during this period, or ruptures between strategies to codify spectatorship in a homogenizing way and the actual facts of a growing immigrant, and, in particular, female viewership.[15] *Intolerance* marks this disconnect, for example, in its obsessive focus on a "crisis of femininity."[16] Each of its four storylines depict the rescue of unfairly persecuted persons, assume a highly moralistic tone, and draw from much of Griffith's earlier

225

work based upon rescue fantasies of women, as in *The Lonedale Operator*. However, as Hansen points out, viewer identification with the victims is fragmented in *Intolerance* because of Griffith's ambivalent staging of scopic desire. Despite an increasingly uniform use of point-of-view shots at the time to frame heterosexual desire, Griffith did not allow the characters much scopic agency in *Intolerance*, and if he did, he instead empowered female figures with a distorted or fragmented gaze.[17]

Farocki's *On the Construction of Griffith's Films* features approximately six minutes from *Intolerance*'s three-hours-plus footage, and within these brief excerpts, it only portrays encounters, or rather failed encounters, between men and women. The scenes are pulled from each of *Intolerance*'s three principle narratives (excluding the shorter Judean one, this includes: the Modern story, ancient Babylon, and the persecution of the Huguenots in the "French" story). Video intertitles analyze each scene in terms of their novel use of a filmic grammar, or for example, the use of shot/reverse shot in illustrating "an exchange of glances rather than words." Yet the examples given do not, in fact, instantiate such an exchange of character glances vis-à-vis corresponding camera angles. The principle example in Farocki's video—the Modern era's Dear One and the Boy playing out a romantic encounter across a closed door—is exhibited across the two video screens, highlighting Griffith's use of alternating shots between the boy and girl that eventually leads to a marriage proposal. Yet there is no actual exchange of looks between them via the camera's eye, disallowing the possibility of viewer identification as it was evolving during this formative period in the development of narrative film.[18] *On the Construction of Griffith's Films* appears to be a straightforward analysis of Griffith's transition to such novel codes in the 1910s, but this carefully chosen scene of desire exposes the ambivalence inherent to this process. The fact that Farocki replays this scene across the divide of two screens only underlines these tensions (figures 12.1 and 12.2).

This ambivalence stems from Griffith's lofty attempt to create a film of universal archetypes in *Intolerance*. Rather than fully embracing emerging codes of scopic desire on screen, Griffith appeals to viewers in a more abstract way in *Intolerance*—asking them to identify with archetypes of the weak and subjugated, not with individual characters.[19] Almost all of his characters are types, such as the Dear One, the Boy, the Musketeer, Brown Eyes, or the Mountain Girl. As narrative film was moving away from broad physical gestures in silent film towards more emotive facial displays, *Intolerance* connects all of its characters' fates in one transhistorical, ecumenical schematic.[20] It rarely offers individualizing close-ups of characters, instead leaving them as generalized types. *Intolerance*'s parallel storyline construction, in other words, equivocally contradicts emerging narrative paradigms that Griffith had helped to develop. Easy viewer identification in the film is disallowed, and more effort is required on the part of audiences to draw interconnections among disparate storylines

Figure 12.1 On the Construction of Griffith's Films (Farocki, 2006).

Figure 12.2 On the Construction of Griffith's Films (Farocki, 2006).

and persons.[21] This was no easy task for a film originally eight hours long, and reduced to just under half of that in subsequent versions. Not only does *Intolerance*'s excessive amount of material disrupt any easy illusion or absorption for the spectator, but so too do the obtrusive intertitles that Griffith added to compensate for the heterogeneous narratives and images. Ultimately, with multiple "parallel worlds," Griffith attempts to demonstrate a "concept of history as eternal recurrence," but the illusion of totality is fragmented by its own excessively totalizing, generalizing impulse.[22] Griffith's work speaks to a particular moment within early

cinema, one that demonstrated, as Gunning argues, global and encyclopedic ambitions, specifically to respond to a newly emerging "worldly" consciousness and techniques of world-picturing. In the case of *Intolerance*, however, this globalizing ethos manifests more as an attempt to display a world developing in diachronic, historical time rather than in an ethnographic, synchronic present, a fact that resonates with Griffith's growing interest in narrative structure.

Griffith believed his aim to be well suited for the new universal language of film, as many envisioned it during this transitional period.[23] Amidst a growing wealth of new information from around the world, the visual, non-verbal grammar of film was to serve as a novel kind of unifying hieroglyphics, a means of spreading knowledge to and among the modern, motley masses.[24] Silent, cinematic images held the promise of eschewing problems of language translation for new immigrant audiences. Film could de-babelize the turn-of-the-century American public sphere through modern consumer culture and popular, "democratic" entertainment.[25] *Intolerance*'s narrative of the destruction of Babylon directly addresses the utopic vision of this pre-conflictual, ideal community, united by one language. Yet the filmic staging of this prelapsarian civilization in the Babylonian narrative is more akin to an Orientalist fantasy à la Timothy Mitchell's account of exoticized and commodified "object-worlds" in the nineteenth century.[26] Indeed, *Intolerance*'s attempt to create a transhistorical "truth" of history and language, constructed upon archetypes and colonialist stereotypes, paradoxically generates messy processes of differentiation and translation through its parallel narratives. It becomes, as the film's title suggests, a "drama of comparisons."[27] This is the crux of *Intolerance*'s ambivalence. Griffith strove to create iconicity, transhistoricity, and univocity through his parallel editing, but ultimately the film's excessive textuality denies any such interpretation. It offers too much information and demands too much reading and deciphering by spectators through an encyclopedic, cross-comparison of heterogeneous images.

It is evident why Griffith's struggle with *Intolerance* would resonate with Farocki: not only as a lesson on the limits of "universal" visual-communicative forms, but also as a mode of data-saturated comparison that ultimately betrays a need for more active interpretation from audiences than was *au courant* at the time. *On the Construction of Griffith's Films* delineates different moments of scopic desire from those that emerge in *Intolerance*'s parallel worlds. These moments signal ambivalences inherent to standardizing processes in editing and viewer identification. As a result, *On the Construction*'s modest presentation indicates a much larger theoretical problematic in contemporary art historical and visual culture scholarship: how do we understand a growing shift in contemporary artistic focus from individual, sociopolitically abstracted spectatorship to heterogeneous, collectively embodied audienceship?

Apprehending transformations in spectatorial codes from a century ago may be of particular value in investigating alternative exhibition formats for contemporary film and moving images in museums, galleries, and online as new modes of world-picturing emerge with even greater global proximity and connectedness in the twenty-first century. Farocki employs installation space as a "cutting room" to critically juxtapose images and to insist on their differentiating, polysemous, social dimension. *On the Construction of Griffith's Films'* silent and brief, double-screen installation in this way recalls early era modes of address, soliciting spectators to engage intersubjectively and to reflect upon their own knowledge and position in making meaning from the artwork. Such a task becomes even more exigent for spectators placed at the center of Farocki's six- or twelve-screen, panoramic displays, bombarded with all types of encyclopedic imagery from street surveillance tapes or machine-made images to historical documents or television clips. How can heterogeneous contemporary audiences critically navigate big data or negotiate a current that crests in statistics and ebbs in stereotypes? Another more modest video installation by Farocki, *In-Formation*, funnels and resists the flow of such a tide.

in-formation (2005), stereotypes, and re-babelization

In-Formation, subtitled a "Silent Film [*Stummfilm*] by Harun Farocki," also calls *Intolerance* to mind. It proffers an excessive flood of images that interconnect a compendium of narratives, despite its limited sixteen minutes. The silent film is constructed similarly to a living-room slide show, either displayed on a television monitor or projected. Each "slide" lasts for about three to four seconds. Whereas *Intolerance*'s cross-cutting accelerates toward the end of the film in order to heighten the drama of the rescue scenarios, *In-Formation* maintains a quickened pace throughout, suggesting a certain constant urgency. Or at least it demands the viewer's sustained attention in response to its bewildering, non-stop visual momentum.

In-Formation appears to present nothing less than a twentieth-century illustrated story of immigration in Germany. It suggests if not truthful, historical recurrence, then critical, historical comparisons. Its imagery, for example, ranges from depictions of Turkish guest workers in former West Germany and an influx of immigrants after the Versailles Treaty to statistics on post-World War II refugees and stateless peoples, up until post-1989 Eastern European emigration and present-day asylum seekers. The slide show jumps back and forth among different historical moments, suggesting a simultaneity or contiguity of different narratives, as with *Intolerance*. Yet these parallel narratives offer a comparison of "facts," not fiction. Indeed, all of the supposedly objective information derives from German state archives such as the Georg Eckert Institute for International Schoolbook Research (Georg-Eckert-Institut für Internationale Schulbuchforschung)

or the Bavarian State Office for Statistics and Data Processing (Bayerisches Landesamt für Statistik und Datenverarbeitung). *In-Formation* offers a cease-less torrent of archival documents, drawings, pictographs, graphs, and maps that are cropped, repeated, zoomed-in or -out from their original paper sources.

Despite its frenetic cutting among disparate historical moments, *In-Formation* offers a guiding linear structure, with an introduction, mid-dle, and conclusion (as with *Intolerance*). Critically, the beginning and end mark it as a type of informational, pedagogical film, and bookend it neatly with images of Figures A and B moving into, and, then at the end, out of a contained space. The video also introduces a theatrical cast of characters, so-to-speak: the Employer, Worker, Men, Women, and Foreigners. This parade of "actors" evokes the archetypes of *Intolerance*. Finally, in the mid-dle of *In-Formation*, a brief sequence—cordoned off by the only two black screens in the film—implies that the movement of peoples is as ancient as humanity, again, similar to *Intolerance* in its suggestion of a transhistori-cal narrative. The sequence flashes different groups traveling in "German" territory from the Bronze Age to approximately the end of the Roman Empire. Yet icons of German nationalism are temporally juxtaposed before and after the black screens. Before the sequence, *In-Formation* offers repeating, pixilated images of the German flag; after it, an ominous map of the Deutscher Reich following the Versailles Treaty appears. Masquerad-ing as a classic, public informational film, then, *In-Formation* concomitantly confronts viewers with the impossibility of such a simple story of human migration in Germany. Though the movement of peoples may seem to be a fundamentally simple act, a neat exchange between A to B, territo-rialization and group identification threaten violence in the multifarious encounters of people that may result.

In-Formation's pedagogical presentation of statistics is by no means ideo-logically neutral. The video's imagery is similar to, or in the style of Otto Neurath's International System of Typographic Picture Education, or ISO-TYPE. Originally termed the Vienna Method of Pictorial Statistics, the ISO-TYPE (as of the mid-1930s) was conceptualized as a uniform system of icons and signs that would be able to channel the greatest amount of information to the largest number of people possible. It would utilize two-dimensional, non-perspectival, and simplified images—recontextualized from every-day, mass communicative forms such as popular films or newspaper cartoons—in order to facilitate an understanding of the world in terms of patterns and systems.[28] Again, Neurath's project fell in line with other modern forms of visual culture that derived from a globalizing, encyclo-pedic ethos. What might have appeared uniform and universalizable in Europe in the 1930s, however, now strikes one as both dated and particular.

ISOTYPE arose during a crucible of social change. Its "speaking signs" and "statistical hieroglyphics" derive from the political situation of Red

Vienna in the 1920s, when Neurath attempted to help advance reforms in housing, health care, and education by the Austrian Social Democrats.[29] In response to the mass homelessness wrought by World War I, for example, Neurath developed a model of modern city planning centered around the ideal, nomadic figure of the "Gypsy-Settler." Undergirded by simultaneously romantic and racist ideas concerning Roma and Sinti groups, this figure would take advantage of both industrial and non-market forces to "self-help."[30] In the latter 1920s, he transferred his utopian aims from the practical sphere of urban development to the realm of museum education and exhibition design. Neurath intended the Vienna Method of Pictorial Statistics, and then ISOTYPE, to democratize knowledge and to promote greater international understanding. The Vienna Method, through its ecumenical sign system, was both intended to teach and empower members of the workers' movement, as well as to contribute to the creation of a "multiethnic urban citizenry," or an international solidarity among workers unimpeded by the difficulties of translating between languages.[31] Neurath was explicitly interested not only in ancient hieroglyphic languages but also in novel, international, and artificial languages being created at the time, such as Esperanto, Basic English, and Interglossa.[32] In this respect, he was just as attuned to the times as Griffith was a couple of decades before, but unlike the director's universalizing aspirations for film, Neurath actually attempted to design and implement a radically new visual, non-verbal language.

What *In-Formation* makes blatant, however, is the inadequacy and failure of ISOTYPE as an all-encompassing visual language, again, just as film failed as a universalizing grammar for Griffith. In one section, for instance, the video depicts abstracted bodies of immigrants, mostly asylum seekers, arriving to Germany from all over the world. Until recently, due to the trauma of World War II, Germany's Basic Law offered the most liberal asylum policy on the continent for fifty years, offering any politically persecuted person the right to refuge in the country. But with almost half a million asylum seekers by the end of 1992, significant post-1989 economic troubles with reunification, and increasing anti-Semitic, anti-Roma, and anti-foreigner sentiment and violence, Germany dramatically restricted its asylum law in 1993. Notably, this restriction has come to serve as the model for the European Union's policy as well. *In-Formation*, unable to represent the tremendous debate and controversy concerning this historical shift in asylum policy after the transformation of German statehood, instead offers an image of one vacuous stick figure pointing a rifle at another stick figure with the label below, "17 million politically persecuted," or rather, "politically haunted" [*politisch Verfolgte*] (figure 12.3). The multi-layered translatability of the German, in this case, offers far more semantic nuance to the anonymous asylum seeker than the flat figural signs.

17 Mio
politisch Verfolgte

Figure 12.3 In-Formation (Farocki, 2005).

Moreover, the "speaking signs" in *In-Formation* effectively silence its diverse historical subjects through stereotyping and abstraction. One sequence, for example, offers a presentation of statistics concerning immigration, work, and consumption in West Germany after WWII, particularly focusing on a Turkish demographic in the 1960s and '70s. It exposes social anxieties regarding integration, family life, and inter-marriages between essentialized groups of "foreigners" and "Germans." At one point, six cropped images of male, presumably Turkish, cartoon-like figures succeed each other in different slides. Each mustachioed man is pixilated to some degree, and some have no facial features except for a mustache. Following this, the video displays five images of Turkish women, all in headscarves. The penultimate woman is only a black shadow, and the last is trapped by a large red circle and "X" across her face (figure 12.4). Though each image lacks detail or depth, the repetition of their visages, reinforcing each other sequentially, constructs a mentally composite base of knowledge concerning "Turkish" people, similar to the *fin-de-siècle* photographer Francis Galton's synthesized, physiognomic "portraits" of criminals or Jews. The authority of such a pedagogically oriented, Powerpoint-like repetition depicts these flat, gendered, and racialized designations *in formation*. Stereotypes are constructed upon something always socially "known" in the dominant public's eye, which perpetuates that certainty with an anxious repetition. Official discursive spheres of government, reportage, and education are here imbued with derogatory, reiterated imagery of "outsiders" that reflect fears concerning national community and economic prosperity.

Figure 12.4 In-Formation (Farocki, 2005).

A century ago, Euro-American modernists still placed faith in pos-
sibilities for an ideal, pre-Babylonian, international language against
the backdrop of an increasingly proximate world. Yet the culturally
diverse, ISOTYPE-based faces and bodies in *In-Formation* are all figura-
tively muted in this *Stummfilm*, equipped with only mustaches rather
than mouths, or trapped like criminals behind the bars of a chart. All
of this data originates in secondary sources, moreover, in official docu-
ments or other public sphere materials, and comes to the viewer via
multiple avenues of mediation, further distancing spectators from the
video's historical subjects. In utilizing a "simple" *Stummfilm* format, this
video exposes the many complex voices that have been lost to a suppos-
edly neutral, visual data presentation. Whereas advocates of pre-sound
film often claimed a kind of universal understanding through silence,
the inclusion of intertitles countered the notion that a kind of
all-encompassing, human comprehension could be arrived at without
any differentiated, language-based communication.[33] *In-Formation* does
not even employ intertitles (in contrast to *On the Construction*), which
reinforces the impossibility (i.e. does not even give lip service to the
possibility) of a pre-Babylonian understanding after and amidst such
widespread immigration, displacement, and movement. Ultimately,
In-Formation's flood of imagery and messy parallel narratives, akin to
the silent "drama of comparisons" in *Intolerance*, babelize the histori-
cal narratives that have been masked *vis-à-vis* its stereotypical ISOTYPE

imagery. Though its multitudinous subjects have been historically and metaphorically muted in the telling of an "official," totalizing, pedagogical version, the video simultaneously resists the weaving of a transhistorical narrative divorced from its unique, plural actors. With such a historical lesson in mind, Farocki has recently worked to craft a twenty-first-century counter-catalog of human action, one that is also encyclopedic and global in scope, but simultaneously contingent, multi-authored, and ever-changing.

from cinema to museums to web catalogs

Whereas Griffith conceived of a utopian, universal visual language in terms of cinema, Otto Neurath believed this language could be developed in the museum.[34] Both were paternalistically committed to teaching messages to the uneducated, mostly working-class masses through popular communication forms, and both swam against the current in their respective areas of creative inquiry. As narrative films were beginning to be shaped linearly, tethered around individual characters and their psyches, Griffith attempted to interconnect archetypical figures in *Intolerance*, instead conveying the idea of historical recurrence.[35] Neurath, in turn, believed that museums should relinquish their adherence to the aura of objects, and rather, attempt to filter through and manifest data for viewers in a way that would enlighten them with greater social awareness. He was particularly curious about the ability of museums to respond to a burgeoning proliferation of imagery in his era, from film, mass advertising, illustrated journals, and so forth, as well as the ability of viewers to process such a mass of information with an increasingly limited attention span.[36] For him, museums could be a repository not for precious objects, but rather for intelligible, edifying information for the working class, displayed in a way that would effectively illustrate structural forces of production, consumption, and labor relations. This language would also be conveyed through types and hieroglyphic signs.

This ambition for accessible and egalitarian social edification echoes the particularly modern idea that circulated during this era to provide "object lessons" to mass audiences. In connecting an early cinema of attractions to the contemporaneous world expositions where they were often displayed, Gunning describes the World's Fair model, sometimes termed "Universal Exhibition," as epitomizing this notion: to convey knowledge through visual, not verbal means.[37] These expositions organized and packaged a kind of global "encyclopedia of civilizations" as an educational experience and "living picture" for audiences (a term also applied to early cinema, though in a somewhat different sense).[38] Moreover, these events were temporary and transportable. In a similar vein, Neurath developed the idea of "nomadic" museum displays—though in order to bring them to the

masses in working-class neighborhoods and community centers, not to situate them as exotic, consumable object-worlds at the center of imperial metropolises.[39] Neurath and his team could easily pack up the exhibitions and distribute them from site to site because they were fluid and reproducible rather than irreplaceable or "authentic" objects, using media such as films, slide shows, and printable graphic charts that could accommodate differently sized spaces.

In-Formation both reads like one of Neurath's "object lessons" from the Museum of Society and Economy in the late 1920s—with imagery touching on themes from "Settlement and Town Planning" (*Siedlung und Städtebau*), "Labor and Organization" (*Arbeit und Organisation*), and "Condition of Life and Culture" (*Lebenslage und Kultur*)—and, in single-channel video form, functions materially like one of Neurath's displayed media objects.[40] *In-Formation*'s placement in a museum context, nevertheless, offers a more contradictory response to twenty-first-century mediascapes and image flows. It is not such an easy task, in fact, to "read" this object, which, again, offers an excessive breakdown in visual codification. Farocki tests his audiences with his expanded, multi-screen installation practice, but this move into spatialized environments does not offer any facile object lessons for an ever more mobile, varied screen culture that surrounds contemporary spectators. Rather, his creative displays function more like the reception areas of many early silent films, which demanded curious foreknowledge and theatrical engagement by their publics. In other words, though Farocki believes that much can be learned from critically engaged, moving imagery in novel spaces, creative exhibition-making no longer promises the kind of panacean value that Neurath attributed to it in the early twentieth century.

In contrast, Farocki has recently embraced an Internet platform with more of the optimistic zeal that characterized Griffith's and Neurath's pedagogic endeavors concerning film and museum display. In 2011, Harun Farocki and Antje Ehmann launched a project that recaptures more of this utopian hope in reproducible media and images, taking advantage of all three forms: film, the museum, and the Internet. *Labour in a Single Shot* is a collaborative effort composed of workshops with filmmakers in fifteen cities around the globe, such as Bangalore, Tel Aviv, Berlin, Cairo, and Rio de Janeiro. At each workshop, facilitated by local contacts at universities or cultural centers, Farocki and Ehmann ask film students and amateur filmmakers to produce single-frame shots of about one or two minutes' duration. They must be continuous, without cuts, overtly mimicking the seminal format of the Lumière brothers' *vues*, or views, as their single-shot footage is often termed. Additionally, each film that has been or will be produced is placed on their web catalog, and most will be installed physically in exhibitions around the world from 2013–2015, including the 55th Venice Biennale and the House of World Cultures (Haus der Kulturen der

Welt) in Berlin.[41] Again, both the globalizing impulse and encyclopedic nature of this project, as well as its evolving, temporary display around the world, evokes the *fin-de-siècle* world exhibition, albeit with the clear intention to resist its imperial legacy and universalizing aspirations.

Labour in a Single Shot's website offers an impressive spectrum of films as well as an expansive quantity of accompanying data. Each film is catalogued under the city and workshop where it was produced, and each grouping includes a copious list of statistics concerning that respective city. The first figure, for instance, is always the number of "Google entries for the city," followed by "Google entries per inhabitant," both of which signal that city's global online connectivity. There are numerous other categories detailed as well, including the prosaic: population figures, average climate, percentage of religions, use of public transportation, and especially data concerning "economic output" (how much a dozen eggs cost, number of work hours necessary to purchase a Big Mac, percentage population below the poverty line, and so on). Yet there is also more exceptional data for each city: Tel Aviv was ranked the "Best Gay City in the World 2011" by www.gaycities.com, while Bangalore has forty million more male Indians because 50,000 female fetuses are aborted each year due to dowry conventions.[42] Online sources are meticulously cited, and the catalog reads like a series of Wikipedia pages, though ones created by diligent and thoughtful contributors.

Moreover, each city portrait includes an ISOTYPE-styled pictogram by the artists Alice Creischer and Andrea Siekmann, with whom Farocki has worked in the past. In 2010, for example, Farocki included work in an exhibition curated by the pair (as well as Max Jorge Hinderer), *The Potosi Principle: Colonial Image Production in the Global Economy*, in which Creischer and Siekmann also presented panels of their reconfigured ISOTYPE-like sign system. Farocki, Creischer, and Siekmann share an interest in the visual modifications that Gerd Arntz, in particular, contributed to Neurath's project.[43] Neurath employed a team of workers for ISOTYPE, and Arntz was the head graphic designer who conclusively streamlined and standardized the signs. However, in contrast to endeavors by Arntz and Neurath such as the naïve book *The Colourful World* (1929), intended as a primer for young readers concerning the major religions and ethnicities of the world, *The Potosi Principle* offers a critical display of a centuries-long visual economy of European cultural imperialism, or the obverse face of World's Fairs.[44] Likewise, the statistics and pictograms on Farocki and Ehmann's web catalog accent a more challenging picture of these global metropolises in terms of labor. Rio de Janeiro's pictogram, for instance, illustrates a bulldozer, garnished with images of a soccer ball (for the 2014 World Cup) and the Olympics rings (for the 2016 Summer Games) (figure 12.5). Whereas these worldwide events (historical and cultural analogues to the World Exhibition) have been touted as opportunities for increased employment

and economic prosperity in Rio de Janeiro, they already have and will undoubtedly induce more local economic casualties and displacements as well.

The statistics, pictograms, and films all function in tandem to offer a more nuanced presentation of labor in varying global centers. Their triangulation suggests subtleties, through context and comparison, which could not be conveyed through one stream of data alone. The statistics provide specificity and factual context for each city, for example, while the films spark singular, compressed moments of interest for a roving, online spectatorship, particularly one that has been conditioned to allocate no more than one or two minutes' attention to videos on YouTube (a more extreme version of mobile audiences in art installations today). Sampling the forty-three films from Hanoi, for example, one can identify, briefly, with the tremendously dull situation of one traffic woman who must stand and wait for long stretches of time in order to lower guard doors whenever trains roll by. Or one may wish to view the outcome of a young boy who must precariously transport a large, unattached block of ice on the back of his bicycle in the darkness of night. Yet another case depicts a more mundane factory film, however, without an individual protagonist with which to identify, or a suspenseful narrative to follow, where young women wearing plastic sandals and face masks sit in a cramped room of sewing machines and stitch an assembly line of gray uniform jackets (figure 12.6). The compact image gains significance as an "object lesson" when coupled with the website's statistics: learning, for instance, in a 2013 report by the Workers Rights Consortium, "Made in Vietnam: Labor Rights Violations in Vietnam's Export Manufacturing Sector," that twenty-seven percent of inspected Vietnamese factories had hard-to-access or no emergency exits; thirty-two percent of those factories employed workers who did not wear the necessary protective clothing; and twenty-three percent included workers who had been exposed to dangerous chemical levels.[45] Perhaps this information will reach a valuable quantity of the ninety-five percent

Figure 12.5 Labour in a Single Shot (Farocki, 2011).

of Vietnamese youth aged between fifteen and twenty-two who are using the Internet, or spread further among the eighty percent of Vietnamese youth who are registered on at least one social networking account online, especially considering that over 850 newspapers and magazines, sixty-eight radio stations, and thousands of news websites in Vietnam are operated by the single Communist Party-controlled military or government.

Wedded together, the films and data may catalyze not only fleeting observations, but also more trenchant insights. Not only individual identification with a figure, or a brief, absorptive experience in a narrative, but also a self-aware, cross-comparative or cosmopolitan reflection upon a larger global public space and forms of labor, and thus even potentially, collective action against, for example, oppressive working conditions in Vietnamese factories. More so than pedagogical primers like *The Colourful World* (1929), *Labour in a Single Shot* may actually engage the attention and/or political commitment of many more heterogeneous, global publics.

With this formidable film project, exhibition schedule, and web catalog, Farocki and Ehmann acknowledge and optimistically insist upon the wealth of invaluable information in today's world. The problem for them is how to focus it and make it pertinent for a massive audience as well. With respect to the web catalog, Farocki and Ehmann claim, "every detail of the moving world is worth considering and capturing. They [the filmmakers] were forced to have a fixed point of view while contemporary documentary films nowadays often tend to stuff one shot after another into a mixture of cinematic confusion."[46] These vues, similar to those of the Lumière brothers', also imply a "certain adherence of the film to reality," as Mary Ann Doane suggests, signaling a potentially indefinite quantity of the "pure storage/recording of time."[47] Indeed, Doane explains how the Lumières' approach to cinematic movement and time was eventually

Figure 12.6 Labour in a Single Shot (Farocki, 2011).

considered "semiotically insufficient," leading to the development of new methods of narration in film.[48] Yet their global, encyclopedic accumulation (1,424 in total) also offers a contemporaneous, world picture (if fragmented and distorted) from this earlier era.[49] *Labour in a Single Shot* aims to achieve something similar in scope: to catalog a moment of contemporaneity through cross-comparative and thoughtfully composed images of labor, but a catalog made and informed by many diverse actors in concert. Compared to the unfiltered, decontextualized, mass storage of YouTube clips, what could serve as a better alternative? Drawing inspiration from the earliest techniques of silent film, this project enhances the quality of the smallest "units" or "bits" of imaged data in the infoscape today, making eyes out of a storm of images.

In the modern information age, increasingly advanced technologies have forced the doors open for mass communication, simultaneously posing the promise of pluralistic, collective empowerment. But the emerging question, intractably, remains the audience themselves—how to foster widespread, capable pattern recognition, hand-in-hand with a deepness of knowledge and thoughtful, cosmopolitan worldview. This project renders unique episodes of labor from around the planet intelligible and intelligent, constituting neither an incomprehensible moving world of cinematic confusion, nor a totalized data archive of all world cultures, but rather an evolving space of imagined, encyclopedic heterogeneity and collectivity.

concluding comparisons: from silence to babel

In 2006, Farocki transformed his film *Workers Leaving the Factory* (1995) into his first large-scale, immersive video installation, *Workers Leaving the Factory in Eleven Decades*, confronting spectators with a twelvefold barrage of imagery. Now in the context of *Labour in a Single Shot*, numerous filmmakers around the world are authoring further Lumière remakes as part of the piece *Workers Leaving Their Work Places in 15 Cities*. Farocki has continually excavated the formative visual language of early film at crucial moments in that language's development. In doing so, he suggests that looking to these protean origins may enable one to momentarily arrest, or even get a grip on the frenzied array of moving-imaged information today. From the Lumière brothers' experimental camerawork to Griffith's attempts at codifying spectatorship and universalizing language through images, such concerns resonate today. How does one focus the camera or the viewer's attention where they are politically needed, especially in an overcrowded, diverse landscape of images? Borrowing from the origins of cinema over a century ago, Farocki has diachronically and synchronically reoriented the potential political meaning of a forty-five-second moving image, placing within its orbit other relevant spectators and creators. The silent, anonymous workers of the Lumières' film now flood out of their factories

along with a cacophony of other filmed laborers from around the world in the twentieth and twenty-first centuries. Farocki and Ehmann's online, co-curated info-mediascape compellingly avers an interconnected, planetary picture of labor relations.

To be sure, this present-day panorama is composed of many more actors and participants and onlookers than were available a century ago, when disparate populations were silenced and stereotyped in global visual regimes determined by gender inequality, imperial subjugation, and forced displacement. Both *On the Construction of Griffith's Films* and *In-Formation* expose this muteness, thematizing the de- and re-babelization of their respective historical subjects. Concurrent with the age of early film, there existed a progressive modernist faith in connecting and even edifying culturally, linguistically multifarious peoples through mass media. Early cinema could offer a means of raising social and political consciousness amidst an expanding yet confounding array of encyclopedic knowledge production from around the world.

Farocki's work advocates the difficult task of differentiating, comparing, and translating from image to heterogeneous image. Assuming such an active interpretative role means planting roots amidst the empty, repetitive torrent of data culture, of not being swept up in a consumerist economy premised upon falsely fungible politics. Though arduous, this will result in not only intelligible, but also intelligent, cross-cultural analysis and understanding. It will hopefully allow diverse publics to apprehend, that is, to both arrest and comprehend, a twenty-first-century infoscape—a contemporaneous, increasingly globalized Babel of images.

acknowledgment

I would like to thank Paul Flaig and Katherine Groo for their invaluable feedback on this essay.

notes

1. On Farocki's relationship to the archive, see Wolfgang Ernst and Harun Farocki, "Towards an Archive for Visual Concepts," in *Harun Farocki: Working on the Sightlines*, ed. Thomas Elsaesser (Amsterdam: Amsterdam University Press, 2004), 261–286.
2. Tom Gunning, "Early Cinema as Global Cinema: The Encyclopedic Ambition," in *Early Cinema and the "National"*, eds. Richard Abel, Giorgio Bertellini, and Rob King (New Barnet, UK: John Libbey, 2008), 14.
3. *Ibid.*, 16.
4. For a more comprehensive analysis of the educational uses of early cinema, see Jennifer Lynn Peterson, *Education in the School of Dreams: Travelogues and Early Nonfiction Film* (Durham, NC: Duke University Press, 2013).
5. Gunning, "Early Cinema as Global Cinema," 14.

6. See also Alexander Streitberger, "Imbricated Temporalities in Contemporary Panoramic Video Art," in *Photofilmic Images in Contemporary Art and Visual Culture*, eds. Brianne Cohen and Alexander Streitberger (Leuven: Leuven University Press, 2015).

7. Thomas Elsaesser's *Harun Farocki: Working on the Sightlines* (Amsterdam: Amsterdam University Press, 2004), a collection of scholarly essays, remains an invaluable resource of essays by and on Farocki.

8. Farocki states that the idea occurred to him when teaching such a single-shot technique to his film students at the Vienna Academy of Fine Arts. Author interview with Harun Farocki, Berlin, 15 June 2013.

9. Antje Ehmann and Harun Farocki, eds., *Cinema Like Never Before* (Vienna: Generali Foundation, 2006), 17.

10. For one of the best examples, see Christa Blümlinger, "Harun Farocki: Critical Strategies," in Elsaesser, *Harun Farocki: Working on the Sightlines*, 315–322.

11. Tom Gunning, "Systematizing the Electric Message: Narrative Form, Gender, and Modernity in *The Lonedale Operator*," in *American Cinema's Transitional Era: Audiences, Institutions, Practices*, eds. Charlie Keil and Shelley Stamp (Berkeley: University of California, 2004), 25–29. See also Raymond Bellour's analysis of *The Lonedale Operator* in *The Analysis of Film*, ed. Constance Penley (Bloomington: Indiana University, 2001), 262–277.

12. Miriam Hansen, *Babel and Babylon: Spectatorship in American Silent Film* (Cambridge, MA: Harvard University, 1991), 44.

13. *Ibid.*, 16.

14. *Ibid.*, 84–85.

15. *Ibid.*, 18.

16. *Ibid.*

17. *Ibid.*, 149–154.

18. *Ibid.*, 151–153.

19. *Ibid.*, 161–162.

20. *Ibid.*, 80.

21. *Ibid.*, 136.

22. *Ibid.*, 168.

23. *Ibid.*, 15–16.

24. *Ibid.*, 185.

25. *Ibid.*, 77, 95.

26. Timothy Mitchell, "Orientalism and the Exhibitionary Order," in *The Visual Culture Reader* 2nd edition, ed. Nicholas Mirzoeff (London: Routledge, 2002), 495–505.

27. *Ibid.*, 186, 203.

28. Nader Vossoughian, *Otto Neurath: The Language of the Global Polis* (Rotterdam: NAi, 2008), 65.

29. Nader Vossoughian, "The Modern Museum in the Age of its Mechanical Reproducibility: Otto Neurath and the Museum of Society and Economy in Vienna," and Sybilla Nikolow, "*Gesellschaft und Wirtschaft*: An Encyclopedia in Otto Neurath's Pictorial Statistics from 1930," in *European Modernism and the Information Society: Informing the Present, Understanding the Past*, ed. W. Boyd Rayward (Burlington, VT: Ashgate, 2008), 244, 259.

30. Romani cultures, romanticized and primitivized as nomadically "free," were often sources of inspiration for European twentieth-century art—a similar, striking example here would be Constant Nieuwenhuys' *Design for a Gypsy Camp* (1956–1958) and *New Babylon* (1959–1974).

31. *Ibid.*, 61.
32. Nikolow, *"Gesellschaft und Wirtschaft,"* 260.
33. See, for example, Béla Balázs, *Theory of the Film* (London: Denis Dobson Ltd, 1953), 25–26.
34. Hansen, *Babel and Babylon*, 15–16.
35. *Ibid.*, 137.
36. Vossoughian, "The Modern Museum," 246.
37. Tom Gunning, "The World as Object Lesson: Cinema Audiences, Visual Culture and the St. Louis World's Fair, 1904," *Film History* Vol. 6, No. 4 (Winter 1994): 425.
38. *Ibid.*
39. Vossoughian, "The Modern Museum," 247–248.
40. Nikolow, *"Gesellschaft und Wirtschaft,"* 261–262.
41. See http://www.labour-in-a-single-shot.net. Accessed 6 May 2015.
42. This latter statistic is taken from www.welt.de. Accessed 6 May 2015.
43. Author interview with Farocki. See also Alice Creischer and Andreas Siekmann, "How to Wear a Scissor-Wielding Trifecta on a T-Shirt," *e-flux* No. 59 (November 2014): http://www.e-flux.com/journal/harun-farocki-or-how-to-wear-a-scissor-wielding-trifecta-on-a-t-shirt-alice-creischer-and-andreas-siekmann/. Accessed 23 February 2015.
44. Vossoughian, "The Modern Museum," 251.
45. http://www.labour-in-a-single-shot.net/en/workshops/hanoi/. Accessed 10 December 2013.
46. http://www.labour-in-a-single-shot.net/en/project/concept/. Accessed 10 December 2013.
47. Mary Ann Doane, *The Emergence of Cinematic Time: Modernity, Contingency, the Archive* (Cambridge, MA: Harvard University Press, 2002), 179, 185.
48. *Ibid.*, 178.
49. *Ibid.*

brianne cohen

found memories of film history

industry in a post-industrial world,

cinema in a post-filmic age

b r i a n r . j a c o b s o n

Alongside their material return in the found footage work of artists and experimental filmmakers, silent films have left a no less remarkable, if more askew, mark on contemporary visual culture as what this chapter terms found memories of film history. "Found memories" defines a category that we might think of as found footage films without the footage—films that evoke tropes and types (and, at times, specific texts) from film history but in remembered, not material, form. Registering something more than inspiration but less than a physical trace of the filmed past, it attempts to theorize how contemporary artists and filmmakers are bringing the aesthetics, politics, and ideas of cinema's silent era to bear on the present.[1] This chapter develops the concept of found memories by focusing on Sharon Lockhart's engagement with cinema's past in two films made as part of her *Lunch Break* project, completed at the Bath Iron Works in Maine between 2005 and 2008. Drawing on a long history of images documenting industrial life—from paintings such as Pieter Brueghel the Elder's *The Harvesters* (1565) and Jean-François Millet's *Noonday Rest* (1866) to photographs by the likes of Charles Sheeler, Jack Delano, and Marion Post Wolcott—Lockhart's project

enacts, promotes, and offers an entry point into a larger process of remembering histories of labor.[2] Its two films—*Exit* and *Lunch Break*—mediate that entry by evoking memories of industry drawn from the early days of cinema.

In *Exit*—a film that documents the workers' daily exit from the Bath Iron Works—those memories echo from cinema's very origins. Scholars have often characterized the film as a kind of remake of the first Lumière short, *La Sortie des usines Lumière* (1895). This chapter departs from such analyses by arguing that the "remake," as a conceptual category, limits more than it opens avenues for interpretation.[3] By deploying another set of analytical categories to explore Lockhart's engagement with *La Sortie des usines Lumière*, the chapter aims to illuminate the many other ways that contemporary cinema and visual culture are engaging with film history but only rarely through the practice of remaking.[4]

In particular, I use André Bazin's analysis of remakes and re-releases in post-war France to read Lockhart's work as a form of *reprise*, or resumption, of cinematic and social concerns found in film's past. Building on descriptions of Lockhart's photos as "film stills" and her films as "still films," I define the form of that reprise by examining how *Exit*'s "found memories" push us to take up the past again through a kind of rephotography. Departing from definitions that assume that rephotography projects' new photos necessarily correspond with a specific location found in an older precursor, I argue that Lockhart's *re-cinematography* produces meaning and memory through a different relationship to the original image. In *Exit*, Lockhart re-photographs not a location but an idea found in early film history. In doing so, she puts that history into dialogue with the present through a form of what Norman Bryson and Jennifer Peterson have separately described as "counterpresence," a concept that this chapter expands to include not just the presence of off-screen spaces or overlooked actions within the image itself but also of past spaces and times.

By bringing the film(ed) past to bear on the present, *Exit* creates a powerful visual politics of industrial representation and the future of labor that Lockhart takes further in the project's title film. In *Lunch Break*, she uses an eighty-minute tracking shot through the factory's interior to engage with film's past in indirect form. Although the film bears no explicit reference to a precursor like *La Sortie des usines Lumière*, it similarly recalls silent cinema's fascination with factory interiors. In particular, I argue that *Lunch Break* recalls and takes up the interest in industrial spaces seen in films such as G.W. "Billy" Bitzer's Westinghouse Works series from 1904 and the politics of labor in films like Sergei Eisenstein's *Strike* (1925).

Lockhart's engagement with industrial history and the technologies with which she does so are both timely and indicative of changes in labor and cinematic culture. Her films point up the tensions of a moment when digital technologies portend the "death" of cinema while automation

and globalization threaten to make industrial labor a thing of the past for workers like those seen leaving the factory in *Exit*. By building on a history of industrial images, Lockhart's *Lunch Break* project brings the memory of earlier political moments to the modern factory. In its reminiscent relationship to early industrial films, it similarly poses questions about the fate of cinema. Expanding on David Rodowick's argument that Lockhart's earlier "still films" reinvest digital aesthetics with the lost duration of analog film and photography, this chapter argues that Lockhart's use of a digital intermediate in *Lunch Break* (to slow ten 35mm minutes to eighty digital ones) reverses that process, instead capitalizing on the halting duration of the digital to envision the end of a form of industrial life that came of age alongside film.[5] Lockhart's synthesis of factory downtime and cinematic slow motion creates a potent allegory not only about the decline of industrial labor in a post-industrial world but also about the transformation of cinema in a post-filmic age.

"a propos des reprises," or, what is a remake?

The current interest in silent cinema recalls the mid-century engagement with film's past that led André Bazin to take up the question of remakes and re-releases in *Cahiers du cinéma*. In the opening to his September 1951 article "A propos des reprises," Bazin marvels that "the real novelty of the summer season on first-run Parisian screens would be the growth of re-releases."[6] Citing the return of films including *The 39 Steps* (Hitchcock, 1935), *Drôle de drame* (Carné, 1937), and the Marx Brothers' *A Night at the Opera* (Wood, 1935), Bazin ponders the enduring value that old films might retain as they age. While the cinephiles behind France's local ciné-clubs might be expected to maintain an interest in film history, what, he asks, could explain the broader public's interest in re-releases? What, moreover, might that interest reveal about film culture, both in practical terms—foretelling a future, he seems to hope, in which cineastes and their investors could dream of attracting a paying public for years rather than months—and as a reflection of a shift in the public's taste for cinema?

Bazin offers every reason to doubt the public's ability (or willingness) to engage with re-released films. In contrast to remakes, where the memory of an old film's previous greatness promises future success in a new form, the re-release threatens the rules of the cinematic marketplace. Facing a logic in which "the new chases the old without respect to merit," even the greatest old film cannot hope to compete, nor even be allowed to share screen time, with the latest releases. Only the old made new again could re-enter the market. Thus, when Chaplin, hoping to profit on his silent success, re-released *The Gold Rush* (1925) in 1942, he added a soundtrack with narration. Likewise, René Clair could re-release *A nous la liberté* (1931) in 1950, but only as a newly restored and shortened version.

The French term for the re-release, *reprise*—from the verb *reprendre*, to take (something) up again—illustrates the multi-faceted character of these films' return. To have their theatrical lives resumed, old films needed distributors and theater owners to take them up again in the hope that audiences would do the same. For their *reprises*, Chaplin and Clair encouraged this return to the past by short-circuiting it, taking up their old work and making it something to be taken as new. In this logic, the "remake" represents only another, more extreme version of the *reprise*. Not just shortened, colorized, "sonorized" [*sonorisé*], or recut, the film remade (Bazin uses the verb *refaire*—to do, or make again) has been taken up again and redone in a form in which audiences can more readily take it up again themselves.

For Bazin, this more radical form of *reprise* illustrates the extra-economic imperatives that explain why audiences would be unlikely to embrace re-released films. In short, he argues that the business of film distribution cannot entirely explain the need to remake rather than simply re-release old films. Here Bazin insists upon film's rootedness in the historical moment of its production. Faced with an art driven by changing conventions of realism and evolving technologies and techniques for producing it, how can the modern viewer be expected to embrace antiquated film styles that fall short of contemporary illusionary codes? Or, as he put it in another article, this need for the new acknowledges that, "film is the only art that ages with us."[7] The problem is only made worse by the appearance of aging stars—signaled so forcefully by Norma Desmond and her "waxworks" friends in *Sunset Boulevard* (Wilder, 1950)—whose enduring screen youth bespeaks the re-released film's historical distance, further shattering the illusion. What's more, even if one could ignore cinema's own forms of aging, the historical realities presented on the screen would surely impinge upon our experience. As a salacious Bazin put it, how could he hope to be seduced by an actress sporting passé styles and speaking a bygone vernacular?

And yet, a spate of *reprises* had found their way back to Parisian screens. Bazin attributed this return to a "decisive modification of the relationship between the public and film."[8] Rejecting the notion that these old films' success signaled the decline of the present film industry, he argues, on the contrary, that it portended "the adolescence of a golden age of cinema" that had produced "a public capable of appreciating these masterpieces despite their age."[9] The quality of the new had made possible a revalorization of the old.

More than fifty years later, what does Bazin's optimistic reading of re-releases and remakes offer to our own moment of return and revalorization? For the reflexive film histories Bazin saw in *Singin' in the Rain* (1945) and *Sunset Boulevard*, today we have *The Artist* (Hazanavicius, 2011) and *Hugo* (Scorsese, 2011). And for the revised *The Gold Rush* and re-released *Drôle de drame*, we might think of the 3D version of *Titanic* (James Cameron, 1997),

the 2012 restoration of *Laurence of Arabia* (Lean, 1962), or the most recent version of *Metropolis* (Lang, 1927).

Rather than using these parallels to proffer a parallel reading of another cinematic golden age, I want to ask what else might be at stake in taking up film's past. For left out of Bazin's analysis is the broader significance of what came with these films' return, in whatever form, to public consciousness. What was it about some films that promised to trigger the public imagination and incite the kind of recognition of common concerns that would ensure their remade success? For the spectator willing to perform this *reprise*—to take up stories, themes, and, in some cases, forms from film history—what else came with it? These, I think, are the questions posed by the work of artists like Sharon Lockhart who are making silent cinema the backdrop for their work today.

taking up the past (again): *reprise*, reminiscence, rephotography

Lockhart's 2008 film *Exit* poses these questions formally by making the *reprise* its very structure. In one eight-minute shot for each of five days, we witness workers walking away from the unseen Bath Iron Works. With each new shot, the viewer is compelled to take up the previous one(s) again, to recall details and notice differences. Jennifer Peterson has described this as a kind of "game" that the film creates for observant spectators.[10] With each *reprise* of the workday's end, the viewer's work begins again. Lockhart structures these *reprises* with a mathematical precision that evokes the abstraction of industrial time. The film's eight-minute shots evoke the eight-hour days of the forty-hour week. The title cards that introduce each new section—MONDAY, TUESDAY, WEDNESDAY, etc.—juxtapose timeless abstraction with the images' specificity. On the one hand, Lockhart offers up *these* workers, seen from behind as they walk away from the Bath Iron Works with the lunch pails so meticulously documented in the project's photographs. On the other hand, it's just another Monday, Tuesday, Wednesday . . . work days. Projected in HD video on a gallery loop—the virtual reel taken up again and again—the film becomes an index of this quotidian repetition. After forty-one minutes, *Exit* returns. Another Monday.

This quotidian structure and looping exhibition format give form to the repetitive character of industrial labor, inviting spectators and gallery-goers to connect the workers at the Bath Iron Works with similar laborers in other factories. The film also evokes a long history of labor with specific resonance in the history of moving images. Beyond the repetitive images of walking workers, lunch pails, and the industrial landscape that echoes the unseen factory, the attentive viewer is pushed to broader questions about the nature of these workers' labor and their experience of it.[11] The film's structure allows such questions to extend beyond its temporal

frame and to the historical horizon. Did last Monday, Tuesday, or Wednesday look like this one? For how many Thursdays, how many Fridays have these workers been exiting the Iron Works? And what about those who did so before them?

As others have noted, the film invokes those previous workers by evoking a history of films documenting workers leaving factories that goes back to the earliest days of cinema. In particular, few have failed to note the film's relationship to the first Lumière film. Peterson, for instance, situates *Exit* in a series of recent works—including Harun Farocki's *Workers Leaving the Factory (Arbeiter verlassen die Fabrik)* (1995) and Ben Russell's *Workers Leaving the Factory (Dubai)* (2008)—that have taken the first Lumière film as a source of inspiration for once again addressing the nature of labor at a moment when many of its conditions are changing.[12] Others have cited the film's debt to structural film while still situating *Exit* in a tidy history with *La Sortie des usines Lumière*—the "first ur-structural film"—at its origins.[13]

For all of their virtues, such readings have tended to obscure other significant influences on the *Lunch Break* project and, as a result, more expansive interpretations of its films. These alternative interpretations point to the varying approaches through which artists and filmmakers like Lockhart have engaged with film's past. In particular, we might better understand a film like *Exit* as both a kind of *reprise* of earlier cinematic (and non-cinematic) concerns—including those of the Lumières—and as a form of remembering that recalls the original film neither as found footage nor simply as another version of the original.

For her part, Lockhart has described *Exit* as "reminiscent" of the Lumière film. From the Latin *reminisci*, or "remember," a reminiscence consists of memories, reminders, or suggestions of past events. The reminiscence evokes the past, bringing it back to the present, in order to recall certain details about it. One who reminisces enacts a kind of recollection of the past, gathering its events together to create a new experience of them.

Lockhart's reminiscence performs precisely these functions. *Exit* re-collects the first Lumière short (and its remakes) as part of a collection of past images of industrial life, including Lockhart's own memories, amassed over the course of more than a year, of the workers in Bath. Those diverse images define the film's form of *reprise*—taking up the Lumière film and putting it in dialogue with other images taken from the history of industrial visual culture. In *Exit*, these found images evoke memories of industrial life and labor—found memories that include but cannot be limited to the memory of cinema's industrial origins.[14]

Lockhart has also situated the *Lunch Break* project and its films in a lineage that goes back to the 1960s, but rather than structural film, she cites precursors in conceptual art. In preparing the project, she took inspiration from Fluxus artist George Brecht's boxed works, a mixed-media series that included *Water Yam* (1963), a box of ninety-three performance scores and a

flipbook (*Nut Bone. A Yamfest Movie*). Photographs of these containers and their objects helped inspire Lockhart's portraits of their modern industrial counterparts—the Bath workers' lunch boxes. In the resulting photos, Lockhart sought, in her words, to "engage the problem that I was dealing with in the film *Lunch Break*: how do you get around the clichés that riddle representations of workers?"[15]

Exit avoids such clichés by refusing simply to remake the Lumière film. Indeed, Lockhart's invocation of Brecht underscores her desire not just to return to representations of labor but also to take up those representations again in a new way. Even the word "Exit" in the film's title points to an alternative relationship to film's past than most have assumed. Rather than a reference to the Lumières' *Sortie, Exit* refers to the instructions for one of Brecht's performance pieces. "I was originally interested," Lockhart explains, "in a word event Brecht had created called *Exit*, which consisted of a card printed with the phrase 'Word Event' and the word 'Exit' below."[16] As Hannah Higgins describes, realizations of the piece to which Lockhart refers, Brecht's *Word Event (Exit)* (1961), "range from looking at an exit sign or acting on it, to having a performative or theatrical relation with others observing the sign, to using this piece as a means by which artists might leave a performance."[17]

While it would be too much to describe Lockhart's film as a re-staging of *Word Event*—as a kind of twenty-first-century Fluxus redux—*Exit* does read like a realization of Brecht's script. Workers enter the frame, workers exit out of view. And one might go so far as to read *Exit* as just as much a remake of Brecht's own 1965 film version of the piece, *Entrance to Exit* (or *Fluxfilm* 10), as *La Sortie des usines Lumière*. After the title, "Flux Film 10," and Brecht's name, the silent seven-minute film includes only a white "Entrance" sign enclosed in two dashed rectangles and an "Exit" sign in black letters on a white background, between which the empty frame shifts between shades of grey, black, and white. Brecht's minimalist structure—an entrance followed by an exit—similarly defines each of Lockhart's subsections. Her daily title cards perform a similar function as Brecht's entrance and exit signs. Between its typographic markers, *Exit* substitutes visual abundance for Brecht's empty frame, but the two films function similarly. Much as the central section of *Entrance to Exit* takes form through the repetition of slowly shifting shades of black and gray, so each day of *Exit* plays on the repetition of a visual field of workers and lunch pails, the varying configurations of which introduce the difference that subtly distinguishes one day from the next.

As such comparisons suggest, we miss some of the sophistication of *Exit*'s formal structure and, by extension, its political charge, by limiting its precursors to the Lumières. Indeed, Lockhart's interest in the everyday bears closer resemblance to the Fluxus event than the Lumière *actualité*. Much as Fluxus artists like Brecht sought to exalt the mundane and highlight its

contingency, so Lockhart elevates the workers' quotidian exit to an event worthy of contemplation. The forgettable act of exiting becomes an event to remember.[18] By asking the viewer to consider five exits, and to remember and compare each in turn, *Exit* invites a form of reminiscent contemplation that opens the text beyond both its visual frame and the specific moments it documents.

Jennifer Peterson has similarly argued that *Exit*'s visual form—the long take, deep focus of its five shots—reflects an emergent visual aesthetic with an attendant form of viewing experience. Peterson explains that *Exit* should be understood as part of a broader group of recent films that suggest the emergence of a new "observational aesthetic" defined by what she terms "conceptual realism." Shaped by their creators' efforts not simply to document the realities of modern industry but rather to "critique the structure of industry they observe," such films use realism as a reflexive political tool.[19] They do so, in part, by gesturing to the worlds and political realities that lie just beyond their visual bounds. In short, what we cannot see becomes just as important as what we can. Borrowing a concept from art historian Norman Bryson, Peterson argues that *Exit* works precisely through this "counterpresence" of the unseen.[20] For Bryson, Lockhart's work contributes to conceptual art's activation of new modes of reception that acknowledge the viewer's poorly understood role in determining the experience and meaning of the art work. In photography, series by such artists as Bernd and Hilla Becher, for instance, demonstrate the value of understanding the single image of an oil refinery or water tower not on its own formal or aesthetic grounds but through the conceptual presence of absent but related images of similar structures in the same series.[21] Put simply, the single image takes on meaning through its relationship to other related images. Bryson argues that something similar is at work in Lockhart's portraits, and the same reading, I would argue, applies to *Lunch Break*'s "portraits" of lunch boxes.

Bryson expands his analysis of counterpresence to include the ways that Lockhart's films extend the spectator's vision and attention beyond the films' primary content. For instance, in *Goshogaoka* (1997), a film composed of ten-minute sections documenting a group of Japanese schoolchildren practicing basketball drills, Lockhart's fixed camera establishes a strict frame of reference within which the viewer's attention is drawn away from the event itself and to the micro-movements and variations within it. Rather than its focus, the routinized drills that the film documents become only the frame for a counter-experience of "chance, occasionalism, and microvariation."[22] Similarly, in *Teatro Amazonas* (1999), Lockhart's fixed-camera view of an audience framed against the backdrop of a row of symmetrical arches watching an unseen performance becomes a study not of order but of the presence of contingencies—coughs, sniffles, and yawns, whispers and exchanged glances—that would, in Bryson's view, normally "fall far below the threshold of attention."[23]

As Peterson has argued, the idea of counterpresence well describes how Lockhart activates that which remains unseen in *Exit*—the factory from which the workers exit, or an unseen seascape hinted at by the sound of calling gulls. Much as in *Goshogaoka* or *Teatro Amazonas*, the viewer's attention is drawn more to the presence of microvariations in the images than to their direct form or content. But we might also extend that counterpresence to the film's intertextual links. For the gallery-goer or attentive viewer, such links no doubt include the project's companion film, *Lunch Break*, the photographs of workers and lunch boxes displayed on adjacent gallery walls or, for others, references drawn from a longer history of representations of labor and technology. Indeed, if *Exit* recalls the first Lumière film, it makes that connection possible in this way: by staging a reminiscent contemplation of textual counterpresence that emphasizes the virtual presence of film's own past.

How do we account for Lockhart's production of such a virtual counterpresence? How does one bridge the physical and historical distance separating the Maine of *Exit* and the Lyon of *La Sortie des usines Lumière*? If counterpresence, in the way Bryson and Peterson have described it, arises from Lockhart's ability to activate the image in unexpected ways or to invoke the absent presence of other images in her projects, whence does she activate the presence of something more remote like the Lumière film?

To answer these questions, I would like to propose that we think of the film not as a remake but as a kind of rephotograph, or, better, as a form of "re-cinematography." Lockhart's explorations of the limits and extensions of film and photography offer evidence for such a reading. Art historian George Baker has described this exploration best, arguing about *Teatro Amazonas* that, just as we might think of Lockhart's photographs as "film stills" (or "cinematic photographs"), so we might think of her films as "still films."[24] In Baker's "expanded field" of photography, a "still film" like *Teatro Amazonas*—or *Exit*—is as much photographic as filmic. Even if they are not photographs, per se, still films are nonetheless, in Baker's words, "linked conceptually to a field mapped out by the expansion of *photography*."[25] Placing such films in this "expanded field" allows us to understand the conceptual links between the work of filmmakers like Tacita Dean who also take still photographs, photographers like Lockhart who make films, and artists like Douglas Gordon who makes films "still" by slowing them down.

Situating *Exit* in this field points to the film's relationship to Lockhart's broader photographic work, including a series of rephotography projects. As Baker has described, Lockhart has turned to rephotography since the 1990s in projects devoted to exploring her own past. In *Untitled Study (re-photographed snapshot)*, an ongoing series begun in 1994, Lockhart is re-photographing her own family photo albums. More recently, she has re-photographed portraits of herself and her sister.[26] These projects

251

anticipate the production of virtual counterpresence with past images seen in *Exit*, and they offer a way of understanding its logic.

Like remaking, rephotography involves a return to a previous text, time, and place that the artist recalls or re-collects for a new context. The new image can, of course, be understood on its own, but it is designed to be read in the presence of its older counterpart. As practitioners like Mark Klett and Peter Sramek have described, rephotography is defined by repetition, reproduction, and reminiscence. In Sramek's words, "[it] leads to questions about why it was important to photograph a particular scene at the time, what factors influenced how it was represented and what it means to re-do it now."[27] These kinds of questions underscore the persistent presence of past images in both the ontology of the re-photographic image and the epistemological approaches to viewing them that they encourage.

In this way, rephotography projects insist upon and foreground counterpresence as their organizing principle. Their basic conceit creates a conceptual bridge that links two photographs into a single image. And those links have an important temporal dimension. Unlike the photographic series by the Bechers or portraits by Lockhart that produce the presence of different spaces and similar objects, rephotography creates a counterpresence of time.

In *Exit* it is this temporal counterpresence that brings the Lumières' *Sortie* back to the present. The film's visual difference from the Lumière film highlights the difference. Lockhart clearly has not re-photographed the Lyon factory facade, nor has she even photographed factory gates at all. But she has created a conceptual link to the Lumière film that goes beyond the films' similar subjects and related titles. Instead, she forges that link through a practice that capitalizes on rephotography's ability to highlight change over time. As Mark Klett has described, "rephotography is particularly good at asking viewers to consider their relationship to time and change."[28]

Such is the question that Lockhart's *Lunch Break* project poses to its viewers. How has labor changed and how is it changing? How can one represent that change without resorting to clichés? *Exit* attempts to do so through a form of re-cinematography that invokes the Lumières' *Sortie* as a counterpresent image of past labor that weighs on our impression of industrial life more than a century later. In a film defined by the temporality of today's working time, it is the presence of that *longue durée* and of all of the found memories it re-collects that delivers the film's criticism of modern working life.

In the project's other film, *Lunch Break*, Lockhart advances that criticism by using found memories of the filmed past to highlight the politics of industrial change. Unlike *Exit*, the film has no evident precursor in early film history. But it generates the same virtual counterpresence of film and labor history by evoking textual references that underscore the value of

looking beyond the remake to understand contemporary cinema's relationship to film history. In doing so, the title film, like *Exit*, also draws attention to the nature of cinematic time, here to deliver a potent message about the changes shaping cinema in the digital age.

lunch break and the visual politics of industrial representation

The production of counterpresence generated by *Exit*'s reminiscent contemplation of the quotidian industrial event takes on new form as Lockhart shifts to the factory interior in the project's title film. In *Lunch Break*, a history of factory images subtends both a visual politics of industry in the "post-industrial" world and a commentary about the state of cinema in the so-called "post-filmic" age. Here Lockhart evokes found memories of film and industrial history that highlight the similar changes facing each in a shared moment of technological transition.

Few locations could better encapsulate those changes than the Bath Iron Works. Founded as an iron foundry on the Kennebec River in 1826, it became home to the Bath Iron Works, Ltd. in 1884, began shipbuilding in 1888, and turned out its first hull in 1890. Since 1973, the Works has filled contracts for the United States Navy, including guided missile frigates, cruisers, warships, and, from 1985 to 2011, destroyers. On the heels of a modernization project begun in 2001, the Works has shifted to new modular construction techniques guided by 3D computer-aided design.[29]

Despite its recent update and new digitally guided production techniques, the Works retains an anachronistic link to its century-spanning industrial history: each day production halts for a collective employee lunch break. This daily downtime marks a notable deviation from the more standard production processes implemented in the wake of widespread factory mechanization. In the post-Fordist world, production stops for no one. But at the Bath Iron Works, the factory machines still sit idle while their operators enjoy an active pause—eating, reading, playing games, and running small businesses that sell food and drinks to their coworkers.

This shared hiatus helped inspire Lockhart to explore the non-working time of modern working life. The project's group portraits—or "lunch break scenes"—reveal the varying forms of workplace sociability that emerge during factory downtime: from conversations around picnic tables to more intimate exchanges on delivery pallets to moments of individual contemplation on folding chairs or at single tables. Photographs of "independent businesses" show how other forms of work carry on despite the official break, evoking labor movement hopes for worker-owned cooperative industry. And portraits of workers' lunch boxes—titled with the name of each owner and his or her trade—leave us to imagine the quotidian lunchtime narratives played out with their forms and contents.

The project's title film further animates this process by carrying the viewer through the factory during a single midday break. Over the course of eighty minutes, we slowly traverse the Works on a trajectory defined by the insistent linearity of the factory aisle. A seemingly limitless vector of fluorescent bulbs, meeting its reflection on the concrete floors at the distant horizon, lends consistency to an otherwise varied landscape of pipes, cables, and tubes; lockers, containers, and cabinets; and, of course, workers. Scattered along the aisle's margins, some two-dozen workers sit, stand, eat, read, and talk, some alone, others in twos and threes. One eats a sandwich. Two relax in rolling desk chairs. Several read newspapers. Another sleeps.

Scholars have tended to overemphasize the idea that these images of industrial life are especially rare. Taking their cue from Harun Farocki's claim that "over the last century virtually none of the communication which took place in factories, whether through words, glances, or gestures, was recorded on film," many of the film's first critics have staked part of its uniqueness on the fact that it represents industrial labor at all.[30] To be sure, narrative cinema has largely pushed representations of industry—and especially industrial conflict—to the margins of the mainstream. Describing the same kind of production of counterpresence that Bryson and Peterson identify in Lockhart's other films, Sabine Eckmann thus rightly notes that *Lunch Break* "brings into focus everyday life situations that typically escape our media-saturated attention and collective consciousness."[31] But even Farocki's own *Workers Leaving the Factory*, a project built on re-collected fragments of cinema's industrial past, demonstrates that such images have long been part of a history of cinema—just not the theatrical sort—that has received increasing attention from film and media scholars in the two decades since Farocki's film.[32]

More compelling than the mere fact of representing life behind the factory gates is how *Lunch Break* does so. Like *Exit*, the title film creates a form of counterpresence by evoking industrial views from film history. The film's power, in other words, emerges not from its unique attention to factory interiors but rather from its similarity with earlier films' ways of bringing working life to the public eye. Further departing from the realm of the remake, *Lunch Break*—via no precise precursor—re-collects critical scenes from cinema's history of industrial imagery.

The film recalls these scenes through its formal conceit—the single take tracking shot. From the earliest industrial films to the present, filmmakers have made the tracking shot a consistent formal element of technological representation. In its ability to encapsulate and accentuate both the scale and fluidity of infrastructural systems and industrial processes, the tracking shot has long injected dynamism into potentially banal manufacturing scenes. In its ability to foster continuous fluidity, the tracking shot has become a key means for aligning cinematic motion with machine-made movement—creating a kind of affinity between film and other machines.

Arguably the most compelling and earliest examples of this vitality and synchronicity appear in the American Mutoscope and Biograph Company's 1904 Westinghouse Works series. Produced by G.W. "Billy" Bitzer for the Westinghouse display at the 1904 Louisiana Purchase Exposition in St. Louis, the series consisted of twenty-nine films.[33] Among them, three panoramas shot inside the Works stand out. In *Panorama of Machine Co. Aisle*, *Panorama View Street Car Motor Room*, and *Panoramic View Aisle B.*, Bitzer's camera—mounted on an overhead rigging system used to transport materials across the factory—glides slowly down the aisles to capture a capsule view of modern industrial practice. Like the "phantom rides" that created panoramic views by making the locomotive a kind of cinematic prosthesis, Bitzer's factory panoramas produce a striking form of machine-age synchronicity. The factory acts as a motor for cinematic motion, and the completed films that arrive at the end of the assembly line become its mechanical productions.

Lunch Break evokes these scenes by inverting them, both in content and form. Bitzer's images of work become Lockhart's portrait of rest. The high-angle view of Westinghouse meets its mirror reversal at Bath's ground level. And the soundscape we can only imagine for the silent panoramas come to life in the score by Lockhart, composer Becky Allan, and James Benning. In this way, much as *Exit* takes up the image of industrial life in *La Sortie des usines Lumière*, so *Lunch Break* becomes a *reprise* of Bitzer's Westinghouse panoramas. The latter scenes echo silently as the counterpresent images of a bygone period of industrial labor, the fading traces of which still persist at the Bath Iron Works.

Those traces of labor history give form to the *Lunch Break* project's visual politics. By highlighting the forty-hour workweek in *Exit*'s temporal structure and the daily downtime that defines the other film and photos, Lockhart invokes the Progressive Era and New Deal reforms that made these routines possible.[34] The counterpresence of Bitzer's Westinghouse films creates a link between that history of labor politics and the persistence of its outcomes in factories like the Bath Iron Works. In a film otherwise devoid of obvious signs of labor struggle—including Lockhart's own union-supported fight to film inside the Works—found memories like the Westinghouse films help generate the film's counterpresent visual politics.[35]

Other found memories re-collected by *Lunch Break*'s defining tracking shot include more explicit cinematic moments of class struggle. In the opening sequence of *Strike*, for instance, Sergei Eisenstein establishes the film's factory setting in a shot that bespeaks the same affinity between film and industrial technologies. Like Bitzer before him, Eisenstein uses a camera mounted on an overhead rigging system to send the viewer gliding down the factory aisle for ten seconds of smooth, machine-made visual motion. In *Strike*, however, the tracking shot reveals a revolutionary scene.

While the factory appears to run as smoothly as the shot itself, that calm only portends the storm brewing in the aisles below.

Nothing quite so ominous appears in *Lunch Break*. Indeed, one should not overstate its politics. This is not a film about a nascent industrial action so much as a waning form of working life.[36] But such are the cinematic memories elicited by a project about the life of the laborer in an era of factory mechanization, high unemployment, and gross inequality.[37] And they are of a kind with the images collected by Lockhart and reproduced in the Vienna Secession catalog that accompanied the exhibition. Interspersed with Lockhart's portraits of Bath workers at lunch, the catalog collects paintings and photographs not only of lunch scenes from earlier eras but also of American workers on strike in the 1930s, '40s, and '50s. Those photographs—re-collected on the catalog page—form the counterpresent visual memory bank that informed *Lunch Break*. And they rest just out of view in our experience of it, waiting to be resumed, recalled, re-collected, or remembered.

taking a break in the post-filmic age

Lunch Break's visual politics of labor in the age of mechanized production works in tandem with its consideration of the state of film in the age of digital technologies. A century after their development as critical components of the second industrial revolution, both cinema and industrial manufacturing have witnessed technological transformations in the digital one. The counterpresence of early cinema activated in the project's two films underscores that shared trajectory. To recall industrial history, Lockhart mines the history of film; to take up the industrial present, she pushes us to consider cinema's present.

In each case, she focuses on time—the temporality of working life at the Bath Iron Works and the nature of time in photography, film, and digital cinema. In *Exit*, the two meet in a rigorously calculated expression of film's ability to compress days and hours into minutes and seconds. In *Lunch Break*, Lockhart reverses this temporality. The tracking shot that traverses the aisle is a slow-motion crawl—rather than compressing time, the film expands it. Here we find the temporal version of George Baker's description of Lockhart's earlier films as "still." The shot takes (its) time. But to what end? What does this slowness, this stillness allow the viewer to see and experience? What does the film's expanded temporality tell us about industrial life and cinematic form?

Sabine Eckmann argues that the film's slowness contributes to its commentary on post-industrial labor. "Slowness," she writes, "reverses the common values of economic progress accomplished through labor and production."[38] It does so by encouraging a form of spectatorship that activates the kind of counterpresence described by Bryson and Peterson. The

film's "lasting intensities of slowness," in Eckmann's words, "test our perceptual imagination, as spatial assemblages of the unseen everyday."[39]

But it also evokes the virtual counterpresence of cinema's past. Just over an hour into the film, for instance, a worker removes a bag of popcorn from a microwave and turns to walk down the aisle. For the next three minutes, the camera follows in his footsteps in a kind of impromptu motion study à la Muybridge, Marey, or, more suggestively, Frank Gilbreth. A century after Gilbreth's micromotion scientific management studies, Lockhart's slow-motion study of downtime paces and gestures—turning a page, raising a cup, biting a sandwich—might be read as a mocking rejoinder to Taylorist efficiency (if only we could see the microwave's suspended digital countdown!). The worker's slow walk heightens the temporal intensity produced when we first realize that the camera moves at all. We feel the force of each step and the weight of time held in suspension.

In this way, *Lunch Break* seems to bring the past to bear on one of the key questions posed by those who have pondered the nature of cinema—and specifically, cinematic time—in the digital age. Put most succinctly by Babette Mangolte, "why is it difficult for a digital image to communicate duration?"[40] For Mangolte, the essential differences between film and digital come down to affect. In contrast to the film projector and its photograms, the shutter-less digital projector and its pixels make motion graphic, not sensorial. And in contrast to film—in which "time is inscribed in the emulsion grain," which is always changing, always renewed—in the digital image, "time is encoded in a bit-map" in which only some pixels change, creating a comparatively static, experientially predictable image.[41]

In *Lunch Break*, in contrast, duration becomes paramount both in spite of and as a result of its digital form. Lockhart creates this form of duration through a complex digital manipulation of the photographic image. James Benning explains Lockhart's process as follows:

> *Lunch Break* begins with a ten-minute tracking shot on 35mm
> film down a 1,200-foot hallway. At 24 frames per second,
> ten minutes of film captures 14,400 still frames . . . Trans-
> ferring the 35mm film to a high-definition digital medium,
> Lockhart then copied each frame eight times, lengthening
> the film to eighty minutes. Upon projection, each frame is
> now seen eight times longer—that is, not 1/24 of a second,
> but 1/3 of a second.[42]

This emphasis on the individual frame embeds a reference to still photography in the film. As Benning puts it, "in effect, what we see is a series of 14,400 still photographs, each shown for 1/3 of a second . . . placing the viewing experience somewhere between cinema and photography."[43] Put another way, *Lunch Break* represents the fusion of Lockhart's earlier films and

photographs. At once film still and still film, it synthesizes the relationship between still and moving images in Lockhart's work that Baker has termed "attunement"—"the attempt to bring forms close, to have them 'rhyme.'"[44] Here, Lockhart creates a form of duration for digital cinema by introducing a rhythm and rhyme to the digital image.

She does so by producing a different form of photo-cinematic slow motion. As Benning notes, this is neither camera slow motion—which, at 8x, would capture 192 frames per second, each of which would still be projected for 1/24 of a second—nor is it left to a computer algorithm.[45] Instead, Lockhart both acknowledges and challenges the algorithmic ontology of digital images by choreographing a kind of minimalist dance of the pixels. Photographic frames repeat, change at the dissolve, and repeat again. This strategy creates a form of digital duration—a rhythm of stillness and motion—precisely by playing on the technological constraints of the pixelated image that, for Mangolte, make filmic duration a thing of the past.

In this sense, we might ask if the "film" might be better described, finally, not as a film, but as a work of digital cinema? As a hybrid of 35mm filming and digital editing and projection, *Lunch Break* highlights the tensions of cinema's moment of technological transition. It is a work that approaches that moment through a deeply thoughtful awareness of cinema's technological past, a past that runs through its very conception. In this way, *Lunch Break* is layered not simply with digital data—as David Rodowick might describe—but with recollections, reminiscences, and *reprises*—found memories—for cinema's digital future.[46]

conclusion—industry, technology, time

However we might classify *Lunch Break*, the work's real achievement is the dialogue that Lockhart has created between the politics of industry and the aesthetics of digital cinema. Filmmakers have long taken advantage of the close affinity between cinematic technologies and the world of modern machinery. Those films have become a found memory bank for the artists and filmmakers who are using digital cinema to examine the spaces and paces of post-industrial manufacturing. But few, I think, have so convincingly wedded industrial politics with cinema's shifting (im)materiality. And few have so astutely connected (or "attuned") the emerging cinematic time of the post-filmic age with the waning industrial temporality of post-industrial labor.

Lockhart's experiments with time may, in part, reflect the process of experimentation that comes with the use of a new medium. But there's also something significant about the relationship between film and video technologies and the industrial technologies they record, an affinity that invites such experimentation. These experiments with industrial time and film time hearken back to the same experimentation with the new medium

of cinema in the kinds of found memories that Lockhart's work evokes, from the Lumière workers' end-of-day *sortie* to Bitzer's images of time checks at the Westinghouse Works. As such films suggest, when we study works of art in the age of mechanical and digital reproduction, we would do well to train our eyes on the instances when reproduction—especially industrial reproduction—becomes the work of art.

In taking up these kinds of past images, the *Lunch Break* project takes its place in a broader artistic landscape littered with references to other aspects of cinema's silent past. The novelty of this work is the form—call it reminiscence, re-collection, rephotography, *reprise*—through which it promises to activate old images in new contexts and to push its viewers to find fitting frames of reference. In a world in which such references circulate only a few clicks away, projects like this one demonstrate the valuable potential that found memories have to engage new viewers and activate past politics. From this context, artists like Lockhart are pointing the way to a cinematic future built on a found past endlessly reprocessed, recycled, re-formed, and re-activated, sometimes as found footage, often as found memories.

notes

1. These films make possible what Jaimie Baron terms the "archive effect," but they do so by evoking memories of the filmed past rather than using its archived fragments. See Baron, *The Archive Effect: Found Footage and the Audiovisual Experience* (Abingdon, UK: Routledge, 2014), 9.
2. See, for instance, the images in Sabine Eckmann, *Sharon Lockhart: Lunch Break II* (St. Louis, MO: Mildred Lane Kemper Art Museum, 2011).
3. As Leo Braudy has rightly asked, "is 'remake' a useful interpretive or theoretical category? Does it tell us anything more than what it says on the face?" Braudy, "Afterword: Rethinking Remakes," in *Play it Again, Sam: Retakes on Remakes*, ed. Andrew Horton (Berkeley: University of California Press, 1998), 328.
4. Kathleen Loock and Constantine Verevis note that the remake is only "one of several industrial and cultural activities of repetition (and variation) which range from quotation and allusion, adaptation and parody, to the process-like nature of genre and serial filmmaking." See Loock and Verevis, "Introduction: Remake | Remodel," in *Film Remakes, Adaptations and Fan Productions*, eds. Kathleen Loock and Constantine Verevis (London: Palgrave Macmillan, 2012), 2. For more about remakes, see Verevis, *Film Remakes* (Edinburgh: Edinburgh University Press, 2005), *Dead Ringers: The Remake in Theory and Practice*, eds. Jennifer Forrest and Leonard R. Koos (Albany: State University of New York Press, 2002), and *Play it Again, Sam*.
5. David Rodowick, *The Virtual Life of Film* (Cambridge, MA: Harvard University Press, 2007), 160.
6. André Bazin, "A propos des reprises," *Cahiers du Cinéma* Vol. 1, No. 5 (September 1951): 52. All translations are my own unless otherwise noted.
7. André Bazin, "Remade in USA," *Cahiers du Cinéma* Vol. 2, No. 11 (April 1952): 54.

8. Bazin, "A propos des reprises," 56.
9. *Ibid.*
10. Jennifer Peterson, "Workers Leaving the Factory: Witnessing Industry in the Digital Age," in *The Oxford Handbook of Sound and Image in Digital Media*, eds. Carol Vernallis, Amy Herzog, and John Richardson (New York: Oxford University Press, 2013), 606.
11. *Ibid.*
12. *Ibid.*, 598.
13. See Matthias Michalka, "Realities of Time: Notes on the Fictionality of Lunch Break," in *Sharon Lockhart: Lunch Break*, Sabine Eckmann (St. Louis, MO: Mildred Lane Kemper Art Museum, 2010), 48; Edward Bacal, "Sharon Lockhart and Steve McQueen: Inside the Frame of Structural Film," *Cine-Action* No. 91 (Spring 2013): 9.
14. As George Baker has described, Lockhart has made memory a key element of earlier projects such as the *Audition* series (1994), in which children pose for photographs that mimic a scene from Truffaut's *L'Argent de poche* (1976). George Baker, "After 'Photography's Expanded Field,'" in *Between Stillness and Motion: Film, Photography, Algorithms*, ed. Eivind Røssaak (Amsterdam: Amsterdam University Press, 2011), 126–127.
15. James Benning, "James Benning Interviews Sharon Lockhart," in *Sharon Lockhart: Lunch Break*, Sabine Eckmann (St. Louis, MO: Mildred Lane Kemper Art Museum, 2010), 107.
16. *Ibid.* See page 106 for a reproduction of Brecht's *Word Event* (1961). The card also appears in *Lunch Break Times*, a newspaper issue published by Lockhart to accompany *Sharon Lockhart: Lunch Break* at the Mildred Lane Kemper Art Museum at Washington University in St. Louis.
17. Hannah Higgins, *Fluxus Experience* (Berkeley: University of California Press, 2002), 93.
18. In his analysis of earlier Lockhart films, *Goshogaoka* (1997) and *No* (2003), Rodowick has similarly identified what he describes as Lockhart's "fascination with the choreography of quotidian acts deployed in a continuous duration." See Rodowick, *The Virtual Life of Film*, 158.
19. Peterson, "Workers Leaving the Factory," 600.
20. *Ibid.*, 607.
21. Norman Bryson, "From Form to Flux," in *Sharon Lockhart*, Dominic Molon (Chicago: Museum of Contemporary Art, 2001), 82.
22. *Ibid.*, 88.
23. *Ibid.*, 92.
24. Baker attributes "still film" to Douglas Crimp's work about Robert Longo. George Baker, "Photography's Expanded Field," in *Still Moving: Between Cinema and Photography*, eds. Karen Beckman and Jean Ma (Durham, NC: Duke University Press, 2008), 185.
25. *Ibid.*
26. See Baker's analysis of how this re-photographic practice informed her work in *Pine Flat* (2005). Baker, "After 'Photography's Expanded Field,'" 127–128.
27. Peter Sramek, *Piercing Time: Paris after Marville and Atget: 1865–2012* (Bristol; Chicago: Intellect Ltd., 2013), 14.
28. Karen Breuer, "Mark Klett, Rephotography, and the Story of Two San Franciscos," in *After the Ruins, 1906 and 2006: Rephotographing the San Francisco Earthquake and Fire*, Mark Klett (Berkeley: University of California Press, 2006), 6.

29. See https://www.gdbiw.com/History.html. Accessed 13 April 2014.
30. Sabine Eckmann, for instance, describes these as "never-before-seen images." See Sabine Eckmann, "Times and Places to Rest," in *Sharon Lockhart: Lunch Break* (St. Louis, Mo: Mildred Lane Kemper Art Museum, 2010), 24; and Harun Farocki, "Workers Leaving the Factory," trans. Laurent Faasch-Ibrahim, *Senses of Cinema* No. 21 (July 2002), http://sensesofcinema.com/2002/21/farocki_workers/. Accessed 29 April 2014.
31. Sabine Eckmann, "Introduction," in *Sharon Lockhart: Lunch Break*, 12.
32. As Steve Ross has argued, moreover, industrial life and class conflict were significant components of silent American cinema. See Steven J. Ross, *Working-Class Hollywood: Silent Film and the Shaping of Class in America* (Princeton, N.J.: Princeton University Press, 1998). For details about the films used in *Arbeiter verlassen die Fabrik*, see Farocki, "Workers Leaving the Factory."
33. For more about this series and the context of its production, see Oliver Gaycken, "The Cinema of the Future: Visions of the Medium as Modern Educator, 1895–1910," in *Learning With the Lights Off: Educational Film in the United States*, eds. Devin Orgeron, Marsha Orgeron, and Dan Streible (Durham: Duke University Press, 2011), 67–89.
34. The product of decades of labor struggle that resulted, in America, in a series of reductions in working hours in the early twentieth century, the forty-hour workweek became a legal standard in the Fair Labor Standards Act of 1938.
35. Although initially denied due to security concerns, Lockhart's requests to film in the Works eventually succeeded thanks to the support of Local 6, the union that championed the project. See Benning, "James Benning Interviews Sharon Lockhart," 102.
36. In this respect, the film contributes to what Jennifer Peterson has described as a "focus on industrial subjects" that has offered "a front row seat [. . .] at the deathbed of industrial manufacturing." See Peterson, "Workers Leaving the Factory," 598.
37. In the afterword to a catalog about the project's inspiration and development, András Pálffy, president of the Vienna Secession (where *Lunch Break* was first exhibited in 2008), emphasizes that *Lunch Break* is about "a sociocultural phenomenon that [Lockhart] sees under threat from the conditions of global capitalism and continued attempts to streamline production." See Pálffy, "Afterword," in Eckmann, *Sharon Lockhart: Lunch Break II*, 90.
38. Eckmann, "Times and Places to Rest," 25.
39. Eckmann, "Introduction," 13.
40. Babette Mangolte, "Afterword: A Matter of Time. Analog versus Digital, the Perennial Question of Shifting Technology and Its Implications for an Experimental Filmmaker's Odyssey," in *Camera Obscura, Camera Lucida: Essays in Honor of Annette Michelson*, eds. Richard Allen and Malcolm Turvey (Amsterdam: University of Amsterdam Press, 2003), 263.
41. *Ibid.*, 264.
42. In a final step, Lockhart added a dissolve between the last frame of each sequence and the first frame of the next. Benning, "James Benning Interviews Sharon Lockhart," 101.
43. *Ibid.*
44. Baker argues that Lockhart's film *Pine Flat* "attunes itself to photography" while the photographs in that series "attune themselves to film"—all as part of "a turning back of Lockhart's medium upon itself, a return of

cinema to its photographic pre-history." That turning back to cinema's pre-history is part of what I'm calling the *Lunch Break* project's production of virtual counterpresence. See Baker, "After 'Photography's Expanded Field,'" 128.

45. Benning, "James Benning Interviews Sharon Lockhart," 101.

46. See Rodowick's analysis of *Russian Ark* (Alexander Sokurov, 2002) and the "digital event" in Rodowick, *The Virtual Life of Film*, 164–174.

a youtube bestiary

twenty-six theses on a post-cinema of

fourteen

james leo cahill

u is for user's manual, untimely mediations, untimely media

These theses take inspiration from the structural model of the bestiary, the exhibition practices of the cinema of attractions, and YouTube's database form. They attempt to think about the "back and forth" relations between the digital database of YouTube and early film aesthetics and practices through a print article in the form of an early modern pedagogical instrument.[1] Each entry is intended as a discrete attraction, but collectively they may be linked, cross-referenced, and juxtaposed into a larger, if ultimately heterogeneous, set of arguments and reading experiences. A number of recursive concepts—actualités, anthropocentrism, attractions, contingency, events, the real—and privileged figures—Bazin, cats, Eisenstein, Vertov—return and traverse multiple entries, and coalesce into three interrelated arguments regarding (1) an examination of animals as attractions and the conceptualization of a cinema of animal attractions; (2) the recurrence of early film aesthetics and its intellectual and artistic reception within the newer media context of YouTube; and (3) a set of ethical and

moral reflections on human-animal-environment relations that emerge from the confluence of animals and media. Individual entries also point to videos posted on YouTube, which, due to the ephemeral nature of the platform, means that many may disappear and others, which complicate these arguments, will surely emerge. A playlist of many of the videos discussed in these theses can be found on YouTube under the title "A YouTube Bestiary."[2]

The modest historiographical purchase of these theses may be summarized by the term *strategic anachronism*: a knowing temporal disordering that nevertheless engages thinking historically. Anachronisms refer to temporal displacements—too early, too late, out of joint, the *untimely*—while also providing figures for nonlinear, heterogeneous senses of time and historical perspectives. The resurgence of actualités and attractions, which appear *for the time being* as two of the dominant and dynamic aesthetics on YouTube and other media platforms, may appear anachronistic from the perspective of a linear development of moving image media. The uncanny similarities between the aesthetics of the first decade of film and the first decade of YouTube reveal the manner in which *previously surmounted* aesthetic modes persist into the present and invite a reconsideration of the timelines for actualités and attractions. Perhaps their obituaries have been written prematurely.

Attention to residual or recurrent modes casts a suspicious eye upon the breathless ideologies of the new in discourses of new media—to the extent they imply teleological historical narratives or coincide with a market-driven logic of celebrating perpetual novelty in uncritical manners (including the forms of amnesia this entails). These theses make slightly anachronistic use of the analytic approaches developed by film and media historians to better account for the specificities of film's first decade on its own terms. This conjuncture may guide thinking about the first decade of online video platforms in relation to previous practices and techniques, to what is specific about them, and for what we can, following Alexandra Juhasz, "learn" from YouTube, which in turn necessitates new conceptual approaches.[3]

These theses may be read in the (mostly) linear, alphabetic order that follows, or selectively read in random order. Connections between the entries have been suggested in brackets at the end of each entry. {See A–Z}

a is for actualités, anachronisms, animals, attractions

"Runaway Horse on Nevsky" (chos580, Russia, 2012), a twenty-seven-second video posted on the video aggregation platform YouTube on 23 July 2012, brings together actualités, anachronisms, animals, and attractions (figure 14.1). The video captures the unexpected arrival of two animals—a galloping horse and barking dog—on the main thoroughfare

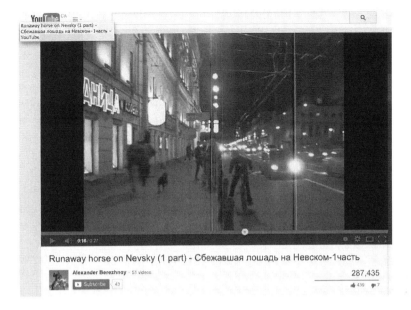

Figure 14.1 "Runaway Horse on Nevsky" (2012).

of St. Petersburg, Russia, as captured by a nocturnal *flâneur* Alexander Ber-
ezhnoy. The horse and dog, running at full pace, burst into the camera's
field of vision from behind Berezhnoy's left shoulder. Right before the
arrival of the animals, an astonished group of pedestrians and a cyclist
heading toward the camera stop in their tracks, moving out of the path of
whatever is coming.

A runaway horse in a major metropolitan center in the twenty-first
century, among honking cars and harsh fluorescent lighting, has an anach-
ronistic quality to it, as if this scenario had been grafted from a story in the
nineteenth-century illustrated press, a scene out of Pathé's comic chase
film *Le cheval emballé* (*Runaway Horse*), (Louis Gasnier, Pathé, France, 1907), or
an animal adventure story. Formally, this video brings together qualities of
two of the dominant aesthetic modes of film's first decade: actualités and
attractions. Actualités, linked in French to an etymological set of terms
for actual, current, topical, and timely, primarily refer to filmed views of
notable current events, public rituals, the marvels of modernity, exotic
images, and scenes of everyday life.[4] Attractions refer to a type of film char-
acterized by an exhibitionist visual display and an aggressive direct address
to the spectator. Attractions aim to astonish and innervate the spectator.
The term "attractions" also names a period in moving image media's his-
tory (approximately 1895–1906) in which these films represent a dominant
aesthetic.[5] The camera set-up and visual composition of "Runaway Horse
on Nevsky" makes use of diagonal lines of action, mostly static framing,

265

and a focus on figures approaching the camera reminiscent of the set-ups of the Lumière and Edison operators. The sudden puncture of the frame by the horse and dog, full of speed, animal energy, unpredictability, and danger, fits the description of an attraction.

Scholarly conceptualizations of the cinema of attractions train their gaze, as Wanda Strauven notes, both back to popular traditions and forwards to avant-garde experimentation.[6] In Tom Gunning's and André Gaudreault's work on the cinema of attractions and kine-attractography developed over the past two decades, and in Sergei Eisenstein's theorization of attractions in the 1920s to 1940s from which they drew inspiration, attractions work through a temporal conjunction of the old and the new, engaging the registers of comparative history, anachronism, and untimely returns and reanimations. Contemporary media scholars, including Henry Jenkins, Teresa Rizzo, and Joost Broeren, have taken up this concept to discuss the strong connections between the aesthetic experiences of early-twentieth-century film attractions and the post-filmic, post-cinematic early twenty-first-century digital attractions on YouTube.[7] This bestiary speculates on specific lessons to be drawn from conceptualizing a post-cinema of *animal* attractions, for which questions of temporal and ontological alterity are paramount. {See N, O}

b is for beginnings, bestiaries

Beginnings, origins, firsts, and births are vexing problems for film and media historians. They require caution if the goal is to pursue thinking historically without settling into teleological chronologies and progressive conceptions of development that simply valorize present conditions as logical endpoints. So what to make of an "origin" as performative and nonchalant as "Me at the Zoo" (jawed, USA, 2005), the first video publicly posted on YouTube on 23 April 2005 by co-founder Jawed Karim? The eighteen-second video, filmed by Yakov Lapitsky, features a single medium close-up shot of Karim standing in front of the elephant enclosure of the San Diego Zoo. We seem to have come upon this scene already in progress. Alternating his gaze between the camera lens and the elephants, Karim remarks, "The cool thing about these guys is that they have really, really, really long, umm . . . trunks. And that's cool. And that's pretty much all there is to say." Returning to the scene of film-based motion pictures' origins in animal locomotion studies, Karim's video explicitly stakes YouTube's "birth" in images of animals and slightly puerile humor. Scenes from zoos, cradle of childhood memories, and images of elephants, avatars of memory (they never forget), stage the promise of the new platform as a "digital repository," or memory bank. "And that's pretty much all there is to say."

But of course there is much left unsaid and more to say about this video and the displacements of its off-color joke about the size of elephants'

trunks. The original "About Us" page on YouTube made the following solicitation:

> Show off your favorite videos to the world. Take videos of your dogs, cats, and other pets. Blog the videos you take with your digital camera or cell phone. Securely and privately show videos to your friends and family around the world . . . and much, much more![8]

So begins YouTube's bestiary *in medias res*.

A bestiary is a collection of animals. As a literary genre, bestiaries present an illustrated compendium of descriptions and stories about animals intended to serve as a pedagogical instrument. They are frequently organized in alphabetical order—A is for Animal—lending them both a rigid *and* arbitrary structuring principle.[9] Allegorical in nature, each entry of a traditional bestiary combines natural history with moral instruction, using animals to teach humans how to live, and how to pursue the good.[10] In the era of moving images, the French critic André Bazin speculated that the primary lessons gleaned from animal films were not about animals, but about media: "Animal films reveal the cinema to us."[11] Moving images of animals, the ingredients of a modern bestiary, in Bazin's assessment, acted as allegories of the medium, instructing us in its primary virtues and limitations. For Bazin these revolved primarily around the ethics of montage and as such effected a displacement of ethical questions from the treatment of animals to the treatment of animals *on film* (which also enables new ways of posing ethical questions). Considering YouTube's bestiary requires that we ask: what do animal videos reveal and *teach* us about animals *and* about YouTube? {**See H, W, Y**}

C is for Contingency

Fishing, with its combination of active skill, patience, and chance, provides an apt metaphor for the production of wildlife media, but also for the experience of moving through the countless videos posted to YouTube's database (at least as long as we remain unaware of the logics of its algorithms). These elements are foregrounded by the video "The One That Got Away/ Shark Bait" (Sarah Brame, USA, 2012), which offers the frisson of a chance encounter with wild animals, those classic figures of contingency. The video features a young woman and two male friends fishing from a backyard dock off the sound at Myrtle Beach, South Carolina on a rainy afternoon. As she lifts a red drum she has hooked out of the water, a bull shark jumps out of the brackish water and snatches the fish. The trio of friends shouts expletives, first of pure surprise, and then to identify the presence of the shark to people off-screen as a warning: "It's a shark! A shark! A big-ass

shark!" This depiction of the tiny victory of catching a fish disrupted by the sudden appearance of a shark elicits first shock and then the jubilation that despite losing the little fish, the big fish got caught on camera: "I got that on camera!" "He got that on camera!" YouTube stokes a utopian fantasy of total repository: nothing escapes record, no moment is lost, everything is shareable, and even the one that got away is saved, transformed from (potentially) traumatic loss to a source of pleasure. In a perpetual play of *fort–da*, contingency and capaciousness form YouTube's primary dialectic. {See E, G, I, M, R}

d is for database, domestication

Video aggregating platforms such as YouTube are first and foremost databases that handle an immense amount of information: the website claims that over 100 hours of video are uploaded every minute and the site receives over one billion visits every month.[12] Richard Grusin and Trond Lundemo have both noted that the sheer size of data on YouTube adds a dimension of the Kantian mathematical sublime and the incalculable to its promise of putting plentitude at one's fingertips.[13] This sensation is perpetuated by the seemingly endless series of linked videos determined by a user's browsing history. The database gives structure to the disparate and seemingly contingent parcels of information uploaded to its servers. Videos are "tagged" (like wild animals under observation in a nature preserve) and enter into traceable relationships with strings of other tagged data. The videos are fed by, supported through, and integrated into a vast and energy-hungry infrastructure of servers, cable, cellular towers, and code. One way of considering each video is as a visible condensation of these systems, not so much in the content these videos show as in their very existence: each video indexes the integration of the profilmic world, mobile filming device, and larger communication networks and infrastructures. Similar to its parent company Google, the backend of YouTube's database engages in fishing, capturing, and collecting user data and demographics, hence the platform's continuous inducements to sign in and identify oneself. It gives a second, imperative sense to YouTube's motto, "Broadcast Yourself."

YouTube connects private and public spaces, experiences, properties, and selves. Along with the capture of contingency, the other primary content category of animal videos on YouTube comprises domestic animals and scenes of domestication.[14] Videos of piles of kittens riding vacuum cleaners in "Kittens Riding Vacuum" (melodyparris, USA, 2008), of a cockatoo called Snowball dancing to the Backstreet Boys in "Snowball (TM)—Our Dancing Cockatoo" (BirdLoversOnly, USA, 2007), or of a dog compelled to mimic humans by barking "I Love You" (the same message mouthed by inventor Georges Demenÿ in his 1891 experiments

with the phonoscope) in "Mishka says 12 words" (gardea23, USA, 2010) cultivate the reassuring pleasures of companionship, familiarization, and anthropocentric anthropomorphism. These videos rehearse a sentimental relation between humans and animals, borne by both cross-species affection and a narcissistic pride on the part of the human owners to see themselves reflected and confirmed by their animal others—like so many cartoon birds and forest animals magnetically attracted to the beautiful Snow White. But sentimental domestication and anthropomorphism are unstable endeavors that can also lead into uncanny valleys or sudden reversals.[15]

One such reversal is captured by the single-shot video "Bunnies Can Fly . . . Proof" (Joey Gore, USA, 2013), depicting a young family releasing a foundling rabbit into the suburban wilds after caring for it for a week. The mother explains to her young daughter that they are going to let "Kermit" go, so he can return to his mommy. Just before she places the rabbit on the yard, she exclaims, upon spotting another rabbit, "There's your mommy! Go get her!" The baby rabbit hesitates in the grass, and then dashes off across the yard only to be scooped up mid-stride by a bird of prey. As the raptor flies off with the squealing rabbit the family members (and surely many spectators of the video) are reduced to stunned silence.[16] The video captures the collision of two ideologies of animal life: the sentimental view of nature, kinship, and domestic relations bound up in the naming of animals and ascribing human family relations to them (Kermit and his mommy), and the view of nature as ruled by the so-called "code of fang and claw," predation, and the food chain. {See R, T, Y}

e is for event-based cinema

Events, Mary Ann Doane argues, exist at the "cusp between contingency and structure."[17] One of the distinguishing characteristics of the temporality of early cinema is its "curious merger" of these antipodes.[18] The post-cinema of animal attractions on YouTube, with its mix of actualité and attraction, is frequently a cinema of the event in the two competing but entangled senses suggested by Doane. The first sense refers to events as the documenting of planned occasions, rites of passage, and rituals, such as baby's first trip to the zoo, weddings, the release of a baby rabbit back into the suburban wilds, or the execution of Topsy the elephant, as immortalized by the Edison company in the 1903 actualité *Electrocuting an Elephant*. The second sense of event encompasses unpredictable, singular, unrepeatable instants or happenings that exceed calculation, seemingly falling out of the sky to puncture homogenous time with its dramatic sense of difference. Both senses of the event are present in "Bunnies can fly . . . Proof" and in the documentary Surrealism of "Mariachi Connecticut Serenades a Beluga Whale" (captainkickstand, USA, 2011) (figure 14.2).

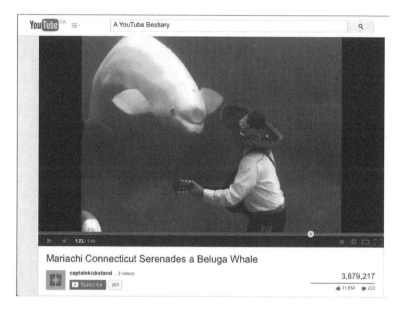

Figure 14.2 "Mariachi Connecticut Serenades a Beluga Whale" (2011).

This video was made on the occasion of a wedding held at the Mystic Aquarium in summer 2011, staged in front of the confinement tank for a beluga whale called Juno. A trio of the mariachi musicians hired for the ceremony improvises a version of the Haitian standard "Yellow Bird" for their captive audience, who appear to show interest in their performance.[19] The video is remarkable and moving: the romance of this staging of a serenade to soothe the animal in a shabby tank captures a serendipitous and fascinating cross-species encounter. The white whale bobs its head along with the band, making face-to-face contact with the different musicians. The whale appears to be moved by the music—perhaps emotionally, certainly physiologically—and one minute into the performance, it begins emitting a cloudy stream of liquid shit. As it does so, it raises its blowhole above water, perhaps to avoid self-contamination by its own feces.

This evacuation stains the image. It draws attention away from the wonder of the encounter and toward its obscenity. The video's beauty brings the obscenity more sharply into focus. It is not the shit, the only evacuation possible in this circumstance, but rather the confinement that appears obscene. The encounter reveals the spectacle of a life flattened into a captive and eternal present tense, almost entirely deprived of open horizons for our entertainment. The spontaneous performance at a wedding and the attempt to reverse the roles, and produce a source of momentary captivation for the whale, becomes an instant of "profane illumination."[20] It presents an unexpected critical insight into the conditions of captivity that

provide the conditions of possibility for the encounter and for the foundation of our pleasure. {See C, I, R, S, Z}

f is for felines, filming ubiquitously, filmmaking animals

Cats are a ubiquitous aspect of internet culture, with cat videos making up an important genre of YouTube postings. In recognition of this, in August 2012 the Walker Art Center inaugurated the "Internet Cat Video Festival," which awarded its first Golden Kitty Award to the existential musings of a black cat depicted in "Henri, Paw de Deux" (Will Braden, USA, 2012). Cat video enthusiasts, in spontaneous acts of media history, have claimed anachronistic precedents for cat videos in the French physiologist Étienne-Jules Marey's *La Chute du chat* (1894), W.K.L. Dickson's *Boxing Cats* (1894), Louis Lumière's *La Petite fille et son chat* (1899), and George Albert Smith's *Sick Kitten* (1901), which have all been posted on YouTube with variations of the title "World's First Cat Video." As one of the technical pioneers of motion pictures, Marey recorded hundreds of sequential images of animals in motion, from insects to elephants, including several sequences demonstrating Newton's Law of Attraction with falling cats (one dropped right side up, another upside down) under the heading "La Chute du chat."[21] Like the famous sequential photographs of a galloping horse produced by Eadweard J. Muybridge under a commission from Leland Stanford in 1878, intended to settle a gentleman's bet as to whether all four hooves of a horse left the ground at once, there is a basic empirical drive to Marey's examination of whether cats always land on their feet (and by what means). In each instance, scientific observation is put into direct conversation with common knowledge and folklore. The bestiaries of Marey and Muybridge also emphasize the strong archival aspect of motion picture technologies: the fantasy of a total history in excess of the wildest dreams of even the most ambitious *fin-de-siècle* advocates of film archives as a historiographical instrument.[22] This drive begets such videos as "Teddy the Asshole Cat" (krmrmlp, USA, 2012), in which a black cat perched atop a crowded bureau knocks a jar of vitamins onto the floor with its paw and then looks directly at the camera and yawns, as if thoroughly unimpressed with its own mischievous confirmation of the law of attraction.

The sheer number of videos catching such minor incidents as Teddy the cat knocking objects off furniture presents another aspect of YouTube videos: a compulsion for ubiquitous and continuous recording due to the proliferation of inexpensive and easy to use cameras—particularly on cellular phones—as well as dispersed modes of distribution supported by the ease of uploading a video recorded on a phone directly to the internet. The increasing memory capacities of portable cameras, as well as the increased facility of remote linking by wireless feeds, have also enabled filming in

271

the absence of a human camera operator. This is commonly encountered through "nanny cam" domestic surveillance footage of pets going about their business free from direct human discipline, such as a beagle "caught" moving a kitchen chair next to a counter in order to gain access to a toaster oven and empty it of chicken nuggets in "What my beagle does when [we] are not home. Beagle gets into hot oven" (Rodd Scheinerman, USA, 2013), or the dog prohibited from jumping on the furniture who does just that the minute humans leave the home in "When the dog stays at home alone/ Пока никто не видит" (When no one is looking) (ignoramusky, Russia, 2014). But it has also enabled field recordings in remote locations, such as park trails, as used in the National Film Board of Canada interactive documentary *Bear 71* (Leanne Allison and Jeremy Mendes, Canada, 2012). In a variation of the observer effect in physics, wherein observation impacts the phenomena observed, cameras left to run in the absence of human operators feed the fantasy of capturing more authentic animal behavior. *Truth thirty fields per second.*

Ubiquitous filming has also had the fortuitous unintended consequence of enabling filmmaking animals, such as the many clips of animals accidentally encountering or absconding with cameras.[23] These accidental encounters often produce abstract and arresting images of cameras liberated from human directing and attention. They emphasize the Copernican dimension of photographic media: the camera's capacity to gaze with a non-human indifference and to see otherwise. This is beautifully captured in the footage of "Seagull Stole GoPro" (Lukas Karasek, Slovakia, 2011), in which a bird picks up and flies off with a small portable camera, giving a brief aerial view of Cannes as it flies to a high ledge of a château, and in "Crab Makes a Movie (aka Oops! Dropped My Camera in the River!)" (megyerdon/Ryan Strout, USA, 2011). The latter video begins with the camera's owner jumping into the water and losing hold of the camera, which films its own descent to the depths of the water. Shortly after it settles on the bottom of the riverbed two crabs scurry over to the camera and one takes hold of it, turning the lens toward the surface of the water in the process. The crab hovers over the camera, its lens catching parts of its carapace in blurred focus due to being too close (not unlike the wayward thumb caught in many amateur photographs). While the crab occupies the foreground of the image, fish dart past in the middle distance, and the murky shadows of humans appear as a recessed presence near the distant surface of the water, eventually diving down into view and recovering the camera. These videos invite contemplation of non-anthropocentric perspectives and the consideration of contexts that extend beyond human concern, producing fleeting images of the very contingency of one's perspectives. {See C, G, K, W}

g is for gopro cameras

GoPro digital video cameras, used in the recording of both "Seagull Stole GoPro" and "Crab Makes a Movie," are lightweight, durable, and fit into waterproof and shockproof casings designed to mount easily onto bodies, limbs, or objects for hands-free and eyes-free filming (the basic models do not have a viewfinder). Their ruggedness and mid-range price makes them popular among sky and sea divers, cyclists, skateboarders, kayakers, paddle boarders, and surfers. In their design and marketing, GoPro cameras are presented as instruments made for capturing stunts and natural attractions—they are sold as fostering an extreme cinema realized through a cinema of extremities, wherein the human user and device mutually extend into each other, so it is not always clear who or what is agent and appendage: they are like crittercams for humans.[24] GoPros received considerable cultural caché from their use in the aquatic documentaries *Leviathan* (Lucien Castaign-Taylor and Véréna Paravel, USA, 2012) and *Storm Surfers 3-D* (Justin McMillan and Chris Nelius, Australia, 2012), as well as countless amateur videos, frequently self identified in their titles as "shot with my GoPro" and readily recognized by their wide-angle fish-eye lenses. These videos often feature a continuous passage from surface to depths of water and take advantage of the seemingly endless traveling shots and 360-degree visual field that aquatic mobility affords. Like classic attractions, their exhibitionist display is reduplicated by the explicitness of the act of visualization that the devices perform. Go-Pro footage continually enunciates its source of production, the Go-Pro brand itself, as an inextricable feature of its attractions.

GoPro cameras hold out the promise of visual immediacy and immersion, but also a highly enunciated mode of recording, best realized in the voluminous underwater footage uploaded to YouTube. "Shark Attack 3-13-2014 in the CAYMAN ISLANDS" (Jason Dimitri, USA, 2014) delivers both: beginning with a customary immersion shot (entering the water), the footage depicts a first-person perspective of a spear-fishing excursion that is disrupted by the sudden appearance of a reef shark, first noticed when its left pectoral fin enters the camera's frame. The hunter becomes the hunted. The shark bumps the diver and then begins to quickly circle and lunge at him (or rather his container of speared lionfish) as he frantically tries to evade the shark and move toward the water's surface, stopping halfway up to avoid the bends. The shark then charges him from below, making two snapping passes at the diver, who thrusts his spear toward it (making only minimal contact) in an effort to scare it off. The shark then settles back near the bottom of the sea, investigating the container full of lionfish that the diver dropped to divert the shark.

These unexpected close encounters deliver the images of mortal danger so dear to André Bazin and his notion of a cinema of the real, elaborated

in his cluster of essays about cinema and exploration.[25] Bazin would have loved such entries into YouTube's bestiary. Reflecting upon a post-war "rebirth" of the pre-war, silent era travel and adventure films, now driven according to Bazin by scientific and anthropological research rather than exoticism, he proposes a "law of minimal sensationalism" (*spécularité*): which notes in general that "the greater the dramatic and spectacular interest of the events, the rarer and more dubious the footage."[26] He finds an exception to this rule in amateur-produced footage, in the moments when making a film and experiencing adventure—and particularly mortal danger—fold into each other, and recording an event and participating in it become the same gesture within the same temporal duration. Bazin sees this in the blurred and barely legible moments in the documentary *Kon-Tiki* (Thor Heyerdahl, Netherlands, 1950), such as the appearance of whales that threaten to capsize the tiny raft: "It is not so much the photograph of the whale that interests us as the photograph of the *danger*."[27] This ethos of risk is manufactured into GoPro cameras and embraced by many of its users, as seen in "Shark Attack 3-13-2014." But in a notable shift from the darker aspects of Bazin's interest in mortal danger, in the comments accompanying the video by the maker of "Shark Attack 3-13-2014," he expresses an understanding of the shark's and the reef's imperiled status, and his wish not to harm either. These comments suggest an approach to a cinema of the real that takes up the expanded Copernican gaze of the camera to consider the mutual fragility, contingency, and exposure of environment, animal, and human beings. {See C, F, K, R}

h is for the honey badger

"This is the honey badger. Watch it run in slow-motion. It's pretty bad-ass. Look! It runs all over the place." So begins "The Crazy Nasty Ass Honey Badger (original narration by Randall)" (Randall/czg123, USA, 2011), the wildly popular video posted to YouTube in January 2011. Made with footage from the National Geographic program *Snake Killers: Honey Badgers of the Kalahari* (2002), Randall's narration, delivered in high camp style, mixes astonishment, wry observation, and profane satire about this animal's predation and dietary habits as well as sharp commentary on the major tropes of wildlife media. A residue of the relationship of early films to the work of the barkers and *bonimenteurs* who presented them to audiences persists in Randall's direct address commentary, which explicitly trains spectators' attention ("Ooh look! It's chasing things and eating them") and cues reception ("Eww, that's so nasty"). The queer performativity of the vocal inflections of the narration calls out the default heterosexism of most wildlife programming. The commentary on the honey badger's running in slow-motion and backwards pretends to naïvely conflate profilmic motion with its technical representation, effectively playing the duped spectator

in order to call attention to our own faith in such representations of natural history. "The Crazy Nasty Ass Honey Badger" is most pointed in using anthropomorphism ironically to suggest an anti-anthropocentric commentary regarding our projection of human moral values upon animals. Randall's genealogy of morals positions this beast beyond good and evil: "Honey Badger don't care. Honey Badger don't give a shit . . ." *Thus spake Honey Badger.* {**See W, X**}

i is for index

Events such as "Runaway Horse," "The One That Got Away," or "Shark Attack 3-13-2014" diminish the anxious pronouncements regarding the decay of the indexical status of the photographic image or the loss of a purchase on the real in the era of digital imagery. Aspects of raw footage differ when recorded on celluloid or to a digital storage format. The impression of light upon silver nitrate emulsions or upon charge-coupled devices involves different degrees of translation; and attention to the different material specificities matter. But the truth claims—or solicitations of belief, no matter how irrational—and reality effects of digital video still rely upon similar combinations of a faith in presence, an existential bond between the object and its image that results from temporal and spatial co-presence and processes of automatic generation, and modes of extra-textual support (textual explications, institutional endorsements). Even if the index as physical impression and trace has been minimized by the additional mediation involved in recording digital images, the indexical nature of digital media retains its force in the form of what Mary Ann Doane, after Charles Sanders Pierce, calls the indexical sign's deictic function, a gesture that communicates no content beyond pointing to something as *there* (a digit is also a finger).[28]

The point of YouTube's animal videos: *Animals were there. People pointed cameras at them.*

The point of YouTube: *Keep pointing and clicking.*

{See C, E, G, R, S}

j is for jumping

"There are no leaps in nature, *precisely because* nature is composed entirely of leaps."[29] The jump or leap of an animal in flight often produces an incongruous shift in perception amongst the leaper and witnesses. Numerous are the videos of an animal's line of flight that leads it to unexpectedly jump into the picture framed by humans, such as the penguin and the otter caught leaping aboard boats in order to escape pursuing orcas in "One Lucky Penguin" (BCLark142, USA, 2008) and "Alaska Killer Whale vs. Witty Otter" (JoeMillerUS, USA, 2012); the impala that crashes through the

window of a tourist's SUV when chased by cheetahs in Kruger national park in "Cheetah Chases Impala Antelope into Tourist's Car on Safari" (Barcroft TV, South Africa, 2013); or on a more gentle note, the bird that surprises a man by landing on him in "Crazy Bird Lands On Me!?" (RantWithJeff, USA, 2012). During these collisions the people and their vehicles become temporary props for the animal's improvised itinerary, and one's normal sense of things becomes slightly destabilized. One catches a glimpse of the virtual capacity for things to be otherwise: for a boat to function like a floating island, a car as a safe haven, one's arm a branch to land upon or alight from.

Jumps and leaps suggest a model of thinking about historical change through the sudden encounter between heterogeneous variables, where, in the spirit of Engels, quantitative series suddenly produce a qualitative difference. Entangling nature and culture, historicity and the topical, Walter Benjamin refers to such phenomena as the "tiger's leap" (*Tigersprung*) into the past.[30] This leap challenges progressive and anthropocentric models of historiography with dialectical images that bring past modes anachronistically into the present, with potentially explosive effects. The accumulation of the urgent jumps and leaps of animals, and of the tiger's leap of actualités and attractions back into untimely topicality on YouTube, produce a dialectical image of two modes of precariousness, one natural and one cultural-technological. {See B, E, F, N, O, W, Z}

k is for kino-eye

The "You" in YouTube promises an efflorescence of a personal cinema, and in large part much of the user-generated content falls into this category. A subset of the many animal and nature videos (including footage of climatological events) belongs to an observational mode of documenting that pushes at the limits of an *impersonal* media, whose gaze is inclusive of phenomena beyond that of humans alone. In addition to the cameras appropriated by animals, closed-circuit and surveillance cameras such as "Tsunami Recorded by CCTVs [Surveillance Cameras] 3/11/2011" (RocketNews24, Japan, 2013), and cameras mounted onto extremities, kayaks, paddleboard paddles, bicycles, and other vehicles often capture perspectives unavailable to the people operating them, such as in "Great White Sharks El Porto Surfers have close encounter with multiple sharks" (Nathan Anderson, USA, 2013). This capacity recalls the program for a new cinema proposed by the Soviet-era film team The Council of Three—Dziga Vertov, Mikhail Kaufman, and Elizaveta Svilova—as the birth of the Kino-Glaz (Kino-Eye).

The Council of Three called for the use of the camera and cinematic apparatus (editing and projection) to explore the world cinematically, taking advantage of its capacity to separate itself from the mimetic reproduction of human vision. Their aim was to construct revolutionary visions of the world that would be "wholly different from that of the human eye"

and lead to "the creation of a fresh perception of the world."[31] This project was both critical and utopian in its analysis of present circumstances (in the world and its depiction by film) and its constructivist production of a new vision of the world. Vertov and his comrades explicitly posited their kino-eye and its "factory of facts" against Eisenstein's "factory of attractions."[32] In order to rethink the human condition, they argued, one must take advantage of the inhuman qualities of the camera to see beyond and outside the human in its present situation.

YouTube animal videos tend to be single-shot affairs, without the creative anatomy, geography, and temporality produced by montage prescribed by the Council of Three. In the realm of YouTube animal videos, editing primarily takes the form of temporal elisions to cut out the "boring parts," and the closest thing to a montage practice may be the many *supercuts* organized thematically into compilation reels such as "Animals Can Be Jerks—Supercut Compiliation 2013" (FRIKK, USA, 2013) or "Guilty Dogs—Supercut Compilation 2013" (FRIKK, USA, 2013). To the extent that they hold any radical potential, it resides in the occasional non-anthropocentric perspectives. These moments take up the task of the Kino-Eye to work against replication of human vision and to reinvent the eye. Fostering this capacity of the media and platform may herald the birth of Kino-Eye 2.0. {See **G, M, W, X**}

l is for looking at you

Animals Looking at You, Paul Eipper's 1928 book, is a haunted text. Eipper begins with the melancholic admission "Animals are fast disappearing" and offers a set of reflections on the lives and deaths of individual animals he has encountered in captivity. He dreams of making nature films comprising close-up shots of insect faces and a slow-motion film with the "greed of vision" of a lizard's periscopic eyes. The book concludes with the author in a field in Sweden, playing both Hamlet and Polonius as he stares at a shifting menagerie in the clouds, as vaporous as the animals everywhere disappearing on earth. Exiting his reverie, he is delighted to notice a blackbird perched besides him, *looking at him*.[33] Eipper explores the attraction to animals, animals as attractions, and the attraction of animal attention that drives each visitor to the zoo: *hey animals, look at me!*

This desire for animal attraction frequently serves as a narcissistic affirmation, that each of us merits the rapt attention of animals. It is not enough to reduce animal being to their "to-be-looked-at-ness" as displays in a zoo, we must also force them to take interest in us.[34] The videos "Lion tries to eat baby PART 1" (jpbsmama, USA, 2012) and "Kids at the Zoo: Compilation" (Petsami, USA, 2014) show young parents grabbing the attention of captive animals by placing their children before the Plexiglas of lions and other apex predators, and expressing delight as these creatures

277

paw, swipe, and press themselves against the glass as they try to bite and devour the children. The supposedly cute scenes are cruel to both the captive animals and the unwitting children, with each example containing a potential snuff film as one day the glass will break. It renders animals and children alike mere scraps to be served up to the viral video machine. {**See D, X, Y, Z**}

m is for mouth

Prior to the Kino-Eye, there was the Kino-Mouth. James Williamson, in his film *The Big Swallow* (1901), and Luigi Pirandello, in his novel *Shoot! (Si Gira!)* (1916), imagined cinema to be a matter not of eye but of the mouth and incorporation.[35] Pirandello's novel takes the form of the diaries of a camera operator working on an animal snuff film called *The Lady and the Tiger*—a safari melodrama designed to climax with the killing of a tiger purchased from a local zoo. Reflecting upon his profession, the narrator likens the cinematograph to a bloodthirsty spider and to a tapeworm that greedily devours life.[36] The film studio where he works even maintains a menagerie in order to keep the camera well fed, appeasing cinema's animal appetites. Pirandello's camera devours the visible world; it swallows everything.

This negative view of cinema is positively Hegelian in outlook. Hegel believed that unlike humans, who reflectively incorporate, animals blindly *devour* the world in an unreflective manner. In considering this distinction, Derrida notes with some irony that Hegel's system of thought can also be characterized as "a great digestive system": the concept of Spirit is capable of incorporating and digesting everything, leaving nothing behind, as the entirety of history and philosophy are preserved by the sublation (*Aufhebung*) of his dialectics.[37] YouTube, as a repository of film and video and a network of mobile cameras and amateur videographers, *spurs* the fantasy of an infinitely capacious, total archive of world events (the only limits on YouTube are those of "good taste" as determined by the site). Pirandello's ravenous metal spider weaves a worldwide web. {**See C, K**}

n is for the new, o is for the old

Sergei Eisenstein teaches us to watch YouTube with a sensitivity to the temporal heterogeneity of the past in the present and the present in the past while offering the means to theorize its animal attractions. His final silent film, *The Old and the New* (also known as *The General Line*), released in 1929, explicitly addresses the questions of historical comparison and animal attraction in the form of a bovine wedding. The scene, in which a collective of peasants stage a marriage between a heifer and a bull, elaborates Eisenstein's vision of the montage of attractions as a "copulative" process.[38] The scene offers an opportunity to rethink the concept of attractions through

a literal montage of animal attraction. Eisenstein introduced his concept of the "montage of attractions" in a set of essays written in 1923 and 1924. Inspired by the films of Méliès, the circus, sideshows, rollercoasters, and the reflexology of Pavlov and Bekhterev, Eisenstein originally conceived of attractions as aggressive shocks calculated to produce precise ideological effects. The classic—though, as he would admit, flawed—example of the montage of attractions appears in the conclusion of *Strike* (1925) when he juxtaposes shots of protesters being fired upon with documentary footage of a bull being slaughtered. The fatal blows to the bull's head produce an association between the protesters and the animal—*the workers are being slaughtered*—while also allegorizing the intended effects of the film upon its spectators.

In his writings of the late 1930s and 1940s, Eisenstein revised his notion of attractions. He reconsidered the term to account for attractions and montage formations internal to the frame, but he also began developing a more nuanced account of the spectator and one finds a visual rehearsal of these ideas in *The Old and the New*. Jacques Aumont argues that Eisenstein reformulates the montage of attractions in a less deterministic and more dynamic manner through the concept of ecstasy/*ek-stasis*. Eisenstein defines ecstasy, with the help of Friedrich Engles's *Dialectics of Nature*, as "the leap outside of oneself" which produces the "necessary passage to something else, to something of a different *quality*, something contrary to what precedes."[39] The two temporalities and qualities held in dialectical tension in *The Old and the New* produce concrete images of ecstasy in the famous cream separator sequence and the bovine wedding.

The wedding begins with women, set in contrasting diagonal lines, calling out for the bride three times. The first time a young flower girl appears; the second time a kitten with a flower around its neck marches down the aisle; and finally the heifer, decorated in ribbons, garlands of flowers, and a veil emerges from a barn to the delight of the women. They then call for the groom, the bull procured from the Sovkhoz (state farm), who in a succession of five Méliès-style substitution edits, grows from calf to majestic bull, who is then led out of the barn to meet his "bride." Eisenstein presents a series of shots from the points of view of the bull and heifer, including a tracking shot toward the rear of the cow and close-ups of her quivering udders as "seen" from the perspective of the amorous bull (a literal attraction toward the other animal), and a set of superimpositions of the bull decked out in flowers from the perspective of the cow. These are followed by quick cuts between the bull running toward the cow and the cow getting ready for the collision. As the bull and cow collide, a series of flash cuts give images of explosions, fireworks, and fast-flowing liquids, followed by a shot of eight calves: the result of this copulative montage of animal attraction.

We see a leap in *quantity* (from two bovines, many) and a leap in *quality* in the rapid transformation of a calf into a bull, and then of both animals into

279

energetic images suggesting the transformation of the solid animals into liquid and gaseous states. This transformation to a different quality also concerns the spectator, now addressed, as Aumont notes, not as a passive target but as a desiring subject.[40] Eisenstein's understanding of transformation, development, and historical change is, as he makes clear in his writing on Disney, anything but linear or teleological, and this is emphasized by the conjunction "and" in the title *The Old and the New*. His notes on Disney praise the "plasmatic" qualities of early animation (but also real phenomena) for showing forms making leaps and bounds up and down the rungs of the "ladder of evolution."[41] Through this reading of animation, Eisenstein developed what can be called a *montage of animal attractions*.[42] In direct reference to the concept of attractions he developed in his youth, Eisenstein reconceives of attractions as ecstatic leaps away from and out of static ontologies, figuring a mode of nonlinear evolution as revolution, a perpetual turning into something else, striving to leap into new forms and ways of being otherwise. It is this transformative energy, when coupled with an anti-anthropocentric perspective (another form of ek-statis at the level of species) that fuels the utopian dimension of cinematic animal attractions. {See A, J, U, W}

p is for photogénie

Photogénie has migrated from photography to film to digital video. The astronomer François Arago, Christophe Wall-Romana notes, initially used the word photogénie—"created by light"—in reference to his friend Louis Daguerre's daguerrotype photographic process.[43] The term entered popular parlance in the middle of the nineteenth century in reference to the capacity of people, places, beings, and things to be translated by the photographic camera in a captivating manner. Its conceptualization, however, came about by its migration into a different (if related) medium. The first wave of film theorists in France—Louis Delluc and Jean Epstein in particular—used photogénie as a portmanteau for their speculations on the essences of cinema. Epstein's classic definition of the term referred to it as "any aspect of things, beings, and souls that enhances its moral quality through cinematographic reproduction."[44] Wall-Romana's analysis of the term emphasizes that photogénie accounts for the "melding of the filmic with the pro-filmic [. . .] that 'enhances' the model's 'moral quality'" that also accounts for a particularly heightened mode of embodied cinematic reception that Epstein characterized as a "primitive, foetal, and very much animal sensibility."[45] Delluc and Epstein often referred to natural phenomena such as light reflected off running water, crashing waves, and the blossoming of flowers in time-lapse cinematography as key examples of photogénie—and a small subset of their fellow critics—Colette, Marcel Defosse, and Émile Vuillermoz, all emphasized the importance of animals

for producing and conceptualizing photogénie, a line of thought they developed under the heading *photogénie des bêtes* (animal photogénie).[46]

Like attractions, the short videos on YouTube have also revived photogénie as a viable aesthetic practice and productive concept, alive in the many videos focused on pure motion, visual dialectics of particularity and abstraction, and the capacities of the medium, such as the manner in which underwater footage focused on the *blue* of the ocean itself begins to refract and pixilate for lack of a clear object of focus and also when there is too much to focus on, as happens during the alternate filming of a bait ball and the deep blue abyss in "BIGGEST BAIT BALL EVER CRAZY FISH AND MASSIVE SHARKS SHOT W/ GOPRO HERO2 HD" (pedalorthrottle, USA, 2012). Animal photogénie played a critical if marginalized role in the earlier discourses on photogénie. The proliferation of animal videos on YouTube that focus on the interplay of animal motion and medium recommend a reconsideration of animal photogénie as a theoretical program attentive to the entanglements of media and users and the manners in which the subject-effects of cinema may extend, and extend beyond the human, and it is here that the moral dimension addressed by Epstein re-emerges. An intuitive and widespread resurgence of animal photogénie sensitizes viewers to the potential *animal sensibility* and creature feeling triggered by moving image media. {See G, T, W, Z}

q is for quagga

The last living quagga, a type of zebra native to the South African veldt that looks like it forgot to put on its pants (its front is striped, its hind quarters solid), died in captivity in the Netherlands in 1883, just as early experiments with photographic motion pictures began to gain traction, and Muybridge and Marey began producing their chronophotographic bestiaries (on media that are also going "extinct"). In the music video "Q is for Quagga" (Randy Laist, USA, 2011), a YouTube troubadour explains that the animal's name is onomatopoetic, "so everytime you say the quagga's name, it's like a quagga speaking from beyond the grave." Film came too late to "save" the quagga from extinction in the form of a luminous taxidermy. Akira Mizuta Lippit argues in *Electric Animal* that as "everywhere animals disappear," they commence a spectral existence in cinema and other technical media.[47] From such a perspective, YouTube serves as a virtual pet cemetery and wildlife and audiovisual media preserve. With the quagga, however, spectrality has now taken a fleshy existence.

The quagga—or Rau quagga as they are called to mark their anachronistic leap back to life—have been the subject of an adventurous reanimation project.[48] It is the result of a program of "breeding-back," a type of genetic archaeology based upon the insight from genetic testing of taxidermy specimens that quaggas are a subspecies of the plains zebra.

Through the careful breeding for the recessive traits of plains zebras, the quagga—or a credible simulacra of them—have seemingly been brought *back* into existence, a re-existence born of the genetic code of long dead creatures pursued back [in]to the future. {See A, C, D, U, Z}

r is for the real (fake!)

In a critical assessment of Bazinian realism and its fascination with on-screen animal death, Pascal Bonitzer argues that wild animals serve as the "most radical figure" for the *real* (not to be confused with *realism* or *reality*).[49] Their appearance, disappearance, and comportment is unpredictable and largely beyond the control of humans, and in their capacity to devour and be devoured they charge footage with the quotient of mortal danger, that in Bazin's assessment was one of the few singular and irreducible events that "justifies the term [. . .] *cinematic specificity*."[50] Animals appear to exist primarily through expressions of instinct and drive. Their purportedly spontaneous, irrational actions often reveal the cracks and fissures in our symbolic systems, for which death marks an absolute exteriority. Film footage of animals tends to always have a strong documentary element to it, invested with a sense of presence rather than representation, particularly when showing the death of an animal. Even when they appear in fictional narrative films, as Akira Mizuta Lippit argues, their presence requires the American Humane Association's "No animals were harmed . . ." partitioning disclaimer in order to ensure a firm distinction between film and reality—an acknowledgement of both film's powerful reality effects and its status as representation.[51]

On YouTube a general faith in cinematic realism collides with a faith in the power of cinematic illusion and manipulation. A quotient of skepticism and debate pervades the comments to animal videos on YouTube, as seen in the variations of "*fake!*" that commenters left in response to "Shark Attack 3-13-2014." This is born of the astonishment and suspicion regarding digital renderings, which often have an aura of possessing powers in excess of the actual capacities for fabrication. This skepticism is nourished in part by exceptional hoax videos like "Golden Eagle Snatches Kid" (MrNuclearCat, Canada, 2012). The video depicts a golden eagle swooping down and trying to fly off with a toddler playing in a park. It was designed to show off digital manipulation skills that play with the reality effects of photographic media by cannily casting two of the most unruly subjects to film—babies and wild animals—in order to depict an encounter with the *real* in the form of the deadly and unpredictable business of the food chain.

Videos of encounters with wild animals on YouTube act as the frontier between a well-stocked preserve for the cinema of the real in the digital era and the site where its boundaries are being re-negotiated. Real, fake, real, fake! {See C, D, E, I, M}

s is for safari

"Battle at Kruger" (Jason Schlosberg, USA, 2007), filmed by David Budz-
inski and Jason Scholsberg at the Kruger National Park in South Africa in
2004, and uploaded to YouTube in May 2007, is one of the most seen animal
videos on YouTube, with over seventy-four million viewings. This remark-
able footage, shot from inside a tour vehicle, depicts a pride of lions attack-
ing a juvenile Cape buffalo at a watering hole. As the lions take down the
buffalo at the water's edge, a large crocodile grabs its hind leg, commenc-
ing a tug of war between the two groups of predators. Suddenly, a herd
of adult buffalo gathers and drives away the lions, recovering the juvenile
buffalo. During the entire event, a series of voices comment upon the
event in excitement, confusion, and astonishment. A male voice with a
South African accent, presumably the guide, repeatedly expresses incredu-
lity at witnessing such a rare event, the likes of which he's only ever seen
on video. At the end of the video, one of the witnesses says to the videogra-
pher, "you can sell that video," a prescient remark, considering that a year
after it posted on YouTube National Geographic made a television special
with Budzinski and Scholberg about their video: *Caught on Safari: The Battle at
Kruger* (2008).

The violent encounter, with its unusual outcome for the prey, connects
to the long history of wildlife media, while also measuring the changes in
attitude toward filming and interacting with wildlife. Historians of wildlife
media frequently cite the role of hunting and safari films in establishing
the generic conventions and popularity of wildlife media, pointing to the
box office failure of the safari travelogue *Roosevelt in Africa* (1910), shot by the
wildlife pioneer Cherry Kearton, who accompanied the former American
president on his travels, when compared with the popularity of the sen-
sational "pre-make" *Hunting Big Game in Africa* (1909), shot in a studio by
William N. Selig using captive animals being shot by a Roosevelt imper-
sonator.[52] The popularity of "Battle at Kruger" is in no small part due to its
sensational violence, and its documentation of the "code of fang and claw"
fetishized by wildlife films from the 1910s onward. But it also measures the
extent to which the colonialist trophy hunts of the early twentieth-century
safari have shifted to the hunt for visual trophies: wherein the fantasy of
witnessing animals with minimal interruption by humans is now privi-
leged and works through technological extensions (from telephoto lenses
to remote-control camera-equipped drones) rather than direct presence.
{See B, C, E, G, I}

t is for théâtre du vieux-colombier, television, 👍 (thumbs-up)

"Post-cinematic" refers to a periodizing and descriptive concept. It names a
moment in which cinema is no longer the dominant referent for media. It

also refers to the shifts brought about by the reconfiguration of the means of production, distribution, and exhibition of motion pictures heralded by the industry's switch to digital cameras and projectors, online distribution, and the move from a single big screen to a distributed proliferation of screens at multiple scales, from cellular phones to Jumbotrons, in both private and public spaces. Experiments with cinema's configuration, as institution and social practice, have long existed at the margins of the industry. Cinema and other media may be understood as *iterative* phenomena, only realized in their uses, rather than as possessed of predetermined, stable ontologies.[53]

Jean Tedesco, programmer of the avant-garde cinema at the Théâtre du Vieux-Colombier in Paris, founded in 1924, experimented with part of the classic formula of cinema through his pedagogical "repertoire du film," intended to teach audiences how to watch film and *see* cinematically. In the program notes for the inaugural season of the Vieux-Colombier he wrote, "How many *habitués* of the Vieux-Colombier have not dared to venture into a cinema for fear of being tormented too frequently by film serials [. . .] only to learn, often too late, that amongst so much nonsense was something beautiful?"[54] The repertoire programs were an explicit act of taste formation and pedagogy, comprising brief passages from films deemed by Tedesco to be either "classic" (his term) or particularly endowed with photogénie, which were to be shown "in a dignified setting and sympathetic atmosphere."[55] Tedesco particularly favored scientific and animal films as part of his education of the spectator's eye and his elevation of the spectator's tastes.

Video platforms like YouTube realize part of Tedesco's ideal of a repository of photogénie that trains and enables ways of watching media with a discerning eye. The conditions of reception and attendant social configurations have become increasingly "sympathetic," if not dignified, as they have become dispersed and reconfigured around personal computers and portable devices. Online videos cultivate disseminated publics and produce discourses on their reception (including a repeated rehearsal of arguments over the treatment of animals featured in videos), while shifting from an explicit appeal for *snobisme* to a more populist mode of address.

Calling YouTube post-cinematic without qualification to include the other media it hybridizes risks limiting the analysis to only a part of the equation. The Tube in YouTube, and the company's motto "Broadcast Yourself," take television as its primary referent. The aesthetic experience of following a seemingly endless chain of associated videos on YouTube echoes the variety format and interactive aspects of *early* television programs like DuMont's *Photographic Horizons* (1948–1949), Allen Funt's *Candid Camera* (1948–2004), and the cavalcade of spectacles of bodies in pain presented in wrestling, boxing, and roller derby, which were soon supplanted

with filmed content. The increasing integration of advertising both before and during videos on YouTube also brings it much closer to a financial model and experiential pattern established by television. But where discourses of broadcast television emphasized liveness, the discrete bursts on YouTube emphasize, as Henry Jenkins has noted, "realness" rather than "liveness," the authenticity of the actual, produced with a slight temporal delay, more common to actualités.[56] The search function, on the other hand, suggests an individualization of the repertoire vision of Tedesco's experiment with cinema. The explicit taste-formation has become distilled into the survey buttons that allow for no ambivalence: thumbs-up and thumbs-down. {See A, D, P, R}

v is for viral videos

Toxoplasma gondii is a parasite found in cat feces. Researchers at Oxford University found that rats infected with the parasite undergo a fundamental rewiring of their brains that alters their behavior: where uninfected rats flee from feline scents, infected rats become "fatally attracted" to it.[57] This has led other scientists to speculate about the effects of the parasite on the brains and behavior of human hosts, ranging from increasing one's propensity for cats, to increased tendencies for risky behavior and even suicide (reports note the reactions frequently differ based upon the gender of the infected).[58] Might it also increase attraction to cat videos, those most "viral" of viral videos?

Viral—of or like a virus—is a potent metaphor. Part of what it replicates is a tendency to use the language of evolutionary biology (viruses, memes, swarms, hives) to name and explain new media phenomena, and through this habituation, to implicitly naturalize historically contingent phenomena. In the case of YouTube, "viral" names the manner in which videos get rapidly disseminated through a cultural milieu; the awareness of its existence spreading like a contagion from one viewer to the next thanks to a combination of networked communications and word of mouth. The primary function of a virus, William Burroughs wrote in his consideration of the viral nature of human language, is replication.[59] Its existence is defined by its *communicability*: the manner in which it spreads like a communicable disease.

Viral videos feed upon our attention. Their literal value determined by the number of eyes trained upon them.[60] The power of animal attraction captures it. Can these viruses—frontier phenomena between nature and culture, organic and inorganic life, evolutionary biology and marketing—also alter our brains and behavior in terms of an attentiveness to animals? Or do they merely increase our participation in the replication of viral videos? Whither the cinema of fatal attractions? {See A, F, G, R, W}

285

w is for walking along the shore with a cat

Bestiaries are supposed to provide moral instruction. Could a bestiary of moving images do so in any other way than through a reflection on a tracking shot, or as the French call it, *le travelling*, that most morally freighted cinematographic gestures?[61] A *travelling* represents the entirety of the video "猫と歩く Walking along the shore with a cat" (ealmore3, Japan, 2012) (figure 14.3).[62] As the title and accompanying haiku suggest, the video records the trajectory of a stray cat promenading along the concrete seawall at Ginowan, Okinawa, framed against crashing waves. This hand-held *travelling* records the small disruptions, detours, and shifts in attention of the cat as it makes its way down the seawall, set to a soundtrack mixing the found sound of the crashing waves and wind with the Martinique musician Kali's "Mwen Desann St Pie." The camera work is virtuosic in its responses to the cat, coming in close to study the animal's countenance and gracefully arching away to give it distance when human proximity appears to make it anxious. Its framing situates the animal within a larger environmental and historical context of beautiful subtropical seas haunted by remnants of imperial wars, colonial and military occupation, and environmental degradation (including remnants of Agent Orange disposed of by the US military in the area). The moral, and morality, of this *travelling* shot derives from the mutual adjustments of the two heterogeneous beings to each other and their larger environment. The video improvises a parallel course, but one open to strays and to straying from too straight a path. As with history, the intentions are often inscrutable and the ultimate destination is unknown.

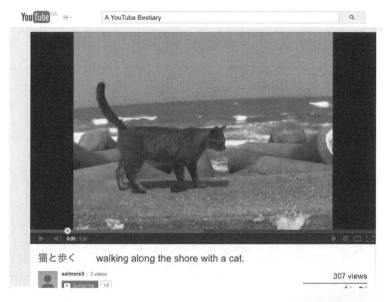

Figure 14.3 "猫と歩く Walking along the shore with a cat" (2012).

This moral lesson is less the product of pedantry than of the virtues of YouTube's initial reliance upon and exploitation of amateur production. The amateur—unprofessional and amorous (doing something *for the love of it*)—suggests a personal stake that matters in terms of how we see and share the world, what we choose to record and preserve, what merits our attention, and what ultimately attracts us. In this context it bears returning to Eisenstein's imperative toward ecstasy as a way to rethink attractions as animal attractions. Ecstasy, ek-stasis, is not an abandonment of temporal urgency for a timeless experience (some variation of tune in, turn on, drop out), but rather the pursuit of a leap out of the self and a serious and playful engagement with anachronism and untimeliness. The ek-statis of animal attraction responds to a need to imagine ways of being beyond self-identical identity or solely human limits, and of shifting our orientations and critical regards. Rare as they might be, these moments of a post-cinema of animal attraction may tutor us to have amorous eyes, attuning us to precariousness, to the strange, to attractive singularity, and teaching us to wander and track the world, to look back and forward, with an eye towards itineraries beyond our own. {See A, D, F, J, K, N, O}

x is for x

"Since Copernicus man has been rolling away from the center towards X."[63] Nietzsche's assessment of the impact of the Copernican revolution (shifting from a geocentric to a heliocentric conception of the universe), forces a reconsideration of humans and of anthropocentrism. The human can no longer be taken for granted as the center of the universe or even as something *given*, but rather as something that inhabits, as in algebraic equations, the place of an unknown variable, an x.

Paul Valéry describes a similar experience of displacement when caught by the gaze of an animal. In his text "Animalités", Valéry reflects on this "strangest of encounters":[64]

> The gaze of dog, cat, or fish gives me the feeling of a point
> of view, of a being-seen-by, and consequently, of a private,
> intimate, or reserved place, of a chapel where the things
> I know are not, and where there are things I do not know.
> I am unaware of what I signify in this place. There is a mode
> of knowing me there. And I am forced to consider myself
> like a word for which I do not know the meaning in an
> animal system of ideas.[65]

Caught by the gaze of an animal, Valéry encounters the relativity of his own point of view and knowledge. He experiences himself as but one set of coordinates in a broad field of variable possibilities. Unlike the trap of

the Sartrean and Lacanian gazes, for Valéry this is a potentially marvelous experience. In this text he grants interiority ("a point of view," "a private, intimate [. . .] reserved place") and a specific type of thinking ("an animal system of ideas") to the animals regarding him, and he believes he can learn something from them. These moments force him to consider himself as an unknown word, perhaps an x. Valéry goes on to describe the mutual gaze of animal and human as a "virtual double negation"—the double-strike-through that produces an x, and calls solitary being into question.[66] This gaze produces a crossing and entanglement of beings that leaves both parties potentially altered.

The spatial and temporal mediation of moving images produces a deferred encounter, which will never be mutual in precisely the same manner as experienced in the physical and temporal presence of another creature. What YouTube's repository of animal encounters offers—as with "Dramatic Tarsier stares at you for 10 hours" (e7magic, USA, 2012), a loop of the small bug-eyed primate gazing directly into a video camera—is an opportunity, both everyday and unusual, to rethink rather than replicate the experience of this gaze, and the variables it reveals us to be. {See H, K, L}

y is for youtube

W.C. Fields's golden rule (attributed): Never work with children or animals.

YouTube's golden rule (distributed): ~~Never~~ work with children and animals. {See A–Z}

Z is for Zoos

"In the zoo the view is always wrong. [. . .] The zoo cannot but disappoint."[67] "Why Look at Animals?" John Berger's devastating essay on the disappearance, reification, and marginalization of animals in capitalist modernity, ends at the zoo, the very site where YouTube "begins" with "Me at the Zoo." Berger polemically describes zoos as monuments to the impossibility of a genuine encounter with animals and symptomatic of the multitude of ways in which humans have marginalized and subjugated them. Like paintings hanging in a museum, the animal exhibits at zoos offer a series of framed views of scenes of animal life removed from circulation, and cut off from larger contexts. From "Me at the Zoo" onwards, YouTube's videos have documented the captive and marginalized lives of animals, as well as an urgent need on the part of humans to connect (sometimes cruelly) with them.

Berger's pessimistic account of the increasingly circumscribed present and future of animals is premised upon a very romantic notion of the past, but the overarching argument traces the rupture from a relationship to

animals as humanity's silent partners, offering "unspeaking companionship," to a relationship to animals as our silenced inferiors.[68] For Berger, it is unclear if anything less than a return to a pastoral existence will do—and he is dismissive of the possibility of photographic media playing any role but an alienating one. Even the best made and revelatory nature documentation does little else but highlight the normal invisibility of animals to man: a perspective betraying Berger's iconotechnophobic and anthropocentric attitudes.[69] But to the extent moving images may help one think about the x status of humans, and look beyond the horizons of an anthropocentric gaze, Berger's pessimism need not be absolute.

If they are not ultimately silenced by marginalization or extinction, the silence of animals may inspire the emergence of a post-cinema of silence, of a reflective human silence born of a learned modesty: a new silent cinema. {See B, L, Q, X}

acknowledgments

This text has benefitted from discussions with the students in "Animals and Cinema," taught at the University of Toronto in Fall 2011 and Fall 2013. I also thank René Thoreau Bruckner, Aubrey Anable, Nic Sammond, Miriam Siegel, Paul Flaig, and Katherine Groo. Part of the research for this text was conducted with support from a Social Science Humanities Research Council Insight Development Grant.

notes

1. Bart Testa, *Back and Forth: Early Cinema and the Avant-Garde* (Toronto: Ontario Art Gallery, 1992).
2. "A YouTube Bestiary": https://www.youtube.com/playlist?list=PL1ywS5W OxI6ptjsRy8smZJLZsUbYQwinI. Accessed 20 March 2014.
3. Alexandra Juhasz, *Learning from YouTube* (Cambridge, MA: MIT Press, 2011): http://vectors.usc.edu/projects/learningfromyoutube/. Accessed 17 March 2014.
4. See Richard Abel, *The Ciné Goes To Town: French Cinema 1896–1914* (Berkeley: University of California Press, 1994), 91–92; and Frank Kessler, "Actualités," in *The Encyclopedia of Early Cinema*, ed. Richard Abel (New York: Routledge, 2005), 5–6.
5. See André Gaudreault and Tom Gunning, "Early Cinema as a Challenge to Film History (1986)," in *The Cinema of Attractions Reloaded*, trans. Joyce Goddin and Wanda Strauven, ed. Wanda Strauven (Amsterdam: Amsterdam University Press, 2006), 365–380; Tom Gunning, "An Aesthetic of Astonishment: Early Film and the (In)Credulous Spectator," *Art and Text* 34 (Fall 1989): 31–45; Tom Gunning, "The Cinema of Attractions: Early Film, Its Spectator and the Avant-Garde," in *Early Cinema: Space, Frame, Narrative*, ed. Thomas Elsaesser (London: BFI, 1990), 56–62; and André Gaudreault, *Film and Attraction: From Kinematography to Cinema*, trans. Timothy Barnard, foreword by Rick Altman (Urbana: University of Illinois Press, 2011).

6. Strauven, "Introduction to an Attractive Concept," in *The Cinema of Attractions Reloaded*, 16.

7. Henry Jenkins, "YouTube and the Vaudeville Aesthetic," *HenryJenkins.org* (20 November 2006): henryjenkins.org/2006/11/youtube_and_the_vaudeville_aes.html. Accessed 14 March 2014; Teresa Rizzo, "YouTube: A New Cinema of Attractions," *Scan: Journal of Media, Arts, Culture* Vol. 5, No.1 (May 2008): http://scan.net.au/scan/journal/display.php?journal_id=109. Accessed 7 September 2013; and Joost Broeren, "Digital Attractions: Reloading Early Cinema in Online Video Collections," in *The YouTube Reader*, eds. Pelle Snickars and Patrick Vonderau (Stockholm: National Library of Sweden, 2009), 154–165.

8. YouTube's original "About Us" quoted in Jean Burgess and Joshua Green, *YouTube: Online Video and Participatory Culture* (Malden, MA: Polity, 2009), 3.

9. The bestiary format was adopted for many educational primers. For recent appropriations, see Claire Parnet's video interviews with Gilles Deleuze and ecological writer Caspar Henderson's *The Book of Barely Imagined Beings: A 21st Century Bestiary* (London: Granta, 2012). Robert Ray's *The ABCs of Classic Hollywood* (New York: Oxford University Press, 2008) also takes up the alphabet structure to make an argument about the relations of details to the whole in his provocative examination of classic Hollywood cinema.

10. See Terence Hanbury White, *The Book of Beasts: Being a Translation from a Latin Bestiary of the Twelfth Century* (New York: Putnam, 1954).

11. André Bazin, "Les films d'animaux nous révèlent le cinéma," *Radio, Cinéma, Télévision* No. 285 (3 July 1955): 2–3, 8. Unless otherwise noted, all translations from French are my own.

12. These statistics come from YouTube's Press section: https://www.youtube.com/yt/press/statistics.html. Accessed 28 March 2014.

13. Richard Grusin, "YouTube at the End of New Media," and Trond Lundemo, "In the Kingdom of Shadows: Cinematic Movement and its Digital Ghost," in Snickars and Vonderau, eds., *The YouTube Reader*, 60–67; 319–329.

14. Anandam Kavoori generalizes that domestication is the general thrust of animal videos on the platform in his *Reading YouTube: The Critical Viewer's Guide* (New York: Peter Lang, 2011), 58–67.

15. The term "uncanny valley" comes from Masahiro Mori, "The Uncanny Valley," trans. Karl F. MacDorman and Norri Kageki, *Spectrum IEEE* (12 June 2012): http://spectrum.ieee.org/automaton/robotics/humanoids/the-uncanny-valley. I use Mori's term in a more generalized sense of a threshold when resemblance suddenly turns disturbing. Accessed 20 March 2014.

16. In "Death, Women, and Rabbits," an unpublished undergraduate research paper produced for my 2013 Animals and Cinema course, Denise Nouvion trenchantly observes that despite its disturbing content, the stunned silence after the fatal event presents a rare moment of rupture in the language and logics of anthropomorphism and domestication on YouTube, inducing viewers to consider this rabbit not as a set of pre-determined signifiers, but as a distinct individual creature.

17. Mary Ann Doane, *The Emergence of Cinematic Time: Modernity, Contigency, The Archive* (Cambridge, MA: Harvard University Press, 2002), 140.

18. *Ibid.*, 140–141.

19. Jamie Feldmar, "Insanely Cute Video: Juno the Beluga Whale Serenaded by Mariachi Band," posted on *The Gothamist* (3 August 2011): http://gothamist.

com/2011/08/03/video_mariachi_band_serenades_juno.php. Accessed 17 March 2014.

20. Walter Benjamin, "Surrealism: The Last Snapshot of the European Intelligentsia," in *Selected Writings*, Vol. 2, part 1, 1927–1930, trans. Edmund Jephcott, eds. Michael W. Jennings, Howard Eiland, and Gary Smith (Cambridge, MA: Harvard University Press, 1999), 207–221.

21. For a philosophical examination of cats on YouTube, see Adam and Luke Kuplowski's Cocteau-inspired *Le Club des amis des chats*: http://clubdesamis-deschats.tumblr.com. Accessed 10 March 2014.

22. In 1898, Boleslas Matuszewski proposed the creation of an official film archive at the Bibliothèque Nationale de France to serve future historians. Matuszewski, "A New Source of History," trans. Laura U. Marks and Diane Koszarski, *Film History* Vol. 7, No. 3 (1995): 322–324.

23. On animal-made videos see Florien Leitner, "On Robots and Turtles: A Posthuman Perspective on Camera and Image Movement after Michael Snow's *La région centrale*," *Discourse* Vol. 35, No.2 (2013): 263–277.

24. On the mutual enfoldings of technology and user, see Donna Haraway, "Crittercams," in *When Species Meet* (Minneapolis: University of Minnesota Press, 2008), 249–263.

25. André Bazin, "Cinema and Exploration," *What is Cinema*, Vol. 1, trans. Hugh Gray (Berkeley: University of California Press, 2005), 154–163. This essay appears in Volume 1, "Ontologies," of *Qu'est ce que le cinema* (Paris: Éditions du Cerf, 1958). Reprints of two of the articles that form of the base of "Cinema and Exploration" appear as "L'evolution du film d'exploration," parts 1 and 2 in *Cahier du Cinéma* (November 2008): 96–98, and (December 2008): 84–85.

26. Bazin, "L'evolution du film d'exploration," part 1, 98.

27. Bazin, "Cinema and Exploration," 161.

28. See Mary Ann Doane, "The Indexical and the Concept of Medium Specificity," *differences: A Journal of Feminist Cultural Studies* Vol. 18, No. 1 (2007): 128–152.

29. Friedrich Engels, "Mathematics," in *The Dialectics of Nature* in *Karl Marx and Friedrich Engels, Collected Works*, Vol. 25, ed. Eric Hobsbawn et al. (New York: International, 1987), 549.

30. Walter Benjamin, "On the Concept of History," in *Walter Benjamin: Selected Writings*, Vol. 4, 1938–1940, trans. Edmund Jephcott et al., eds. Howard Eiland and Michael W. Jennings (Cambridge, MA: Belknap Press of Harvard University Press, 2003), 395; and Ulrich Lehmann, *Tigersprung: Fashion in Modernity* (Cambridge, MA: MIT Press, 2000), 241–247.

31. Dziga Vertov, "The Council of Three," in *Kino-Eye: The Writings of Dziga Vertov*, trans. Kevin O'Brien, ed. Annette Michelson (Berkeley: University of California Press, 1984), 14, 15, 18.

32. Vertov, "The Factory of Facts (By Way of Proposal)," in Michelson, ed., *Kino-Eye*, 59.

33. Paul Eipper, *Animals Looking at You*, trans. Patrick Kirwan (New York: Blue Ribbon, 1933 [1928]), 2, 55, 163.

34. I borrow "to-be-looked-at-ness" from Laura Mulvey, "Visual Pleasure and Narrative Cinema," *Screen* Vol. 16, No. 3 (1975): 6–18.

35. Luigi Pirandello, *Shoot! The Notebooks of Serafino Gubbio, Cinematograph Operator*, trans. C.K. Scott Moncrieff (Chicago: University of Chicago Press, 2006).

36. *Ibid.*, 68–69, 54.

37. Daniel Birnbaum and Anders Olsson, "An Interview with Jacques Derrida on the Limits of Digestion," *e-flux journal* No. 2 (2009): 2.

38. Sergei Eisenstein, "Beyond the Shot (1929)," in *S.M. Eisenstein: Selected Works*, Vol. 1: *Writings 1922–34*, ed. and trans. Richard Taylor (Bloomington: Indiana University Press, 1988), 139. See also Anne Nesbet, *Savage Junctures: Sergei Eisenstein and the Shape of Thinking* (London: I.B. Taurus, 2003), 95–115.

39. Jacques Aumont, *Montage Eisenstein*, trans. Lee Hildreth, Constance Penley, and Andrew Ross (Bloomington: Indiana University Press, 1987), 64. See also, Luka Arsenjuk's entry on *Dialectics of Nature* in *Reading with Sergei Eisenstein*, eds. Ada Ackerman and Luka Arsenjuk (Montreal: Caboose, forthcoming).

40. Aumont, *Montage Eisenstein*, 50.

41. Sergei M. Eisenstein, *Disney*, trans. Dustin Condren, eds. Oksana Bulgakowa and Dietmar Hochmuth (San Francisco: Potemkin Press, 2012), 15.

42. James Leo Cahill, "Grafomanie und Zoophilie: Zwie Punkte auf Sergei M. Eisensteins Linie," trans. Elisabeth Winkelmann, *Kunstforum International* No. 225 (2014): 90–99.

43. Christophe Wall-Romana, *Jean Epstein: Corporeal Cinema and Film Philosophy* (Manchester: Manchester University Press, 2013), 25.

44. *Ibid.*, 26.

45. *Ibid.*, 26, 28.

46. See James Leo Cahill, "Animal Photogénie: The Wild Side of French Film Theory's First Wave," in *Animal Life and the Moving Image*, eds. Michael Lawrence and Laura McMahon (London: British Film Institute/Palgrave, forthcoming 2015).

47. Akira Mizuta Lippit, *Electric Animal* (Minneapolis: University of Minnesota Press, 2000).

48. See D.T. Max, "Can You Revive an Extinct Animal?" *New York Times Magazine* (1 January 2006): http://www.nytimes.com/2006/01/01/magazine/01taxidermy.html?_r=1&pagewanted=print. Accessed 27 March 2014.

49. Pascal Bonitzer, "L'écran du fantasme (bis)," *Cahiers du Cinéma* 236–237 (March–April 1972): 31–40.

50. André Bazin, "Death Every Afternoon," in *Rites of Realism: Essays on Corporeal Cinema*, trans. Mark A. Cohen, ed. Ivone Margulies (Durham: Duke University Press, 2003), 30.

51. Akira Mizuta Lippit, "The Death of an Animal," *Film Quarterly* Vol. 56, No. 1 (2002): 9–22; and the scorching investigation of the AHA's complicity with major productions reported by Gary Baum, "No Animals Were Harmed," *The Hollywood Reporter* (25 November 2013): http://www.hollywoodreporter.com/feature/. Accessed 28 March 2014.

52. Gregg Mitman, *Reel Nature: America's Romance with Wildlife on Film* (Cambridge, MA: Harvard University Press, 1999), 5–58; Derek Bousé, *Wildlife Films* (Philadelphia: University of Pennsylvania Press, 2000), 37–83; Cynthia Chris, *Watching Wildlife* (Minneapolis: University of Minnesota Press, 2006), 11–25; and Palle B. Peterson, *Cameras into The Wild: A History of Early Wildlife and Expedition Filmmaking, 1895–1928* (Jefferson, NC: McFarland & Company, 2011), 71–72.

53. Haidee Wasson, "Protocols of Portability," *Film History* Vol. 25, No1–2 (2013): 236–247.

54. Jean Tedesco, "Recueil factice d'articles de presse, de programmes et de documents concernant la direction du Vieux-Colombier par Jean Tedesco: saisons cinégraphiques. 1924–1928," Archives of the Bibliothèque Nationale de France, Richelieu, Arts du Spectacle, SR96/362, "Saison 1924–1925," 5.

55. *Ibid.*

56. Jenkins, "YouTube and the Vaudeville Aesthetic."

57. M. Berdoy, J.P. Webster, and D.W. MacDonald, "Fatal Attraction in Rats Infected with *Toxoplasma Gondii*," *Proceedings of the Royal Society of London* Vol. 267, No. 1452 (2000): 1591–1594.

58. Kathleen Mcauliffe, "How Your Cat is Making You Crazy," *The Atlantic* (6 February 2012): http://www.theatlantic.com/magazine/archive/2012/03/how-your-cat-is-making-you-crazy/308873/?single_page=true; and James Hamblin, "Do Cats Control My Mind?," *The Atlantic* (5 December 2013): http://www.theatlantic.com/health/archive/2013/12/do-cats-control-my-mind/282045/. Accessed 30 March 2014.

59. William Burroughs quoted in Jussi Parikka, "Contagion and Repetition: On the Viral Logic of Network Culture," *ephemera* Vol. 7, No. 2 (2007): 298.

60. On the political economy of attention, see Jonathan Beller, "The Cinematic Mode of Production: Towards a Political Economy of the Postmodern," *Culture, Theory and Critique* Vol. 44, No. 1 (2003): 91–106.

61. For an overview of the special status of the tracking shot (*le travelling*) from the late 1950s onwards, see Serge Daney, "Le Travelling de *Kapo*," *Trafic* No. 4 (1992): 5–19.

62. Thanks to Luke Kuplowsky for bringing this video to my attention.

63. Friedrich Nietzsche, *The Will To Power*, trans. Walter Kaufmann and R.J. Hollingdale, ed. Walter Kaufmann (New York: Vintage, 1968), 8.

64. Paul Valéry, "Animalités," in *Oeuvres*, Vol. 1 (Paris: Gallimard, 1957), 401–402.

65. *Ibid.*, 401.

66. *Ibid.*

67. John Berger, "Why Look at Animals?" in *About Looking* (New York: Pantheon, 1980), 22, 26.

68. *Ibid.*, 6.

69. *Ibid.*, 14.

laughter in an

ungoverned sphere

f i f t e e n

actuality humor in early cinema and

web 2.0

r o b k i n g

introductory premises

The major premise of this paper can be stated as follows: the forms and strategies of moving image humor have among their conditions of possibility the technological properties of the media by which they are produced and circulated. That is, the technological processes of visual media are preconditions for specific forms of humorous representation. There is nothing earth-shattering in this claim: it has long been established, through the work of critics like Rudolph Arnheim and Walter Kerr, that the silent comedians frequently constructed gags that exploited the peculiarities of film technology (the way in which, say, the reduced sense of depth in the cinematic image allowed the gag of Keaton "entering" the movie screen in *Sherlock Jr.* [1924]).[1] Extended to a principle of comic historiography, however, such a premise becomes more far-reaching. It entails a rejection, for instance, of the idea that visual humor has developed along a linear, evolutionary trajectory of change, as well as of the inverse presumption of a kind of transhistorical permanence to humor's forms. Rather, at each

technologically given moment, we are dealing with media-technological constellations that become enabling conditions for the emergence—and, as we will see, cyclical re-emergence—of certain forms of visual humor (e.g., various types of gags, sources of amusement, etc.); that is, we are dealing with how the transmission of humor by particular technologies may alter and inflect its capabilities for expression. No doubt such a standpoint risks lapsing into a technological determinism, so it is worth underlining that the issue here is one of preconditions, not necessary effects or consequences. Thus a second premise: that the emergence and development of humorous forms—by which I mean the realization or suppression of possibilities given by moving image technologies—occur in relation to those technologies' changing social and cultural milieus. So we are dealing not simply with conditions of possibility but with the ways in which those conditions may be frustrated or fulfilled given the particulars of the social situation.[2]

This matrix of ideas is adapted from current trends within German media studies, in particular what Wolfgang Ernst dubs "media archeology" as a specific style of media-theoretical thinking. In contrast with the cultural studies orientation of Anglo-American media studies, media archeology proposes a more hardware- and technology-oriented perspective for which analysis must always begin, as Ernst puts it, from a "close examination of technical media as they actually operate."[3] As such, media archeology has been described as a form of "posthuman cultural studies" that takes the point of view of technological factors as catalysts for mutations in cultural perception and knowledge. Applied to the history of screen humor, what this implies is an approach that seeks the differences and discontinuities that visual media technologies may have introduced into conventions of comic representation.

The present paper will pursue this impulse through a comparative exploration of the role of humor within two distinct media-technological constellations, roughly a century apart. Specifically, I will be comparing the earliest comic motion pictures (that is, from the period prior to the ascendancy of the story film, c. 1903–1904) with contemporary internet humor (particularly so-called viral videos that circulate within the web's socially networked "Web 2.0" incarnation). One of the advantages of such a comparison is that, in bookending the twentieth century, it brackets off the dominant paradigm of moving image comedy as "mass" entertainment, instead allowing an assessment of technological potentialities in a relatively ungoverned sphere of their organization. For much of the last century, I have argued elsewhere, the relevant circumstances that shaped moving image humor were the operations of a mass culture that orchestrated its comedic genres and representational practices in relation to the social formations associated with the idea of the masses.[4] Yet early cinema was not yet inscribed within these standardizing logics, while contemporary media practice suggests their potential displacement by new forms of

grassroots creativity online. The value of comparing early film with online videos, in this sense, is that it generates a purview that opens onto possibilities both *before* and, arguably, *after* the conscription of screen humor to a mass cultural paradigm—onto territories both not yet and no longer circumscribed by a necessary deference to the logic of mass entertainment. What kinds of humor will we find there? And how might attention to these suggest new frameworks for the historiography of screen humor?

Note that I have largely avoided the word "comedy" so far. The term comedy designates an established cultural mode for which laughter is the intended goal (e.g., stand-up comedy, romantic comedy); it stands, in other words, for a discursive practice or tradition. But media archeology is about non-discursive practices, about media effects that precede their symbolization or formalization within culture and discourse; so that we will need to talk not about comedy but about the *comic effects* that moving image technologies make available.

The third premise of our archeology of screen humor will thus be the terminological distinction separating "comedy" from that which is "comic."[5] Something is "comic," it is said, if it simply generates our amusement, irrespective of intention. In this sense, the term is identical to "funny" or "comical" in referring to *anything* that causes us to laugh, whether a professional comedian telling a joke in a club or an individual awkwardly stumbling over a paving stone. By contrast "comedy" is limited to spheres of representation and intent: something is presented to us *as a comedy* in the sense in which it obeys certain aesthetic and performative codes that cue us to expect to laugh. These two terms need not converge. It is easy, for instance, to think of a comedy that is not comic, that fails in its mirthful intention, just as it is easy to think of something that provokes a guffaw but that we would never—except maybe metaphorically—describe as being a comedy. (Consider, for instance, Senator Marco Rubio's thirsty grab for a water bottle during the nationally televised Republican response to President Obama's 2013 State of the Union Address—a split-second struggle to maintain political dignity in the face of raw bodily need worthy of the highest slapstick art, yet not itself slapstick comedy.)[6] With that in mind, we might further nuance our terms by differentiating comedy as a *mode of representation* from the comic as a *property of perception*. (Thus, The Big Bang Theory [2007–present] "is" a comedy but I do not "find" it comic, etc.). This insistence on perception—that something is comical if and only if it is perceived to be so—is necessary given the socially situated nature of humor. One of the peculiarities of comedy among all the arts, indeed, is the incorrigibility of audience response: a joke, for instance, is funny if and only if you laugh at it. Otherwise—and assuming it has been understood—it is a failed joke. Thus does Sigmund Freud, in his study of jokes, quote Shakespeare's Love's Labour's Lost: "A jest's prosperity lies in the ear/Of him that hears it, never in the tongue / Of him that makes it."[7]

These qualifications will, it is hoped, bear fruit later. For the present, it suffices to consider how they apply to the objects of our analysis: How, in short, does the distinction between "comedy" and the "comic" provide a rubric for assessing the relation between early cinema and Web 2.0 as these have served as media for humor?

early cinema and comedy

A very straightforward—although as I hope to show, misleading—answer might be advanced simply by mapping our two pairings (early cinema/Web 2.0, comedy/comic) atop of one another. Early cinema, one can imagine proposing, was at the start a vehicle for *comedy* insofar as it was shaped by preexisting comedic media—vaudeville, comic strips, etc.—whose practices were simply extended into the new medium. Online humor, by contrast, has proven most reliably viral when it involves a kind of unmediated, real-world encounter with the *comic*; hence the centrality of found-footage or actuality-style material—including such familiar classics as "Double Rainbow," "Leave Britney Alone!" and many others—whose comicality is not a matter of deliberate staging or intent but exists solely in its perception and circulation, in the "ear that hears it."[8] Such a hypothesis, at least as it touches cinema, is broadly in keeping with recent historiographic perspectives that insist on the medium's intermediality—its profound dependence upon preexisting media forms—during its earliest years. What we call cinema, it is said today, initially existed in an intermedial situation for which technological novelty was harnessed to a range of preceding cultural practices. The leading scholarly voice here has surely been that of André Gaudreault, who has gone so far as to propose that "Early 'cinema' *was not yet cinema*," in the sense in which the medium, at least until around 1908, lacked an autonomous institutional identity.[9] Rather, Gaudreault understands early film as no more or less than a tool, an instrument whose optical rendering was put in the service of adjacent media forms and genres. What the Lumières, W.K.L. Dickson, and Georges Méliès "did," in this respect, was simply to use the new device as a vehicle for reproducing and extending pre-existing cultural traditions (what Gaudreault terms "cultural series"): photography for the Lumières, vaudeville for Dickson, magic sketches for Méliès.[10] The early development of film form was then not a specifically "cinematic" development at all, but rather an application of film to the representational norms of non-cinematic media forms.

There is no trick to applying this model to early film comedy. In point of fact, the very earliest films made by Auguste and Louis Lumière in the spring of 1895 with their recently patented *cinématographe* include a famous case in point: a staged sketch about a bad boy, a gardener, and a hose generally known today as *L'Arroseur arrosé* (*The Sprinkler Sprinkled*). Already at the time of the film's making, the gag was a familiar comic-strip chestnut in

France: a first version had appeared in 1885, two more in 1887, with a fourth provided by France's leading comic-strip artist Christophe in 1889.[11] Nor was such direct transposition exceptional. The very existence of screen comedy during the mid- to late 1890s was only possible because of a series of appropriations of gag situations and character types from an already existing repertory of comedy in adjacent media—vaudeville sketches and comic strips in particular. A case in point would be the "bad-boy" film—single-shot films depicting the pulling of a prank that constitute perhaps the earliest important genre in American fiction filmmaking, yet which derive from a rich tradition in small-town comic tales and stage farces (dating as far back, for example, as Thomas Bailey Aldrich's *The Story of a Bad Boy* [1869]).[12] Comic strips, equally, remained a mainstay above and beyond *L'Arroseur arrosé*, perhaps nowhere more so than at American Mutoscope and Biograph, which derived material from the funny pictures more than any other US studio (e.g., a series based on Carl Schultze's "Foxy Grandpa" in 1902, a "Happy Hooligan" series in 1903, based on Frederick Burr Opper's strip, etc.).[13] Such sources accorded well with the brief, one-shot framework of early cinema, generating a proliferation of prank narratives that followed the straightforward cause-effect gag template of *L'Arroseur arrosé*: a rascal—usually a young boy, if not a comic-strip character like Happy Hooligan—sets up a prank to which a second character falls victim (a bucket of water propped atop a door, a shoelace tied to a laundry wringer, etc.). Also well-suited were comedic vaudeville acts, whose modular format readily allowed for brief "bits" to be extracted from longer routines and performed before the camera—a tendency that extends from the earliest Edison shorts through to later films like *The Dog Factory* (Edison, 1904), one of numerous filmed records of the familiar "sausage machine" routine of the turn-of-the-century vaudeville stage.[14]

Other examples could be cited, but only to confirm a point that should already be clear, that the emergence of early *film* comedy was accomplished through a transposition of already existing comedic media. Still, what such an etiology leaves unstated is the presence of material that did not fall within such genres but that nonetheless may have produced laughter—material that was *comic* without actually being *comedy*—and it is here, I believe, that media archeology shows its usefulness. For example, the Lumières' *L'Arroseur arrosé* may well be the brothers' first "comedy," but is it for that reason any more amusing than their prototypical home movie, *Querelle enfantine (Babies' Quarrel)* (1896), showing two babies struggling over a spoon? Interestingly, both films were classified as comedies when released in the US the following year (the latter being a "laughable little comedy"), although the shared designation here masks a fundamental difference—namely that in the case of *L'Arroseur arrosé* the action is predetermined as comic, whereas in *Babies' Quarrel*, the comic nature of what transpires emerges out of accident, from the unselfconscious sadism

with which one baby steals a spoon from the other and uses it as a poking weapon—none of which, surely, was immanent to the decision to start filming.[15]

It is in fact precisely the "accidental" quality to what is here recorded that betrays the crucial blindspot in any intermedial reading of screen humor, since it points to forms of comic attraction that cannot easily be related to previous cultural series. After all, to what pre-existing cultural series does *Babies' Quarrel* belong? The obvious answer would be still photography, with the Lumières' *cinématographe* here taking on the recording duties of the family photo.[16] But such a position, while it surely respects the impulse behind the Lumières' use of their invention, leaves the comic upshot of the film strangely untouched, and for a reason that hardly eludes analysis; namely, that *still* photography is not so well fitted to these kinds of comic effects. To describe *Babies' Quarrel* as "subordinate" to photography thus risks overlooking the mirth-provoking aspect of the film that transcends such subordination. What is required for mirth, as a minimal premise, is a durational temporality: the perception of humor, one recent cognitive study proposes, engages the mind in a "time-pressured heuristic" that involves the framing of expectations and their subsequent derailment.[17] But the temporality of reading a photograph tends toward an "all-at-onceness" that renders this cognitive two-step difficult (albeit not impossible; see below), forcing expectation and deviation to coexist awkwardly within the same moment of apprehension. As Vilém Flusser notes, the process of interpreting still images differs fundamentally from their moving counterparts, since the former tend not to be decoded in strictly linear fashion, from a "start" to a "finish." Rather, in a still image we "get the message first"—all at once—"and then try to decompose it." Photographs are, in this sense, like "dams placed in the way of the stream of history, jamming historical happenings."[18] Humor, however, thrives not on "dams," but on "happenings"; it requires a form of succession for which meaning unfolds in a process of emergence and surprise. As soon as such successiveness is secured—as it is when photography transitions into moving images—humor becomes permanently available.

None of this is meant to imply a hard and fast distinction: there obviously are funny photos. In such instances, however, humor succeeds only when the still photograph rubs against the grain of its own medial "all-at-onceness" to encourage a more linear decoding. This typically occurs in one of two ways: first, when there is a directional temporality somehow "built into" the image (the way a photo's composition establishes a primary focus that is then comically deflated by some secondary detail; the contemporary viral trend of photobombing is a good example); or, alternately, when the photo itself, as a whole, is the thing that deviates from expectations (successiveness here being realized in the way the viewer carries certain pre-existing expectations that are overturned at the instant of viewing).[19] In

all such instances, however, the successive temporality required for humor will be generated not so much from the side of the object (the photo) but rather on the side of the subject (the viewer) who encounters the still photograph and who, as such, "creates" humor's temporality in the process of encounter.[20] Which is to say that the single photograph relies strongly on the viewer to generate the *timing* that comicality implies—hence, arguably, the fragility of still photography's mirth-inducing capacities. In the case of film, by contrast, such a temporality is immanent to the apparatus itself, which in consequence binds subject to object in the durational unfolding of any number of mirth-producing actions.

It follows, then, that there is a kind of actuality-based humor in cinema that (a) resides precisely in the media distinction between still and moving images and (b) is independent of, indeed logically anterior to, comedy. This surely is why early actuality films, though not strictly *comedies*, are so often profoundly *comic*. As Mary Ann Doane has shown, the basic fact of duration—built into the technology of the medium itself—creates a margin of indeterminacy for the unfolding of events, what she describes as an "unprecedented alliance between representation and unpredictability," that contains the permanent potential for unexpectedly comic moments.[21] From the medium's inception, of course, cinema's unique power was often associated with this kind of dehierarchizing of representation, freed from the codifications of any intended signification. One thinks here of the early commentators who celebrated the breeze rustling the leaves in the trees in the first Lumière films, or the pounding of the surf in Birt Acre's *Rough Sea at Dover* (1895); or of the English writer who, writing in 1896, compared film with what he called the "realism" of pre-Raphaelite painters, noting that both "are *incapable of selection*; they grasp at every straw that comes in their way; they see the trivial and important, the near and the distant, with the same fecklessly impartial eye."[22] One thinks also of that chance poetry of motion that French filmmakers of the 1920s came to name *photogénie*, as a kind of expressive singularity unexpectedly revealed beneath the lens of the camera. Surely, though, the inadvertently comic moments discussed above are simply the humorous side of this same coin? Film's new accounting of the world—that leveling, "any moment" plenitude of its indexical capture of the real—revealed possibilities for viewing that thus oscillated between a kind of aestheticizing fascination with the everyday, on the one hand, and unmediated hilarity, on the other. Nor, moreover, should we limit our purview to actuality footage: early fiction films similarly give the spectator ample opportunity for witnessing profilmic accidents or happenstance whose meaning comically refuses to be constrained to hierarchies of narrative meaning. The equestrian inexperience of one of the bandit actors of *The Great Train Robbery* (Edison, 1903), who attempts to mount his horse from the wrong side; an actor's overzealous concern to keep his hat straight while playing an unconscious woman in *From Leadville*

to Aspen (American Mutoscope & Biograph, 1906)—readers will surely have their own favored examples to add to this list.

It follows, though, that our initial hypothesis cannot be quite right; that the humor of early cinema resides *not* only in the medium's role as a vehicle for other comedic traditions. Rather, there are two trajectories of cinematic humor to be explored, each dependent on a distinct reading of the apparatus, as medium or machine: one of these trajectories—predicated on intermediality—insists on cinema as a *medium of reproduction* for extrapolating pre-established genres and traditions of comedy; the other—predicated on media archeology—insists on a new style of reality-based humor emerging from the ontology of cinema as a *time-based machine* bound to the contingency of unfolding events.

comedification/de-comedification

Media archeology thus ultimately leads to what has been an overlooked dialectic for the historiography of screen humor, one that differentiates between a conventionalized system of comedy genres and a techno-indexical realm of comic contingency. I want, then, to turn to the question of historiographic implications in order to unpack what this dichotomy might mean for a historical understanding of screen humor. What, for example, are the processes that belong to this dialectic? It is perhaps not the least of our consequences that the question of class finds itself displaced. The historiography of early screen humor has been approached by many scholars (myself included) in terms of a struggle between class-based models of "low" slapstick comedy vs. "sophisticated" situation comedy.[23] But it does not detract from the reality of that struggle to observe that this process was logically and, indeed, historically posterior to the dialectic that I am here identifying. The terms slapstick and situation exist only on one side of our dialectic, on the side of genre; whereas what the moving image more uniquely represents for the history of humor, media-archeologically interpreted, is a new episteme for laughter that no longer required generic models—that, in a profound sense, *no longer needed comedy*. The media-archeological exercise, then, will be to track this episteme as it has haunted and shaped the forms of screen humor.

Two historical processes can be specified in this respect. The first concerns the way in which the medium's photographic receptivity to comic accident came to be discursively and practically regulated in relation to an emergent system of comedy genres, thus favoring the apparatus's development as a medium. Attention to this process intersects with recent scholarship that has explored the formal and production methods of narrative cinema as devices for managing contingency.[24] But it differs in the case of humor, where the effort was not simply to *subordinate* contingency to narrative meanings—less to "exclude the unexpected," as Ernst puts it—but,

more paradoxically, to systematize the non-systemic, to incorporate happenstance as a reproducible formula of comedy; that is, *to turn comic accident into comedic pseudo-accident*.[25] I am thinking here foremost of the numerous "What Happened" films of the early period, the pretense of which is precisely that of the camera having "captured" a chance comic moment to which the viewer becomes privy. To name only a few: *What Happened When a Hot Picture Was Taken* (American Mutoscope & Biograph, 1898), *What Happened to a Fresh Johnnie* (American Mutoscope & Biograph, 1900), *What Happened on Twenty-third Street, New York City* (Edison, 1901), *What Happened to the Inquisitive Janitor* (Pathé Frères, 1902), *What Happened in the Tunnel* (Edison, 1903), *What Happened to the Milkman* (Lubin, 1903), and *What Happened to a Camera Fiend* (Paley and Steiner, 1904).[26] *What Happened on Twenty-third Street* has been cited by Doane as a key instance of early cinema's predilection for contingency; more singular, to my mind, is what the film suggests for a media archeology of screen humor.[27] The single-shot film contains no markers of comic intent; rather, it presents itself as a straight actuality, apparently a simple street scene in which passers-by walk hither and thither. A man and woman (actors A.C. Abadie and Florence Georgie) eventually emerge from the crowd, walking side-by-side toward the camera. A gust of air blows up from a sidewalk grate to lift the woman's skirt; she playfully defuses her embarrassment with an open laugh and the couple walks on.

Note here how such a film conflates our foregoing distinction between comedy and the comic: the film *is* a comedy, in the zero-degree sense of being a representational form designed for laughter, but a comedy whose conceit is that no representational codes are in play, that we are witnessing something that simply happened, something "purely" comic. We may, in fact, speak of the *comedification* of comicality, as though what is being reflexively staged is the discovery of the immanent comic potential of the moving image and its subsequent repackaging as a reproducible formula.[28] But, in that case, what is encountered here is a decisive rupture in the intermedial context in which film comedy first developed—not a filmed vaudeville skit nor a comic-strip adaptation, but nothing less than the first stirrings of a truly *cinematic* genre of comedy, of a new cultural paradigm for the production of laughter whose condition of possibility is the ontology of the medium itself. Following media scholar Brett Mills, we will call this genre—whose pretense is not to be a genre—*comedy verité*.[29]

What happened to the "What Happened" genre? Such films were produced only so long as cinema remained within the prehistory, so to speak, of its subsequent identity as an emerging mass medium. We are, in other words, still under the sway of that basic fascination exerted by the reproduction of movement through time, only here with an effort to regularize the medium's techno-indexical novelty as the basis of a reproducible comic effect. It is thus significant that the next stage in this "comedifying" process would tilt the delicate balance of the "What Happened" films decisively

toward the standardized formulas of genre filmmaking. Coinciding with the "What Happened" cycle's decline, for example, there now emerged chase comedies like Biograph's *Personal* (1904), which, as often noted, implement a kind of "managed irregularity" that permits impromptu variations even as it confines them to an overall sameness—the way, that is, that the repetitive form of chase comedy provides a predictable system for regularizing comically *un*predictable variations in the pursuers' traversals of space (the way in which, e.g., one pursuer will leap over an obstacle like a fence, another will crawl under it, another will fall down climbing it).[30] More telling still is the simultaneous appearance of a number of reflexive film comedies like Biograph's *The Story the Biograph Told* (1904) that incorporate the medium's indexical availability to happenstance as a narrative device in situation-style comedies of spousal exposure and shaming. A wayward husband is inadvertently filmed committing some miscreant act—typically adulterous—which is then projected onscreen, commonly at a movie theater attended by his wife. The plot device features prominently in a number of films peppered throughout the nickelodeon era, including titles like *Getting Evidence* (Edison, 1906) and *Bobby's Kodak* (Biograph, 1908); enters into the stock-in-trade of domestic comedies in the 1910s, with Roscoe Arbuckle's *A Reckless Romeo* (Comique, 1917), a noteworthy example; and even extends into the sound era, where it is central to the plot of the Laurel and Hardy feature *Sons of the Desert* (MGM, 1933). As Charlie Keil rightly notes, such "reflexive scenarios point to the capacity of cinema [. . .] to replay past moments of time" in testimony to the medium's status as a technology of reproduction.[31] But they also serve as memorial to the immanent comicality of that technology, whose "feckless" capacity to capture accident and impropriety fizzed through the early period as a prominent source of mirth—only here consecrated as a plot device within the paradigms of situation comedy, and hence contained.

The path of media archeology thus reveals a history that leads from "genuine" moments of comic contingency (*Babies' Quarrel*) to the staging of contingency (*What Happened on Twenty-third Street*) to comedies about the filming of contingency (*The Story the Biograph Told*). "Comedification" names this process whereby comic possibilities inaugurated by moving image technology were appropriated to generic categorizations, a thumbnail of how cinema *qua* machine (with comic effects) was subsumed to cinema *qua* mass medium (with comedy genres).

But we will also need at this point to add a second, corollary process of "de-comedification" that in turn merits analysis as to *its* media and technological conditions, although tracking this logic will require that we now leave the confines of early cinema. Inverting the logic just described, de-comedification names the ways in which the increasing dissemination and ease of use of indexical moving image technologies have subsequently permitted the cyclical re-entry of contingency over the last century, a kind

of recurrent de-semanticizing of humor that has periodically restored the happenstance pleasures of the recording apparatus's machinic functioning. A full analysis of this second process would, then, have to move not merely beyond the confines of early cinema but also beyond cinema itself, in order to take into account a much broader moving image history. It would need to examine, for instance, the specific media conditions that enabled television shows like Allen Funt's hidden camera series *Candid Camera* (1948–2004), the idea for which initially evolved out of Funt's experiences with military surveillance technologies at the Army Signal Corps; or to consider how the dissemination of home video technologies in the 1980s gave rise to programs like *America's Funniest Home Videos* (1989–present)—all testifying to a kind of technologically enabled escape from comedy whose recurrence belies any assumption that screen humor's is a linear development. It would have to consider, too, how such reality-based pleasures have themselves been subject to a continued process of comedification that would appropriate them to reproducible formulas, in keeping with the operative procedures of the earlier "What Happened" cycle; how, for instance, the burgeoning of reality television over the last two decades has inspired a surfeit of "comedy verité" shows like *The Office* (UK, 2001–2003; US, 2005–2013) and *Parks and Recreation* (2009–2015) that mimic the format of the television "docusoap" as the basis of a new style of contemporary sitcom.[32] Above all, however, attention to these processes will need to address how and why the humor of real-world happenstance has recently made a historically unprecedented resurgence in the form of non-comedic viral videos online, to which this paper now turns.

web 2.0 and the forms of online humor

Over a century after the Lumières offered up the comic spectacle of bickering children in *Babies' Quarrel*, audiences had another chance to laugh at sibling squabbles, this time online, when the YouTube video "Charlie Bit My Finger—Again!" began to go viral at the end of 2007. Like the Lumières' "Childish Quarrel," the video testifies to the comic dimension of unwitting infant cruelty. Uploaded by the children's father, who used the YouTube platform simply to distribute the footage to relatives, the one-minute video shows Harry Davies-Carr (aged three) putting his finger in the mouth of his one-year-old brother Charlie, who bites. "Charlie bit me!" Harry exclaims. He again puts his finger in Charlie's mouth and again is bitten. "Ouch! Ouch, Charlie! OWWWWW! Charlie, that really hurt!" The infant Charlie inadvertently breaks into something resembling a sadistic laugh. "Charlie bit me," Harry adds, recovering into a smile. Internet users evidently found something they liked. By the end of 2007, the video had over a million views; two years later it was the most viewed online video ever, with 130 million views.[33] As of the time of writing, it has been viewed

over 800 million times and remains the most viewed YouTube video that is not a professional music video.

It might seem strange to offer "Charlie Bit My Finger—Again!" as an immediate comparison with the Lumières' family movies; nobody, surely, would argue for more than a circumstantial similarity, a chance linkage between infant media and infant subjects. For our purposes, however, the similarity can clarify the linkage binding digital platforms to the re-entry of a kind of actuality-based humor in our contemporary moment. Marginalized by the standardization of comedic genres during the mid-1900s, the humor of real-world contingency and accident has in recent years made an unprecedented resurgence to claim center stage in the form of non-comedic videos that acquire viral status online. When *Time* magazine posted its list of "YouTube's 50 Best Videos" in 2010, fully a third of the clips fell within this category, including such now-classic instances as "David after Dentist" (depicting a seven-year-old boy's reaction to anesthesia), "Grape Lady Falls!" (wherein a woman stomping grapes falls over and howls), and "Miss Teen South Carolina" (in which a contestant at the 2007 Miss Teen USA contest offers a garbled response to a pageant question).[34]

How can we understand the popularity of such viral actualities? Any answer must first acknowledge the very broad array of comedic material that today circulates online. The situation of the internet, in terms of humorous content, is in this respect somewhat parallel to that argued by Gaudreault for early film: digital media have indeed developed in part in a "state of complementarity" vis-à-vis pre-existing comedic practice. Internet humor can thus be viewed, at least to some degree, as a kind of hodge-podge of traditional modes, only now dressed up with the special sauce of online culture: jokecraft has been relocated onto comedians' Twitter feeds, where the traditional practice of sharing jokes is absorbed into the process of retweeting; sketch comedy is adapted to sites like FunnyorDie.com, which now allows viewers to vote ("funny" or "die"); and catchphrases and one-liners take electronic form in the meme images and gifs that online users circulate as shorthand comic ripostes. A writer for the comedy news website *Splitsider* summarizes the dynamics of humor's online circulation:

> Between the rise of Twitter, Tumblr, podcasts, and web videos, it's no secret that mobile comedy is quickly becoming the next big thing. While the accuracy and relevance of TV ratings continue to dwindle, online view counts, retweets, and comedian/fan interconnection have flourished and changed the way we discover and share our favorite performers, and in turn how they choose to release and promote their work. Few forms of entertainment are better designed for on-the-go enjoyment than comedy, and a

bevy of websites, production companies, and comedians have taken advantage of the age of constant mobile connectivity to redefine comedy as we know it.[35]

Mobility certainly is key here, as the *Splitsider* writer implies. The modular, bite-sized basis of much humorous expression makes it eminently appropriable for circulation and consumption online (just as, a century earlier, it facilitated the production of brief, one-shot comic films).[36]

Still, what such a perspective fails to explain is why virality has most intensively attached to non-comedic/actuality material. Granted that contingency remains equally available for digital as well as analog visual media, the question arises: why this return now? Here, I would argue, it is less the mobility of new media than their sociality that is the pertinent issue. For if there is one thing that digital technologies have notably added to our experience of this kind of material it is the ability to annotate, link to, remix, and, ultimately, share it. A number of properties of our contemporary media infrastructure are pertinent in this respect: digital interfaces that are configured for both output and input, streaming video technologies enabled by greater network bandwidth, HTML documents that permit the embedding of video files—all of these allow for a continual reincorporation of videos into new online contexts that percolate rapidly through dispersed social networks.

Some care is, however, needed on this point, since the appeal to sociality alone cannot support a distinction between actuality-based humor and other kinds of comic material. As noted earlier, *all* humorous discourse, of whatever kind, is socially situated in the sense in which it is uniquely audience-dependent, requiring an act of transmission for its very existence (no audience, no joke, Freud noted). Humor is also inevitably social in the sense in which it functions strongly as an in-group discursive operator, binding together those who "get" a given joke against those who don't, those who laugh against those who are laughed at. As such, humor of whatever kind has been a good fit for—arguably, a prime catalyst in enabling—the participatory and networking aspects of contemporary convergence culture: not only does it demand to be shared but, in being so, it validates the shared sensibilities upon which online communities thrive.

But there is a question of degree here, and the case can be made that actuality footage engages those sensibilities in a uniquely prominent way. Because these texts are *comic* without being *comedy*, any attribution of humor to them becomes a particularly forceful declaration of sensibility—a potent assertion of cultural capital in which the user declares her own role in the discovery and production of the comic. Unbidden, the user's laughter imposes the incorrigibility of its own reading; shared, the footage becomes a gambit for other users staking their claims to similar comic discernment. Actuality-based humor thus achieves a symbolic centrality

in social terms that comedy proper cannot so readily achieve; for what is at stake in such instances is not simply "funniness," but more pertinently the agency of the user who declares her ability to repurpose texts as a gesture of sensibility. One may indeed speak of such videos, in an online context, as constituting a kind of "found-footage" comicality, in the sense in which online communities reappropriate, relabel, and recirculate material originally generated for non-humorous reasons. There is then, once again, a de-comedifying of humor, which is now freely discovered outside of the borders of generic conventions; but there is also a way in which such actuality-based videos now provide surplus value as "social activators" for the networked exercise of taste. If the indexicality of the moving image (*qua* technology of reproduction) first permitted the *capturing* of comic contingency, then the sociality of the internet (*qua* technology of distribution) has augmented its *spreadability* across the current media landscape.[37]

cultural capital and comic perception in action

A particularly revealing instance of this intertwining of cultural capital and comic apprehension was provided by the recent "Worst Twerk Fail EVER" video that went viral in the late summer of 2013, generating nine million views on YouTube within a week, following its appearance on *The Jimmy Kimmel Show* on 3 September.[38] Circulated on the heels of the controversy generated by Miley Cyrus's now infamous performance at that year's MTV Video Music Awards, the YouTube clip consisted of home video footage of a young woman attempting to twerk while standing on her head, only to fall crashing down onto a coffee table, in the process setting her pants leg on fire from a tumbling candle. Initial YouTube comments included many that simply endorsed the validity of a comic reading ("lol that shit was funny," "holy shit I almost died laughing," etc.), a large number of sexualizing puns ("She is so HOT!"), an even larger number of puns riffing on the title of Alicia Keyes's 2012 song "Girl on Fire," and a number of complaints from those who refused to see the humor in an apparently dangerous accident ("Cause you know guys, people getting set on fire is really funny").[39]

A week later, however, a sudden twist profoundly altered the terms of the clip's reception: on 9 September, Kimmel revealed that he had staged the stunt with the help of a professional stuntwoman named Daphne Avalon. Kimmel gloatingly showed a montage of TV hosts whom he had successfully suckered, and then said to Avalon: "Thank you for helping us deceive the world and hopefully put an end to twerking forever." In the wake of this revelation, the battle lines of YouTube commenters were reconfigured—not between those who found it funny and those who didn't, but between those who knew it to be fake vs. Johnnies-come-lately unwittingly treating the film as genuine. A typical exchange would now involve one of the latter claiming their right to a comic reading ("Am

I wrong for laughing so hard? . . . lmaoooooooo") only to be immediately disabused by throngs of others mocking their lack of savvy ("Sorry to break the news but this was fake").[40]

Kimmel's trick here was to game the presumption on which comic discrimination is practiced in actuality-based online videos; namely, that the footage has not been staged with comedic intent—that is, that it is not *comedy*—such that the perception of comicality is a function of the user's sensibility alone. In the dispersed and anonymous culture of the internet, I have suggested, actuality footage has become a privileged site for online users seeking to assert their comic discernment; yet a hoax like Kimmel's embarrasses such assertions by negating the faith in contingency on which they depend. One's claim to perceive humor in real events is ruined by the revelation that one has misperceived the "reality" of those events in the first place. No doubt this is why Kimmel's stunt was characterized as "trolling" and greeted with hostility by many users, none more extensively than *Slate* contributor Daniel Engber in a 10 September piece titled "Why We Should Be Mad at Jimmy Kimmel." Kimmel's fakery, Engber argued, constituted nothing less than:

> a hostile, self-promoting act [. . .] rendered as ironic acid that corrodes our sense of wonder. If the Web provides a cabinet of curiosities, full of freakish baubles of humanity, the hoaxer smashes it to bits [. . .]. YouTube shows the world in all its weirdness, and gives a window on the geek sublime. When liars spread their hoggish propaganda, they mist the landscape with distrust.[41]

Or, as YouTube commenter TheKevinDaniel summarized more pithily: "we fell for it. Shiet."[42]

laughter in an ungoverned sphere

The media-historical two-step is clear: indexical moving images enable our perceptions of comicality to enter a space of anteriority *vis-à-vis* what cultural traditions have accumulated as comedy; new media add the platform on which those perceptions can be widely shared, contested, or even—in the case of Kimmel's prank—undermined. Still we have to be sure that we do not too readily identify this anteriority to the conventional *forms* of comedy with any necessary deviation from humor's conventional *functions* or *effects*. Has the media character of comic forms like early actualities or contemporary viral videos come into play in a way that facilitates genuinely alternative possibilities for humor? Certainly, it has steered laughter far beyond constraints of propriety. That the various comic forms discussed here are *not* comedies (in the case of actuality-based footage) or at

least do not present themselves as such (in the various forms of comedy verité) is in fact the crucial point, since it is this that provides them with the sheen of lying outside the symbolic forms that ordinarily govern representation and response. What is in all instances encouraged is a form of laughter that operates outside of considerations of decorum; that allows laughter to be directed at real-world situations in self-conscious repudiation of what would ordinarily be an appropriate response. This point is especially pertinent to an understanding of streaming viral videos that, precisely because they are consumed outside of socially coded frameworks of theatrical or television exhibition, promise all the more to deliver what Casper Hoedemaekers has termed a " 'forbidden' dimension that elicits the thrill of illicit *jouissance*."[43] That is, we know it's wrong to laugh—at grape lady's howls of genuine pain, at a woman's pants apparently catching fire, at "Afro Ninja" falling flat on his face—but we feel ourselves within an "ungoverned sphere" in which we can and do laugh at these things anyway, which indiscretion becomes the source of a forbidden pleasure.[44] The controlling and repressive gaze of the Other has been suspended so as to produce online the space for a laughter that knowingly seeks pleasure in disregard of taboos (hence the alignment of much viral footage with an idea of "political incorrectness").[45]

Here, however, it is well to remember our opening premise—that the forms and possibilities of moving image humor have as their preconditions specific media-technological constellations—and to consider whether indexical imaging technologies themselves play a role in loosening our relation to taboos. Put simply, does indexicality itself have consequences for the kinds of things we feel ourselves entitled to laugh at? Such is perhaps the implication of Wolfgang Ernst, who describes indexical imaging technologies in terms of the "cool mechanical eye," or the "cold gaze," to refer to that grounding property of technologically enabled vision that logically and ontologically precedes the "human" or "scenic" uses that any camera may be made to serve. "With the emergence of photography, the idea of the theatrical gaze literally staging the past [as in prior imaging techniques like, e.g., painting] is displaced by the cold mechanical eye, a technologically neutral code rather than a subjective discourse."[46] What indexical media record is first of all the "noise" of the world that comes before any effort to shoehorn that noise into a system of semantic codifications. It is, moreover, precisely an awareness of this "de-subjectified" cold gaze to which the viewer is returned whenever contingency strikes. In such instances, our viewing is restored to that base-level mechanical functioning of the camera as a neutral witness that, simply in the act of recording, has "happened" to register inadvertent events. Whether generated by the Lumières' *cinématographe* or a Logitech webcam, visual evidence of this sort is thus what Ernst describes as a "*cold medium* of the past as opposed to *hot* historiography"; it is an indexical trace, not a discourse.[47]

But if that is the case, then the social dynamics of actuality humor are problematized from the outset by the technological properties of its mediation. To the extent to which the cold gaze becomes a way of stepping outside a human perspective, then it also initiates a mode of perception that implies a social separation, a rupture that frees us from the ordinary proscriptions that shape our relation to people and things. The "cold gaze" of indexical media enables a machinic way of seeing utterly unbeholden to social niceties. What is permitted, in such a mediation, is a separatist laughter whose object no longer has any claim to empathy or understanding; what is risked, in the process, is a power of exclusion freed to direct its derisory impulses at those who are already "other," already excluded (again, witness the flagrantly racist, sexist, classist, and homophobic qualities of many viral videos). The irony and the danger is that actuality-based humor, so far from securing something new, is instead merely channeled back toward that zero-degree laughter that operates as a Hobbesian gesture of superiority and remove—that hostile laughter that revels in the disgrace of an "animal-like" character and that, in contemporary viral form, has been raised to a principle of relating to social reality itself.[48]

beyond comedy/beyond mass culture

It is time to offer some concluding thoughts. In contrast to some two-and-a-half thousand years of basically written or theatrical comedy, the technology of moving image media announced, at the close of the nineteenth century, the arrival of a radically new kind of humor belonging to the "real," rather than to the symbolic order of existing genres, and which has more recently been brought to a kind of fruition online. This sense of fruition obviously needs qualification: nobody, surely, would argue that the conventional genres of comedy have somehow been dispatched as modes for the enjoyment of laughter, although arguably their dominance is now more thoroughly displaced than at any previous moment in the history of moving image media. Equally, one should be cognizant of the broad array of pressures that have already begun to circumscribe online actuality humor in the present: for instance, the rise of YouTube hoaxes that, like Kimmel's, abscond the presumption of authenticity to redirect humor at the viewer, who now becomes the "mark" in a carefully orchestrated prank; or the operations of a show like Comedy Central's viral video compendium *Tosh.0* (2009–present), whose regular "Web Redemption" segments subordinate contingency by inviting people from embarrassing videos to provide an explanatory context for the acts depicted; or a rising generation of brand-sponsored online personalities who have begun to professionalize viral humor, using apps like the six-second Vine to distribute ultra-compressed, pranks and skits to millions of followers. What

nonetheless remains quite singular in our contemporary media moment is the resilience of found-footage comicality against such predations: the networking properties of the internet and social media in general, which allow users to distribute content that affirms shared sensibilities, have sustained contingency-based humor far beyond its earlier media incarnations.

What can be described as the techno-epistemological paradigm of this kind of humor thus finally emerges not only as prehistory and postscript but also as an ambiguous and fraught alternative to mass cultural screen comedy. *Prehistory*, because when the Lumières offered audiences the comic pleasures of *Babies' Quarrel*, this was primarily the result of a kind of research phase into cinematic possibilities, the discovery of potentials that were not accounted for by preexisting representational forms. *Postscript*, because the contemporary digital paradigm in which streaming videos thrive is one for which the architecture of mass culture (which is mass produced and distributed for the broadest audience possible) has been challenged by the networked infrastructure of today's convergence culture (which is characterized by the grassroots circulation of media content within and among a diversity of user groups). And *alternative* because such humor has permitted the shift of accent that displaces the intention of the producer in favor of the sensibility of the user who now flouts symbolic forms and structures by finding humor in material generated with no comedic intent. It thus proves impossible to understand the history of moving image comedy without also acknowledging a counterforce, zigzagging through that history that uncovers humor not in the conventions of "comedy" per se but as a property of recorded reality. Unfortunately, it has so far proven difficult to place much faith in that alternative.

acknowledgment

This one's for Sam and Sully. I wrote it when you used to bite my finger.

notes

1. See, for example, Rudolph Arnheim on Charlie Chaplin's *The Immigrant* (1917) in *Film as Art* (Berkeley: University of California Press, 1957), 36–37, as well as Walter Kerr's chapters "Keaton: Exploring the Gap Between Life and Lens" and "Keaton as Film" in *The Silent Clowns* (New York: Da Capo Press, 1975), 135–142, 225–235.

2. For example, it may well be the case that representational technologies lend themselves to a range of possibilities in their formative stages; but it is also true that that flexibility will typically be closed down as each medium develops toward a consensus identity. See, for instance, Trevor J. Pinch and Wiebe E. Bijke's "The Social Construction of Facts and Artifacts: Or, How the Sociology of Science and the Sociology of Technology Might Benefit Each Other," in *The Social Construction of Technological Systems: New Directions in the*

Sociology and History of Technology, eds. Wiebe E. Bijker, Thomas P. Hughes, and Trevor J. Pinch (Cambridge, MA: MIT Press, 1987), 17–50.

3. Wolfgang Ernst, *Digital Memory and the Archive*, ed. Jussi Parikka (Minneapolis: University of Minnesota Press, 2013), 25.

4. See my *The Fun Factory: The Keystone Film Company and the Emergence of Mass Culture* (Berkeley: University of California Press, 2009).

5. This distinction derives from Steve Neale and Frank Krutnik, *Popular Film and Television Comedy* (London: Routledge, 1990), 15–16.

6. The online video of course went viral: "Marco Rubio Pauses Speech for Water Break," *YouTube* (12 February 2013): http://www.youtube.com/watch?v=19ZxJVnM5Gs. Accessed 17 September 2013.

7. See Sigmund Freud, *Jokes and Their Relation to the Unconscious*, trans. James Strachey (New York: W.W. Norton and Co., 1963), 177. The quoted passage is from Act V, Scene 2 of the Shakespeare play.

8. "Leave Britney Alone!" *YouTube* (10 September 2007): http://www.youtube.com/watch?v=kHmvkRoEowc. Accessed 27 November 2013; "Yosemitebear Mountain Double Rainbow 1-8-10" *YouTube* (8 January 2010): http://www.youtube.com/watch?v=OQSNhk5ICTI. Accessed 27 November 2013.

9. André Gaudreault, *Film and Attraction: From Kinematography to Cinema*, trans. Timothy Barnard (Urbana: University of Illinois Press, 2011), 67.

10. *Ibid.*

11. Donald Crafton, *Before Mickey: The Animated Film, 1898–1928* (Chicago: University of Chicago Press, 1982), 37. See also http://www.topfferiana.fr/2010/10/arroseurs-arroses. Accessed 26 June 2014.

12. On the "bad boy" film, see Peter Krämer, "Bad Boy: Notes on a Popular Figure in American Cinema, Culture and Society, 1895–1905," in *Celebrating 1895: The Centenary of Cinema*, ed. John Fullerton (Eastleigh, UK: John Libbey Press, 1998), 117–130; and Tom Gunning, "Crazy Machines in the Garden of Forking Paths: Mischief Gags and the Origins of American Film Comedy," in *Classical Hollywood Comedy*, eds. Kristine Brunovska Karnick and Henry Jenkins (London: Routledge, 1994), 87–105.

13. See Crafton, *Before Mickey*, 37–44.

14. The routine involved a large box-like device, into which puppies would be dropped and sausages come out the other end. Earlier examples include *Charcuterie mécanique* (Lumière, 1896), *The Sausage Machine* (American Mutoscope & Biograph, 1897), and *Fun in a Butcher Shop* (Edison, 1901).

15. The "laughable little comedy" description is quoted in Charles Musser, *The Emergence of Cinema: The American Screen to 1907* (Berkeley: University of California Press, 1990), 141.

16. Indeed, Gaudreault is quite explicit on this point, claiming that "Lumière's kinematography was a continuation of photography." Gaudreault, *Film and Attraction*, 87.

17. See Matthew M. Hurley, Daniel C. Dennett, and Reginald B. Adams, Jr., *Inside Jokes: Using Humor to Reverse-Engineer the Mind* (Cambridge, MA: MIT Press, 2011), 121.

18. Vilém Flusser, *Writings* (Minneapolis: University of Minnesota Press, 2002), 23, 127; quoted and discussed in Mark Poster's introduction to Vilém Flusser, *Into the Universe of Technical Images* (Minneapolis: University of Minnesota Press, 2011), xvi.

19. What I have in mind are photos where widely accepted conventions of photographic representation are themselves violated, as in the case of other viral trends like awkward family photos, awkward prom photos, etc.

20. I am indebted to Paul Flaig for this observation.
21. Mary Ann Doane, *The Emergence of Cinematic Time: Modernity, Contingency, the Archive* (Cambridge, MA: Harvard University Press, 2002), 180.
22. Quoted in Stephen Bottomore, "1896: Ain't It Lifelike!" *Sight and Sound* Vol. 51, No. 4 (Autumn 1982): 295.
23. See, for example, my own *The Fun Factory*, as well as Steve Neale and Frank Krutnik's influential chapter "Hollywood, Comedy, and the Case of Silent Slapstick," in their *Popular Film and Television Comedy*, 96–131.
24. Doane, *The Emergence of Cinematic Time*, esp. ch. 6; Rob King, "The Discourses of Art in Early Film or, Why Not Rancière?" in *A Companion to Early Cinema*, eds. André Gaudreault, Nicolas Dulac, and Santiago Hidalgo (Malden, MA: Wiley-Blackwell, 2012), 141–162.
25. Ernst, *Digital Memory and the Archive*, 107.
26. I derive this list from Jane Gaines, "What Happened to the Philosophy of Film History?" *Film History: An International Journal* Vol. 25, No. 1–2 (2013): 74.
27. Doane, *The Emergence of Cinematic Time*, 180–181.
28. The term "comedification" is taken from John Limon's *Stand-up Comedy in Theory, or, Abjection in America* (Durham, NC: Duke University Press, 2000).
29. See Brett Mills's essay, "Comedy Verité: Contemporary Sitcom Form," *Screen* Vol. 45, No. 1 (2004): 63–78.
30. My term "managed irregularity" is adapted from Doane's description of the chase film as a genre that "subsum[es] individual irregularity beneath the rule of aggregate regularity." Doane, *The Emergence of Cinematic Time*, 192.
31. Charlie Keil, *Early American Cinema in Transition: Story, Style, and Filmmaking, 1907–1913* (Madison: University of Wisconsin Press, 2001), 85.
32. Notable other examples include *Curb Your Enthusiasm* (2000–present), *Extras* (2005–2007), *Life's Too Short* (2011), *Derek* (2013), *Summer Heights High* (2007), *Angry Boys* (2011), and *Ja'mie: Private School Girl* (2013), and *The Comeback* (2005, 2014).
33. See Matthew Moore, "Finger-biting Brothers Become YouTube Hit," *Telegraph* (5 December 2008): http://www.telegraph.co.uk/news/uknews/3564392/Finger-biting-brothers-become-YouTube-hit.html. Accessed 11 November 2013. And "Harry and Charlie Davies-Carr: Web Gets Taste for Biting Baby," *The Sunday Times* (1 November 2009): http://www.thesundaytimes.co.uk/sto/ingear/tech_and_net/article189173.ece. Accessed 11 November 2013.
34. "YouTube's 50 Best Videos," *Time* (29 March 2010): http://content.time.com/time/specials/packages/article/0,28804,1974961_1974925_1974954,00.html. Accessed 21 November 2013.
35. Megh Wright, "Jokes to Go: A Guide to Mobile Comedy," *Splitsider* (18 October 2012): http://splitsider.com/2012/10/jokes-to-go-a-guide-to-mobile-comedy. Accessed 14 October 2013.
36. On modularity and online humor, see David Gurney, "Recombinant Comedy, Transmedial Mobility, and Viral Video," *Velvet Light Trap* No. 68 (Fall 2011): 8–9.
37. The notion of "spreadability" is derived from Henry Jenkins, Sam Ford, and Joshua Green, *Spreadable Media: Creating Value and Meaning in a Networked Culture* (New York: NYU Press, 2013).
38. http://www.youtube.com/watch?v=CddMD3QqTFs. Accessed 18 October 2013.
39. *Ibid.*
40. *Ibid.*
41. Daniel Engber, "Why We Should Be Mad at Jimmy Kimmel," *Slate* (10 September 2013): http://www.slate.com/blogs/browbeat/2013/09/10/worst_

twerk_fail_ever_video_hoax_jimmy_kimmel_should_be_ashamed_
and_we_should.html. Accessed 21 October 2013.

42. http://www.youtube.com/watch?v=CddMD3QqTFs. Accessed 18 October 2013.
43. Casper Hoedemaekers, "Viral Marketing and Imaginary Ethics, or the Joke
 That Goes Too Far," *Psychoanalysis, Culture and Society* Vol. 16, No. 2 (2011): 176.
44. Predating YouTube, "Afro Ninja" is a classic Internet meme depicting a
 stunt man who attempts a back flip during an audition for a Nike com-
 mercial: http://www.ebaumsworld.com/video/watch/169. Accessed 19
 December 2013.
45. The point here is Hoedemaekers'. See "Viral Marketing and Imaginary
 Ethics, 174.
46. Ernst, *Digital Memory and the Archive*, 46.
47. *Ibid.*, 47.
48. "Animal-like" is from Umberto Eco, "The Frames of Comic 'Freedom,'" in
 Carnival!, ed. Thomas Sebeok (Berlin: Mouton Publishers, 1985), 2.

"the biggest kuleshov

experiment ever"

s i x t e e n

a conversation with guy maddin

about *séances*

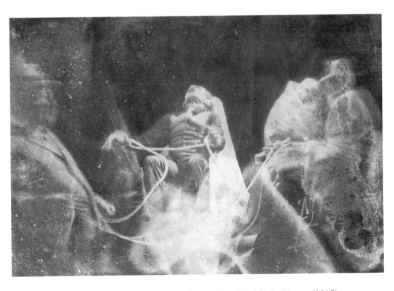

Figure 16.1 Image of cinematic *spiritisme* from Guy Maddin's *Séances* (2015).

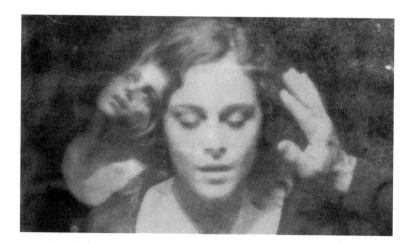

Figure 16.2 Images of cinematic *spiritisme* from Guy Maddin's *Séances* (2015).

In their 1932 manifesto, British filmmakers and critics Oswell Blakeston and Kenneth Macpherson demanded their readers go *"Back to Primitives!"* and transmute into "cine-psychics, cine-sensitives, cinemediums, clairaudients, clairvoyants."[1] Guy Maddin's *Séances* (2015) provides a spirited, twenty-first-century affirmation of this call to fuse primitive cinema with paranormal return. The Canadian filmmaker and self-admitted "primitive" has recently shot dozens of re-makes of lost, destroyed, or unrealized films from across cinema's history. Holding séances with actors, Maddin plays the role of medium, channeling the spirits of these films through his own surreal vision. Working with Evan Johnson, Maddin has assembled these films into two projects: a feature, *The Forbidden Room* (2015), and *Séances*, an online platform through which anyone can contact the ghosts of film history past. Throughout his now thirty-year career, Maddin has been consistently haunted by anachronistic film genres and styles, merging his own secret passions and family history with lurid melodramas and ancient myths. Inspired by the historical analogy between early cinema and the contemporary moment of online art, *Séances* does not simply resurrect lost films in reverential pastiche; rather, each singular visit channels multiple cine-spirits, producing randomly nested narratives further warped by simulated celluloid decasia, pixel datamoshing, and, finally, auto-destruction. One of the most inspired of artists making silent cinema anew, Maddin sees media through the haunted eyes of a medium. What follows is an edited transcript of a conversation between Guy Maddin and Paul Flaig, conducted on 5 January 2015 in Winnipeg.

In *My Winnipeg* you describe a séance conducted by prominent Winnipeggers of the 1920s as a "nocturnal confabulation" connecting their

present to a "world they expect to inhabit in the future." With *Séances* you connect our present digital world not to the future, but film's past and specifically to lost, destroyed, or never-made films. You have had this lost film project in mind for a long time. Could you describe its origins?

It is a long time. Although I don't think I had arrived on a séance metaphor until more recent times, until around the time of *My Winnipeg* (2007). The first time I consciously re-made a lost film, or what I thought was a lost film, was in 1994. I was commissioned by the BBC to shoot a four-minute filmic flight of fancy on any artist of my choice and I chose Odilon Redon. But I was thinking purely in plot terms; I didn't know how to make little reveries or meditations—I was just such a hard-wired melodramatist. I had recently become an Abel Gance fanatic and I really wanted to see *La Roue* (1923) and *La fin du monde* (1931), but all I could do was look at the Facets video catalog—there was no internet—and it just seemed like the movie was lost and I knew that there were other lost movies by canonical directors and I thought the only way I could ever see these things is if I just made them myself and watched them. I thought that would be a fun way to start, to take the basic love triangle of *La Roue*—all I had was a one paragraph synopsis of it—and shoot a version of it, but in the charcoal smudged, lithograph world of Odilon Redon and his Baudelaire illustrations. I made my own secret Abel Gance re-make of a lost film [*Odilon Redon or the Eye Like a Strange Balloon Mounts Toward Infinity* (1995)], four minutes long. Turns out it wasn't lost, it exists, and it's four hours long, so now I have my version and his version, four minutes and four hours. But the idea thrilled me, lost or not, of re-making films.

I was emboldened by what little I knew about that great Salome craze at the turn of the century when Strauss wrote an opera, Beardsley drew all these Salome illustrations for Oscar Wilde's play, Gustav Moreau painted a lot of Salome portraits. Every artist could do his or her own gloss on Salome and I thought, "Why can't we just treat these early cinema works as sacred texts and do our own version of them, whether it's a painting, a collage or a short movie?" I often just put on a short movie shoot the way Mickey Rooney and Judy Garland would put on a musical in a barn: "Hey kids, let's have a short this weekend and have some fun." So I knew exactly what to do when I got a commission from the Toronto International Film Festival in 2000 to make a five-minute tribute to the festival: I made my own version of *La fin du monde* [*Heart of the World*], which I thought was lost but isn't and used the same idea: I took the four-sentence plot synopsis and did my own version of it.

I found myself daydreaming that someday it would be nice to make a whole bunch of these. After I made *My Winnipeg* and IFC sold the DVD rights to some company that promptly went bankrupt and I realized my

movie was the only one not available on DVD in the world, I got tired of my films, which I know are for a very narrow slice of the demographic, just being slid on shelves instantly. My French distributors, ED Distribution, are really good: through this incredible amount of hard work they reach about as many of the people inclined to like my movies as possible. But it doesn't take an idiot to realize that the internet can do that in a few minutes, that it will reach everyone that might be inclined to like you sooner or later. It occurred to me around 2007 that my next project should be an internet project and maybe these lost movies would be it.

I'd hired Evan Johnson to help me research lost film titles because I've always hated the actual hard work of being anything but a dilettante. He really got into the project and he started making really strong conceptual suggestions and pretty soon instead of just being a researcher he became a writing partner and project partner and frankly he's thought about it way more than I have. I'm running breathlessly to catch up with him. We ended up working on it as an internet project and a feature film has resulted called *The Forbidden Room*, but what remained more important in my heart. I hope the internet project is going to reach some people, that some critics find it intriguing. I have a frank and hilarious relationship with Noah Cowan, one of the former directors of TIFF and now the director of the San Francisco Film Society, and I was telling him about my hopes to make this kind of art on the internet and he said, "Art on the internet is impossible." I think he would retract that statement now, but it occurred to me that kind of dismissive remark was made about cinema exactly a hundred years earlier and look where we are now. It's like he slapped me with a pair of gauntlets.

What was the research process for this spectral history of cinema? How did you come to choose the diverse set of films featured in *The Forbidden Room* and on the *Séances* site, directed or conceived by von Stroheim, Mizoguchi, Weber, Dovzhenko, among others far less well known?

They weren't very diverse at first. They were just, "Hey, let me see if Alfred Hitchcock has any lost films." Yeah, he does: *The Mountain Eagle*, his first one is lost. "Hey, let me see if D.W. Griffith has any." Yeah, sure: *The Greatest Thing in Life*, his apology for the racism in *Birth of a Nation* (1915). "Let me see if Murnau or Lang have any . . ." So I assembled this dream list of films. The list of films I wanted to make was impressive, but then I just looked at it and the list was a bunch of white males, the usual suspects, and so by that point Evan asked Bob Kotyk, another former student of mine, to come on board. So the three of us spent a lot of time looking into crevices a little bit more and we discovered that in the early years of cinema almost every country, almost every gender, almost every budget level, almost every decade of film history, every religion, has its lost films, and that films get

lost for a number of different reasons and that the definition of "lost" is, as [Henri Lefebvre's book] *The Missing Pieces* very ambitiously and exhaustively illustrates, amorphous.[2]

I first started to stretch my definition of what's lost by drooling over a list of Jean Vigo's unrealized films and my quick rationalization was, "Well, we lost Vigo too early so these are lost films, the ones he didn't make." Who knows if he would have made them; every filmmaker has a list of projects where they go "Eh, I'm not making that, that's terrible. I have no interest in making that even though I jotted that down." Perhaps none of those Vigo films would have ever been made even if he had lived to be ninety. But I saw a couple that seemed like real primo Vigo stuff and asked Luce Vigo, his daughter, and she gave me permission—I don't even know if permission is needed—and her blessing and that was important before shooting his unrealized film, *Lines of the Hand*.

That started the idea of including unrealized pictures. I started to look up all these cool, at first canonical directors' unrealized projects and then I discovered this actress/producer, Haydée Chikly, from Tunisia, and her film about a woman fighting an arranged marriage and therefore her own cultural traditions. Her film was lost and for all I knew she was lost. A lot of Soviet filmmakers disappeared in the Stalinist era because their films didn't quite measure up, or because of ideological problems, or because Stalin just felt like it. And there were a bunch of Cambodian films made in the seventies destroyed by the Khmer Rouge, their makers executed. There was a script by the blacklisted screenwriter, Edward Chodorov, called *The Lynching of Elizabeth Taylor*—a fantastic title and I like to picture this violet-eyed beauty staring down her lynch mob but it was a different Elizabeth Taylor—that was never shot because of the political climate in America. And then you start thinking of all the marginalized races in various countries: African-Americans, Native Americans, Canadians that never got to make any films at all. What's lost because of genocides? You start thinking like a Roman Catholic, who thinks of heaven as holding the souls of the dead and the unborn in this big murk. I'm an atheist, but I start believing in ghosts when I'm holding a camera in my hands. I like the idea of these less famous and maybe even utterly unnamed projects that are all just existing in limbo, waiting to be brought down. You find out that in the first couple decades of film that film was almost considered women's work by a lot of people and so there are a lot more female directors in the first couple decades, maybe as many as there are now, but in the intervening century there were virtually none. Just studying the evidence of lost films is like studying the films that exist, a history of the twentieth century, of our gender attitudes, racial attitudes, class attitudes, it's all there and globally too.

In the "Arrival" section of the *Séances* website you remind visitors that approximately "80% of films made in the silent era are lost forever." Yet

in contrast to so many historians, theorists, and found footage artists, *Séances* does not dwell so much on films as fragile, ephemeral, or decaying matter, but rather as ectoplasm, haunting spirits a filmmaker or spectator might contact and reanimate.

Each film has a spirit. Although I'm not a spiritual person, there was a central metaphor of séance that I used just to help justify the project, but I started to believe it. If you repeat your own bullshit often enough you actually find out that the reason you bullshitted in these exact words is that on some level it is true to you. You start to believe it and then you realize, you're not just believing in your own bullshit—it's actually true! Movies are often described as having no known final resting place and that's a terminology often used to describe missing people. There's no closure and their remains are buried—if they're buried—outside the churchyard, that's for sure. So ghost stories describe unhappy spirits that just need closure in their spirit lives to be at rest. I started thinking of these lost movies as movies with no known final resting place or maybe they are out there and can be saved, but right now they are doomed to wander the landscape of film history unhappily unable to project themselves for people who might see them. The best way to see them would be through a séance, so as to contact these unhappy spirits.

Conveniently enough the word "séance" just means a seating. In France it has come to mean a seating in the dark in front of a movie screen. Here in North America it has long meant a seating in the dark to see some kind of projection of something that no longer is. You could easily argue that a movie is a projection of something that no longer is because within seconds of a picture being taken of someone that exact someone no longer is, they're already changing. In both séances, on the yonder side of the Atlantic and ours, it's the same thing: it's a bunch of people gathering together in the dark, sitting down and wanting to be enchanted, wanting to believe in what they see before their eyes for a short duration and then the lights come on. In both cases, the medium is a mountebank: a director or the paranormal medium. They are a mountebank that people want to believe in for a while and then everyone goes home and talks about how much they bought it, how enchanted they were by the whole thing, how taken by it they were. In other words, they're virtually the same thing, the paranormal séance and the movie séance. People have long described movies as dreaming in the dark, but it is a kind of believing in the dark too. The metaphors aren't at odds with each other; they're pointed in the same direction.

The séance was a convenient way of taking my once glib assertion, "If I want to see these lost films, I'll have to make them myself," and suddenly realizing that since all filmmakers are mountebanks and mediums for what is in their head and what they want to put in the heads of their viewers, that just like a paranormal séance medium they want to show people

what they want to see without realizing it, I had a very neat and tidy rationale for just re-making my movies as séances. I liked the idea of just taking it upon myself to re-make these things and I could call them the spirits of my mountebank's interpretation of the spirit of these films. That gave me the excuse not to imitate Murnau, Lang, Sternberg and other inimitable gods and just represent my own shabby, backroom fortune-teller's version. They could be as shabby as all my other movies because I am just the crappy medium.

There is also the double meaning of "medium," which connotes both a spiritual go-between as well as the singular of "media." In combining these senses of medium—a huckster spiritualist and digitally reanimated, online display of originally analog films—you suggest no easy translation from one space or time to another, since in-between stands the filmmaker or audience's projections.

That's all I could be. Everyone has finally figured that out about documentary filmmaking or about any medium. A security camera is unreliable, it is representing one point of view of something. The instant you represent something you've commenced a partially dishonest process. It's a medium and gloriously subjective. It ain't mathematics.

You've mentioned one inspiration for *Séances* as a specifically web-based project: the echo of cinema's initial dismissal heard in contemporary suspicions of online art. *Séances* doesn't simply allow its visitors to point, click, and watch a particular summoning from start to finish, but rather makes each visit to the site absolutely singular. Can you describe how the site works?

There is a website version, but there is also an app for a tablet or smart phone. You are basically doing the internet equivalent of sitting down in a dark room, contacting the spirit of a lost film. Individual films are put into a program and get broken up into fragments. You get a fragment of these films we shot, which are fifteen to twenty minutes long, and then the fragment will be interrupted as the strength of the signal from this lost spirit gets pushed aside by another unhappy spirit that's eager to talk to you for a while and then by another and then another one. Then there are weak spots where things will flare up from the narrative going on beneath or some other place, maybe even an interruption from YouTube or from some other website will come in as things clamor for attention up in the Cloud. And then you slowly work your way back and get at least one more visit from the interrupting signals. It is a fifteen-minute experience of these narrative fragments.

By using cookies the program keeps track of what the viewer has seen so far and can increase the likelihood of the viewer seeing not just

321

a fragment, but, if they visit enough, seeing the entire lost movie. But it will be different every time they see the film because there are constantly changing intertitles as well as dialogue (these lost, silent films are allowed to talk). As mediums, Evan and I can make the relationship between characters confused so that the people who are lovers in one visit to the app might become brother and sister, or father and daughter next time. The storyline, which might be a baron in need of a gardener, might become a revolutionary meeting with a counter-revolutionary. The stories are rewritten drastically by us as the charlatans that we are. There are alternate versions put up there and, in the biggest Kuleshov experiment ever, there are different props, different scores, different color timing, sometimes in full color, sometimes in a really skewed pallet, sometimes in black and white but tinted. There are countless variables for each movie so that you quickly have, at thirty movies, around one million permutations, enough combinations so that a visit to the website produces a viewing experience that is actually given its own unique title. The first title generated in our test was *Wise Trumpets of the Milky Midnight* (figure 16.3). But no sooner is that title generated and the viewing experience created then it is destroyed and never seen again. So the interactive actually creates a movie out of lost film materials, then destroys and loses it again. I'm hoping that a certain non-sequitur component can now and then create interesting material— and we can stack the odds a little bit—but that material will then be lost. Now I can't stop people from shooting it from their iPhone, but it will be some inferior facsimile and it will still be something more special in the moment. I'm hoping it will be something more like what theater is supposed to be like, but never is: great and ephemeral. We've toyed with the idea of making it a communal experience, where you'd go online and you'd have to wait for two or three other people to share the séance with you and as they inevitably got bored and check their e-mail, the signal would get weaker, as people unclasp their hands from you. That outtakes involving flubbed lines or hanging boom mics would be swapped in at that point and the signal would start degrading in interesting ways, in both analog emulsion decasia and also in digital pixel datamoshing.

The feature film we've made out of it is called *The Forbidden Room*, which is named after a long-lost Allen Dwan picture—just what the world has been clamoring for. Another great career move. "We want more Allen Dwan!" He only made four hundred features in a career no one is interested in. Although he did have a partial retrospective at MoMA recently, he's no household name. We did get John Ashberry to write one of the pieces in it, *How to Take a Bath*.

I have been perceived to be a faux film pioneer, like someone pretending to go back in time and make old-timey movies. In reductive terms you could easily say that and at one point I even saw myself as that and thought, "Geez, I'll have to make one film of every genre and work my way through

Figure 16.3 The very first randomly generated title in *Séances* (Maddin, 2015).

every step in film history." But I know with *Séances* that I actually feel like a real pioneer. I can't monetize it, but like all other internet pioneers they had no idea how to monetize either. I know people won't watch *Séances* in large numbers, but I feel like a pioneer, I am trying to figure out how to make art on the internet. My favorite idea of the project is losing the work because it is a reaction against the documentation of everything and I like the idea of just losing things again. That's where it is a hybrid between film and internet. Now you get to be lost, time to start losing.

In many of your features prior to *Séances*, the more you moved into the subjective, personal, or autobiographical, the deeper you reached into film history. In the loosely autobiographical trilogy of *Cowards Bend the Knee* (2003), *Brand upon the Brain* (2006) and *My Winnipeg* (2007) you adapted a range of silent film conventions, references, and techniques, ranging from empurpled intertitle prose to expressionist lighting to benshi-like narration. The more Guy Maddin became a character in your films, the more film history cloaked that character in its earliest forms, perhaps similar to the way you act as medium in the séances of filming or screening lost films.

323

My entire film career has been informed by pragmatic concerns, right away. What separated me from a lot of the members of the Winnipeg film group when I first started is that I knew I could never be technically or financially strong enough to make the films they dreamt of making. They wanted to make *Star Wars* (Lucas, 1977). My only hope is to make inevitably primitive technical accomplishments; with directing of actors and the art department, everything is going to be shabby. I had seen enough,

I hadn't seen many, but I had seen *L'Age d'or* (Buñuel, 1930), *Un Chien Andalou* (Buñuel and Dali, 1929) and knew that limitation could be turned into an incredible strength. So my first few films tried to turn my blatant weaknesses into strengths. I had a choice at that point whether to work on my weaknesses or to indulge them more and I guess it was just easier to indulge them more. I briefly strayed from that in the mid '90s with my feature, *Twilight of the Ice Nymphs* (1997), where my producer made me shoot in 35mm, full color, taking me closer to the mainstream, but I wasn't ready yet. I didn't have the right script to make a crowd-pleasing movie and didn't have the freedom to pick up the camera and just be primitive and see where it took me. I retreated into Super 8 movies and quickly fell in love with Super 8. Because the cameras make so much noise but also are so cheap and I wanted to make a movie in a hurry I made *Cowards Bend the Knee*, the first of those you mention. I wanted to make a movie quickly and cheaply, just let what few sets I had be lost in shadows and film grain.

I also had lost myself by feeling like I didn't have anything to say. Shortly before making *Cowards Bend the Knee*, I read some Euripides hoping to find some ancient, really durable story to adapt. I thought, "Well, Euripides is still on the bookshelves after 2500 years, maybe there is something there." So I read *Electra* and *Medea* and I thought "Wow, I've just been through a relationship that's basically the *Electra* story except instead of being Electra's brother, Orestes, I was Electra's boyfriend." But all the other characters were there. I didn't mean to make it so autobiographical, but I just identified with it on a one-to-one correspondence, point by point. And I shot the movie with all sorts of other character names; my name was going to be Fran Huck, which was the name of my favorite hockey player when I was a kid. But all along I thought of it as me. It could enable me to be more masochistic and more honest and I just got to beat myself up properly until I felt I had been punished almost enough and saved some punishment for the next film. During the editing, I put my name on it, which felt ultra liberating. I'm such a slow learner. I had already been making films for fifteen years. I finally understood how authors access their own feelings and then disguise them.

Describing the ways you've disguised yourself in your films, you appeal to certain forms: tragedy, myth, melodrama. Do you find that there are certain moments in film history particularly loaded with mythological stuff or matter? That they, like your films, seem primitive, but not in the sense of being incompetent or unprofessional, but in the sense of being anthropologically or autobiographically primitive, somehow close to origins and first causes? Does a medium's childhood resonate with your own childhood, whether it be silent films, early talkies, or 1950s' TV shows like the fictional **Ledge Man** featured in **My Winnipeg**?

Figure 16.4 A spirit extracted from actress Maria de Medeiros in *Séances* (Maddin, 2015).

Figure 16.5 Digital distortion and simulated decasia in *Séances* (Maddin, 2015).

One example is from early television, with what seems to be one of my earliest childhood memories: I could have sworn I was watching, over and over again, a daily TV show like *Ledge Man* where someone goes out on a window ledge and threatens to jump. I remember watching on the couch this long process of someone wanting to jump and then being talked back in eventually. It turns out there was a 1950s' movie starring Richard Basehart called *Fourteen Hours* (Hathaway, 1951) about a man going out on a ledge, but what happened was Twentieth Century Fox took a lot of its movies and re-made them as TV shows and that was one of them. That's probably what I watched as a three-year-old with my parents on the couch. I was just trying to cull

up mythic memories for *My Winnipeg* and I don't know why I latched onto that one but it just seemed like a good idea. I know in the early days of television, TV was often live, especially locally, that it didn't start until lunch time, that there were fifteen-minute-long shows at lunch, all sorts of weird programming things for someone my age, who was coming into the world at the same time TV was really taking root. It was Wayne Koestenbaum, in an essay he wrote for the Criterion edition of *My Winnipeg*, who pointed out something I had never thought of, but I think it is the way myths work.[3] He thought that *Ledge Man* was, as a daily TV show, postponing my brother's suicide every day, instead of there being a sudden suicide. I remember hearing about my brother's suicide while lying on that same couch. All day long while my brother wasn't coming home I was reassuring my parents while watching TV, while watching *Third Man on the Mountain* (Annakin, 1959), while watching *A Member of the Wedding* (Zinneman, 1952), [saying] "Oh, he'll come home." And then the doorbell rang and the police came and I was in that same position when I watched *Fourteen Hours*.

You can only speculate about myths and what they meant to you, but it's a good example of how I work instinctively, I grab things and by the time they have settled in to their places and by the time I finish talking about them, by the time I finish editing and shooting them they do become plausible glosses on something that really matters to me. So my own history and my own pre-history seems more universal when it's a *Song of Roland* or a *Mahabarata* or an Old Testament story or Euripides, they just seem more durable. Those early cinema pieces, especially the lost ones, seem more primal and so mythically powerful. They're probably boring, ninety-nine percent of them are probably horrible for all I know, but they just sound so intriguing and tantalizing when you're reading little trace elements. My mom is still alive, she was born in 1916. At least half of the lost films were made after she was born, during my mom's lifetime. If she could remember who I was she might even have seen them and been able to tell me about them. They are not as ancient as the Dead Sea Scrolls or Euripides, but they seem ancient because they are the earliest form and then we have our own dawn of existence, which seems ancient.

It would be a mistake to think that you are simply recreating older films, as a pastiche of some stable set of film conventions taken from the past into the present. You seem to instead focus on thresholds between arts, with film entering into conversation with antecedents like spirit photography, early contemporaries like symbolist painting, competitors like television, or descendants like the internet. And there are film's own historical tensions and transformations, from silence to sound, black and white to color, celluloid to pixel.

Film more than any other art form is probably closer to a perfect hybrid of art and industry. Authors still try to sell books and painters were

usually working, at certain points in the history of painting, under the patronage of wealthy people. So it's not the only art form affected by money, but film occupies a special place because of its industrial haste to sell products to people with fast-changing tastes. Trends changed faster in film than they did in painting or writing and you can identify a film by year, from any film in film history you can probably make a pretty good guess, if you are a film buff, about what year it was made. Everyone talks about how silent film vocabulary was still expanding when in its industrial haste the move to sound seemed inevitable. The technology was there to make talking pictures when Edison shot *The Sneeze* (1894), but it was just a matter of economics, of demand and supply and suddenly, in Hollywood's industrial haste, the conversion to sound was made. In this haste, perfectly robust vocabulary units are continually tossed overboard and left on the roadside of film history, so I've always felt: why not go back and re-use them? Painters are always re-purposing techniques, have been referencing the past for centuries, millennia. For the entire time movies have been on the earth, modernist and post-modernist writers have been re-cycling things, so why can't you use these vocabulary units to your advantage? I was first inspired by [Josef] von Sternberg's sparse use of intertitles in *Scarlett Empress* (1934). He has a full talking picture, but he has the odd intertitle in there. Why not mix them up? Video artists have been doing it since the invention of the video camera, ad nauseam almost.

You are attracted to the moments when cinema, in its "industrial haste," stumbles, where odd juxtapositions or anachronistic collisions in form, technology, or story interrupt some future step forward in film history.

I like mistakes. One of the great inspirations was just watching my daughter when she was little. I became a father at age twenty-one. I watched her make art quickly and if she made what adults consider a mistake she'd turn it into a super heart-breaking strength in her work. It took Cy Twombly probably forty years to be able to draw like a child. I'm bored by the pace on film sets. I can work quickly and make mistakes, but I am delighted by the mistakes. I was watching *Sans Lendemain* (1939), an early Max Ophüls movie and he's not a sloppy filmmaker, he's unbelievably meticulous. But in *Sans Lendemain* he wanted to close in the mise-en-scène a little bit by double exposing veils in the foreground on some of his stationary shots, but at one point the double exposure slopped over into one of his tracking shots so there is a veil sitting there perfectly still while the camera is moving underneath and I guess by the time it was processed they had the choice to either not use the shot at all or to include it and hope to get away with it. There's this rare sloppy moment, a mistake by

Max Ophüls, which is unbelievably exciting to see because all of a sudden it's like Oscar Micheaux or Ed Wood. Every frame of work by those two geniuses calls attention to its manufacture, to its artificiality. All of a sudden when Max Ophüls does that it's like a brief cameo by Micheaux. For someone looking for ever-new flavors in the film viewing experience that was exciting to me. The industry has made mistakes too and those are exciting: that abortive move to 3D in the '50s, which just produces headaches and blood clots, those weird formats of film—9mm films, 65mm films, Todd AO, that gorgeous early 70mm film with John Wayne [*The Big Trail* (Walsh, 1930)], Gance's polyvisions, all these things impossible to now see properly. When they are presented to us they are something less rather than something more because they are all crammed in. It's just a way of going back in time.

Maybe that can be traced to my peculiar family history, where I am by far the youngest child and at the dawn of my memory I have this suicide. I didn't like reading because I was dyslexic, but I was left with a big stack of family photo albums, all in black and white, that go back not just to the years immediately before my birth, when I had three happy siblings, all alive, and younger parents without bald spots and wrinkles, packed into a station wagon that no longer existed going to places all over America whereas I just stayed at home and watched TV. But I had all these vacuum-sealed hours at home alone with these photo albums, imagining how wonderful the pre-history was. The photo albums went back to the late nineteenth century even and I could figure out these storybook-like people who only existed in black and white. It was really hard to reconcile my real-life loved ones with their black-and-white youthful versions of themselves in two dimensions. I was always trying to place myself in the great flow of time and all I had to go by was these photo albums and then by extension television and then as I got older, movies and movie history, pop culture history, records, but all that stuff I enjoyed always in terms of how old my mother was or whether my brother was born yet when this or that came out. The fact that I inherited my brother's bedroom the instant he was reported dead. I actually occupied this space and fantasized that I had become him and fantasized, like so many children, how sad everyone would be if I were dead. My brother is exactly ten years older than me so I sort of know how old he would look now had he lived. I played all these great flow of time games with myself. When I finally started looking at film properly, as an adult at age twenty-four, when I met all my film buff friends, I was already fully formed, heart-throbbingly obsessed with time. I wasn't nostalgic necessarily, although I was, but it was a beyond nostalgia. Strangely I didn't even love my relatives as much in the present as I should have. I was loving the idea of them and found it easier to love them once they were dead. Once my dad died I was really able to

dedicate myself to loving him. Once my aunt Lil and my grandmother died I was able to love them, dream about them, and turn those dreams into movies. It's a real self-centered way, almost like an '80s video artist self-centered way—which is the worst kind—of loving other people, which is through your own self-love.

note

1. Oswell Blakeston and Kenneth MacPherson, "We Present—A Manifesto! And a Family Album (Pre-War Strength)," *Close-Up* Vol. 9, No. 2 (June 1932): 92–93.
2. Henri Lefebvre, *The Missing Pieces*, trans David L. Sweet (Cambridge, MA: MIT Press, 2014).
3. Wayne Koestenbaum, "My Guy's winnipeg," Criterion.com (20 January 2015): http://www.criterion.com/current/posts/3937-my-guys-winnipeg. Accessed 4 July 2015.

contributors

Rick Altman is Professor Emeritus of Cinematic Arts and Comparative Literature at the University of Iowa. His monographs include *The American Film Musical* (Indiana, 1987), *Film/Genre* (BFI, 1998), *Silent Film Sound* (Columbia, 2004), and *A Theory of Narrative* (Columbia, 2008). He is also editor of *Sound Theory, Sound Practice* (Routledge, 1992) and co-editor, with Richard Abel, of *The Sounds of Early Cinema* (Indiana, 2001). Since 1998 he has performed his Living Nickelodeon, a recreation of short programs from the early cinema era, at conferences, museums, festivals, and universities around the world.

Constance Balides is Associate Professor of Communication and Director of Film Studies at Tulane University. She has published widely on women and early cinema, feminism and film history, and contemporary film and post-Fordism in collections and journals, including *A Feminist Reader in Early Cinema* (Duke, 2002), *American Cinema's Transitional Era: Audiences, Institutions and Practices* (California, 2004), *Screen, Camera Obscura*, and *Signs*. She received the Society for Cinema and Media Studies Pedagogy Award in 2013.

James Leo Cahill is Assistant Professor of Cinema Studies and French at the University of Toronto and is a co-editor of *Discourse: Journal of Theoretical Studies in Media and Culture*. His writing on French cinema, experimental media, theory, and animals appears in the journals *Discourse*, *Ecce* (Japanese), *Framework: The Journal of Cinema and Media*, *Journal of Visual Culture*, *Kunstforum International* (German), *Spectator*, and *Zarez* (Croatian), in the anthologies *Screening Nature* (2013) and *Animal Life and the Moving Image* (BFI, forthcoming 2015), and in numerous artist's catalogs and gallery texts. He is presently completing a manuscript on Jean Painlevé, Geneviève Hamon, and Cinema's Copernican Vocation.

Brianne Cohen is visiting Assistant Professor of Contemporary Art History at Amherst college. From 2012–2015, she had a post doctoral fellowship at the Université catholique de Louvain and Lieven Gevaert Research Centre for Photography in Belgium. She is a co-editor of *Photofilmic Images in Contemporary Art and Visual Culture* (forthcoming 2015). She is currently working on a book manuscript, provisionally titled *Europe in Common: From Spectatorship to Collectivity in Contemporary Art*.

Jonah Corne is Associate Professor in the department of English, Film, and Theatre at the University of Manitoba. His articles on silent film, digital spectatorship, ruins, among other topics, have appeared or are forthcoming in *Literature/Film Quarterly*, *Film International*, *College Literature*, *Criticism*, and the anthology *Thinking in the Dark: Cinema, Theory, Practice* (Rutgers University Press, forthcoming October 2015).

Paul Flaig is Lecturer of Film and Visual Culture at the University of Aberdeen. His articles have appeared in *Cinema Journal*, *Screen*, *a: the journal of culture and the unconscious*, *The Brecht Year Book* as well as several edited collections. He is currently preparing a manuscript on receptions and re-appropriations of American slapstick film in Weimar Germany, based on his doctoral research.

Katherine Groo is Lecturer of Film and Visual Culture at the University of Aberdeen. Her articles have appeared in *Cinema Journal*, *Framework*, and *Frames*. She is currently completing a book entitled *Bad Film Histories: Ethnography and the Early Archive* (University of Minnesota Press, forthcoming), which explores early ethnographic films and what these visual artifacts mean for film history, historiography, and the archive.

Brian R. Jacobson is Assistant Professor of Cinema Studies and History at the University of Toronto. He is the author of *Studios Before the System: Architecture, Technology, and the Emergence of Cinematic Space* (Columbia University Press, 2015) and essays in *Film History*, *History and Technology*, *Early Popular Visual Culture*, and *Amodern*.

Rob King is Associate Professor in the Film Program at Columbia University, where he is working on a study of sound slapstick and Depression-era mass culture. He is the author of *The Fun Factory: The Keystone Film Company and the Emergence of Mass Culture* (University of California Press, 2009) and co-editor of the volumes *Early Cinema and the "National"* (John Libbey, 2008), *Slapstick Comedy* (Routledge, 2011), and *Beyond the Screen: Institutions, Networks and Publics of Early Cinema* (John Libbey, 2012).

Guy Maddin is an internationally acclaimed Canadian filmmaker, installation artist, and author. His extensive body of work includes *Tales from Gimli Hospital* (1988), *Archangel* (1990), *Careful* (1992), *The Saddest Music in the World* (2003), *My Winnipeg* (2007), and *The Forbidden Room* (2015). Both his feature-length and short films resurrect the codes and conventions of silent and early sound cinemas as well as a host of other media and artistic traditions. His most recent project, *Séances* (2015), brings his experiments with old media online. He teaches at the University of Manitoba and his writing has appeared in *Film Comment*, *The Village Voice*, and the collection *From the Atelier Tovar: Selected Writings of Guy Maddin* (Coach House, 1999).

Jennifer Lynn Peterson is Associate Professor in the Film Studies Program at the University of Colorado Boulder. She is the author of *Education in the School of Dreams: Travelogues and Early Nonfiction Film* (Duke University Press, 2013). Her articles have appeared in *Cinema Journal*, *Camera Obscura*, and *The Moving Image*, as well as anthologies such as *A Companion to Early Cinema* (Wiley-Blackwell, 2012) and *Learning with the Lights Off* (Oxford, 2012).

Brian Price is Associate Professor of Film and Visual Studies at the University of Toronto. He is the author of *Neither God nor Master: Robert Bresson and Radical Politics* (University of Minnesota Press, 2011), and co-editor of two anthologies, *On Michael Haneke* (Wayne State University Press, 2010) and *Color, the Film Reader* (Routledge, 2006). Along with John David Rhodes and Meghan Sutherland, he is a founding co-editor of *World Picture*.

Catherine Russell is Professor of Film Studies at Concordia University. She is the author of *Classical Japanese Cinema Revisited* (Intellect, 2011), *The Cinema of Naruse Mikio: Women and Japanese Modernity* (Duke, 2008), *Narrative Mortality: Death, Closure and New Wave Cinemas* (University of Minnesota, 1994), and *Experimental Ethnography: The Work of Film in the Age of Video* (Duke University, 1999). She has edited special issues of *Camera Obscura* and *Framework* and has published articles in numerous collections and journals, including *CineAction!*, *Jump Cut*, and *Transformations*.

Paolo Cherchi Usai is the Senior Curator of Motion Pictures at the George Eastman House. He is co-founder of the Pordenone Silent Film Festival and

of the L. Jeffrey Selznick School of Film Preservation. He is the author of *The Death of Cinema* (BFI, 2001), *David Wark Griffith* (Il Castoro, 2008), and *Silent Cinema: An Introduction* (BFI, 2000). He also directed the experimental feature film *Passio* (2006).

Yiman Wang is Associate Professor of Film and Digital Media at the University of California, Santa Cruz. She is the author of *Remaking Chinese Cinema: Through the Prism of Shanghai, Hong Kong, and Hollywood* (Honolulu, HI: University of Hawaii Press, 2013). She is currently working on two book projects: one on Anna May Wong and the other on animality in cinema. Her articles have appeared in numerous journals and edited collections, including *Quarterly Review of Film and Video, Film Quarterly, Camera Obscura, Journal of Film and Video, Literature/Film Quarterly, Positions: East Asia Cultures Critique, Journal of Chinese Cinemas, A Companion to Chinese Cinema* (Wiley-Blackwell, 2012), *The Oxford Handbook of Chinese Cinemas* (Oxford, 2013), *Silent Cinema and the Politics of Space* (Indiana, 2014), and *Sinophone Cinemas* (Palgrave, 2014).

Joshua Yumibe is Associate Professor and Director of Film Studies at Michigan State University. He is the author of *Moving Color: Early Film, Mass Culture, Modernism* (Rutgers, 2012), co-author of *Fantasia of Color in Early Cinema* (Amsterdam, 2015), and the co-director of the Davide Turconi Project.

about the american

film institute

The American Film Institute (AFI) is America's promise to preserve the history of the motion picture, to honor the artists and their work, and to educate the next generation of storytellers. AFI provides leadership in film, television, and digital media and is dedicated to initiatives that engage the past, the present, and the future of the motion picture arts. The *AFI Film Readers Series* is one of the many ways AFI supports the art of the moving image as part of our national activities.

AFI preserves the legacy of America's film heritage through the AFI Archive, comprising rare footage from across the history of the moving image, and the *AFI Catalog of Feature Films*, an authoritative record of American films from 1893 to the present. Both resources are available to the public via AFI's website.

AFI honors moving image artists and their work through a variety of annual programs and special events, including the AFI Life Achievement Award, AFI Awards and AFI's 100 Years . . . 100 Movies television specials. The AFI Life Achievement Award has remained the highest honor for a career in film since its inception in 1973; AFI Awards, the Institute's almanac

for the twenty-first century, honors the most outstanding motion pictures and television programs of the year; and AFI's 100 Years . . . 100 Movies television events and movie reference lists have introduced and reintroduced classic American movies to millions of film lovers. And as the largest non-profit exhibitor in the United States, AFI offers film enthusiasts a variety of events throughout the year, including AFI Fest, the longest-running international film festival in Los Angeles; and AFI Docs, a five-day international documentary film festival that takes place at landmark venues in Washington, DC and the world-class AFI Silver Theatre, the independent film hub of the metropolitan region. The AFI Silver Theatre also offers year-round programming in the Washington, DC metro area.

AFI educates the next generation of storytellers at its world-renowned AFI Conservatory—named the number 1 film school in the world by *The Hollywood Reporter*—offering a two-year Master of Fine Arts degree in six filmmaking disciplines: Cinematography, Directing, Editing, Producing, Production Design, and Screenwriting.

Step into the spotlight and join other movie and television enthusiasts across the nation in supporting the American Film Institute's mission to preserve, to honor, and to educate by becoming a member of AFI today at AFI.com.

American Film Institute

Robert S. Birchard
Editor, *AFI Catalog of Feature Films*

index

Page numbers in *italics* indicate illustrations

341

index

index

349